The Iconology of Abstraction

This book uncovers how we make meaning of abstraction, both historically and in present times, and examines abstract images as a visual language.

The contributors demonstrate that abstraction is not primarily an artistic phenomenon, but rather arises from human beings' desire to imagine, understand and communicate complex, ineffable concepts in fields ranging from fine art and philosophy to technologies of data visualization, from cartography and medicine to astronomy.

The book will be of interest to scholars working in image studies, visual studies, art history, philosophy and aesthetics.

Krešimir Purgar is Associate Professor in the Academy of Arts and Culture at J. J. Strossmayer University, Osijek, Croatia.

Cover image: Ryoji Ikeda, *micro | macro*, Carriageworks, Sydney, 2018. Image: Zan Wimberley, courtesy of Ryoji Ikeda Studio.

Routledge Advances in Art and Visual Studies

This series is our home for innovative research in the fields of art and visual studies. It includes monographs and targeted edited collections that provide new insights into visual culture and art practice, theory, and research.

The Iconology of Abstraction

Non-figurative Images and the Modern World

Edited by Krešimir Purgar

Routledge
Taylor & Francis Group

NEW YORK AND LONDON

First published 2021
by Routledge
52 Vanderbilt Avenue, New York, NY 10017

and by Routledge
2 Park Square, Milton Park, Abingdon, Oxon, OX14 4RN

Routledge is an imprint of the Taylor & Francis Group, an informa business

© 2021 Taylor & Francis

Library of Congress Cataloging-in-Publication Data
Names: Purgar, Krešimir, editor.
Title: The iconology of abstraction: non-figurative images and the modern world/Krešimir Purgar.
Description: New York: Routledge, 2020. |
Series: Routledge advances in art and visual studies |
Includes bibliographical references and index.
Identifiers: LCCN 2020003658 (print) | LCCN 2020003659 (ebook) |
ISBN 9780367206048 (hardback) | ISBN 9780429262500 (ebook)
Subjects: LCSH: Visual metaphor. | Abstraction. | Art, Abstract.
Classification: LCC P99.4.V57 I29 2020 (print) | LCC P99.4.V57 (ebook) |
DDC 302.2/26–dc23
LC record available at https://lccn.loc.gov/2020003658
LC ebook record available at https://lccn.loc.gov/2020003659

ISBN: 978-0-367-20604-8 (hbk)
ISBN: 978-0-429-26250-0 (ebk)

Typeset in Sabon
by Deanta Global Publishing Services, Chennai, India

Contents

Figures

Contributors

Michael Betancourt is Professor of Motion Media Design at the Savannah College of Art and Design, Georgia, USA. His writings have been translated into Chinese, French, Greek, Italian, Japanese, Persian, Portuguese and Spanish. His publications include the books *The History of Motion Graphics* and *The Critique of Digital Capitalism*, and articles published in *The Atlantic*, *Make Magazine*, *CTheory* and *Leonardo* that complement his movies, which have been screened internationally at the Black Maria Film Festival, Art Basel Miami Beach, Contemporary Art Ruhr, Festival des Cinémas Différents de Paris, Anthology Film Archives and Millennium Film Workshop, among many others. His archive is michaelbetancourt.com

Linn Burchert is a postdoctoral researcher at the Institute of Art and Visual History at Humboldt University in Berlin, Germany. From 2014 to 2017, she was a research associate and doctoral candidate in the Department of Art History at the Friedrich Schiller University in Jena. Her dissertation *Das Bild als Lebensraum. Ökologische Wirkungskonzepte in der abstrakten Kunst, 1910–1960* (2019) investigates ecological concepts in abstract modern painting. Her published essays have treated topics including concepts of nature and rhythm in modernity as well as theories of reception and artistic production.

Silvia Casini is Lecturer in Visual Culture and Film at the University of Aberdeen, Scotland. She studies the aesthetic, epistemological and societal implications of scientific visualization. Her work has been published in international journals such as *Configurations*, *Leonardo*, *Contemporary Aesthetics*, *Nuncius* and *The Senses and Society*. Her first monograph *Il Ritratto Scansione* (in Italian) was published by Mimesis. Thanks to a Leverhulme Research Fellowship, she is completing a book for the MIT Press Leonardo book series. The book embarks the readers upon a journey from the laboratory world of biodata-visualization, image production and interpretation to these images' extended life in works of art.

Claude Cernuschi earned his PhD from the Institute of Fine Arts, New York University, USA. He has taught at New York University, Duke University and Boston College. He is the author of *Race, Anthropology, and Politics in the Work of Wifredo Lam* (2019), *Barnett Newman and Heideggerian Philosophy* (2012), *Re/Casting Kokoschka: Ethics and Aesthetics, Epistemology and Politics in Fin-de Siècle Vienna* (2002), *"Not an Illustration, but the Equivalent": A Cognitive Approach to Abstract Expressionism* (1997), *Jackson Pollock: Meaning and Significance* (1992) and *Jackson Pollock: "Psychoanalytic" Drawings* (1992). He has also published essays in journals such as *Art Bulletin*, *Art History* and *Word & Image*.

Diarmuid Costello is Professor of Philosophy and Co-director of the Centre for Research in Philosophy, Literature and the Arts at the University of Warwick, UK. He is a past chair of the British Society of Aesthetics and a recipient of AHRC, Leverhulme Trust and Alexander von Humboldt research fellowships. He works across post-Kantian aesthetics, analytic philosophy of photography and post-1960s art history and theory. His *On Photography: A Philosophical Inquiry* appeared with Routledge in 2018, and he has co-edited special issues of the *Journal of Art and Aesthetics*, *Critical Inquiry* and *Art History* on philosophy, theory and criticism of photography.

Paul Crowther served as a long time Professor of Philosophy at the University of Galway, Ireland, and is an author specializing in the fields of aesthetics, metaphysics and visual culture. Among his many books are *How Pictures Complete Us: The Beautiful, the Sublime, and the Divine* (2016); *Phenomenologies of Art and Vision* (2014); *The Kantian Aesthetic: From Knowledge to the Avant-Garde* (2014); *Phenomenology of the Visual Arts (even the frame)* (2009); and *Defining Art, Creating the Canon: Artistic Value in an Era of Doubt* (2007).

Clemens Finkelstein is a doctoral candidate at Princeton University, New Jersey, USA. His work explores the history and theory of art and architecture at the field's junction with media studies and the history and philosophy of science and technology. His research interests encompass vibration theory, color science, design technics, sound modernities, disability studies and transmedia art. He has worked extensively as an editor and curator, currently serving as a curator-at-large at the A+D Architecture and Design Museum in Los Angeles. He recently authored "Architectures of Excarnation: An Ontology of Defleshing" (*San Rocco*, 2019) and "Vibe: Operative Ambience, c. 1969" in *The Sound of Architecture* (forthcoming).

Marie Gasper-Hulvat is Assistant Professor of Art History at Kent State University at Stark, Ohio, USA. Her research interests include early Stalinist art and visual culture as well as the pedagogy of art history. She has published on Malevich in *Print Quarterly*, *Il Culturale Capitale* and *The NEP Era Journal*, as well as on Russian icons in *RES: Anthropology and Aesthetics*. Her Scholarship of Teaching of Learning (SoTL) has appeared in the *Journal of Experiential Education* and *Art History: Pedagogy and Practice*. She completed her undergraduate degree in Theology and French at Xavier University and graduate degrees in History of Art at Bryn Mawr College.

Bruno Lessard is Associate Professor at the School of Image Arts at Ryerson University in Toronto, Canada, where he also serves as Director of the Documentary Media MFA program. He is the author of *The Art of Subtraction: Digital Adaptation and the Object Image* (2017). He has co-edited *Critical Distance in Documentary Media* (with Gerda Cammaer and Blake Fitzpatrick, 2018). He is currently writing a monograph on Chinese documentary filmmaker Wang Bing, as well as a philosophical study of digital play. An exhibiting photo-based artist, his work can be found at www.brunolessard.com.

Birgit Mersmann is Professor of Modern and Contemporary Art at the University of Duisburg-Essen, Germany. Her interdisciplinary research covers image and media theory, visual cultures, modern and contemporary East Asian and Western

art, global art and art history, migratory aesthetics, interrelations between script and image and documentary photography. Recent monographs and edited books include *Handbook of Art and Global Migration. Theories, Practices, and Challenges* (2019); *The Humanities between Global Integration and Cultural Diversity* (2016); *Schriftikonik. Bildphänomene der Schrift in kultur- und medien-komparativer Perspektive* (2015); and *Transmission Image. Visual Translation and Cultural Agency* (2009).

Regina-Nino Mion is a postdoctoral research fellow at the Estonian Academy of Arts. Her research interests include theories of pictorial representation, visual art and phenomenology. Her publications are mostly focused on Edmund Husserl's theory of image consciousness and aesthetics. She has received a number of research grants including the Swiss Scientific Exchange Programme Sciex-NMSch Fellowship, TÜBITAK Research Fellowship for International Researchers and the Mobilitas Pluss Postdoctoral Research Grant. Her current postdoctoral research project is titled "Image or Sign: A Phenomenological Study of Pictorial Representation". She has been elected as a member of the Executive Committee of the European Society for Aesthetics.

Winfried Nöth is former Professor of Linguistics and Semiotics at the University of Kassel, Germany, where he was Director of the Interdisciplinary Center for Cultural Studies until 2009. He was visiting professor at Wisconsin and Humboldt University and has been a Professor of Cognitive Semiotics at Catholic University São Paulo (PUC) since 2010. He is an Honorary Member of the Int. Associations for Visual Semiotics and Edusemiotics. Nöth is author, coauthor, resp. editor of *Handbook of Semiotics, Origins of Semiosis, Semiotics of the Media, Imagem: Comunicação, semiótica e mídia, Crisis of Representation, Self-Reference in the Media, Semiotic Theory of Learning* and other books and papers on general semiotics, cognitive semiotics, visual semiotics and Charles S. Peirce.

Ana Peraica is Visiting Researcher at Danube University Krems, Austria, and Visiting Lecturer at Central European University in Budapest, Hungary. Her research interests are in photography and media art, as well as post-digital photography. She authored *The Age of Total Images* (in print), *Fotografija kao dokaz* (2018), *Culture of the Selfie* (2017) and edited, among other: *Smuggling Anthologies* (2015) and *Victims' Symptom. PTSD and Culture* (2011).

Blaženka Perica is Assistant Professor of Art History, Theory and Visual Culture at the Arts Academy of the University of Split, Croatia. From 1986 to 2007 she worked as a curator in Germany and she concluded her PhD at the University of Kassel in 1999 with Prof. Hannes Böhringer on the subject "*Specific Objects*. Theorie und Praxis im Werk von Donald Judd". She has worked as a research associate and/or curator in several museums (Kunstsammlung NRW, Museum Wiesbaden, Schirn Kunsthalle Frankfurt) and in various renowned galleries in Germany. She is the author of a number of articles and exhibition catalogs and a curator of many solo artists' and group exhibitions including "Dimensions of humor", 11th Triennial of Croatian Sculpture (2012) and 38th Split Salon (2013).

Krešimir Purgar is Associate Professor at the Academy of Arts and Culture in Osijek, Croatia. His scholarly interests comprise visual studies, image theory,

iconology and abstract art. He has authored *Pictorial Appearing—Image Theory after Representation* (2019) and *Iconologia e cultura visuale—W.J.T. Mitchell, storia e metodo dei visual studies* (2019). He edited *W.J.T. Mitchell's Image Theory—Living Pictures* (2017) and *Theorizing Images* (with Žarko Paić, 2016). He is preparing a multi-authored reference collection *The Palgrave Handbook of Image Studies* (2021).

Michael Reinsborough is Lecturer at the School of Oriental and African Studies (SOAS), University of London, UK, and Visiting Researcher at the University of the West of England, Bristol, UK, in the Social Sciences Research Group where he works with BrisSynBio, a BBSRC/EPSRC Synthetic Biology Research Centre, located at the University of Bristol. After being awarded a PhD in the History of Science (Queen's University Belfast), he began his research career with the Center for Nanotechnology and Society, Arizona State University (CNS-ASU), then going on to work in the Department of Global Health and Social Medicine, King's College London, as part of the Human Brain Project Foresight Laboratory.

Yanai Toister is Director of the Unit for History and Philosophy at Shenkar College of Engineering, Design and Art, Israel. Toister's artwork has been shown at venues including Kunstahalle Luzern; the 11th International Architecture Exhibition at the Venice Biennial; Kunstmuseen Krefeld; Fotomuseum Berlin; Tel Aviv Museum of Art and the Israel Museum. Toister's writing has been published in various catalogs and journals (including *Mafte'akh Lexical Review of Political Thought*, *Philosophy of Photography*, *CITAR*, *Ubiquity*, *Journal of Visual Art Practice and Photographies*). Toister's book *Photography from the Turin Shroud to the Turing Machine* will be published in 2020.

Anselm Treichler is Research Assistant at the Chair of Architecture and Visualization at the Brandenburg University of Technology, Cottbus-Senftenberg, Germany, and completed his PhD in Art History at the Humboldt-Universität zu Berlin. During his doctoral studies he also worked as a research assistant at the University of Bern, Switzerland. His research focuses on the history of modern art and architecture, the aesthetics of abstraction and the architectural and art theory. Anselm earned his MA in Art History, Philosophy and Law from the Humboldt-Universität zu Berlin. During his graduate studies, he founded and led the interdisciplinary seminar *Art and Law* at the Humboldt-Universität zu Berlin and has lectured at the Freie Universität Berlin, Germany.

Dario Vuger is a doctoral candidate at the Department for Philosophy of the University of Ljubljana, Slovenia. He currently holds an MA in Philosophy, Art History and Museum Studies. His main scholarly interests are contemporary aesthetics, philosophy of technology, theory of the spectacle and post-digital art practices. He is a member of the Croatian Philosophical Society and is a frequent contributor to the projects of the Center for Visual Studies in Zagreb. He contributed to numerous local and international scholarly journals (*Synthesis philosophica*, *Phainomena*) and conferences.

Acknowledgments

In the strict disciplinary genealogy of art history, the term *abstraction* refers to a style that corresponds to very precise time coordinates and is most often defined either as an ambivalent end of the historical teleology of figurative art, or as the beginning of the period of modernity that emphatically insisted on the artist's individuality. If we separate both from the notion of historical development that is so close to the basic premises of the history of art, abstract images would be just an incomprehensible cluster of colors and shapes that do not deserve consideration in the context of high values and *connoisseurship* so characteristic of the works of art. Therefore, to be engaged with abstract material in visual communication in general presupposes either a competent art historian who equally appreciates old masters and avant-garde artists or an expert in completely different areas who is able to "read" abstract images as any of us is able to read newspaper articles or traffic signs. In the first case, it is the historians of culture, art and science who have affirmed abstraction as a legitimate, historically constructed visual code, while in the second case it is about astronomers, cartographers, radiologists and all those who are able to decipher modern visual codes incomprehensible to the common people.

In the perspective outlined above, I believe it is extremely rare that a university professor's career can be marked by pursuing exclusively or mostly abstract images *per se*. So, being radically interdisciplinary, this book could not have been an outcome of an individual effort either. *The Iconology of Abstraction* could only have emerged from the contributions of scholars from various fields of science and their focus on the communication aspects of the most diverse kinds of images. While developing the contents of the book, it proved to be a particular challenge to me as its editor to make the convincing connection between the so-called pure or high art on one side and images whose purpose is purely instrumental on the other. Therefore, the purpose of this book should not be sought either in the field of art history, although many articles published in these pages refer specifically to this area, or in the field of technical sciences, although a significant part of this book is devoted to the technical conditions of visibility. This book's "natural" field is image science, a disciplinary branch that required every contributor involved to treat abstraction as a pervasive phenomenon that equally influenced both history and modernity, art and science, daily life and advanced technology. I therefore thank all the authors for always bearing in mind that their contributions, regardless of the particular area of interest, were part of a fascinating phenomenon of the *non-figurative* that equally terrifies and fascinates the human race from the first glimpse to the stars to micro-visualizations of the genetic structure of living beings.

I thank the students of the postgraduate program in literature, film and theater studies at the Faculty of Humanities and Social Sciences in Zagreb who have attended with great interest my courses in image science, theory of conceptual and abstract art. I am thankful also to the directors of this program, professors Nikica Gilić and Tomislav Brlek, who have included my courses in a program that one does not encounter every day in a department of comparative literature. I thank the staff from the Staatsbibliothek in Berlin who once more provided me with a productive work atmosphere during my study stay at this institution in the summer of 2019 devoted to the editorial work on this publication. Finally, I express my sincere gratitude to Helena Sablić Tomić, Dean of the Academy of Arts and Culture at the Josip Juraj Strossmayer University in Osijek, for providing me with an inspiring place for scholarly work and teaching, for daily meetings with motivated students and colleagues and for giving me so many opportunities to reflect on different aspects of visual material, all of which immensely contributed to the interdisciplinary character of this book.

Introduction

Do Abstract Images Need New Iconology?

Krešimir Purgar

Although we can find non-figurative representations throughout human history, it was only during modern times that abstract pictures came to the center of theoretical prominence. This shift was prompted by modern art, which disrupted the principle of mimesis that was for more than two thousand years the main principle of visual representation in Western culture. But, for many people, images of abstract art still mean "nothing". At the same time, rather complicated technical diagrams, mathematical and weather forecast graphs, subway maps, cartographic images, medical examination images (CT, MRI), visualizations of outer space, computer-generated blueprints, internet-based digital paraphernalia and other forms of contemporary abstraction are being recognized and comprehended without much effort. This book tries to uncover how we make meaning of abstraction, both historically and in present times.

The human drive for abstraction is certainly not an invention of modern times. According to German art historian Wilhelm Worringer, "the urge to abstraction" arises not because of cultural incompetence at mimesis but out of a psychological need to represent objects in a more spiritual manner. The first radically abstract artists, such as Kazimir Malevich and Wassily Kandinsky, wrote about abstraction as a way to unleash the supremacy of pure feeling or to make the spiritual visible. They wanted to represent the ineffable, the non-representable, that which resides in the human spirit—is purely conceptual and cannot be shown in the form of something we already knew from nature, history, other pictures, etc. The same is true with the contemporary abstract, both art and non-art images. Why is there more urgency now than ever before to plunge into manifold relations between art, science and technology? It is not only because contemporary art ever more often borrows its visual and technical material from communication technologies, the computer industry and virtual reality devices; it is also because the very nature of art and technology converges in unexpected ways.

The Iconology of Abstraction wants to come to terms with this paradox of representation and show how the "urge to abstraction" has permeated fields as different as geography and medicine and visualizations of space and fine art. In order to do that, the book will first explain why people created images that did not resemble anything from their natural experience and why this sort of visual representation became so important at the beginning of the 20th century. The contributions will demonstrate that it was always the same underlying principle and logic pertinent to abstract images: there were always, in all historical periods as there are today, so many things we cannot actually represent but can only conceptualize and imagine—be it the interiority of the soul, one's psychic mood, the expanse of the city, a beating heart or

another galaxy. The book will show that, contrary to common belief, abstraction is not characterized by the absence of *meaning* but the absence of *direct visual information*. For example, a human heart looks much different when observed in its natural state during an autopsy compared to the way it looks when observed during a medical examination with an ultrasound device. Obviously, this is not because medical doctors do not know what the heart really looks like, but because the technology is still not capable of realistically visualizing the interior of a living human body. So, medicine uses different degrees of abstraction to visualize what is otherwise not seeable. The same applies to visualizations of outer space: we can only make approximations about what it looks like based on the available information and the most advanced technologies of visualization. Therefore, the problem of a lack of visual information and the ensuing semiotics and aesthetics is the central topic of this book.

The eighteen contributions will show that abstraction is not primarily an artistic phenomenon, but is generated from people's urge to have control over and enter into what is uncontrollable and impenetrable. Abstract art wanted to overcome the world of visible things and step into the ineffable world of the human spirit in the same way that the geographical representation of Mercator's projection wanted to present the otherwise unrepresentable sense of space. Although the urge to abstraction was common to all ages of human development, this book focuses on the 20th and 21st centuries, for consistent studies on abstraction only cover little more than the last hundred years. Notwithstanding the importance of the historical approach to pictorial phenomena, one possible iconology of abstraction should be able to make a distinction between conditions of *production* and the changeable *meaning* of forms: for example, cartographic representations of the New World were less a depiction of (or abstraction from) a mathematically conceived physical space but more of a classical, figurative representation of cities, ports and mountains. The reason for that was the technical impossibility to represent what is not directly visible to the eye.

The paradox of general pictorial abstraction is that it developed together with the advancement of the technology that allowed it, while our appreciation of old masters' paintings, for instance, is affected by contemporary conditions of visibility, that is, our own "ways of seeing",[1] and not those historically available in the times of Giotto or Caravaggio. In spite of the fact that it would be completely wrong to say that modern times, compared to past epochs, have less insight into what can be seen directly, it is quite certain that what we cannot see we can still only imagine. Inasmuch as historical abstraction (or perhaps more fittingly, *abstracting*) is not a consequence of the impossibility or the lack of skill to represent something in a figurative manner, avant-garde and contemporary abstract images are not a sort of escapism from the natural world. Exploring abstraction is a different task altogether: to represent what has not yet been presented in a visual form and to show what is not open to view. The specific task of one comprehensive iconology of abstraction is therefore to deal with all those multifarious transactions, from material invisibility (cognition, intentions, feelings) to visible immateriality (digital communication, immersive experiences, virtuality).

The problem of communicating with images that represent "nothing" cannot be solved before we reconcile with the immanent paradox that is associated with (1) the representation of "nothing" (invisible, inaccessible, non-transparent) and (2) the role of language that brings the non-transparent to everyday communication interactions. In other words, it is necessary to put the arbitrary elements of spoken language into the function of the arbitrary elements of pictorial presentation, because it is only through

the interaction of one and the other that we can establish visual re-presentation, that is, the abstract image to be experienced as an independent entity that "lives" on both language and image. But have we not at the same time betrayed both language and image? Robert Steiner offered the term "grammar of abstraction" in which he tried to reconcile the inability of language to express extra-linguistic phenomena, as well as the inability of the image to represent in abstract shapes that which is often present in the imagination and the mind.

It is quite expected that Steiner came to his original position as a philologist and literary theorist, not as an art historian or visual semiologist; in other words, the imaginable and the unimaginable, the real and the fairytale in literary theory, live in much greater harmony than the way in which figuration and abstraction coexist in art history. While philology always necessarily observes that which is "internal" and "external" through the prism of grammatical and syntactic structures as a necessary condition of a literary work (even when they are deliberately omitted in a particular literary language), the discipline of art history is not constituted in such a way that it views works of art as "pure visibility", as a configuration of lines and colors unmediated by language. This is also the main reason why this discipline views contemporary abstract art mostly in the context of the historical avant-gardes, that is, as the constant echo through which reverberates the epoch when art history, armed with its most powerful tool—iconography—could still say something meaningful about the art of its time.

Before devoting ourselves to the time of the emergence of the historical gap between the works of figuration and abstraction, and then the time of the radical cultural separation of artistic from the so-called applied images, it would be useful to look at some aspects of Robert Steiner's "grammar of abstraction". Let us start with this statement first:

> Grammatically speaking, representation is an originary trope signifying the necessity of translating pictorial into verbal phenomena without having to acknowledge either the movement or its complex consequences for the truth content of aesthetic analysis. The problem of representation serves as an arena for the institutional claims of truth content in the discursive treatment of pictorial objects which has a happy and necessary by-product of finding in language a way for the most visually "inaccessible" works to be made readable.[2]

Therefore, there is no such "inaccessible" or incomprehensible abstract image that could not obtain in the language some kind of justification and thus institutional legitimacy. *Mutatis mutandis*, then, there is no reason why abstract art images would not always be recreated and considered original, since in this case the language used to interpret them in critique and theory would always be just a "by-product" and not a real competitor to the abstract art image in the domain of artistic expression. If this book dealt only with artistic images, the problem of the relationship between visual and verbal language and their interrelation, as discussed by Steiner, would not exist at all for our discussion: it is much more important for any visual representation in the artistic domain to be able to "discover" what language cannot, and then present what it discovered in a way that language could never do, than to discover something and just wait until it is translated into the language of criticism and theory of art. Any work of visual arts always starts from the irrefutable fact that the transcendence of

reality through image never produces the same effect as describing reality through critical or scientific text (and vice versa). In other words,

> If "art is not required to understand itself", it is because we are able to analyze works either as they call attention to the debts they owe outside themselves visually or to the debt language owes them; the semantic "ineffability" of a painting is, in this sense, a failure of discourse.[3]

Therefore, if our topic was merely an artistic abstraction, then we would be looking at ways in which the "failures of discourse" in describing abstraction can be exploited by producing a new semantic framework within the disciplinary fields of image studies, much like the way Paul Crowther brilliantly demonstrated in his many philosophical and phenomenological works on this topic and in this book (which will be discussed later).[4] Since we have set ourselves a different task here—to study the status of abstraction independent of the socio-communicative role of this type of image—it is necessary to examine whether, and if so in what way, non-figurative representations can be considered in the context of some general characteristics of visual representations. One of them is certainly the problem of sign and signifying, which involves the need to answer these three key questions: (1) if the abstract image is a sign in semiotic terms, do we necessarily need to know what is it the sign of, (2) if we know what it is a sign of, do we always have to know what such an image means and (3) is its existence as a sign and (non-)meaning directly related to its unique meaning as pictorial representation? For more detailed answers to the semiotic aspects of these questions, we refer to the prolegomena in this book by Winfried Nöth, "Why Pictures Are Signs; The Semiotics of (Non)representational Pictures", in which this author explains, among other things, that "Forms and colors are not determined by their mere quality or the artist's spontaneous intuition, but by a chromatic and geometrical morphology and syntax, whose validity is not only restricted to this particular picture". In this way, an image is not only referencing the external codes by which it is interpreted as an image of something communicable (and by which we most often come to its meaning), but it is also "a sign related by visual laws to the colors and forms that constitute their object".[5]

But can any abstract image, for example, a computerized tomographic image of the vertebral part of the spine, be constituted by colors and shapes in such a way as to make the depiction of that part of the human body veridical? To someone who is versed neither in radiology nor in the history of artistic styles, such a depiction is no more akin to the actual spine's appearance than Picasso's 1937 portrait of Dora Maar, which is a credible portrayal of the person whose appearance was allegedly painted. Someone who is versed in radiology but not in abstract art is likely to seek to interpret Picasso's image as some kind of code, but will not necessarily know what the code is. One who understands both radiology and analytical cubism will know that both images are credible representations: in the first case, it is the visible appearance of an invisible part of the human body, and in the second it is a visual fact that does not have its objective equivalent. Is it, then, at all possible in practical terms to determine the beginning and end of meaning, what Robert Steiner calls the "meaning of meaning", that is, to define the interspace of meaning so that we always know whether an abstract image, artistic or not, is something beyond itself? Leaving aside terms such as "semiosis", "open work", and "deconstruction", which are not very helpful when

trying to relate divergent concepts such as iconology and ontology (of images), we must first ask: what signs are signs of meaning?[6]

Discussions about abstraction in art began at the turn of the 19th and 20th centuries and were triggered by the abandonment of the classical paradigm of artistic representation, which was strongly characterized by the ideals of natural form born in antiquity and reinvigorated during the Renaissance period. The first author to join the theorizing of this turn toward non-figuration was Conrad Fiedler with his book *On Judging Works of Visual Art* of 1876, four years after Claude Monet painted his eponymous painting *Impression, Sunrise*. In his work, Fiedler strongly advocated art that is not dependent on the visible, natural world but based on its own rules, one of the most important of which was the amalgamation of the visual perception of the observer on the one hand and the pictorial effect of the image itself on the other, which he called "pure visibility" [*Reine Sichtbarkeit*]. In Fiedler, we find traces of Immanuel Kant's ideas from his *Critique of the Power of Judgment*, favoring the position of an artist who transforms reality in the process of artistic transcendence, primarily with his mind. Particularly characteristic of this are these two claims of Fiedler:

> [For the artist] the essence of the world which he tries to appropriate mentally and to subjugate to himself consists in the visible and tangible Gestalt formation of its objects. Thus we understand that to the artist perceptual experience can be endless, can have no aim or end fixed beyond itself.[7]

And a little later:

> Technical skill as such has no independent rights in the artistic process; it serves solely the mental process. Only when the mind is not able to govern the creative process does skill attain independent significance, importance, cultivation, and so becomes worthless artistically. From the very outset the mental process of the artist must deal with nothing but that same substance which comes forth into visible appearance in the work of art itself. [...] The substance of such a work is nothing else than the Gestalt-formation itself.[8]

Specifically, this author makes no mention of abstraction in art but thoroughly insists on the role of the artist to apply his own conceptual knowledge in the contemplating (or abstract thinking) of the world: "Everyday life puts to the test much more frequently the extent and precision of a person's conceptual knowledge than the completeness of his visual conceptions".[9] From this position, it is clear that Fiedler is still not speaking about the work of ideas in the sense that conceptual art did during the second half of the 20th century, and that insisting on the importance of visual perception in him is primarily a propaedeutic purpose of more strongly incorporating abstract thinking in the judgment of works of the visual arts. On the other hand, he sees the artist as a person who must use his own imagination for "Gestalt-formation" [*Gestaltung*], which refers precisely to the need to produce new forms in the visual arts, rather than those that follow pre-existing ones in nature.[10] Fiedler's work should be credited, first and foremost, with developing Kant's theses and applying them to the visual arts, and then with educating the observer's perception and his intellectual preparation for the emergence of radically new art forms that would come three decades later.

For the contemporary (although still provisional) iconology of abstraction, the theses of another German theorist, Wilhelm Worringer, from his 1908 book *Abstraction and Empathy. A Contribution to the Psychology of Style*, are even more important; we could even call them "epochal".[11] In this book, for the first time, abstract forms in cultural history are given the importance of one of two diametrically opposed tendencies in human beings: those toward abstraction and those toward empathy. Worringer takes the notion of "empathy" from the *Aesthetics* of the philosopher Theodore Lipps, who gave it two values—positive and negative. According to Lipps, when we feel pleasure in a work of art, we completely surrender to it and unite with it in "positive empathy"; on the other hand, a sense of dissatisfaction produces the conflicting effect of "negative empathy". Worringer believes that the difference between the two types of experience of works of art is not theoretically relevant and that the positive and negative values of any kind cannot explain the effect of the work of art. In essence, negative empathy is not a product of failed art but a consequence of the need for a completely different kind of expression. Each artistic period carries its own affinities, and it is not always geared toward achieving the same goal. With the help of Alois Riegl's theory of "artistic volition",[12] Worringer argued that the effect of a work of art is the result of two antagonistic instincts in man: the urge to abstraction and the urge to empathy. The will to form is different in all periods and in all peoples, but the underlying impulses of will arise from these two opposing tendencies. In order to understand abstraction in its historical context, it is important to consider that Worringer does not interpret it in relation to some supposed ideal of visual representation; it is not a primitive, underdeveloped or, in any sense, handicapped form of representation, but rather the opposite: an expression of the original creativity of the human spirit versus nature as a given.

The urge to abstraction stems from the psychic state of epochs and nations toward the world, nature and the cosmos:

> Whereas the precondition for the urge to empathy is a happy pantheistic relationship of confidence between man and the phenomena of the external world, the urge to abstraction is the outcome of a great inner unrest inspired in man by the phenomena of the outside world.[13]

In Worringer's concept, abstraction is not only a pure creative principle that distinguishes non-figurative forms from organic forms but also a basic human need to influence the natural order, to impose its human specificity on the given order of the universe. It must be admitted, however, that the German philosopher understood, in the notion of abstraction, primarily geometric shapes which, by their ornamental regularity, differed so much from organic forms in nature, rather than the abstraction of Kandinsky. On the other hand, he thought it would be wrong to claim that people aspired to specifically geometric abstraction, "for that would presuppose a spiritual-intellectual penetration of abstract form, would make it appear the product of reflection and calculation".[14] It was about the fact that people, in their earliest stages of cultural development, sought most to imprint on nature their own stamp of humanity; nature was then an unknown area for them to master, and this was only possible by opposing nature and the creation of inorganic forms that legitimized man's "will to form". In Worringer's conception, abstraction in this way became a form of emancipation and culturalization. While he calls the urge to organic forms and nature "[a]

esthetic enjoyment as objectified self-enjoyment", the urge to abstraction is "a self-affirmation, an affirmation of the general will to activity that is in us".[15]

Although it has remained very influential to this day, being the first to detach abstract art from the disciplinary fatalism of art history, for today's intellectual tastes, Worringer's theory insists too much on theoretical universality. In short, he attributes the urge to abstraction to the northern nations, while the urge to empathy is characteristic of southern European Mediterranean cultures. Formally, Worringer's claim is correct, but it does not take into account, for example, the religious circumstances following the spread of the Reformation and, consequently, the decision of the Council of Trent regarding pictorial representation, which significantly influenced the inorganic form of the Protestant Germanic north as well as the organic form of the Catholic south. Another German author, the art historian Erwin Panofsky, with his concepts of *perspective as a symbolic form* and, moreover, *iconology as a coherent science of interpreting works of art*, sought to establish a universal discipline that would study the historical development of art on a scientific basis. Unlike his equally famous predecessor Aby Warburg, who approached the problem of establishing the discipline of art history from the position of cultural history and image science in general, in the production of images Panofsky clearly gave preference to artistic artifacts over other fields of visual culture, and that enabled him to focus on relationships of style, form and meaning.

His iconological method is best known for determining, in the analysis of each object, the unique parameters he calls "objects of interpretation" and "acts of interpretation".[16] Thus, being methodologically similar to Heinrich Wölfflin's method, all works of art are subjected to the same analytical matrix, i.e., the same conditions of comparison. However, while Wölfflin's proto-semiotic method was designed primarily to indicate the differences between Renaissance and Baroque art, Panofsky conceived of his iconology in such a way that it could be applied to all artistic productions of the prehistoric, ancient, medieval and neo-classical epochs. The "object of interpretation" refers to (1) the purely perceptual-formal properties of the work of art as we see it—Panofsky called it "primary or natural subject matter" and by such analysis we come to the first level of the "act of interpretation", that is, a "pre-iconographical description"; (2) at the second level of interpretation, we look at the "secondary or conventional subject matter" in the work of art, discover which stories and allegories it visually represents and thus arrive at an "iconographic interpretation"; and (3) the third level is the "iconological interpretation", by which we aim to notice its "intrinsic meaning or content".[17] This seemingly simple concept (hence its popularity) allowed the history of art to be definitively constituted as a discipline that was equally interested in the "philological" background of art—that is, for all those narrative motifs without which a complete understanding of the meaning of the work of art would not be possible—as well as the study of its formal, stylistic aspects.[18]

However, Panofsky placed one limitation on his method inasmuch as he believed that those works which were not made on the basis of mythological, biblical or other narrative templates could not be applied to his principles of analysis:

> Iconology, then, is a method of interpretation which arises from synthesis rather than analysis. And as the correct identification of motifs is the prerequisite of their correct iconographical analysis, so is the correct analysis of images, stories and allegories the prerequisite of their correct iconological interpretation—unless

we deal with works of art in which the whole sphere of secondary or conventional subject matter is eliminated and a direct transition from motifs to content is effected, as is the case with European landscape painting, still life and genre, not to mention "non-objective" art.[19]

If Panofsky believed that works of abstract art, as well as all representations lacking a philological background, were not suitable for iconological analysis because they lacked a literary origin, this would mean that what the picture is about must always be visible and demonstrable by something beyond itself. Of course, it was quite clear to him that a very precise iconographic analysis could lead to an erroneous iconological meaning, but this danger is far less if the pre-iconographic (formal-perceptual) level of the work seeks to give an iconological (social-contextual) interpretation directly: "Even our practical experience and our knowledge of literary sources may mislead us if indiscriminately applied to works of art, how much more dangerous would it be to trust our intuition pure and simple!"[20] From an objective assessment of this attitude, it does not result that Panofsky considered contemporary "non-objective" art less valuable, but rather that his scientific method of analyzing art objects could only work if we limited it to works with narratively recognizable themes.

Panofsky's method was a serious and highly detailed system that needed to enable art history to be certified as the master-discipline of all visual representations. Regardless of the reservations that this author had toward the application of iconographic components in pictures that do not offer real literary content, traditional iconology still occupies an important place within the discipline of art history. Contemporary art criticism, though often unaware of it, inscribes into the works of art the alleged intentions of the artist or, in formally non-figurative forms, loads meanings as if they were demonstrable by comparison with some written source. Another way for art historians to misinterpret Panofsky's traditional iconology for the purpose of analyzing contemporary art is to describe the formal aspects of a work as if a minute description of the figurative aspects of the figurative picture (not to mention conceptual practices) can help it to reach its "intrinsic meaning" or iconological content.

Panofsky himself pointed out the potential misunderstandings that could have been caused by the inappropriate use of his method when he made it very clear that the reciprocity of form and content could not be established, even when the narrative sources of the picture seemingly leave no room for doubt. For example, in the right panel of the so-called *Bladelin triptych* by Rogier van der Weyden from 1400, representing the New Testament scene *The Adoration of the Magi*, we see a small baby in a whirlwind of golden rays hovering in the clouds above the three men who are staring up at him. A pre-iconographic analysis would not yet let us know that the baby was the little Jesus and the kings Balthazar, Melchior and Caspar, who had come to worship the newborn Son of God. But even the iconographic analysis of this picture reveals its iconological potential, because the iconographic text on the basis of which van der Weyden created this picture does not conceive the scene in this way; namely, the "official" source of this account, the Gospel of Matthew (2:1–2), says literally this: "[Saying,] Where is he that is born King of the Jews? For we saw His star in the east, and have come to worship Him".[21] As the New Testament recounts, the birth of Jesus was heralded to the Kings by the appearance of a falling star in the night sky rather than by his own appearance in the image of a young child as portrayed by this Dutch painter. In a strictly iconographic sense, van der Weyden's painting is a semi-abstract collage, for

a key element of one narrative (the Birth) is cut and implemented into another (the Adoration of the Magi).[22] A symbol cannot be equated with meaning, and it is precisely in the interstice between artistic canon and a deviation from the canon that an iconological meaning comes to the fore.

Despite his reluctance to even consider that non-objective art could qualify for iconological analysis, Panofsky was convinced that

> the discovery and interpretation of these "symbolical" values (which are often unknown to the artist himself and may even emphatically differ from what he consciously intended to express) is the object of what we may call "iconology" as opposed to "iconography".[23]

Bazon Brock, the contemporary German art theorist, critic and artist, proposed that modernist abstraction may also be viewed from the iconological perspective as it qualifies for all three levels of interpretation. He contends that abstract paintings contain an unspoken and unwritten sequence of sentences that can explain the artist's intentional path to creating a concrete work. In order to understand the work of art, and especially works of radically abstract art like *The Black Square* by Kazimir Malevich, the observer must engage in some sort of allegorical discourse that will help him to interpret it. The following thesis of Brock is particularly interesting:

> A square is not a more abstract figuration than the pictorial representation of a cow. The representation of a square is no less figurative than the photograph, drawing or sculpture of a cow—whoever makes a square can use a figurative template for it as much as the draftsman of a cow. Only the conventional meanings of cow and square are different.[24]

The thread that Brock is following here is mostly in line with the semiotic theory of Nelson Goodman: conventional signs differ according to culturally acquired meanings, but no sign can be naturally or intrinsically referred to any object, meaning that any conventional shape does not correspond to any particular thing.[25] What we negotiate upon is its content, and Brock says it will vary depending on how it is used or evaluated in the iconological examination of the culture of a certain epoch, no matter if we use a particular sign as a work of art or in a scientific illustration, as a commercial good or as furnishing, or otherwise. Following that line of argumentation, for Brock,

> every painting—the black square by Malevich as well as the cows in the pasture by Rubens—not only can but must be viewed in terms of Panofsky's distinction in terms of both primary and secondary as well as intrinsic meaning.[26]

Still, every art history student will tend to link iconology to the study of the narrative plot of classical art in the West, and it is certainly unusual that one theorist, an expert in English literature by disciplinary vocation, entitled his first programmatic book on the effects of *all* images, not only classic and not only artistic—*Iconology: Image, Text, Ideology*. I am referring here to W.J.T. Mitchell, a long time professor at the University of Chicago whose intellectual bio-bibliography alone testifies to the fact that neither is iconology any longer the sanctified territory of art historians nor should the agency of images be divided by categories such as art, non-art, popular, political,

high or low. Should we wish to understand the interrelation of visual artifacts that make our everyday communication possible and meaningful (in spheres as diverse as art and political struggles), we need to approach them in a completely different way, notwithstanding the fact that art and politics, for instance, may never actually come close to one another. It is also interesting that in this book, first published in 1986, Mitchell refers only casually to the founder of iconology as a scientific discipline. In the first lines, he says:

> If Panofsky separated iconology from iconography by differentiating the interpretation of the total symbolic horizon of an image from the cataloguing of particular symbolic motifs, my aim here is to further generalize the interpretive ambitions of iconology by asking it to consider the idea of the image as such.[27]

When Mitchell speaks of critical iconology in his numerous works, he refers mainly to the need to dispel the ideological-conventionalist criteria in art and in the visual sphere; hence, the attention paid to the famous Panofskyan apologue of a passerby who greets an acquaintance by removing his hat.[28] Greeting by lifting the hat from the head is not only an indicator of an event that actually happened in time and space, nor is it only a sign of respect for another person, but it is also a symptom of social norms, both of the individual and of society as a whole. Mitchell is interested in the mechanisms of visual culture and the way(s) in which they condition the formation, use and interpretation of images as cultural symptoms. However, in speaking of "critical iconology", he never takes or invokes the Panofskyan iconological method, since he does not recognize in any particular method or in any disciplinary theory a universal, critical position sufficient to the analysis of images; in this perspective, he feels closer to the deconstructionist "anti-method" of Jacques Derrida as the philosophy of the perpetual incompleteness of the work.

I believe that Mitchell's institution of iconology as a "cultural symptomatology" is one of his most significant contributions to understanding the world of images. Although this is a term he never used himself (I applied it for the first time in the book *W.J.T. Mitchell's Image Theory: Living Pictures*), I think it is a key method and an original way of analyzing images.[29] First of all, since he never determines his own disciplinary theoretical position, Mitchell does not see critical iconology—or *visual studies* as it is most often referred to—as a discipline that starts from the predefined settings of existing disciplinary practices, but rather as an "in-discipline", as a Derridian deconstruction of foreseeable meanings. However, this does not mean that there is no method in Mitchell, but only that it should be sought outside the disciplinary nomenclature of the humanities. Thus, he does not start from the theoretical model and then apply it to the object of analysis; on the contrary, he starts from the object or phenomenon or, in other words, he first tries to identify the given phenomenon through individual media, works of art, films, natural or cultural events, political speeches, ideological prerequisites, etc. In the second stage, he connects these phenomena in apparently disparate but symptomatic groups of images or concepts, in which they often appear together in their characteristic contexts. The most important thing for this method is that the key theoretical terms are "produced" (anticipated and applied) *during* the analytical practice itself, which is diametrically opposed to the procedures of disciplines such as semiotics, psychoanalytic theory, gender studies or Panofskyian iconology.

I will not claim here that Mitchell's iconology alone may resolve the problem of understanding abstract images, but rather that it came closest to creating a specific atmosphere of in-disciplinarity in contemporary humanities that was desperately needed in order for images of our time to be understood as images of precisely *our* time, and not some other, long-gone epochs. His method is characterized by what traditional iconology feared the most: individual interpretation as opposed to the taxonomical grid, an interdisciplinary mindset as opposed to powerful, pre-determined tools. This position is equally influenced by cultural and visual studies on the one hand and by natural sciences, mostly biology and paleontology, on the other. Both streams of his thinking, cultural and biological, will prove theoretically crucial for our discussion, as they naturally go along well with loose ends of meaning so typical of non-figurative images. In the third book of what he calls his "iconological series", *What Do Pictures Want?* from 2005, Mitchell states that

> The task of an iconologist with respect to images and pictures is rather like that of a natural historian with respect to species and specimens. [...] While we can recognize beautiful, interesting, or novel specimens, our main job is not to engage in value judgments but to try to explain why things are the way they are, why species appear in the world, what they do and mean, how they change over time.[30]

I propose that we understand this "biological metaphor" not as a methodologically, let alone historically, proven tool but as a kind of systemic disruption in our relation to images—as if they are able to direct our opinions, make us change our minds, create and dismantle beliefs. They are like living organisms that you see every day and interact with, which either let you do or prohibit you from doing things with them, while you still may not know anything substantially relevant to how these images work or in what way they affect you.

Just to give one example, one of Mitchell's better known iconological insights is not to establish universal rules of interpretation but to compare specific cultural symptoms with common biological models. This American scholar believes that "there is a way in which we can speak of the value of images as evolutionary or at least coevolutionary entities, quasi life-forms (like viruses) that depend on a host organism (ourselves), and cannot reproduce themselves without human participation".[31] Drawing on his own distinction between images and pictures, where the former are referred to as mental and cultural visualizations while the latter are concrete objects, images may be compared to species and pictures to specimens; their relation is thus defined in a sort of reversed trans-substantiation, whereby biological entities (pictures) are transformed into cultural symbols (images). As we have shown, Panofsky's iconology, together with traditional art history in a general sense, goes in the opposite direction: they are constituted on the basis of always already legitimized cultural symbols (historical artifacts) that only need to be taxonomically described as pictorial entities. In a very insightful text on Mitchell's iconology, Norman MacLeod remarks that "the taxonomist's problem has always been how to describe and explain the variation *within* species, while at the same time describing and explaining the gaps in variations *between* species".[32] That is the reason why Panofsky could establish a viable system "within species" in a three-level analysis—pre-iconographic, iconographic and iconological—but could not implement it "between species" in pictures without narrative text behind them, like landscapes, portraits and abstract pictures.

As a paleontologist and a scholar of natural history, MacLeod readily accepts Mitchell's biological metaphor, drawing on his distinction between picture and image, but gives it a slightly different accentuation. Although they might both be imbued with a personification of life, in the sense that pictures are individual organisms with concrete physical expressions while images correspond to a more general set of rules, MacLeod says that pictures are alive only to the extent of their actual importance as physical objects.[33] Pictures would thus be more like fossils that have preserved the traces of some previous life and eventually regain life only if people understand them as pictures and not just as any other kind of visual information. For our discussion it is very significant that fossils, like many pictures of modern art, are incomprehensible for most people (art historians included), while abstract representations in synoptical charts, medical examinations and cartography are understood (at least by experts) almost as a mother tongue.

Why is it that abstract pictures are so notoriously difficult to grasp? One explanation would be that we cannot see anything in them because there is nothing to be seen except that which we see; the ensuing statement is that art pictures, abstract ones especially, serve to establish new "rules of visibility", as Stefan Majetschak pointed out.[34] We do not believe what we see, but we see what we believe. Scientific imaging is a good example of that: radiological scans of the human body and visualizations of the universe are only technical approximations of things that exist but are not open to view. What these "things" really look like is much different from how we see them in pictures provided by a family physician or a NASA public relations department. People normally do not care whether these pictures need to be "taken" outside or inside of a visible spectrum, although for them this makes the difference between conjecture and certainty. The abstract pictures of Jackson Pollock are in a physical sense more realistic than fabulous visualizations of real planets photographed and processed by machines during unmanned interplanetary missions. In a museum, Pollock's artwork is not just exhibited directly in front of us; it is a palpable object, a canvas, with which we have a connection thanks to the portion of the electromagnetic spectrum that is visible to the human eye.

When the English newspaper *The Independent* published photographs of Jupiter on June 7, 1997, in a caption it was remarked that "it looks like a Turner painting". Martin Kemp contends that all images of the Galileo and Magellan missions are based on a commitment to display styles that originate in a history of European painting. In order to represent those impressive panoramic landscapes, such as the images of Venus made during the Magellan mission, sent by the spacecraft, it was necessary to derive the data while making a whole series of choices regarding all aspects of representation, which resulted in the demonstration of a clear affinity for painting—from the decision to make maps based on orthodox criteria of perspective to the decision regarding false colors, as well as modifications that needed to be made because of distance.[35] The visibility of these images is constituted through the function of their use. Not only that, Majetschak stresses, they would not exist in this form if they did not seek to represent unknown areas within known image models.[36]

It is therefore even more surprising that art history has managed to surmount the obstacles of traditional iconology by using other means, like stylistic analysis, archeology and historiography—not just iconography—but it did not succeed in dealing either with abstract pictures produced after the historical avant-gardes or with pictures outside the consecrated realm of art. The reasons for this failure go well beyond

Panofskyan iconology and have to do more with a self-imposed sense of teleological finitude present in art history, in spite of the brilliant examples of disciplinary openness and thematic inclusiveness offered by Alois Riegl and Aby Warburg more than a century ago. Mitchell is aware of the fact that the idea of images, let alone artworks, having not just a life of their own but a life of a lesser kind of living creatures, like parasites who live on other creatures' vital energy, must be very disturbing for image experts and common people alike:

> If images are like species, or (more generally) like coevolutionary life-forms on the order of viruses, then the artist or image-maker is merely a host carrying around a crowd of parasites that are merrily reproducing themselves, and occasionally manifesting themselves in those notable specimens we call "works of art".[37]

For him, the biological metaphor is much more than just a new trope or merely a polite way to deconstruct a rock-solid edifice of art history: it is the experiment of engaging with artworks and their seemingly unshakeable value in a broader social context, contesting their social immobility and constantly forcing us to change our acquired beliefs.[38]

It is our desire that this book be read and interpreted as a step toward establishing an interdisciplinary iconology that will be able to address all pictorial phenomena. After two epochal steps in this direction—first by Erwin Panofsky, who established the analytical, transhistorical method applied to artistic artifacts, and then by W.J.T. Mitchell, who loosened disciplinary constraints and proposed new terminology in constant change—here we seek to apply the principles of general image science to non-figurative or abstract images in art, science and technology equally. This book is intended to be read in the order in which the individual texts are arranged so that the reader can fully understand its underlying logic and connect in the most constructive way of scientific scrutiny with an open field of meaning, for we believe that methodological approaches to abstraction in art (rarely in other fields) are often considered to be counterintuitive and pose an insurmountable obstacle to the observation and interpretation of abstract visualizations.

This book is divided into four parts and also, uncommonly for edited collections of this kind, has a prolegomena and coda that we believe provide some kind of intellectual encouragement to move into a scientific analysis of the open field of non-figurativeness; we felt that these introductory and concluding messages were, in different ways, necessary to convey at the very beginning and at the very end of the book. Winfried Nöth explains in the prolegomena why every pictorial visualization should be approached as a semiotic sign, since images not only serve us to signify known things and concepts, but are a basic condition of humanity because they contribute to the cognitive role of the human intellect. Following Charles Sanders Peirce, he reminds us that a pure icon is a borderline case of iconicity, which means that a sign, in order to be a sign of something, must differ from what it refers to. So, the problem with hyper-realistic pictures is basically the same as with abstract ones: while the former are too similar to their referent to be a sign of it, the latter may be signs of anything that is conventionally agreed upon and not just self-referential signs of themselves.

In the first part of the book, through the approaches of five authors, we seek to outline the contours of iconological hermeneutics in a historical and theoretical context. Anselm Treichler gives an exhaustive account of one of the first proponents of

abstraction in the arts—Wilhelm Worringer—systematically explaining why abstract representations were crucial for the development of the modern understanding of art, image and creativity. Marie Gasper-Hulvat builds thematically and historically on previous insights on Kazimir Malevich, offering her original interpretation of the relationship between the sacred and the profane in the founder of modern artistic abstraction. The following three chapters explain how it is possible to discuss the fundamental aporias of abstract art and why non-figurativeness is one of the fundamental aspects of representation theory. Blaženka Perica offers new insights into the theoretical approach to Minimal Art, arguing that some of Michael Fried's constitutive theses of the era of high modernism, referring specifically to that style, need to be reconsidered, primarily by counteracting the extremely precisely articulated intentions of the proponents of that movement themselves. Regina-Nino Mion defends the view that abstract pictures can be representational and therefore have specific content or subject matter. She contends that what they are about is abstracted from some previously visible figurative content, that they are spiritual and therefore derived from previously invisible content or that their subject matter is produced exclusively for the picture and made visible only on its surface.

In the second part, we move away from concrete theoretical-historiographical problems and try to bring the phenomenon of abstraction closer to a more general position of non-objecthood in art and philosophy. Diarmuid Costello wishes to explain how it is possible that in the philosophy of photography there still prevails the common impression that there is something inherently problematic about the very idea of abstraction in photography, namely, how it is possible for documentary art par excellence to be abstract. In order to answer these questions, he first poses three more fundamental ones: what is photography, what is abstraction and what is abstraction in photography? Paul Crowther shows how the phenomenon of optical illusion on a pictorial surface enables the construction of a general theory of meaning for abstraction as opposed to a common belief that abstraction is not able to provide meaning in a strict sense. In order to do that, he focuses on the relation between allusive meaning and the concept of "transperceptual space". This is followed by a conceptually related thesis by Claude Cernuschi, who demonstrates how formal simplicity and systemic consequentiality in Barnett Newman have produced a very precise idea of time and temporality. Cernuschi's proposal may be understood in a way that some abstract pictures, presented as a coherent system of thought, are able to convey complex notions that are extremely important to all humanity. Bruno Lessard illuminates the multifaceted relationship between French philosophy and painting by adding to the list of important French intellectuals who showed a philosophical interest in painting the names of two neglected philosophers who published extensively on abstraction in art: Michel Henry and Henri Maldiney. Lessard examines how their phenomenological approaches could be used to reconceptualize the discourse on abstract art in both modern art history and 20th-century French philosophy.

In the third part, five authors deal with different aspects of the interrelation between analog and digital abstraction in traditional media such as painting and drawing on the one hand and new media, such as multimedia art installations and the internet, on the other. Michael Betancourt, pointing to the continuities between early abstract art (such as painting or the visual music film), the productions of the mid-20th century film avant-garde and the contemporary abstractions generated

by digital processes, tries to uncover the predilections to abstraction in the modern human history. This is followed by a highly original account of a classic modernist abstraction in which Linn Burchert argues that atmospheric and climatic phenomena such as temperature, light and humidity were of interest not only to the impressionists and the neo-impressionists but also to artists making non-figurative images such as Robert Delaunay and Yves Klein in France, or Wassily Kandinsky, Paul Klee and Johannes Itten at the German Bauhaus school. Birgit Mersmann in her chapter asks fundamental questions—for example, how do the experiences of real "lived" abstraction and the virtual reality experience of data abstraction relate to each other and how does contemporary software abstraction work its way from complexity to abstraction, and vice versa, in a transcoding loop, from abstraction to complexity—in order to trace new interrelations of digitally mediated art and information visualization. Clemens Finkelstein turns our attention to the Japanese multimedia artist Ryoji Ikeda, whose entry into the space of particle physics and physical cosmology, particularly in his digitally produced installation *micro | macro*, sheds new light on the conceptualizations and technologies of contemporary abstraction. The chapter explains new methods of non-figurativeness on the border between pure art and advanced technology, dealing predominantly with newly raised questions of perception on the border between reality and virtuality. Dario Vuger then delineates the contours of digital landscapes of the internet, presenting new or reactualized phenomena of glitch art and vaporwave in a broader context of cyberculture. These abstract or semi-abstract forms of aesthetic experience and illusion are a kind of ammunition for the argument that we are entering a stage in our history that can be described as post-internet, meaning that the internet itself has become fully integrated and fully realized in the modern way of life.

In the fourth part, we deal with visualizations that can only be conditionally called abstract, but which actually represent the link between the materially existing and the materially invisible. A particular challenge to the iconology of abstraction are the realities inaccessible to the view in which approximation is often equated with abstraction. Silvia Casini engages the reader with some of the key historical and conceptual milestones in the passage from the logic of a linear, single-point perspectival space to brain imaging techniques and modelling, like MRI. She argues that this shift is enabled by the Cartesian coordinate system, which is, simultaneously, a drawing device and the setting for experiments to take place. Michael Reinsborough deals with the parallels between the functioning of neural networks in the human brain and the possibility of visualizing them beyond the usual real-abstract contradictions. His neuroscientific approach uncovers many similarities between the visualizing functions of the human brain and abstract representations in a stricter sense, for instance, laws or descriptions of how images in the sciences represent or attempt to represent their object. Ana Peraica shows that what we often consider to be challenges for modern technology already existed in the artistic visions of earlier times. In a specific case study of the relationship between aerial shots in early experimental films by László Moholy-Nagy and the contemporary technology of Google Earth, the author argues that the problem of abstraction is the result of complex interactions between history, culture and strategies of visibility.

The book ends with a kind of paradox, one which clearly outlines the contours of one possible iconology of abstraction. In a coda, Yanai Toister argues that the way the images of the Messier 87 Galaxy were created—that is, using computer-generated

visualizations of the black hole fifty-five million light-years from Earth—clearly demonstrates our urge to abstraction. Just like Wilhelm Worringer stated more than a hundred years ago, this author also thinks that when people are interested in picturing that which they do not see, but which is present nevertheless, and when they strive to represent the invisible nature of the human race or the universe, there are always smaller or bigger parts of the unknown that need to be imagined, and therefore constructed based on calculation, approximation and abstraction.

It is obvious that the fate of abstraction from the viewpoint of our own moment in time can be observed in different ways, depending on whether we are interested in abstraction as a creative tool or as an anthropological fact. Let's start with the latter: Wilhelm Worringer was the first to consider anthropology of abstraction as a relevant force in the development of the human race, and the case that Toister brought up with images of the Messier 87 Galaxy is precisely aimed at showing that abstraction is not the result of the desire for simplification or the saturation with "realism" but the need for the information we possess to be used to discover what we do not have insight into. So, as we said at the beginning, exploring abstraction is a different task altogether—to represent what is not yet presented in a visual form and to show what is not open to view. That would be "synthetic iconology" in the true sense of the word but not in a way Panofsky meant by that, i.e., by gathering relevant image data, but *producing* data to finally see what we don't normally see, in neuroscience, psychology, astronomy and elsewhere. But that is only one side of this problem, and it would be a mistake to reduce the whole of contemporary art and visual communication to just one anthropological urge, however powerful. When we talk about abstraction as part of "cultural symptomatology", which arises from the direct and deliberate influence of humans on their own natural, urban and social environment, then we need something more substantial that would explain how humans interact with the environment and each other.

From the perspective of today, it seems that the phenomena of abstraction in the visual arts and sciences can only be interpreted by the interplay of techno-imagination and cultural-anthropological conditions. Both of these forces act independently but are inextricably intertwined without the possibility of human control. So the question arises: do abstract images need some new iconology? If we put man against technology, then the answer is positive. *Techno-abstraction* explains to us the procedures for producing abstract images based on data gathered from the functioning of the human brain, natural phenomena, space explorations and the like; the emphasis here is on the notion of *production*. On the other hand, *bio-abstraction* refers to the direct attempt of those many individuals, mostly artists, who seek to creatively materialize our human nature, emotions, desires and fears using all possible technical and personal means. In any case, it is an attempt to visualize both real objects and mental constructions that are not accessible to view. Technology has contributed to the creation of abstract images as much as pure "urge to abstraction" throughout art history. I think we can no longer look at technological abstraction separately from biological abstraction which was born of pure necessity, as Worringer teaches us. Artists like Ryoji Ikeda and synthetic visualizations like the image of Messier 87 Galaxy, but also brave new interpretations of paintings by classic modern artists, are breaking the boundaries between techno-abstraction and bio-abstraction, demanding a completely new iconology.

Notes

1 Here I am using John Berger's phrase, succinctly coined in his eponymous book from the early seventies (John Berger, *Ways of Seeing*, London: Penguin Books, 1972).

2 Robert Steiner, *Toward a Grammar of Abstraction: Modernity, Wittgenstein, and the Paintings of Jackson Pollock*, University Park: Penn State University Press, 1992, pp. 13–14.

3 Ibid., p. 14.

4 Cf., for instance, Paul Crowther, "The Logic and Phenomenology of Abstract Art", in Paul Crowther (ed.), *Phenomenology of the Visual Arts (Even the Frame)*, Stanford: Stanford University Press, 2009, pp. 99–119; Paul Crowther, *The Phenomenology of Modern Art: Exploding Deleuze, Illuminating Style*, London: Continuum, 2012 or Paul Crowther, *Phenomenologies of Art and Vision: A Post-Analytic Turn*, London: Bloomsbury, 2013.

5 Cf. Winfried Nöth, "Why Pictures Are Signs; The Semiotics of (Non)representational Pictures", this volume.

6 Steiner, *Toward a Grammar of Abstraction*, p. 50.

7 Conrad Fiedler, *On Judging Works of Visual Art*, Berkeley: University of California Press, 1957 [*Über die Beurteilung von Werken der Bildenden Kunst*, 1876], p. 43.

8 Ibid., p. 56.

9 Ibid., p. 36.

10 The translator and editor of the American edition of Fiedler's book, Henry Schaefer-Simmern, cites an indicative reason why, in the second edition of 1957, Fiedler's term *Gestaltung* was translated as "Gestalt-formation": "In the early and middle eighteenth century, *Gestaltung* was used by German philosophical writers (Herder, Goethe) in their qualitative descriptions of works of art as self-sustained unities of form in which all parts receive their artistic meaning only by their interfunctional relationship to the whole" (ibid., p. vii).

11 Wilhelm Worringer, *Abstraction and Empathy: A Contribution to the Psychology of Style*, New York: Elephant, 1997. The book was first published in 1908 in Germany as *Abstraktion und Einfühlung* by Piper Verlag, Munich. It was first published in English in the United States in 1953.

12 Worringer interprets Riegl's concept as follows: "Riegl was the first to introduce into the method of art historical investigation the concept of 'artistic volition'. By 'absolute artistic volition' is to be understood that latent inner demand which exists per se, entirely independent of the object and of the mode of creation, and behaves as will to form. It is the primary factor in all artistic creation and, in its innermost essence, every work of art is simply an objectification of this a priori existent absolute artistic volition" (ibid., p. 9).

13 Ibid., p. 15.

14 Ibid., p. 19.

15 Ibid., p. 24.

16 Erwin Panofsky, *Meaning in the Visual Arts*, New York: Anchor Books, 1955, pp. 39–40. The chapter referred to here, "Iconography and Iconology. An Introduction to the Study of Renaissance Art", was originally published in the volume *Studies in Iconology*, Oxford: Oxford University Press, 1939.

17 Ibid.

18 The immense popularity of Panofsky's method has largely deterred art historians from following what Aby Warburg suggested in his work earlier, which is "history of art as history of images". In short, Warburg's writings did not, on the one hand, offer a similar formulaic typology, and, on the other, and more importantly, Warburg's proposal for the cultural history of paintings could be interpreted as degrading the special status of the work of art (cf. Horst Bredekamp, "A Neglected Tradition? Art History as 'Bildwissenschaft'", *Critical Inquiry* 29, no. 3 (Spring 2003), pp. 418–428).

19 Panofsky, *Meaning in the Visual Arts*, p. 32.

20 Ibid., p. 38.

21 Ibid., pp. 33–34.

22 The French art historian Louis Marin pointed out a similar problem in his book *Opacité de la peinture: Essais sur la représentation au Quattrocento*, Paris: Éditions de l'École des Hautes Études en Sciences Sociales, 2006. At interest here is the painting *Annunciation* by Benedetto Bonfigli of 1460 in which we see this New Testament scene with the angel on

the left hand side and the Virgin on the right, just being touched by the divine ray of the Holy Spirit. The presence of other angels in the top left hand corner of the picture and the bearded figure who most likely represents God is not any kind of a surprise in this iconographic unit. Nor does the figure of St Luke, the narrator of this scene, placed between the angel and Mary, surprise us at all. What is untypical for this kind of depiction, says Marin, is the combination of functions that have devolved upon Luke—first of all within the reality of the image, then as the author of his own Gospel, and then as the figure of a saint. For Luke is not just the author of the Gospel, from which Bonfigli has appropriated a scene, he is also the patron saint of painters and artists. However, Luke is present in the painting as the person who is yet to record the story that follows (i.e., the Annunciation), like an actor on a film set ready to perform a scene for which the screenplay has yet to be written. We are informed of this by the empty book into which Luke will write what is about to happen and what is actually going on in the paradoxical simultaneity of the time of event and the time of representation. In this scene, Luke is at once the author and leading man of the tale; he belongs at once to contemporary (Renaissance) and New Testament time; he is at once the writer of the Gospel and a representative of those who in the following centuries were to visualize it in various ways; the whole composition of the painting of Benedetto Bonfigli is a highly complex metapictorial commentary on the relationship of text, image, event and interpretation (Louis Marin, *Opacità della pittura. Sulla rappresentazione nel Quattrocento*, translated by Elisabetta Gigante, Florence: La Casa Usher, 2012, pp. 17–18).

23 Panofsky, *Meaning in the Visual Arts*, p. 31.
24 Bazon Brock, "Zur Ikonographie der gegenstandslosen Kunst", in Bazon Brock and Achim Preiß (eds.), *Ikonographia. Anleitung zum Lesen von Bildern*, Munich: Klinkhardt u. Biermann Verlag, 1990, pp. 314–316.
25 Cf. Nelson Goodman, *Languages of Art*, Indianapolis: Hackett Publishing Company, 1976.
26 Ibid.
27 W.J.T. Mitchell, *Iconology: Image, Text, Ideology*, Chicago: University of Chicago Press, 1986, p. 2.
28 Mitchell refers to a passage from Panofsky's essay "Iconography and Iconology" (as published in *Studies in Iconology*) and describes this apologue as "a primal scene of Panofskyan iconological science" (cf. W.J.T. Mitchell, *Picture Theory: Essays in Verbal and Visual Representation*, Chicago: University of Chicago Press, 1994, p. 25).
29 On these and other aspects of Mitchell's iconology, see Krešimir Purgar (ed.), *W.J.T. Mitchell's Image Theory: Living Pictures*, New York and London: Routledge, 2017, and Krešimir Purgar, *Iconologia e cultura visuale. W.J.T. Mitchell, storia e metodo dei visual studies*, Rome: Carocci, 2019.
30 W.J.T. Mitchell, *What Do Pictures Want*, Chicago: University of Chicago Press, 2005, p. 86.
31 Ibid., p. 87.
32 Norman MacLeod, "Images, Totems, Types and Memes: Perspectives on an Iconological Mimetics", in Neal Curtis (ed.), *The Pictorial Turn*, New York and London: Routledge, 2010, p. 94.
33 Ibid., p. 92.
34 Cf. Stefan Majetschak, "Sichtvermerke. Über Unterschiede zwischen Kunst- und Gebrauchsbildern", in Stefan Majetschak (ed.), *Bild-Zeichen. Perspektiven einer Wissenschaft vom Bild*, Munich: Wilhelm Fink Verlag, 2005.
35 Ibid., pp. 114–117. Cf. Martin Kemp, *Visualizations: The Nature Book of Art and Science*, Berkeley: University of California Press, 2001.
36 Cf. Majetschak, "Sichtvermerke".
37 Mitchell, *What Do Pictures Want*, p. 89.
38 Ibid., p. 92.

1 Prolegomena

Why Pictures Are Signs: The Semiotics of (Non)representational Pictures

Winfried Nöth

1.1 Are Pictures Signs?

In the framework of a semiotics that conceives of itself as a theory of culture, it goes without saying that pictures are signs. Nevertheless, this premise has been doubted, mainly by theoreticians of art, who insist in considering their object of study as one that is essentially different from the domain of signs, symbols and meanings.[1] That pictures are not always signs, and even when they are, their sign function is often secondary, has been the argument of a theory of artworks founded in phenomenology.[2] Its proponents claim that 20th-century nonrepresentational art provides the ultimate evidence of the fact that pictures can no longer be considered as signs. Such pictures do not represent anything. They "show" or "exhibit" nothing but themselves.[3]

In contrast to such arguments, this chapter develops the thesis that all pictures, including abstract and other nonrepresentational paintings, *are* signs. Its aim is to show that the arguments against a general semiotics of pictures suffer from the lack of an adequate sign model and have been developed without due consideration of the results and tendencies of visual semiotics.[4] They ignore research in the semiotics of painting, which has never been restricted to representational pictures and has done much research in nonrepresentational painting, too.[5]

The question of whether pictures are signs can be answered from a terminological or a theoretical point of view. From a terminological point of view, the history of the concept of sign and its equivalent in other languages must be consulted to answer the question of whether the concept of sign is applicable to pictures. From a theoretical point of view, an adequate sign model must be adopted to answer the question. The focus of this chapter is on the theoretical question, but a brief survey of the meaning of the term "sign", with respect to pictures in European cultural history, will be given for the sake of historical contextualization.

1.2 Terminological Findings

In ancient European semiotics, pictures were not yet among the phenomena enumerated as signs. The Greek Stoics and the Epicureans used the concept of sign in a narrower sense, which covered only indices, such as landmarks, military signals, weather signs, symptoms of disease or signs predicting future events (Meier-Oeser 1997, XVI). With Saint Augustine, the notion of sign went beyond such restrictions to cover also conventional signs, including words. His definition, which states that "a sign is something that presents itself and furthermore something else to the mind",[6] was so broad

as to be applicable to pictures too. However, in the list of examples of signs that Augustine gives, pictures are not mentioned.

The explicit inclusion of pictures into the class of signs begins with the Scholastics. In his treatise *On Signs* of 1267, Roger Bacon proposes a typology, according to which pictures [*imagines*] and paintings [*picturae*] belong to one of the five main classes of signs.[7] From the point of modern semiotics, it is interesting to note that the Scholastics defined pictures as natural in contrast to intentionally "given" signs, such as words. Pictures are natural signs because they function as such by their own nature and due to the "correspondence" between the picture and the depicted, not because of the intention of a sign producer, as in conventional signs (*On Signs* I.1). (Notice that the criteria "by their own nature" and "due to a correspondence" reappear in Peirce's definition of the iconic sign.) Of course, pictures may be the result of an intention, says Roger Bacon, but it is not this intentionality that makes them signs: "Whether the artist wants it or not, the picture always represents that to which it is similar" (*On Signs* I.15).[8]

The definition of pictures as natural signs, which sounds strange today, was elaborated by the Iberian late Scholastic semioticians of the 15th and 16th centuries, who introduced the category of the artificial sign [*signum artificiale*] as a subcategory of the natural sign. Pictures could be both natural and artificial signs because "artificial" meant "produced with art",[9] whereas "natural", as seen above, meant "iconic". During these centuries, semioticians began to discuss such questions as to whether the picture of something no longer existing, such as the portrait of a deceased emperor or the image of a merely imaginary creature, should be considered as a sign or not.

In the subsequent history of the concept of sign, pictures mostly remained included in the category of sign, although in the Age of Rationalism, they were often neglected. Nevertheless, in a treatise entitled *Semiotik* by Johann Heinrich Lambert of 1764, "depictions and imitations" appear again as one of three major sign classes besides the arbitrary and the natural signs.[10] About 1800, there is the theory of painting as a sign system in the semiotics of the French ideologue Destutt de Tracy.[11] Since the new beginnings of semiotics in the second half of the 20th century, the study of pictures as signs has become an exemplary field of research in Applied Semiotics.

It is true that the concept of sign, still in the 20th century, has also been defined in a narrower way that excludes pictures and, sometimes, even words. Susanne K. Langer, for example, under the influence of Cassirer's *Philosophy of Symbolic Forms*, defines both words and pictures as symbols, and in her terminology, which restricts the concept of sign to indexical signs or signals, symbols are not signs.[12] However, this terminology has not become generally accepted in modern semiotics.

1.3 The Crisis of Representation as a Crisis of the Pictorial Sign?

The assertion that works of nonrepresentational works of art are no longer signs is closely related to the debate of those who have deplored the so-called crisis of representation.[13] Evidence of this crisis is allegedly abundant in modern art, which confronts us with abstract pictures that seem to have lost their referents. Supposedly, the loss of the referent in pictorial representation had reached its climax in the images of virtual reality, in which reality was no longer depicted but actually created. Some scholars in the field of image studies came to the conclusion that digital images are the prototypes of pictures that represent nothing and hence cannot be signs.[14]

However, if representing something without a referent in the visible world of "reality" is a symptom of a crisis of representation, this crisis is certainly as old as the world of pictures in general. Indeed, pictures that represent something nonexistent in "real" space and time are as old as the history of art. Michelangelo's *Creation of Adam* and his *Final Judgment* are clearly pictures that do not denote any real human beings, since no painter can have witnessed the first or the last day of humankind. It may even be the case that Leonardo's *Mona Lisa* is no real but a merely imaginary portrait of a lady.[15] Nevertheless, the imaginary or fictitious beings represented in these paintings, even if they are no faithful portraits of historical figures, are certainly iconic signs of possible human beings and iconic depictions of the painters' knowledge of men and women in their biological nature and cultural setting.

The assumption that only those pictures are signs that depict something real, just as a photograph does, suffers from the reductionist view that every sign must have a material object as its referent. It is an assumption that only testifies to a crisis of an inadequate sign theory.[16] Consider the logical consequence of such a theory for the semiotics of language.[17] Words could only count as language signs if they depicted objects such as "apple", "house" or "fish", whereas words such as "love", "dragon" or "good" that depict no "concrete" objects would have to be excluded from the class of verbal signs.[18] However, if one accepts the widely held view that all words are verbal signs, one would have to come to the counterintuitive conclusion that the word "dragon" is a sign, whereas the picture that represents the same dragon is not a sign.

It is true that the referent of the sign, sometimes also called "denotatum" or "designatum", has indeed been reduced to "things" in the sense of material objects in the history of semiotics, for example, by the logical positivists.[19] However, as early as in the writings of the Scholastic semiotician William of Ockham, the sign clearly does not stand for a "thing", but for something that "evokes something in a cognition".[20] If those who defend the thesis of the nonsemiotic nature of pictures argue still today on the basis of an outdated sign model, their conclusion that pictures are not signs only testify to the inadequacy of their semiotic premises.

Böhme, for example, in accord with his plea against the alleged hypertrophy of semiotics,[21] goes on to distort the semiotic approach to pictures as follows:

> The simplest reply to the question concerning the essence of the picture is: a picture is a sign. However, what is more trivial than the statement that a picture depicts something that is not the object, but refers to it. A picture makes something present that is not there itself. It refers to something else and has its essence in such reference.[22]

After his discussion of Leonardo's *Mona Lisa* as an example of a picture without a referent, and hence of a picture that is not a sign,[23] Böhme comes to the following conclusion, clearly based on a sign model reduced to the sign-referent dyad: "What is then a picture? The fact that a picture can be a picture without having a referent obliges us to assume a being of pictures that is independent of the being of the things".[24] While Boehm restricts his critique of the interpretation of pictures as depictions to those who have an inadequate concept of picture, Lambert Wiesing extends this critique to the concept of sign in general. However, his own view of the sign as a depiction of an object is clearly inadequate and it is inappropriate to substantiate his thesis that pictures are not signs. Wiesing argues:

From a phenomenological point of view one can say: pictures are the things whose visibility becomes autonomous. Pictures show something that differs from whatever they are themselves—in contrast to an imitation, which imitates and also wants to be that which it imitates. However, something on which you can see something other than what is present is not necessarily a sign of this other thing.[25]

Even from an everyday understanding of the German word *Zeichen* ("sign") used in this line of argument, it is hard to see why something that shows (German: *zeigt*) something which is not itself should not be a sign (*Zeichen*).

In Ogden and Richards's much quoted semiotic triangle of 1923,[26] the reductionist dyad of the sign and its referent was expanded to a triad. It distinguishes the sign itself (or sign vehicle) from its referent, which relates the sign to the world beyond the sign, and from its meaning, which relates the sign to a mental world of ideas. This model has often been confounded with Peirce's triadic model of the sign, in comparison to which it suffers from a number of weaknesses. In contrast to Peirce's object of the sign, Ogden and Richard's referent is once more a material object. Furthermore, their triangle may be reduced to two independent dyads, allowing for signs with meaning but without a referent (such as the dragon) and for signs with a referent but without meaning (such as proper names). According to Ogden and Richards's triangle, only the picture of a concrete object, such as an apple or a fish, can be a triadic sign with both meaning and an object of reference. The word "dragon" and the picture of the dragon, for example, are only dyadic signs, which have meaning but no referent. The result of this approach can only be the crisis of a semiotic theory restricted to signs that depend on the empirical evidence of their referents.

Such reductions of the semiotic triad to two independent dyads are not possible in the framework of Peirce's semiotics.[27] Every sign, and hence every picture, is a genuine triad involving both meanings (interpretants) and (referential) objects as the correlates of the sign. However, Peirce's theory of the genuinely triadic nature of the sign does not mean that the object of a dragon is a really existent being that looks like the figure shown in the picture. Rather, the object of the picture of the dragon and the object of the sign in general are defined in ways that differ greatly from the realist tradition, which claims that only things can be objects.[28]

1.4 Pictures as Signs According to Peirce

In order to define pictures as genuinely triadic signs according to Peirce and thus to come closer to a solution of the nature of their objects, a short account of Peirce's sign model is necessary. One of Peirce's many definitions of the sign is the following:

A sign, or *representamen*, is something which stands to somebody for something in some respect or capacity. It addresses somebody, that is, creates in the mind of that person an equivalent sign, or perhaps a more developed sign. That sign which it creates I call the *interpretant* of the first sign. The sign stands for something, its *object*. It stands for that object, not in all respects, but in reference to a sort of idea.[29]

In our context, the sign, that which "stands to somebody for something in some respect", is the picture. In order to be a sign, it is not necessary that an image should be fixed on paper or canvas. A sign, according to Peirce, can also be a mere thought,

an idea. Hence, a mental image can also be a sign. What is important is that the sign as a picture on paper or as a mental image be "a first", something that comes first to a mind that then relates it to an object as its "second" and an interpretant as its "third".

The object for which the picture stands "not in all respects" can be a concrete object, such as an apple or a fish. However, it can also be a mere idea or something purely imaginary since the object, according to Peirce, is not necessarily some "real" object. Peirce says nothing about the "reality" of this object at all and describes it as something "perceptible, or only imaginable or even unimaginable in one sense".[30] He even goes so far as to speculate that "perhaps the Object is altogether fictive".[31] Hence, not only existent, but also merely imaginary beings, such as dragons, can be objects of a sign.[32] The object of a dragon picture is in the first place the mental image of a dragon with which we are familiar. This mental image, with which we have been acquainted for a long time, is a mental object of the dragon picture, but there are also material objects involved in this sign process. In a long chain of references from sign to sign, the present dragon picture also refers to other paintings, drawings or sculptures of dragons that exist as material objects in our culture. The present picture is an iconic sign of those previous pictures that represent similar dragons. Ultimately, in the continuation of this chain of references, we can even find references to real animals, not to "real" dragons, but to reptiles and perhaps dinosaurs, real world objects to which dragons evince similarities in certain respects.

The interpretants of a pictorial sign are the ideas, thoughts, conclusions, impressions, feelings, or actions the picture evokes. It is important to point out that the distinction between the object and the interpretant is not the distinction between a material and a mental correlate of a sign. All three correlates of the pictorial sign can be of a mental kind, as we have seen. The difference between a mental picture that is a sign, one that is an object, and one that is the interpretant of a sign has to do with the temporal sequence of these three mental images in the sign process. When the mental image is the object, of a sign, it precedes the sign as something that evokes it. When it is an interpretant, the mental image is the effect that the sign has created in a mind. As a sign, it is a mental image that comes to a mind in a sequence of thoughts in which it refers back to other ideas and leads to a new interpretant. While the pictorial object relates to a past, which precedes and causes it, and the sign itself belongs to the present in which it is perceived, its interpretant unfolds in the future, in which it creates its semiotic effects.

Both existent and nonexistent, merely fictional or imaginary, things can thus be the objects of a pictorial sign, since the object of a sign is not necessarily a "thing" in space and time. Instead, it can be anything that determines the sign to represent what it does, a vision, another picture, a legend or some real experience transformed by imagination, whether the painter is aware of these determinants or not. In order to investigate pictures as signs according to these premises, two kinds of pictures will be examined in the following that have often been given as examples of pictures without referential objects, namely, imaginary pictures of things that do not exist and pictures that seem to represent nothing at all.

1.5 Imaginary Maps and Their Objects

A first example is from the history of maps, where imaginary territories can be found because of false, erroneous, speculative or merely legendary evidence. Some of them

show nonexistent, others "unknown" or "not yet known", territories.[33] In which sense are such cartographic representations signs that represent an object?

Consider the island of Brazil west of Ireland on a map of 1522 (Figure 1.1). Unlike the cartographic representation of Ireland, which indicates the geographical coordinates of this territory more or less correctly, the representation of the island called Brazil does not indicate any territory in the Atlantic Ocean, and yet it shows an island. We recognize an island because the drawing is similar to other maps of islands, and in this respect, the drawing is an iconic sign of a possible island. The object of this icon is the mental image that we have of islands in general, a mental schema that makes us recognize this cartographic representation as an island. The shape of the island is also an icon of the many other maps of similar islands with which we are familiar.[34] Furthermore, since the existence of Brazil was not an invention of its cartographer but derives from mythical reports in early Celtic legends, the knowledge of these legends is another determinant of this cartographic sign, whose object is hence partly also of a piece of Celtic mythology.

While nobody denies that a map of Ireland, which accurately indicates an existent territory, is a complex sign, those who defend the naïvely realist view of the referent find it unacceptable to define a map of an imaginary territory as a sign with

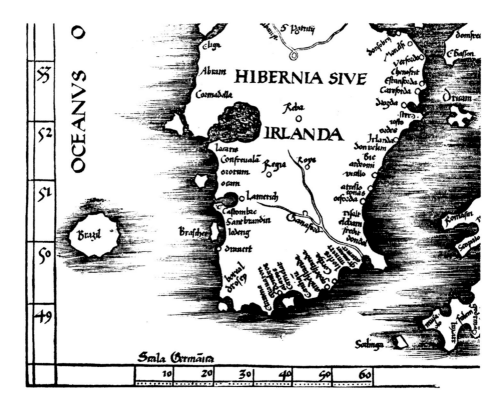

Figure 1.1 The nonexistent island of Brazil on Waldseemüller's map of the "British Isles" of 1522. Source: Carl Moreland and David Bannister, *Antique Maps: A Collector's Handbook*, Prentice Hall Press, 1983, pp. 53–54 (work in public domain).

a referential object. The Peircean view of object, by contrast, is much broader. The object of the sign is that which determines the sign to function as a sign.[35] It can be the experience of a real territory, the thought of such a territory[36] or even the mere imagination of it. Representations of imaginary or even false territories represent objects in this sense. There is always something, whether real or imaginary, natural or cultural, that determines a map to be interpreted as a sign. The objects of a map are the geographical experience of other maps and their territories as well as the cultural knowledge that enables its interpreter to read the map. Thus, even an imaginary map has not only ideas but also the experience of geographical facts as its object.

1.6 Nonrepresentational Pictures and Their Objects

Let us now consider abstract, or better, nonrepresentational paintings as signs and investigate in how far they can be said to stand for an object. The answer is complex. It has to do with Peirce's theory of the pure icon and the category of firstness. Only a rough outline can be given here.[37]

A pure icon is a borderline case of iconicity. An icon in general, which Peirce also calls *hypoicon*, is a sign of an object with which it has features in common, for example, the picture of a red rose is iconic if it shows a red, and not a yellow flower. A pure icon, by contrast, is more than only similar to its object; it is so much like its object that it has become indistinguishable from it. This kind of sign constitutes a kind of degree zero of semioticity, since it is entirely reduced to Peirce's category of firstness, which is "the mode of being of that which is such as it is, positively and without reference to anything else".[38] The pure icon is a sign merely by virtue of its own qualities. Since it is not yet distinguished from its object, it cannot really refer to or "stand for" any specific object.[39] Peirce defines such an icon as a *rhematic qualisign*. He specifies that the pure icon "does not draw any distinction between itself and its object" since it is a sign by virtue of its own particular qualities.[40] As a sign indistinguishable from its object in this way, the pure icon is a self-referential sign.

A pure icon is hence a phenomenon that we perceive as such without relating it to something else. Peirce describes how, even in an act of contemplating a representational painting, we may become so immersed in its aesthetic qualities to the degree that we see it as a pure icon without being aware of its referential dimension:

> [Pure] icons are so completely substituted for their objects as hardly to be distinguished from them. [...] So in contemplating a painting, there is a moment when we lose the consciousness that it is not the thing, the distinction of the real and the copy disappears, and it is for the moment a pure dream—not any particular existence, and yet not general.[41]

Once a picture is contemplated in this way, in total disregard of its referent, it is no longer a hypoicon, but a pure icon. The process of contemplation comes close to what the tradition of aesthetics has defined as the autonomous or self-referential function of art. The painting that has lost its power to refer anything but itself opens the eyes of the beholder to seeing colors and forms as such. In fact, Peirce identifies pure icons elsewhere with pure forms, when he states that "Icons can represent nothing but Forms and Feelings" and that "no pure Icons represent anything but Forms; no pure forms are represented by anything but icons".[42]

A shift from contemplating pictures as hypoicons to contemplating them as pure icons took place in the historical revolution of modern art. When the pictures became liberated from the bonds to their referential objects to function as autonomous compositions of color and form, the difference between the pictorial sign and its object became obliterated, and the meaning of the painting became a mere possibility. Prototypes of pictures as iconic qualisigns are monochrome paintings and works of minimal art, which are among the works of art that have negated most radically the referential nature of the pictorial sign. Any reference to the world of material things, living beings and symbols was programmatically eliminated. Pictures become thus reduced to pure forms and colors, which point to nothing but to themselves.

Is it a contradiction to consider pictures without referents in the traditional sense as signs?[43] In the framework of Peirce's semiotics, such a contradiction does not arise, since it takes into account the possibility of self-reference in signs.[44] As we have seen, a sign can be its own object.[45] According to these premises, a nonrepresentational painting is a self-referential sign whose object is in its own form, color, light reflections and shadings, which constitute a system of chromatic and formal references existing between the pictorial elements only.

However, nonrepresentational pictures are not only signs insofar as they are self-referential. There are other respects in which they are signs. First, they are signs insofar as they belong to the genre of painting. In this respect, they want to convey, so to speak, the message: "I am a work of art (and not some rectangular surface that happens to be yellow)". Secondly, such paintings inevitably refer to previous and current styles or trends of art, even if they are opposed to all of them. Finally, if nothing seems to be meaningful, at least the title of an abstract picture may convey meaning to the painting.

Peirce's category of the iconic sign, of which we have so far discussed the subcategory of the iconic qualisign, comprises two further variants of the iconic sign which are relevant to the semiotic study of nonrepresentational art, the *iconic sinsign* and the *iconic legisign*. While an iconic sinsign is predominantly a singular and unique sign, the iconic legisign is determined by a law or, as we would say today, by a code. Both categories of iconicity are characteristic of two further trends in nonrepresentational art.[46] The prototype of pictures which are predominantly iconic sinsigns is probably Action painting. Jackson Pollock's Action paintings evince singularity and individuality insofar as they show almost nothing than indexical traces of the painter's presence in the picture. His expressive pictorial gestures visualize the movements of his hand and his paint brush, and they show the traces of his paint pots in the process of painting.

The traces of singularity of a work of art are not only restricted to the expressive gestures of the painter's hand, but they can also consist in an invisible demonstrative gesture of choice and presentation. Such gestures characterize the singularity of the *objet trouvé* of the Dada artists. Marcel Duchamp's *Fountain* is an example. It is an object selected from a highly profane everyday context and placed into the radically new context of an art gallery. There it loses its reference to its ordinary use value and becomes a self-referential purely iconic sign instead. It is self-referential insofar as it denies its reference to its original use value. After all, to understand it in terms of its use value would mean to misunderstand its aesthetic value. The dramatic gesture of Marcel Duchamp's choice at a particular moment in the history of art, which was the main cause of its aesthetic value, makes it predominantly an iconic sinsign, which lets

the beholder feel the artist' presence, without whose signature the found object would be mere rubbish. However, there are many other semiotic aspects of this complex work of art. Since the scandal which Duchamp's *Fountain* once caused has become a mere historical reminiscence, this work of art has also acquired the status of a legisign, the class of signs associated with habit and convention since it belongs to the canon of the classics of art history. Furthermore, since the original is lost and only reconstructions of the original can be seen today, these reconstructions can no longer be called sinsigns, since they lack singularity and are mere replicas of the original sinsign.

The third class of iconic signs of relevance to the analysis of nonrepresentational pictures is the iconic legisign. Instead of its mere quality or striking singularity, this kind of sign is characterized by a law that determines its composition. In painting, such laws can be symmetry, balance, polarity, tension, contrast, opposition, invariance, geometrical form or chromatic complementarity. Prototypically, such laws are apparent in the compositional principles of Constructivism and Suprematism—for example, in the paintings of Mondrian.

The structure of Piet Mondrian's paintings, for example, his *Composition in Red, Black, Blue, Yellow and Gray* (1920), obeys the geometrical laws of the construction of rectangular forms, being radically reduced to colored squares and rectangles divided by black lines. A square forms the visual center around which the rectangles are displayed in quasi-symmetrical arrangements, and the colors are chosen to create a harmonious balance without being in perfect symmetry. Forms and colors are not determined by their mere quality or the artist's spontaneous intuition but by a chromatic and geometrical morphology and syntax, whose validity is not only restricted to this particular picture. The picture is a sign related by visual laws to the colors and forms that constitute their object.

Pictures are signs, but to study them from a semiotic perspective requires an adequate sign model. Our discussion has its foundation in Peirce's semiotics. The focus was on imaginary maps and nonrepresentational paintings, whose sign nature has been questioned. The chapter has shown that the concepts of the object of the sign, of pure iconicity, and of self-reference are useful tools in the study of imaginary and nonrepresentational pictures. The third semiotic dimension of pictorial analysis, the study of the pictorial interpretants, had to remain largely excluded from this chapter, not only because of lack of space, but also because there can be little doubt about the fact that pictures exert aesthetic, emotional, and rational effects on their beholders, whose result is, last but not least, the interpretative discourse to which this chapter has tried to be a brief introduction.

Notes

1 See especially Lambert Wiesing, "Sind Bilder Zeichen?", in Klaus Sachs-Hombach and Klaus Rehkämper (eds.), *Bild—Bildwahrnehmung—Bildverarbeitung: Interdisziplinäre Beiträge zur Bildwissenschaft*. Wiesbaden: DUV, 1998; and Lambert Wiesing, "Verstärker der Imagination: Über Verwendungsweisen von Bildern", in G. Jäger (ed.), *Fotografie denken: Über Vilém Flussers Philosophie der Medienmoderne*, Bielefeld: Kerber, 2001; and Gernot Böhme, *Theorie des Bildes*, München: Fink, 1999. The latter finds it necessary to "overcome the hypertrophy of semiotics" by means of a phenomenology of the picture which would assign an only marginal role to the semiotic approach in the study of pictures. His antisemiotic line of argument cumulates in these words: "The theory of the picture has to do away with semiotics in order to become itself", p. 10.

2 Based on phenomenological assumptions, Wiesing argues that there are only two semiotic ways of using pictures: pictures as signs of objects and pictures as signs of perspectives of seeing, including pictorial styles. Typical examples of types of picture that are not signs, according to Wiesing, are the classical collage and even the digital image (cf. "Verstärker der Imagination. Über Verwendungsweisen von Bildern", p. 193).

3 Böhme, op. cit., p. 28.

4 For a survey of the state of the art, see Winfried Nöth, *Handbuch der Semiotik*, 2nd ed., Stuttgart: Metzler, 2000; and Winfried Nöth and Lucia Santaella, "Bild, Malerei und Photographie aus der Sicht der peirceschen Semiotik", in Uwe Wirth (ed.), *Die Welt als Zeichen und Hypothese*, Frankfurt: Suhrkamp, 354–374.

5 Exemplary studies in this context are the semiotic analyses of pictures which the Group has published in their *Treatise of the visual sign* (Francis Edeline, Jean-Marie Klinkenberg and Philippe Minguet (Groupe μ), *Traité du signe visuel*, Paris: Seuil, 1992), or the semiotic studies in painting by the Greimas School, for which Thürlemann's book on a painting by Paul Klee can serve as an example (Felix Thürlemann, *Vom Bild zum Raum: Beiträge zu einer semiotischen Kunstwissenschaft*, Köln: DuMont, 1990). For a survey on the semiotics of images in general cf. Winfried Nöth, "Visual semiotics", in E. Margolis & L. Pauwels (eds.), *The Sage Handbook of Visual Research Methods*, pp. 298–316. London: Sage. For the semiotics of paintings in particular, see Nöth *Handbuch der Semiotik*, op. cit., pp. 434–439.

6 *De dialectica* V 9, f.: "Signum est quod se ipsum et praeter se aliquid animo ostendit". Cf. Stephan Meier-Oeser *Die Spur des Zeichens*, Berlin: de Gruyter, 1997, p. 7.

7 Ibid., p. 54.

8 Ibid., pp. 54–59.

9 Ibid., p. 202.

10 Cf. Nöth, *Handbuch der Semiotik*, op. cit., p. 24.

11 Isabel Zollna, *Einbildungskraft* (imagination) *und Bild* (image) *in den Sprachtheorien um 1800*. Tübingen: Narr, 1990, p. 168.

12 Cf. Nöth, *Handbuch der Semiotik*, op. cit., pp. 40–41.

13 Cf. Winfried Nöth, "Crisis of representation?", *Semiotica* 143 (1/4), 2003, pp. 9–16.

14 Wiesing ("Verstärker der Imagination: Über Verwendungsweisen von Bildern", op. cit., p. 197), for example, argues: "The picture of a chessboard on a computer monitor is not a sign of an absent chessboard, but the presence of an imaginary chessboard". Furthermore: "The computer picture does not refer, but it creates an artificial presence by making the visibility of the picture its purpose".

15 Böhme (1999, 46) gives this example to support his thesis that pictures without a "referent" are not signs and to surprise his readers with his insight that Leonardo da Vinci's painting is hence no sign.

16 According to Gottfried Boehm, the mistake of reducing pictures to depictions [*Abbilder*] has been characteristic of the "conventional" approach to pictures in general: "The conventional concept of picture [...] is based on the idea of *depiction*. It is the idea that pictures *mirror* a *presupposed* reality (in whatever stylistic distortion). What we know and what we are acquainted with meets us once more under exonerating visual circumstances. At any rate, the nature of depiction consists in a doubling". See Gottfried Boehm, "Die Bilderfrage", in Gottfried Boehm (ed.), *Was ist ein Bild?* München: Fink, 1994, pp. 325–343.

17 Cf. Winfried Nöth, "Wörter als Zeichen: Einige semiotische Aspekte der Sprache", in Jürgen Dittmann and Claudia Schmidt (eds.), *Über Wörter*. Freiburg: Rombach, 2002, pp. 9–32.

18 Böhme ignores this parallel when he argues that words are signs in general, whereas pictures, in contrast to words, are not signs but evince a "particular mode of being" (Gernot Böhme, *Theorie des Bildes*, op. cit., p. 46).

19 Cf. Nöth, *Handbuch der Semiotik*, op. cit., p. 137.

20 "Signum est ille, quod aliquid facit in cognitionem venire", as quoted in Nöth (2000, 137).

21 See quote in Note 1.

22 Böhme, op. cit., p. 27, p. 43.

23 See Note 15.

24 Böhme, op. cit., p. 45.
25 Lambert Wiesing, "Sind Bilder Zeichen?", in Klaus Sachs-Hombach and Klaus Rehkämper (eds.), *Bild—Bildwahrnehmung—Bildverarbeitung: Interdisziplinäre Beiträge zur Bildwissenschaft*, Wiesbaden: DUV, 1998, p. 98.
26 Cf. Nöth, *Handbuch der Semiotik*, op. cit., p. 140.
27 Cf. Winfried Nöth, "Representations of imaginary, nonexistent, or nonfigurative objects". *Cognitio. Revista de Filosofia* (São Paulo) 7 (2), 2006, pp. 277–292.
28 Cf. ibid.
29 Charles Sanders Peirce, *Collected Papers*, vols. 1–6, Charles Hartshorne and Paul Weiss (eds.); vols. 7–8, Arthur W. Burks (ed.), Cambridge, MA: Harvard University Press, 1931–1958 [quoted as CP with references to volume number and paragraph], CP 2.228.
30 Peirce, op. cit., CP 2.230.
31 Ibid., CP 8.314.
32 Cf. Nöth, "Representations of imaginary, nonexistent, or nonfigurative objects", op. cit.
33 Cf. Winfried Nöth, "Die Karte und ihre Territorien in der Geschichte der Kartographie", in Jürg Glauser and Claus Kiening (eds.), *Text—Bild—Karte: Kartographien der Vormoderne*. Freiburg: Rombach, 2004.
34 Peirce, op. cit., CP 2.231.
35 Ibid., CP 4.536.
36 Ibid., CP 1.538.
37 For more details, see Santaella and Nöth, *Imagem: Cognição, semiótica, mídia*, 1998, op. cit., pp. 206–226 and Winfried Nöth, "Semiotic form and the semantic paradox of the abstract sign", *Visio* 6 (4), pp. 153–163; "Photography between reference and self-reference"—"Fotografie zwischen Fremdreferenz und Selbstreferenz", in Ruth Horak (ed.), *Rethinking Photography I+II: Narration and New Reduction in Photography—Narration und neue Reduktion in der Fotografie*. Salzburg: Fotohof edition, 2003, pp. 22–39; and "Representations of imaginary, nonexistent, or nonfigurative objects", op. cit.
38 Peirce, op. cit., CP 8.328.
39 Ibid., CP 2.92, 2.276.
40 Ibid., CP 5.74, 4.447.
41 Ibid., CP 3.362.
42 Ibid., CP 4.531.
43 Cf. Francis Edeline et al., *Traité du signe visuel*, op. cit., p. 114.
44 Cf. Gerhard Schönrich, *Zeichenhandeln: Untersuchungen zum Begriff einer semiotischen Vernunft im Ausgang von Charles S. Peirce*, Frankfurt/Main: Suhrkamp, 1990, p. 113.
45 Peirce, op. cit., CP 2.274.
46 Insofar as it is an original and refers to its painter as an individual, every single painting, whether representational or nonrepresentational, evinces singularity. In this respect, every original painting is a sinsign.

Part I
History and Theory of Abstraction

2 The Founding of Abstraction
Wilhelm Worringer and the Avant-Garde

Anselm Treichler

2.1 Introduction: The Two Terms of Abstraction

Expressive abstraction and *geometric* abstraction: these two terms from Wilhelm Worringer's study *Abstraction and Empathy* (1907)[1] have been decisive for the development of 20th- and 21st-century art. For the artists of such movements as *Der Blaue Reiter* and the Weimar-era *Bauhaus*, the concept of *expressive abstraction* aligned perfectly with their artistic intentions. *Geometric abstraction*, on the other hand, was elevated to a new art form by representatives of Suprematism and Constructivism. In his pioneering 1936 exhibition *Cubism and Abstract Art* at the Museum of Modern Art in New York, Alfred Barr sorted recent developments in art into two categories: *geometrical abstract art* and *non-geometrical abstract* (i.e., *expressive*) *art*.[2] To exemplify these two categories, he used an improvisation by Wassily Kandinsky (Untitled, 1915) and Kazimir Malevich's *Suprematist Composition* (undated). In so doing, Barr drew on Worringer's two terms almost thirty years after the publication of *Abstraction and Empathy* and simultaneously limits the evolution of modern art to just two distinct paths.

Gilles Deleuze and Félix Guattari repeatedly refer to Worringer's theory of abstraction in their philosophical theory of thought, for example, in their delineation of two kinds of space, *smooth* and *striated*, in *A Thousand Plateaus* (1980). They refer in particular to the "power of expression"[3] of the abstract line, which carries art beyond the illustrative and narrative. They propose two different types of lines to represent differentiated schools of abstract thought: one type of line is abstract in a geometric sense; the other, an abstract "nomadic line", is the one that is, for them, truly abstract.[4] This nomadic line, "passes *between* points, figures, and contours", describes a smooth space and is characterized by "infinite movement".[5] The nomadic line is the pure abstract line; it evades geometry and form, distills life from the organic and possesses true expressive power.[6] Deleuze and Guattari differ from Worringer in that they do not see the origin of art in geometrical abstraction but in the abstract nomadic line, which for Worringer is the Gothic line. These two trends in abstraction can be found in the works of Piet Mondrian and Jackson Pollock, among others.

A fundamental understanding of abstraction requires close study of the processes of abstraction described in Wilhelm Worringer's work, his references to Alois Riegl and Theodor Lipps and the philosophical-historical context, as well as the reception of abstraction among artists of the avant-garde. The process of abstraction in art around 1900 is marked by an extreme urge toward expansion, toward the dissolution and upending of the familiar, and is characterized by a productive artistic force. Beyond

this close reading, it is also my intention here to show that the process of abstraction cannot be considered unique to art and aesthetics but must be treated as a general phenomenon: Worringer's theory of abstraction is not only relevant to artistic works and movements but also proves to be equally productive for analyzing the history of art and science in the 20th and 21st centuries.

2.2 Wilhelm Worringer's Founding of Abstraction

The history of the term "abstraction" extends back to ancient philosophy. Plato and Aristotle defined abstraction primarily as a mathematical-logical concept.[7] They use the term "concrete" as the constant conceptual antithesis of the abstract. Not until the turn of the 20th century did abstraction become a basic aesthetic concept. Worringer's study *Abstraction and Empathy* represents a decisive contribution to the development of an intensive theoretical examination and reflection on abstraction as an aesthetic theory.[8]

In the 19th century, a discourse emerged around various concepts related to abstraction, mainly in philosophical, aesthetic and psychological theories. Here, the aesthetic concept of abstraction is especially understood in relation to geometry, and with mathematical rules and axioms.[9] Theorists in the field of aesthetics of empathy, among them Johannes Volkelt, speak of the "beauty of simple, abstract forms: the colors, tones, lines, flatness".[10] For Friedrich Theodor Vischer, symbolism endows "abstract, mathematically calculable forms" with aesthetic content.[11]

Worringer constructs his theory of abstraction as an evolutionary history of the human need for art. As an author of art-theoretical, philosophically elaborated aesthetics of abstraction, Worringer turns against the prevailing idea that natural beauty has primacy and departs from imitation of nature as a principle in art. His lasting achievement is that he both radically breaks with the prevailing theory of imitation and mimesis and, at the same time, sketches his own aesthetics of abstraction.

Abstraction and Empathy is Worringer's universalist attempt to explain and redefine art history via the opposing poles of the human *urge to abstraction* and *urge to empathy*. Empathetic art stands for the happiness that stems from a harmonious relationship with the world, and abstraction stands for mastering *Weltangst* or anxiety about the world. Abstraction and empathy form the poles of an all-encompassing spectrum of artistic creation within which forms relate to one another in shifting forms. Therefore abstraction is not just "absolute abstraction";[12] rather it especially reveals itself as a process of abstracting, which in works of art becomes manifest in their charged relationship with nature. The Egyptian pyramid is the classic example of geometric abstraction, while the Greek temple symbolizes organic life. Between them is the Gothic cathedral, which, although constructed out of abstract forces, nevertheless appeals to our sense of empathy.[13]

Worringer explains geometric abstraction as the "*Urkunsttrieb*", or primal artistic impulse,[14] and by doing so establishes a new aesthetic. Citing Tibullus before him, "*primum in mundo fecit deus timor*",[15] for Worringer the principle of abstraction is not an emptying-out of form but a method of overcoming anxiety. He describes this state of fear as a "spiritual dread of space" and sees the origin of artistic creation in the feeling of anxiety that springs from a "great inner unrest […] in man".[16] His theory sets out from an anthropological premise; in his view, a conformity to the law of abstraction is innate to humankind. The process of abstraction and the search for

conformity to the laws of geometry are, for Worringer, a penetration of nature and natural creation. The process leads to an absolute form and purest abstraction by wresting the object of the external world out of its natural context, purifying it of all its dependence upon life.[17]

2.2.1 Empathy and Artistic Volition

Worringer characterizes empathy, a concept he takes up from Theodor Lipps, as the transference of one's own organic vitality onto an object. For Lipps, empathy is an active, intentional act, an experience of the vitality of the self, which can be felt, in objectified form, in the things of the world. Lipps distinguishes between that which a sensible object expresses and that which is felt in it.[18] In contrast to Lipps, Worringer does not see in empathy a universal principle that always and unconditionally shapes our aesthetic relationship with nature, but rather recognizes in it an aesthetic behavior that of all epochs only ever underpinned Greco-Roman antiquity and the Renaissance. The urge to empathy, when taken as the prerequisite of aesthetic experience, reaches its highest expression in the beauty of the organic. The urge to abstraction, on the other hand, is affirmed by the beauty of the inorganic and thus by abstract law and necessity.[19] Worringer finds *ability* too limiting as the sole criteria for tracing the development of art; he attempts to break through this materialistic definition, opposing it with the notion of *volition*.[20] In this, he draws on Riegl's theory of *artistic volition*, which refers to artistic motivation aimed at the satisfaction of psychic needs, in which material factors (in contrast to Gottfried Semper's view) only appear as obstacles.[21] Worringer writes that the creative urge is the decisive element of artistic creation, and "in it's innermost essence, every work of art is simply an objectification of this *a priori* existent absolute artistic volition".[22]

Artistic volition, for Worringer, is entirely subject to the *principle* of abstraction. A prime example of this is the Egyptian pyramid, already put forward by Riegl as an ideal type; here, the cubic is transformed into abstraction, and the form possesses pure geometrical regularity, so that "all the dictates of an extreme urge to abstraction are here fulfilled".[23] For Riegl, the pyramid, with its perfect expression, might even be better described as a "*Bildwerk* rather than a *Bauwerk*".[24] Worringer's understanding of *artistic volition* gave an unfolding artistic movement, characterized by eschewing imitation in favor of the non-figurative, more than just a catchword to go by. Rather, his study lent the movement a conceptual legitimacy. From the beginning, therefore, Worringer's theory was seen as the intention of developing—from the latest movement in art, still very much in its nascent form—a new aesthetic that could influence artistic movements yet to come.

2.2.2 Worringer's Turn to the Process of Abstraction

For an elementary understanding of Worringer's theory of abstraction, we can look at the way he portrays the process of abstraction. He takes the familiar understanding of abstraction and turns it on its head: rather than stylizing a model taken from nature, an abstract entity (for example, an ornament) is naturalized. Here lies the full clout of the twist in his reasoning: a thing is original when it conforms to the laws of the natural form, i.e., its originality lies in the idea and not in any visible natural model.[25] He notes, in reference to Riegl's *Stilfragen*, that the geometric style evincing

the highest abstraction is particularly present in peoples at their so-called most *primitive* cultural level. This grounds his theory of abstraction in ethnopsychology and in ideological premises that leaves it vulnerable to criticism. Despite this weakness in his thesis, Worringer struck a chord in his day, and his study provides a starting point for analyzing contemporary problems such as the experience of uncertainty, alienation and the quest for a new era.

For Worringer, the act of preferring flatness over depth, and thus avoiding spatial illusion, functions as a technique for overcoming a profound sense of anxiety. It achieves a contemplative inner *space* that has overcome the external world. Worringer privileges the plane surface and, with the concept of Gothic line ornamentation, tries to think through the sensual relation to the world beyond the organic.[26] Worringer's conclusion is that both the geometric form and the expressive line are abstract and neither aim at illustrating the natural model. With this argument, he pits himself against the established assumption of a linear progression through the history of art, which proceeds from the primacy of naturalism.

In contrast to its meaning within the philosophical tradition, abstraction in art need not be understood as a negative process of withdrawal or dissociation. Rather, aesthetic abstraction is an active artistic process that seeks to give *expression* to something, for example, something observed in nature, in its most ideal and regular form. In general, the process of abstraction can be understood as the search for an idea that underlies every thing or living being. This characteristic gives artistic productivity an utterly free expressive style, up to and including non-style. Gottfried Boehm, too, assumes the centrality of process for artistic creation and, drawing on Paul Klee, states that the purpose is not to show what is but to make something visible. He gives the central role in this to abstraction.[27] He defines abstract art as "a *genuine interpretation of reality*. It implies its own way of recognizing the world".[28] A central characteristic of abstraction is its flatness and geometrical regularity, as well as the expressiveness of its manifestations. Worringer's concept of abstraction can be understood as the central theory of a comprehensive movement, the *abstract turn*—not only in art but also in aesthetics and science.[29]

2.3 Worringer and the Art of the Avant-Garde

With the two terms, "expressive" and "geometric" abstraction, Worringer succeeded in outlining the trajectories of the artistic production that was emerging at the time. Art history and artistic practice were thereby contemporaneously intertwined. Worringer's phrase "expressive abstraction"[30] precisely described the approach of various artists, in particular that of the artist group *Der Blaue Reiter*. Alongside Franz Marc and Wassily Kandinsky, August Macke was one of the first to recognize the connection and import of Worringer's theory of abstraction to his own work and to translate it convincingly to his artistic practice.[31] This was true from that moment on for all of the artists of the *Der Blaue Reiter*.[32] It would not be long until the theory was also taken up by the *Bauhaus* in Weimar.

2.3.1 *The Will to Form*

The almanac published by *Der Blaue Reiter* shows Kandinsky and Marc's perspective on the development of art. To exemplify their interpretation of art's evolution, they

juxtaposed images from different genres and epochs: a sculpture of a *Foolish Virgin* from the 13th century appears next to the portrait of a lady by Oskar Kokoschka.[33] A few pages further, the comparison of Van Gogh's *Dr. Gachet* (1890) with a fragment of a Japanese woodcut reveals surprising resonances: observing the two works next to one another, their mutual expressiveness is especially striking.[34]

It cannot be determined for certain whether Kandinsky and Marc had read Worringer's *Abstraction and Empathy* at this time, but they were already familiar with his contribution to the anthology *The Struggle for Art*, published in 1911 as a reaction to the conservative *A Protest of German Artists* put together by the painter Carl Vinnen. It had been their idea to organize a counter-publication, and Kandinsky was the one who had convinced Worringer to contribute to it.[35] The essay "The Historical Development of Modern Art" outlines ideas central to Worringer's work and emphasizes

> How transparently clear it seems today that the stylistic character of primitive art is not determined by any lack of skill, but by a different conception of artistic purpose, a purpose that rests on a great, elementary foundation of a sort that we, with our well-buffered contemporary approach to life, can hardly conceive.[36]

The essay lays out Worringer's approach of comparing anti-naturalistic works of earlier epochs and other cultures with works of contemporary art. There is, too, a parallel in the independence of image and text, which also characterizes the almanac. Worringer anticipates this relationship between image and text in *Form Problems of the Gothic*, which was also published by Piper in May 1911. In the preface, he points out that the illustrations are not intended as scholarly confirmations of his statements but rather as "harmonizing with the spirit of the text they accompany".[37] The images in the almanac are similarly chosen so that they are not in the traditional sense illustrative of the text but stand as independent works and accompany the content of the contributions.

As early as 1900, an urge to expand and stretch previous forms of representation and to transgress boundaries of culture and tradition can be seen in artistic production and in art theory. For example, Riegl, as part of his research conveyed in *Late Roman Art Industry* (1901), considers the development of art from antiquity to the Middle Ages. Contrary to previous historiography, he does not see the works of late antiquity as so-called *symptoms of decay*; instead, he re-evaluates them, viewing them as marking a turning point between two epochs. The works of late antiquity are characterized by their detachment from the natural model and exhibit a preference for flat representation. Riegl does not ascribe differences in forms of artistic expression and the tendency to abstraction to a lack of skill but rather to a different kind of formal and expressive will. For Riegl,

> all such human *Wollen* [will] is directed towards self-satisfaction in relation to the surrounding environment. [...] Creative *Kunstwollen* [artistic will or volition] regulates the relation between man and objects as we perceive them with our sense; this is how we always give shape and color to things. [...] The character of this *Wollen* is always determined by what may be termed the conception of the world at a given time [*Weltanschauung*] [...] not only in religion, philosophy, science, but also in government and law.[38]

In the diversity of individual things, Riegl recognizes the law of *Kunstwollen*. Unlike Wölfflin, he sees *Kunstwollen* as an expression of connections across histories of thinking and histories of culture. In light of *Der Blaue Reiter Almanac*, Riegl's *Late Roman Art Industry* and its comparisons between a bronze buckle from Egypt and the corner of a marble window screen from the Duomo in Ravenna no longer appears surprising.[39] Only when the date of Riegl's writing—1901—is taken into consideration does the radical nature of this comparison becomes clear. He breaks the previously fixed boundaries between disciplines, juxtaposing the liberal and the applied arts and placing them on an equal footing. No longer are iconographic and historical relationships foregrounded. Crossing all boundaries, Riegl compares the works in terms of their forms and the will to expression, thus breaking with a materialistic purpose-based aesthetics as represented by Gottfried Semper.

2.3.2 *The Empty Surface as Form*

Coinciding with Riegl's *Art Industry*, an unprecedented essay by Adolf Hölzel appeared, "On Shapes and Mass Distribution in Images" (1901), which in his examination of the relations between point, line and surface already clearly anticipated Kandinsky's ideas about abstraction.[40] Hölzel refers as well to fundamental assumptions from Riegl's *Stilfragen*.[41] As does Worringer, Hölzel finds an essential foundation for his work in the geometric laws of Egyptian art—in particular, the architectonic cut of the pyramids.[42] He sees this architectural construction, in fact, as a "basis for the development of images"[43] and transfers the method of architectural triangulation, which can be found in the Gothic cathedral, to his own work (for example, in *Fugue on a Resurrection Theme*, 1916, Figure 2.1). The relationship between Hölzel's work and Gothic architecture is particularly visible in his stained glass, including the window Hölzel made for Hermann Bahlsen's biscuit factory in Hanover (1915–1918), characterized by a striking intensity of color as well as an abstract, flat presentation.

In his study of surface, Hölzel makes a remarkable discovery: the so-called free or empty surfaces between the figural forms play a decisive role in the image as a whole. He even sees the artist in a "state of dependency with the surface" on which he depicts his subject.[44] Hölzel's particular achievement is that he attributes to *interstitial forms* a significance equal to that of the image itself. When the space between forms has the status of a form in its own right, figure and ground as well as form and free surface take on the same importance. His analysis of the relationships between point, line and surface, as well as his evaluation of the free surface as an autonomous surface in an image, goes beyond the abstraction of point and line as well as surface ornamentation. Thus, as early as 1901, Hölzel paved the way to abstraction.[45]

A central characteristic of Worringer's theory of abstraction is the avoidance of space and the privileging of flatness. Flatness is at the center of both Hölzel's artistic and theoretical works; in interstitial forms, he discovers the void, and thus negative space, as a ground-breaking feature of abstraction. Through Hölzel's re-evaluation of the surface form, the object becomes secondary. He develops the basic idea of abstract color painting, as we later see it executed by Mondrian, Kandinsky, Malevich and others. In the 1910s, a turning away from representations of objects and nature took the form of utter abstraction, through a focus on pure surface. Mondrian's tree studies and tree paintings clearly show the process of abstraction: the typical forms associated with the tree, the trunk and forking branches, can still be discerned in *Composition*

Figure 2.1 Adolf Hölzel, *Fugue on a Resurrection Theme*, 1916, oil on canvas, 84 × 67 cm. Photo courtesy of Landesmuseum für Kunst und Kulturgeschichte Oldenburg, LMO 14.717; photo: Sven Adelaide. Image rights not transferable.

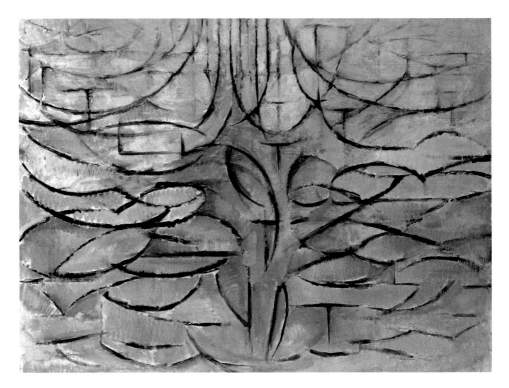

Figure 2.2 Piet Mondrian, *Flowering Apple Tree*, 1912, oil on canvas, 78.5 × 107.5 cm, exhibited in Gemeentemuseum, Den Haag (work in public domain).

Trees II (1912/1913). In other works, Mondrian journeys deeper and deeper into the idea of the tree. In *Flowering Apple Tree* (1912, Figure 2.2), he uses the tree and the surrounding area as a virtual grid whose horizontal and vertical black lines act as a subtle organizing principle. He fills the spaces in between with complementary areas of color. Kazimir Malevich takes his geometric abstraction of colored surfaces to the extreme by depicting the square surface as such, without any pictorial commentary (*Black Square*, 1915).

2.3.3 *The Expanded Process of Abstraction*

The avant-garde movement is characterized by a profound urge toward dissolution and renewal. This is accompanied by a search for the innermost structures and conformities to the laws of nature, the universal idea par excellence. Marc assesses the avant-garde's artistic moves toward the destruction of the natural model and the representation of the governing principles underlying surface appearances as the "reversal of all that is familiar".[46] On October 15, 1914, in a letter from the military hospital in Schlettstadt, Marc writes to his wife about his new approach to natural science:

> You'll be surprised that I'm thinking so much about "science" these days, as opposed to earlier. I couldn't find a counterpoise to modern science in art in the way I had imagined. But it must be found, and not *au détriment des sciences*,

but in full reverence for the European exact science; it is the foundation of our Europeanness; if we are really going to have an art of our own, it can't live in enmity with science.[47]

Building on the process of abstraction and the study of the laws underlying art, it is possible to bridge the gap between art and scientific investigation, as Marc hoped.

The process of abstraction must not be singularly located in art and aesthetics but must be regarded as a general phenomenon that also includes natural science.[48] Natural science and medicine employ image-making techniques to visualize their research, thus making their processes of abstraction newly visible. Sigfried Giedion, in a 1931 lecture, analyzed this broadening of our field of vision as follows:

> The microscope, the X-ray machine, these have forged a new ability to see. The immense world of anonymous and abstract things, the whole realm of the amorphous, now falls into our sphere of waking experience. The range of possible feeling is growing. Under the microscope, there arise associations between a cluster of stars and a butterfly wing.[49]

Giedion's assessment reflects his admiration for the new technical inventions, as well as the new opportunities in science they give rise to, and the broadening of the artistic perspective. Worringer, in contrast to this, achieves a radical change in perspective by shifting the focus away from the predominance of imitating nature to a revaluation of art as originating in abstraction. At such an early date as 1907, he laid out a theoretical, aesthetic basis for understanding a world that was becoming more and more abstract, one that Giedion, responding to the technical inventions and what they revealed to the human eye, was merely able to describe.

In their attempt to present the essence of an epoch, artists also absorb the entire world and see the universe as a unified entity. This approach bears a marked similarity to the natural sciences, which seek laws and formulas to establish general principles that govern all areas and that will one day culminate in a unified *Weltformel* (theory of everything). The search for root connections and constructions, common to both disciplines, leads to the pursuit of universality.

In the depiction of abstract, expressive, crystalline, flat and geometric forms, the artists of the avant-garde found their means of expression that allowed them to reproduce the lawfulness and inner construction of natural forms. They moved away from the natural model in order to grasp the basic idea of that which they were representing and, thus, to make a portion of the universal visible. In the natural sciences, we see the reverse process: here, precise, detailed observations of nature ultimately lead to insight into the laws of nature and mathematical formulas as pure abstractions.

Like Worringer, the artists of the avant-garde also locate abstraction at the beginning of art's development. For Marc, even in the earliest cultures an abstract thinking emerges, which he analyzes as *Kunstwollen*. He states that

> Once, very early human beings lived [...] and loved the abstract as we do. [...] How were such products of a pure will for the abstract possible? How were such abstract thoughts conceivable without our contemporary capabilities for abstract thinking? Our European will for abstract form represents [...] an overcoming of the *sentimental spirit*.[50]

There are also some references in Paul Klee's writings and letters to his engagement and agreement with Worringer's theory of abstraction.[51] Worringer's writings represent for Marc a theoretical justification of his views. In his essay "Constructive Ideas of New Painting" in the magazine *Pan*, Marc names two works that might serve as foundations for the dogma of the new art:

> One is the ingenious book by Wilhelm Worringer, *Abstraction and Empathy*, which today deserves the broadest possible attention, and which draws a line of reasoning, strictly grounded in history, that gives fearful opponents of the modern movement some cause for concern. The other, *Considering the Spiritual in Art*, was written by painter Wassily Kandinsky.[52]

This emphasis on the *strictly historical grounding* is interesting; it reveals the artists' desire for confirmation of their views by art historians.

The centerpiece of Worringer's theory of abstraction is the Gothic cathedral; for Walter Gropius, Adolf Behne and Bruno Taut, the cathedral was indeed the symbol of a new generation of artists. Lyonel Feininger's title woodcut for the *Bauhaus* manifesto symbolizes, in its geometric, crystalline form and representation of a cathedral, the ideals of the Gothic in the style of an emerging modernism. The cathedral building is connected with surrounding space through the crystalline, splintered picture plane. The *crystallization* of space thus becomes the abstract representation of a new form. The delicate and geometric precision with which Feininger executed his works gives the structure of the image the appearance of an architectural construction. And precisely therein, according to contemporaries, lay a *secret* Gothic, which Taut for his purposes described in the periodical *Der Sturm* in 1914 as "secret architecture", and which held together "synthetic and abstract" works of architecture, sculpture and painting as in the Gothic period.[53]

2.4 Outlook: The Nomadic Line and Geometric Abstraction

This chapter has shown that abstraction is indeed an essential, but not unique, feature of modern art. Most importantly, following the line of thought Worringer posits, abstraction has to be understood as a process that represents the origin of art. The artists of the avant-garde brought abstraction, in its various expressive forms and theoretical reflections, to a high point in the history of art.

Riegl understands the process of abstraction as a combination of the will for both form and expression, not limited by different genres or epochs. He assesses developments in late antiquity as a process of abstraction, which can be observed again at the transition from the 19th to the 20th century. In their almanac, Kandinsky and Marc build on Riegl's method of freely juxtaposing works of art from different periods and cultures. For them, abstraction is essentially a question of form. Implicitly, they put this question to the reader and the viewer, as a question that will determine the direction that art should take. Art makes use of abstraction as a means of getting at ideas, attempting to render a piece of universal truth visible. Natural science, on the other hand, eventually reaches abstraction through the close study of nature, reducing its findings to laws and formulas. In return, science then creates an artificial visualization of its abstraction processes through imaging techniques.

Worringer's two terms of abstraction, "expressive" and "geometrical", remained influential in the second half of the 20th century for important philosophical and

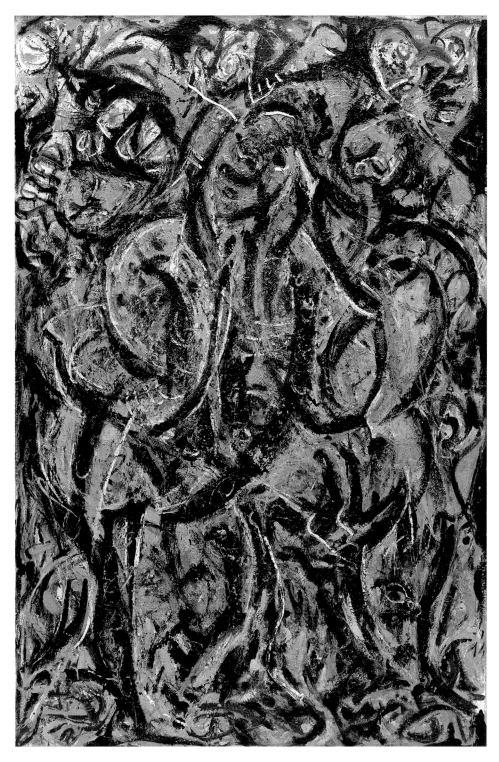

Figure 2.3 Jackson Pollock, *Gothic*, 1944, oil on canvas, 215.5 × 142.1 cm, exhibited in the Museum of Modern Art, New York; photo: Alamy Stock Photo.

artistic trends. Gilles Deleuze extends Clement Greenberg's thesis on modernity's relationship with the Gothic to the fundamental dimension of the nomadic, Gothic line and, in so doing, appeals to Worringer's studies on the Gothic and ornamentation.[54] Deleuze sees a decisive relationship with the Gothic exemplified in Pollock's painting. He recognizes in Pollock's work a "rediscovering [of] the secret of the 'Gothic line'".[55] The Gothic line does not conform to form but rather traces a nomadic movement: it breaks off, changes direction, twists and turns, zigzags, comes and goes in fits and starts.[56] For Worringer, it possesses "the power of infinity [Unendlichkeitspotenz]" that negates body and space.[57]

Jackson Pollock's work *Gothic* (1944, Figure 2.3) marks a turning point in his oeuvre and the beginning of his "all-over" paintings. The forms are dense and continuous with some minor representational notes. Black arches, placed close together, and the flickering of the intervening colors give rhythm to its presentation. The nomadic line does not outline any complete contours of figurative representation but develops its form from a system of turns, which, together with the title of the painting, deliberately reminds the viewer of aspects of Gothic stained glass windows, including the linear alternation of various layers of color. In this respect, *Gothic* is Pollock's first composition with a decentered structure made up of brush marks of a similar kind. Pollock's painting breaks through the order of the modern-day easel painting to become an *all-over mural*, which is decentered, abstract and, above all, flat.[58]

Deleuze interprets Pollock's nomadic abstract line as manual expressive skill, which is also characteristic of Gothic art.[59] This line is characterized by extreme movement and tremendous power, as Pollock's works show. For Deleuze, a line is formally representational even if it does not designate objects but only delineates them, that is, if it isolates forms.[60] The abstract, on the other hand, is a line that does not delineate anything, not even a non-figurative figure.[61] Therefore, for Deleuze, Pollock's lines are abstract (nomadic) lines and are essentially different from the lines of geometric abstract art. In Pollock's drip-paintings, the nomadic lines are liberated from figures and thus become "lines in mutation" that "[pass] *between* things".[62]

In geometric abstraction, Worringer saw the founding of art, which sought to banish anxiety and dread (*Weltangst*) by negating space. The works of Minimal Art are defined by this geometric abstraction, in the extreme smooth, cold hardness of the unapproachable work and the pure surface it displays. Donald Judd's six closed cubes (1969) at the Kunstmuseum Basel are made of cold-rolled dark gray steel. Although the edges are sharp and neatly polished to a finish, the strength of the metal plates is still visible. Six closed cubes of equal size alternate freely in the gallery with patches of open space, each measuring one-quarter of the volume of one of the cubes, in a repetitive rhythm. On the one hand, the cubes become elements of the space; on the other, they redefine it. In their cold geometrical harshness and abstractness, they convey an emotionless quality. The basic geometric shape of the cube is reminiscent of an inorganic, life-threatening objectivity that corresponds to Worringer's perception of the pyramid's lifeless form.[63] They stand thus in contradiction to the need for empathy, existing as pure geometric abstraction.

Notes

1 Wilhelm Worringer, *Abstraction and Empathy: A Contribution to the Psychology of Style*, Chicago: Elephant Paperbacks, 1997.

2 Cf. Alfred Barr, *Cubism and Abstract Art*, New York: The Museum of Modern Art, 1936, p. 19.

3 Gilles Deleuze & Félix Guattari, *A Thousand Plateaus: Capitalism and Schizophrenia*, Minneapolis: University of Minnesota Press, 2005, p. 498.

4 Ibid., p. 496.

5 Ibid., pp. 496, 498.

6 Cf. Ibid., pp. 497–499.

7 Cf. Joachim Ritter (ed.), *Historisches Wörterbuch der Philosophie*, vol. 1, Basel, Stuttgart: Schwabe, 1971, pp. 33–65.

8 Cf. Sabine Flach, *Die Wissenskünste der Avantgarden. Kunst, Wahrnehmungswissenschaften und Medien 1915-1930*, Bielefeld: Transcript, 2016, p. 68.

9 Cf. Jutta Müller-Tamm, "Die »Parforce-Souveränität des Autoriellen«. Zur Diskursgeschichte des ästhetischen Abstraktionsbegriffs", in Claudia Blümle & Armin Schäfer (eds.), *Struktur, Figur, Kontur. Abstraktion in Kunst und Lebenswissenschaften*, Zürich, Berlin: Diaphanes, 2007, pp. 79–92; 80.

10 Johannes Volkelt, *Der Symbol-Begriff in der neuesten Aesthetik*, Jena: Dufft, 1876, p. 1 (translation by the author).

11 Friedrich Theodor Vischer, "Kritik meiner Ästhetik", in Friedrich Theodor Vischer (ed.), *Kritische Gänge*, n.s., no. 5, Stuttgart: Cotta, 1866, p. 137 (translation by the author).

12 Worringer, *Abstraction and Empathy*, p. 37.

13 Ibid., p. 112.

14 Ibid., p. 44.

15 Ibid., p. 15.

16 Ibid., p. 15.

17 Ibid., p. 17.

18 Cf. Theodor Lipps, *Ästhetik. Psychologie des Schönen und der Kunst*, Leipzig: Voss, 1903, pp. 120–126.

19 Cf. Worringer, op. cit., p. 4.

20 Ibid., p. 9.

21 Cf. Alois Riegl, *Stilfragen. Grundlegungen zu einer Geschichte der Ornamentik*, Berlin: Siemens, 1893; Alois Riegl, *Late Roman Art Industry*, Roma: Bretschneider, 1985, p. 231.

22 Worringer, op. cit., p. 9.

23 Ibid., p. 91.

24 Riegl, *Late Roman Art Industry*, p. 27.

25 Cf. Worringer, op. cit., p. 62.

26 Cf. Claudia Öhlschläger, *Abstraktionsdrang. Wilhelm Worringer und der Geist der Moderne*, München: Fink, 2005, p. 43.

27 Cf. Gottfried Boehm, "Abstraktion und Realität. Zum Verhältnis von Kunst und Kunstphilosophie in der Moderne", in *Philosophisches Jahrbuch*, vol. 97, Munich 1990, pp. 225–237, 228.

28 Ibid., p. 226 (translation by the author).

29 Cf. Sabine Flach, "abstrakt/Abstraktion", in Karlheinz Barck, Martin Fontius, Dieter Schlenstedt, Burkhart Steinwachs & Friedrich Wolfzettel (eds.), *Ästhetische Grundbegriffe. Historisches Wörterbuch in sieben Bänden*, vol. VII, Stuttgart und Weimar: J.B. Metzler, 2005, pp. 1–40.

30 Worringer, op. cit., 117.

31 Cf. Elisabeth Erdmann-Macke, *Erinnerungen an August Macke*, Stuttgart: Fischer, 1987, pp. 267–268; Wolfgang Macke (ed.), *August Macke—Franz Marc. Briefwechsel*, Köln: DuMont, 1964, p. 60.

32 Cf. Klaus Lankheit (ed.), *Wassily Kandinsky—Franz Marc. Briefwechsel*, München: Piper, 1983, p. 136.

33 Cf. Wassily Kandinsky & Franz Marc (ed.), *Der Blaue Reiter*, München: Piper, 1914, pp. 100–101.

34 Cf. Kandinsky & Marc (ed.), op. cit., pp. 112–113.

35 Cf. Lankheit (ed.), *Wassily Kandinsky—Franz Marc. Briefwechsel*, p. 29.

36 Wilhelm Worringer, "The Historical Development of Modern Art" [1911], in Rose-Carol Washton Long, Ida Katherine Rigby & Stephanie Barron (eds.), *German Expressionism:*

Documents from the End of the Wilhelmine Empire to the Rise of National Socialism, Berkeley: University of California Press, 1993, pp. 9–13, 11.

37 Wilhelm Worringer, *Form Problems of the Gothic*, New York: G.E. Stechert & Co, 1920, preface.

38 Riegl, *Late Roman Art Industry*, p. 231.

39 Cf. Alois Riegl, *Die spätrömische Kunst-Industrie nach den Funden in Österreich-Ungarn im Zusammenhange mit der Gesamtentwicklung der Bildenden Künste bei den Mittelmeervölkern*, Wien: Österreichische Staatsdruckerei, 1901, p. 204.

40 Cf. Wassily Kandinsky, *Punkt und Linie zur Fläche. Beitrag zur Analyse der malerischen Elemente*, München: Langen, 1926.

41 Cf. Alexander Klee, *Adolf Hölzel und die Wiener Secession*, München, Berlin, London: Prestel, 2006, pp. 41–47.

42 Cf. Adolf Hölzel, "Über bildliche Kunstwerke im architektonischen Raum", n.s., *Der Architekt, Wiener Monatshefte für Bauwesen und dekorative Kunst*, vol. 16, 1910, pp. 9–11, 17–20, 41–44, 49–50; 10.

43 Hölzel, "Über bildliche Kunstwerke", p. 49 (translation by the author).

44 Adolf Hölzel, "Über Formen und Massenvertheilung im Bilde", *ver sacrum*, vol. 4, no. 15, 1901, pp. 246–254, 246 (translation by the author).

45 Cf. Gerhard Leistner, "Komposition in Rot. Hölzel auf dem Weg zur Abstraktion", in Christoph Wagner & Gerhard Leistner (eds.), *Vision Farbe. Adolf Hölzel und die Moderne*, Paderborn: Fink, 2015, pp. 97–125; Marion Ackermann, Gerhard Leistner & Daniel Spanke (eds.), *Kaleidoskop. Hoelzel in der Avantgarde*. Exhibition held at Kunstmuseum Stuttgart, Kunstforum Ostdeutsche Galerie Regensburg, [Exhibition catalogue], Heidelberg: Kehrer, 2009.

46 Franz Marc, "Die konstruktiven Ideen der neuen Malerei" [1912], in Klaus Lankheit (ed.), *Franz Marc, Schriften*, Köln: DuMont, 1978, pp. 105–108, 108 (translation by the author).

47 Franz Marc, *Briefe aus dem Feld*, Berlin: Rembrandt, 1940, p. 17 (translation by the author).

48 Cf. Werner Heisenberg, "Die Tendenz zur Abstraktion in moderner Kunst und Wissenschaft", in Werner Heisenberg (ed.), *Schritte über Grenzen, Gesammelte Reden und Aufsätze*, München, Zürich: Piper, 1984, pp. 227–238.

49 Sigfried Giedion, "Erziehung zum Sehen. Ein Vortrag für die Davoser Hochschulkurse" [1931], in Dorothee Huber (ed.), *Wege in die Öffentlichkeit. Aufsätze und unveröffentlichte Schriften aus den Jahren 1926-1956*, Zürich: Ammann, 1987, pp. 18–22; 22 (translation by the author).

50 Klaus Lankheit (ed.), *Franz Marc, Schriften*, Köln: DuMont, 1978, p. 210 (translation by the author).

51 Cf. Felix Klee (ed.), *Paul Klee, Tagebücher 1898-1918*, Köln: DuMont, 1957, no. 842, 883, 951; Felix Klee (ed.), *Paul Klee, Briefe an die Familie 1893-1940*, Köln: DuMont, 1979, vol. 2, no. 768.

52 Franz Marc, "Die konstruktiven Ideen der neuen Malerei" [1912], in Klaus Lankheit (ed.), *Franz Marc, Schriften*, Köln: DuMont, 1978, pp. 105–108; 107 (translation by the author).

53 Bruno Taut, "Eine Notwendigkeit", in *Der Sturm*, vol. 4, no. 196–197, 1914, pp. 174–175, 174 (translation by the author).

54 Cf. Joseph Vogl, "Anorganismus. Worringer und Deleuze", in Hannes Böhringer & Beate Söntgen (eds.), *Wilhelm Worringers Kunstgeschichte*, München: Fink, 2002, pp. 181–192.

55 Gilles Deleuze, *Francis Bacon: The Logic of Sensation*, New York: Continuum, 2003, p. 108.

56 Cf. Deleuze & Guattari, *A Thousand Plateaus*, pp. 498, 499.

57 Worringer, *Form Problems of the Gothic*, p. 52.

58 Cf. Clement Greenberg, "The Crisis of the Easel Picture" [1948], in Clement Greenberg (ed.), *Art and Culture. Critical Essays*, Boston: Beacon Press, 1965, pp. 154–157; Sebastian Egenhofer, *Abstraktion, Kapitalismus, Subjektivität. Die Wahrheitsfunktion des Werks in der Moderne*, München: Fink, 2008, pp. 254–262.

59 Cf. Deleuze, *Francis Bacon*, p. 106.

60 Cf. ibid., p. 107.
61 Cf. Gilles Deleuze, "Eight Years Later: 1980", in Gilles Deleuze (ed.), *Two Regimes of Madness: Texts and Interviews 1975–1995*, New York: Columbia University Press, 2007, pp. 175–180, 178.
62 Ibid., p. 178.
63 Cf. Worringer, *Abstraction and Empathy*, p. 14.

3 The Iconology of Malevich's Suprematist Crosses

Marie Gasper-Hulvat

Between 1919 and 1922, Kazimir Malevich produced at least seven paintings that unmistakably evoke the foundational symbol of the Christian religion. These works constitute a subgroup of more than sixty abstract paintings that Malevich created between 1915 and 1923. In the years prior to the 1917 October Revolution, Malevich had been one of the most innovative thinkers of the Russian Avant-Garde movement. His development of Suprematist non-objectivity established one of the precedents of pure abstraction in early 20th-century Western art. However, the handful of cruciform paintings, with their unmistakable symmetrical juxtapositions of rectangles in iconologically significant ratios to each other, were the only works he produced in this style that evoked a specific symbolic resonance.

During the era when he made his cruciform abstract paintings, Malevich was in the midst of changing identities—both his own and his milieu's. An arts administrator and educator with tenuous but significant power, he actively participated in the institutions of a fledgling government that held as a central motivating tenet the elimination of the roots of religious belief. In this position, Malevich chose to represent repeatedly an abstract form that unmistakably referred broadly to the Christian religion and, in some cases, specifically to its Russian Orthodox denomination. This chapter explores how Malevich's early Soviet context, during a time of radical avant-garde experimentation into the integration of art into politics, may have influenced the artist's perspective on processes of iconological reception.

After the Revolution, Malevich had largely set aside painting to help establish a Soviet arts administration. He was one of the original members, from mid-1918, of the Moscow IZO Narkompros, the Visual Arts Division of the Commissariat of the Enlightenment; Narkompros was effectively the Soviet ministry of education and culture. In this capacity, Malevich successfully advocated for the establishment of a new museum for contemporary art, the Museum of Painterly Culture, for which the state began to make acquisitions, thereby funding the work of avant-garde artists.[1] Beginning in late 1918, students nominated him to one of seventeen instructor positions at the Moscow-based State Free Art Studios, which was the IZO Narkompros reorganization of two pre-Revolutionary art academies.[2]

In late 1919, Malevich transferred his activities, along with many of his students, to the provincial Vitebsk State Free Art Studios, where he led a group of student followers known as UNOVIS.[3] By 1922, UNOVIS departed from the increasingly dire conditions in Vitebsk for Petrograd; an official statement from the Vitebsk rector in 1923 noted that they "experienced unusually difficult economic conditions in 1921

and 1922. The teachers were starving, and Malevich developed tuberculosis as a result of malnutrition. Essential personal possessions were sold off [...] there was no hope of improving the material situation".[4] In sum, during this era, Malevich struggled to find his place within the emergent Soviet arts systems. Hardly focusing on his own creative activities, he spent a large portion of his productive energy seeking out material support for himself and his student followers. Faced with dire circumstances, they survived by rapidly adapting to the vagaries of the prevailing political winds.

Malevich created the cruciform Suprematist works during the most politically tumultuous era of his lifetime. With the 1917 October Revolution's official abolition of religion in Soviet Russia, Bolsheviks attempted to dismantle the powerful institution of the Orthodox Church, which had served to maintain the Romanov dynasty since its establishment in the early 17th century. The ensuing Civil War did not fully die out until after 1922, after Malevich and his followers retreated from Vitebsk in the face of an imminent Polish invasion that never transpired. During this period, the political flavor of Russia's future was uncertain. Battles raged as much on the fronts between the Red and White military forces as they did in art academies, where avant-garde practitioners like Malevich sought to reinvent artistic education for a new Soviet world. As much as the infamous Red Cavalry fought to intercept foreign armies' grabs for territory, Malevich and his compatriots struggled to acquire not just recognition but also literal space in studios, as they butted heads with the legacy of the imperial academic tradition.

While Malevich's context included a fair dose of bombastically triumphant atheism, during this era it remained unclear which flavors of atheism, anarchy, democracy or autocracy might prevail. If it is perplexing today why Malevich painted images with unmistakable Christian symbolism, it was likely also unpredictable at the time of their creation what Christian symbolism might signify for the future.

3.1 Malevich's Cruciform Geometry

The geometrical formations of Malevich's crosses represent experiments with a variety of configurations of the cross form, each with its own long-standing significations within the Christian tradition. *Hieratic Suprematist Cross*[5] (Figure 3.1), for example, resembles the architectural plans of simple Latin cross churches. Occupying almost the entirety of the picture plane, a horizontal black bar crosses a vertical red bar of approximately the same width. The intersection of these elongated rectangles occurs more than halfway up the canvas, as a transept would intersect at a church's crossing, separating the nave from the chancel. A similar geometric configuration appears in his white-on-white version of the cross, *White Suprematist Cross*.[6] In another work, *Suprematist Cross*,[7] we find a similar juxtaposition of a horizontal black bar against a vertical red bar; however, in this case, it manifests in the form of a small Greek cross, with equal-length arms, again upon a wide expanse of white canvas.

In each of these three compositions, the bars of the cross were almost parallel to the frame of the canvas, although never quite exactly. This reiterated Malevich's formal strategy in other Suprematist works, such as *Black Square* from 1915,[8] which simultaneously reinforced and negated the grid of the canvas with geometric

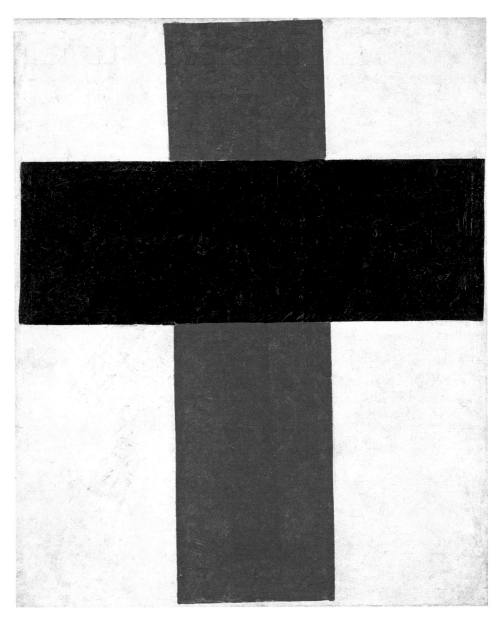

Figure 3.1 Kazimir Malevich, *Hieratic Suprematist Cross*, 1920–1921, oil on canvas, 84 × 69.5 cm, Stedelijk Museum, Amsterdam (work in public domain).

figures that subtly skewed just askance of parallel with the containing ground. Other examples of his crosses, however, make no pretense of conforming to the grid foundation of the canvas. In *Black and Red Cross in Flight*,[9] for example, we find bars of relatively similar proportions to the Latin-cross-type compositions discussed above, again with a black bar horizontally superimposed across a red one.

However, here the cross lies diagonal to the plane of the canvas, with the transept bar intersecting so far up the nave section that it virtually overcomes the chancel portion of the red bar.

Three of Malevich's cruciform Suprematist paintings specifically evoke the singular form of the Russian Orthodox cross. This is due to the second horizontal bar that is shorter and thinner than the primary transept bar and crosses the vertical bar well below the primary arms. In the Orthodox tradition, this lower bar signified the *suppedaneum*, or the footrest, at Christ's crucifixion; it is a feature unique to the Russian context, derived from its Byzantine ancestry.[10] In *Suprematism of the Spirit* from 1919[11] (Figure 3.2), this smaller, lower bar appears in orange and crosses beneath a completely black cross, whose vertical bar is seemingly reinforced by an adjacent, parallel, off-white bar.

At the center of the cross in *Suprematism of the Spirit*, just above the *suppedaneum* and covering more than half of the horizontal bar, Malevich superimposed a white square above the cross. Two other paintings of the cross, both entitled *Mystic Suprematism* and both from 1920 to 1922 (one is represented in Figure 3.3), also include the *suppedaneum* and a geometric form around the center crossing. In each of these works, however, the form is round (a circle in one and oval in the other) and hovers behind rather than in front of the cross. In these latter two, the ovular geometric forms evoke the effect of halos, exalting the cross itself, whereas in *Suprematism of the Spirit* the square form appears to be crucified.

An iconographically significant discrepancy between *Suprematism of the Spirit* and both the *Mystic Suprematism* works concerns the direction of the tilt of the footrest. In *Suprematism of the Spirit*, the footrest bar tilts down to the right, as is traditional in Russian Orthodox iconography. Mythology recounts that this directional tilt signifies the balance of redemption being tilted toward good, in the direction of the repentant thief crucified to Jesus's right-hand side. Andrew Spira connects this iconographical significance directly to the text in the Orthodox liturgy.[12] However, in the *Mystic Suprematism* works, the bar reverses the traditional orientation and tilts down to the left. One could interpret this discrepancy as a commentary upon the place of traditional religion within the new Soviet era; with the cross surrounded by a halo, the old order has been reversed, but with the Suprematist square newly crucified, the state of salvation might be redeemed.

It is unlikely that the discrepancy in the tilt of these footrest bars was lost upon Malevich; his familiarity with Orthodox practice and iconography was extensive. Spira claims that "Malevich did not understand the cross in relation to a preconceived frame of reference",[13] serving instead as a non-objective form outside of religious symbolism. However, reports from Malevich's contemporaries indicate that he was as comfortable discussing the 15th-century iconographer Andrei Rublev's painting of God's beard as he would the modern architecture of Mies van der Rohe.[14] Moreover, Myroslava Mudrak has made a compelling case that Malevich was intimately familiar with traditional Orthodox practices.[15] She argues that he employed themes from Paschal and Lenten liturgies in an early painting cycle and that such work portended a lifelong commitment to an artistic practice that, while not religious, was nonetheless "seeded by Eastern Christianity".[16] She has also contended that Malevich perceived himself as adopting the modern equivalent vocation of pre-modern icon painters and that he attached to the role of the artist a distinct sense of moral responsibility to provide his community with redemptive transformation.[17]

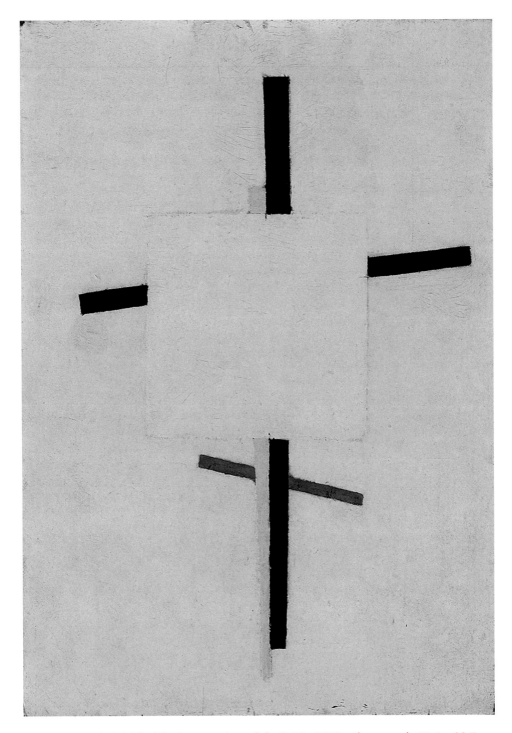

Figure 3.2 Kazimir Malevich, *Suprematism of the Spirit*, 1919, oil on panel, 55.6 × 38.7 cm, Stedelijk Museum, Amsterdam (work in public domain).

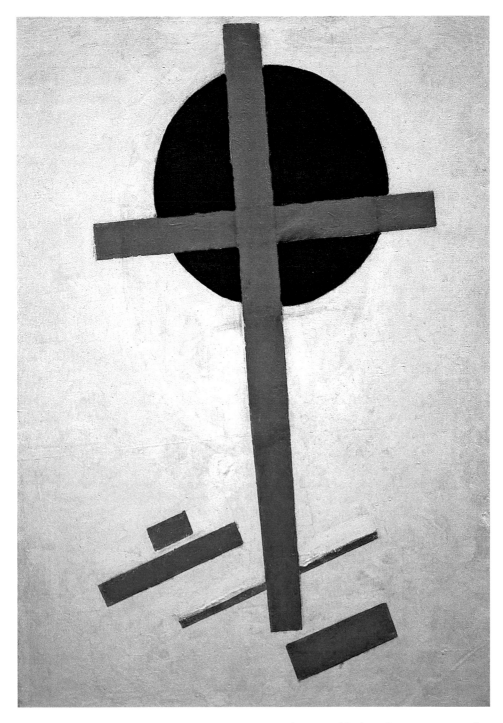

Figure 3.3 Kazimir Malevich, *Mystic Suprematism* (*red cross on black circle*), 1920–1922, oil on canvas, 72.5 × 51 cm, Stedelijk Museum, Amsterdam (work in public domain).

3.2 Malevich's Crosses and the Russian Orthodox Icon

The common Russian viewer would hardly have mistaken Malevich's cross compositions for Orthodox icons, an accident that Malevich surely would have sought to prevent. As in most of Malevich's Suprematist works, these canvases present a variety of geometric shapes, mostly quadrilateral, deliberately organized upon a white background in order to evoke formal problems of balance, weight and distance. Orthodox Christian imagery, immediately prior to the Revolutionary period, in no way resembled Malevich's stark, bare crosses. Decorated with florid ornamentation, featuring figures of saints or angels in an increasingly realist style, contemporary icons typically employed muted, brown-tinted colors. This coloration imitated the olifa- and soot-covered pigmentation of ancient icons prior to extensive restorations that had only commenced a few years prior to the Revolution.

Although Malevich's crosses are clearly not icons, they nonetheless elicit resonances with iconic forms. Charlotte Douglas has proposed that the artist deliberately designed the iconic associations of some of his later works "to produce in the native viewer the sensation of an archetypal timelessness".[18] Indeed, if Malevich's cross forms resemble anything from the history of Russian Orthodox icons, they most closely replicate the details of crosses on the robes of ecclesiastical saints. Yevgenia Petrova noted that "Malevich monumentalizes the squares, circles, and crosses employed by icon painters in the clothes of the saints, elevating them to the level of independent, multilayered symbols".[19] For an example, we can look to late 15th-century icons from the Muscovite School of Dionysii, particularly the paired icons of Metropolitans Alexei and Peter (Tretiakov Gallery, Moscow and Dormition Cathedral of the Moscow Kremlin). In such works, we see an abundance of simplified, abstract cross forms upon white backgrounds to denote the saints' ecclesiastical identity. In these cases, the crosses distinguished the episcopal figures both from monastic or warrior saints as well as from non-bishop priests. Such crosses appear most frequently on the shoulders of the saints and occasionally on the omophorions trailing down to their feet.

Malevich's crosses differ from these iconic precedents in important ways. The lack of a human figure, which is necessary for the ontological essence of an Orthodox icon, is paramount. Nonetheless, even the forms in works such as *Hieratic Suprematist Cross*, with its simple Latin-plan configuration, are significantly different from the classic iconic crosses on ecclesiastical vestments. Malevich's choice to contrast one red bar with a black one would have been highly unusual in traditional Russian Orthodox iconography. In icons such as those of Metropolitans Peter and Alexei, crosses were either red or black, but never a combination of the two colors. Moreover, in traditional patterning of ecclesiastical robes with abstract forms, the *suppedaneum* is never present. The patterns consistently represent a single horizontal bar crossing a single vertical bar; additional bars only appeared on crosses traditionally mounted to the tops of church domes.

Another Malevich composition might evoke traditional iconographic forms, but the manner in which it does so is not consistent with traditional practices. The composition of *Black Cross* (1923)[20] (Figure 3.4) appeared first in *Black Cross* (1915a) as one of the foundational forms of Suprematism. Malevich then reiterated the composition alongside two equally sized copies of *Black Square* (1923) and *Black Circle* (1923),[21] a bold triumvirate made expressly for the Soviet exhibition at the Venice Biennale. All three first appeared in the 1915 *0,10* exhibition, where Malevich introduced his

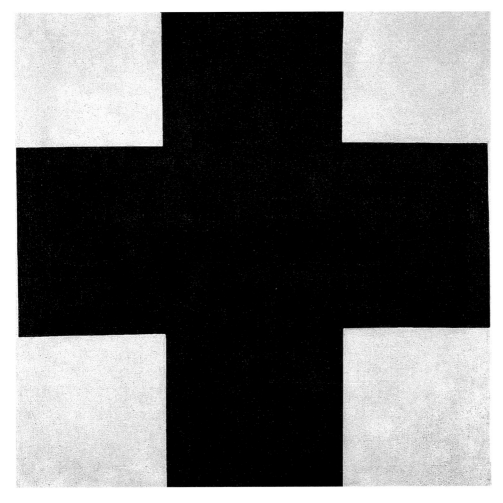

Figure 3.4 Kazimir Malevich, *Black Cross*, 1923, oil on canvas, 107 × 107 cm, Russian
 Museum, St. Petersburg (work in public domain).

Suprematist style and where the iconic associations of his works were first remarked
upon in the press. When Alexandre Benois reviewed Malevich's portion of the exhi-
bition in January 1916, he made connections between *Black Square* and Orthodox
icon traditions. He anchored his commentary on the bold placement of the infamous
primary utterance of Suprematism in the "beautiful corner" of the room, traditionally
reserved for the most important icon of the household.[22]

Although Benois did not comment upon it, the composition of both of Malevich's
Black Cross paintings (1915b, 1915a) approaches traditional iconic cross forms, but
on a grossly exaggerated scale. Such simple, black, Greek crosses also appear upon
ecclesiastical robes in icons of the era of Dionysii, but in rampant repetition. There,
they create an abstract patterning upon the saints' outer robes, but they do not appear
as a single form in isolation. Both the 1915 and 1923 versions isolate the decorative

form and suspend it as a self-sufficient statement alongside the other geometric configurations. These paintings stand outside the set of other cruciform works from the years following the October Revolution, but they nonetheless participate in many of the same strategies. While there remain many resonances between the decorations of robes on icons and Malevich's abstract cruciform paintings, he certainly elaborated beyond the formal iconic ornamentation.

3.3 Reception of Malevich's Crosses

Given the early Soviet context of these cruciform paintings, it is fruitful to consider the reception of these works within the burgeoning state-sponsored atheistic transformation of Russia. Malevich indicated that he understood how the form of the cross could prove problematic in its reception. In a 1925 treatise, "About Posters",[23] a commentary on the production of movie posters, he explained, from the perspective of a third-person observer, how his contemporaries were inclined to make iconographic connections between cross forms and the Christian tradition:

> In another case the painter showed an advertisement on which were drawn two crossing lines, calculated to produce a sharp contrast to the existing advertisements in the street. Doubts arose because this created an association with the cross, and the *one who commissioned it* was scared stiff.[24]

Ultimately, Malevich noted, the commission was only satisfied with an elaborate image of a Pegasus and a palm leaf wreath, eliminating the striking cross composition entirely. Presumably, the implication is that, rather than producing a sharp contrast with other surrounding posters, this conventional, representational image would have blended in with all the others around it.

In the same passage from "About Posters" Malevich continued:

> Some time ago a poster was made on which "three burning candles" were represented; the poster was made in such a way that not a single person, young or old, could avoid it, but the firm refused to accept it from the painter *on the strength of their preconceived notions*, three candles burning in a room are lit up for "the deceased", the board of directors trembled, grew frightened of such an omen and ordered a more pious poster of forget-me-nots and, just in case, celebrated a *te Deum*.[25]

Here Malevich mocked religious superstition in an appropriately atheistic manner for a Soviet citizen. His tone resonates with contemporary political propaganda posters, which frequently depicted religious believers with derision. Such posters featured religious figures covered in crosses and icons, representing them as emaciated, slovenly, unthinking, pathetic cowards and drunkards and the priests and monks who lured them in as malicious scam artists. In the passage above, Malevich made out the unnamed firm's board of directors to be trembling cowards who were afraid of new ideas about the formal composition of visual imagery. He added as a final acerbic flourish that their fear purportedly drove them, "just in case", presumably to avoid mischance or divine wrath, to celebrating a *te Deum*, an ancient hymn and its attendant prayer service.[26] In other words, Malevich caustically derided the commissioners

of this work as having felt the need to publicly declare their faith in a presumably paid-for prayer to God, a formulaic solution to any potentially heretical misstep within the Eastern tradition (despite its Latin name).

Malevich's commentary provides a rare glimpse into the artist's attitudes toward the reception of abstract visual forms. Much of his writing was preoccupied with his deliberately ambiguous Suprematist forms' release from signification. In his foundational text for Suprematism, he proposed to reject the representation of "little corners of nature" in order to break through the "lampshade of the horizon" into the ethereal beyond; in this way, the Suprematist artist could depict on canvas the complete purity of sensation.[27] While his writings were most frequently preoccupied with discussing the independence of the signifier as such, in the above "About Posters" passage, he directly (and sarcastically) addressed the issue of how the unenlightened viewer might erroneously perceive the non-objective formal relationships that were the foundation of his philosophy of art and life.

Given that Malevich wrote these passages in 1925, not long after he quit his abstract cruciform series, it is hard not to wonder if he were directing his cynicism toward the reception practices of his own works. Malevich made it abundantly clear that, in his opinion, formal qualities trumped semiotic associations and that clinging to such associations constituted an ignorant act worthy of derision. He unambiguously laid out his position that societally accepted associations, with any particular formal configurations, did not remain paramount to the value of an image. He implied that one could readily discard such associations at the whim of an artist who found the formal properties of an otherwise representational scheme useful for a composition, in order to make the image "unavoidable", i.e., draw the eye instinctively to it by means of its formal properties. Furthermore, recollection of the previous (and, in these examples, church-related) pre-Revolutionary significations of forms constituted a demonstration of fearful idiocy.

In 1977, semioticians Iurii Lotman and Boris Uspenskij astutely noted that "'To remember' meant being an ignoramus, 'to forget' was to be enlightened".[28] They made this observation within the commentary upon 17th-century Nikonian reforms of the Orthodox Church. Yet one cannot help but observe that this Russian habit of thinking long outlived that era, recurring in later periods of reform.

Malevich's statements seem to indicate that he believed artists should not have to continue to deal with image associations tied to the recently abolished Orthodox belief structures. This is problematic, because it assumes that the Bolsheviks had effectively dismantled the Church not only in official policy but also in people's minds. It is as if he harbored an illusion that Bolshevik propaganda had effectively "enlightened" common people regarding the "backwardness" of religious belief, thereby, likewise, abolishing the associations attached to the images of the cross or the three lit candles. However, the Bolsheviks no more destroyed such associations than they did the church itself, despite their violent persecution of the institution. Even if they had succeeded in eliminating religious practice, one cannot so easily topple the structures of signification.

3.4 Malevich's Crosses as Sincere Signifiers

The solemnity of Malevich's cruciform imagery that was suspended in the mystical expanses of white conflicts with the sarcasm of his words. Sincere interpretations of

these works are typical in recent scholarly discussions. Giorgio Cortenova, for example, views the solemnity of these works as evoking the extreme simplicity of Christian traditions of asceticism; the vast expanses of white laid bare the Suprematist forms as "transfigured into the archetype".[29] The contrast between the sincerity of these works and Malevich's commentary on film advertisements is no less striking than the contrast between the solemnity of Lenin's mausoleum and the mockery of Soviet anti-religious propaganda posters.

Overall, Malevich's cruciform images from 1919 to 1922 appear to be sincere attempts to declare something ambiguously spiritual. Malevich implied as much several years later, in a 1927 letter he wrote to his close confidant Nikolai Suetin. Malevich cryptically commented on his ability to perceive "the waves in the world" and how through the "mystical expressions" of icon painting "we feel the mystical wave that helps us sense God". He then summed up, "I expressed that sensation in Suprematism in the specially configured cross-shaped form".[30] In other words, when Malevich interpreted his own cruciform Suprematist paintings, he explained them as akin to the "mystical expressions" of icons, which gave the sensation of "the mystical wave that helps us sense God". Although he used terminologies that drew upon religious tradition ("God"), Malevich here interpreted his own work in a spiritual manner that avoided traditional religiosity.

Claudia Casali has argued that when Malevich employed the term "God", always using a capital "G", he intended no connection to Christianity; rather, for Malevich, "the figure of God embodies the concept of the infinite creation".[31] Scholars like Casali and Mudrak have consistently affirmed that Malevich did not seek to participate in the discourse of religiosity but rather to use religious concepts, terms and symbols metaphorically in order to convey a sense of spirituality that exceeded traditional religious parameters. Yet Malevich's own interpretation of his use of religious symbols need not be authoritative for explaining his cruciform works. Rather, his 1927 letter to Suetin represents one of a variety of interpretive strategies by which viewers received these works. The 1925 "About Posters" commentary provides evidence of an entirely different interpretive perspective, one to which Malevich seems to have been vociferously reacting.

Another example of evidence as to the reception of these works comes from Malevich's friend El Lissitzky in May 1924. In a letter to his wife, Sophie Lissitzky-Küppers, Lissitzky referred to Malevich's *Suprematism of the Spirit*, the cross painting with a white square superimposed on the traditional place of Christ's torso. He called this painting Malevich's *gekreuzigtes Quadrat*[32] or *perekreshchennyi kvadrat*.[33] Lissitzky-Küppers first published this letter in 1967 in German, and the publication does not indicate the original language of the letter, which is likely German. The correspondence between collaborators and romantic partners (they would be married three years later) could readily have referenced either, or both, linguistic denotations, translating between the writer's native and second languages.

In their entry for *kreuzigen*, the *Oxford Dictionaries* translate *gekreuzigtes* into English as "crucified", which would render Lissitzky's phrase as "crucified square", In Russian, *perekreshchennyi kvadrat* translates to "rebaptized square" or "crossed square"; the corresponding verb *perekrestit'sia* denotes the religious action of crossing oneself. Uspenskij noted that the root verb *krestit'sia*, which means to be baptized, suggests the overall idea of union with Christ's cross by elision with the word for "cross", *krest*.[34] In this semiotic sphere, the phrase *perekreshchennyi kvadrat* evokes a

multitude of connotations with which to interpret Malevich's image. The square might be rebaptized in the spirituality of the new age or in the ethereal Suprematist white background, yet it could also evoke metaphorical connections to Christian religiosity. The square might be united with the cross in the same way that Christ's baptism, through the term *krestit'sia* (to be baptized) and its root *krest* (cross), aligned him at the beginning of his ministry with the traumatic end.

By "rebaptizing" or "crucifying" or unifying the square to the cross, we might perceive the impending martyrdom under high Stalinism of the black square. This extends to all its attendant associations, both to Malevich's own identity (he would sign his last paintings not with his name but with a small black square) and that of his UNOVIS group of students, who self-identified by wearing white arm bands emblazoned with black squares. Indeed, Mudrak commented on how the "messianism" of the early Soviet student collective was grounded in "the tenor of Byzantine liturgical piety" and espoused the spirit "of a church assembly ready to evangelize the uninitiated".[35] If Malevich's student followers aligned themselves with the black square, *Suprematism of the Spirit* reminded them that such a commitment was one of ultimate sacrifice to the Suprematist ideology.

The connection of Malevich's composition to the Christian symbolism of the cross, including the foundational story of Christianity and its continual reenactment within Church ceremony, is abundantly apparent in Lissitzky's description of the work. Such connections reappear in the recollections of fellow avant-garde artist Antoine Pevsner. In a 1957 publication, Pevsner recalled a telling conversation he purportedly had with Malevich sometime between 1917 and 1920, "at the funeral of his disciple, the one he loved and preferred the most"; Vakar and Mikhienko conjecture that this is a reference to artist Olga Rozanova's funeral in November 1918.[36] Pevsner recollected Malevich saying, "We will all be crucified. I have prepared my cross already. You have noticed it in my works, of course". The implication of Pevsner's recollection is that this comment refers to Malevich's cruciform works. The accuracy of Pevsner's recollection is highly specious, according to Vakar and Mikhienko, as well as collector Nikolai Khardzhiev.[37] While this quote might not elucidate anything useful regarding the painter's intentions, it nonetheless reflects important attitudes represented in their reception with contemporary viewers. Regardless of whether Malevich shared these interpretations of the cross' iconographic significance with respect to issues of martyrdom or Orthodox tradition, his contemporaries recognized their unavoidable associations.

3.5 Malevich's Crosses and Their Beholders' "Cultural Equipment"

Erwin Panofsky noted, "The re-creative experience of a work of art depends [...] not only on the natural sensitivity and the visual training of the spectator, but also on his cultural equipment. There is no such thing as an entirely 'naïve' beholder"; the viewer's "own cultural equipment, such as it is, actually contributes to the object of his experience".[38] The evidence from Malevich's own writings and from documents written by his colleagues indicate that Panofsky's words hold true regarding the reception of Malevich's cruciform imagery. The "cultural equipment" provided by centuries of Orthodox influence upon Russian visual cultural experience necessarily impacted the "re-creative" experience for contemporary viewers of Malevich's works, including the artist himself.

Malevich may have had no intention to express any meaning in association with Orthodoxy. This lends his works even more to interpretation through Panofsky's theory of iconology, for he noted,

> The discovery and interpretation of these "symbolical" values (which are often *unknown to the artist himself and may even emphatically differ from what he consciously intended to express*) is the object of what we may call "iconology" as opposed to "iconography".[39]

The theory of iconological interpretation allows us to explain how Malevich's works operated within their own cultural context, regardless of his intended function. Misler and Bowlt have proposed that Malevich's works may often remind viewers of icons or "carry enigmatic references to iconic symbols, but never are they blatantly Orthodox".[40] Indeed, Malevich's works do not operate within the iconographic traditions of Orthodox icons. They can, however, still participate in the iconological vocabulary of these traditions within their reception by viewers.

Nonetheless, we cannot discount the exceptional nature of these works as examples of abstract art, which has historically resisted iconological interpretation. Panofsky took care to exclude the field of abstraction from his theory of iconology, cautioning restraint of application "with works of art in which the whole sphere of secondary or conventional subject matter is eliminated and a direct transition from motifs to content is effected, as is the case with [...] 'non-objective' art".[41] Yve-Alain Bois interpreted Panofsky's caution on this application as a discouragement to the iconological approach toward abstract art, noting that "iconology was declared by its founder to be not the best tool with which to approach abstract art. On that point, he was absolutely right".[42]

However, what both Panofsky and Bois fail to consider is the place of the reception of conventions outside academia, by individuals not steeped in the rigors of art theory. These individuals might include the commissioners of posters, boards of directors of firms producing visual cultural objects created by graphic artists and the public themselves, toward which those objects are directed. The implications of these theories fail to take into account the intersection of abstract form with functional design, where iconological associations persist and where "a direct transition from motifs to content" cannot eliminate them. Yet even within the sanctified art world itself, as the writings of Malevich's colleagues betray, the conventional associations of "cultural equipment" persist, even for those like Lissitzky and Pevsner, both artists committed to the promulgation of abstraction in form.

Malevich did something that he did not intend to do. He created objects that evoked a symbolism that he sought to transcend. He envisioned a spiritual path forward, through Suprematism, that would expand beyond the narrow-minded confines of traditional religiosity. He associated a mystical, redemptive power to his art. However, the effectiveness of his effort toward transcendence depended upon the viewers. Lissitzky's and Pevsner's writings indicate that perhaps his colleagues caught a glimpse of the mystical transformation that he hoped to achieve, but Malevich's own words in "About Posters" suggest that many of his contemporaries took his cruciform compositions at the simplistic and highly problematic level of iconographic signification.

Herein we have the paradox of the art object and its relationship to those who perceive it. The maker perceives it in the same capacity, with his own "cultural equipment"

(i.e., the theoretical underpinnings by which he conceived of its creation), as any other viewer, who likewise brings her own "cultural equipment" to the exchange and interpretation of the object. Within Malevich's early Soviet context, any viewer who could have been a part of the reception of this object would invariably have been inflected by the symbolism attached to the cross form within the Orthodox tradition. The viewer's ability to transcend that symbolic attachment would have largely depended upon their understanding of Malevich's own theories and broader avant-garde understandings of the self-sufficiency of signs. The scope of influence for these theories, however, was much smaller and far less engrained in tradition than those of the Russian Orthodox Church.

Notes

1 Irina Vakar and Tatiana Mikhienko, *Kazimir Malevich: Letters and Documents, Memoirs and Criticism* (trans. from Russian by Irina Vakar and Tatiana Mikheinko), London: Tate Publishing, 2 vols., (2015 [2004]), vol. I, pp. 409–436.
2 Ibid., pp. 437–440.
3 Ibid., pp. 454–582.
4 Ibid., p. 482.
5 Kazimir Malevich, *Hieratic Suprematist Cross*, oil on canvas, 1920–1921(a), Stedelijk Museum, Amsterdam.
6 Kazimir Malevich, *White Suprematist Cross*, oil on canvas, 1920–1921(b), Stedelijk Museum, Amsterdam.
7 Kazimir Malevich, *Suprematist Cross*, oil on canvas, 1920–1927, Stedelijk Museum, Amsterdam.
8 Kazimir Malevich, *Black Square*, oil on canvas, 1915, Tretiakov Gallery, Moscow.
9 Kazimir Malevich, (1919–1920) *Black and Red Cross in Flight* [Oil on canvas]. Formerly at the Museum of Modern Art, New York; sold to private collection on May 11, 2000 (Phillips Auctioneers).
10 Peter Murray and Linda Murray, *The Oxford Companion to Christian Art and Architecture*, Oxford: Oxford University Press, 1996, p. 124.
11 Kazimir Malevich, *Suprematism of the Spirit*, oil on panel, 1919, Stedelijk Museum, Amsterdam.
12 Andrew Spira, *The Avant-Garde Icon: Russian Avant-Garde Art and the Icon Painting Tradition*, Burlington, VT: Lund Humphries, 2008, pp. 149–151.
13 Ibid., p. 149.
14 Vakar and Mikhienko, op. cit., vol. II, 2015, pp. 400–401.
15 Cf. Myroslava Mudrak, "Kazimir Malevich and the Liturgical Tradition of Eastern Christianity", in Roland Betancourt and Maria Taroutina (eds.), *Byzantium/Modernism: The Byzantine as Method in Modernity*, Leiden: NL: Brill, 2015, pp. 37–72.
16 Myroslava Mudrak, "Kazimir Malevich, Symbolism, and Ecclesiastical Orthodoxy", in Louise Hardiman and Nicola Kozicharow (eds.), *Modernism and the Spiritual in Russian Art: New Perspectives*, Cambridge, UK: Open Book Publishers, 2017, pp. 91–114. Available at www.oapen.org/search?identifier=641878 (accessed June 6, 2019), p. 96.
17 Ibid.
18 Charlotte Douglas, *Kazimir Malevich*, New York: Harry N. Abrams, Inc. 1994, p. 38.
19 Yevgenia Petrova, "The Origins of Early Twentieth-Century Russian Art", in Yevgenia Petrova (ed.), *Origins of the Russian Avant-Garde: Celebrating the 300th Anniversary of St. Petersburg*, 2003, p. 21.
20 Kazimir Malevich, *Black Cross*, oil on canvas, 1923(a), Russian Museum, St. Petersburg.
21 Kazimir Malevich, *Black Square*, oil on canvas, 1923(b) and *Black Circle*, oil on canvas, 1923(c), both in the Russian Museum, St. Petersburg.
22 Vakar and Mikhienko, op. cit., vol. II, 2015, pp. 514–517.
23 Kazimir S. Malevich, *The Artist, Infinity, and Suprematism: Unpublished Writings 1913-1933*, in Troels Andersen (ed.), trans. Xenia Glowacki-Prus and Arnold McMillin. Copenhagen: Borgen, 1978, p. 141.

24 Unemphasized text from Malevich (1978, 141), as translated by Xenia Glowacki-Prus and Arnold McMillin; italicized words are author's translation from Malevich (2019).

25 Unemphasized text from Malevich (1978), as translated by Xenia Glowacki-Prus and Arnold McMillin; italicized words author's translation from Malevich (2019).

26 K. Malevich, *The Artist, Infinity, and Suprematism…*, ibid.

27 Kazimir Malevich, "From Cubism and Futurism to Suprematism: The New Painterly Realism, 1915", in John E. Bowlt (ed. and trans.), *Russian Art of the Avant-Garde: Theory and Criticism 1902-1934*, revised and enlarged edition, New York: Thames and Hudson, (1988 [1915]), p. 118.

28 Iurii M. Lotman and Boris A. Uspenskij, "Binary Models in the Dynamics of Russian Culture (to the End of the Eighteenth Century)", in Alexander D. Nakhimovsky and Alice Stone Nakhimovsky (eds.), *The Semiotics of Russian Cultural History*, Ithaca, NY: Cornell University Press (1985 [1977]), p. 50. Original Russian version available at www.historicus.ru/rol_dualnih_modelei_v_dinamike_russkoi_kulturi_do_kontsa_XVIII_veka/ (accessed June 10, 2019).

29 Giorgio Cortenova, "From the East to the East: The Dream of the Spirit", in Giorgio Cortenova and Evgenija Petrova (eds.), *Kazimir Malevich e le Sacre Icone Russe: Avanguardia e Tradizioni*, St. Petersburg: State Russian Museum, 2000, p. 24.

30 Vakar and Mikhienko, op. cit., vol. I, p. 201.

31 Claudia Casali, "Kazimir Malevich's Writings: The Dimension of the Infinite", in Giorgio Cortenova and Evgenija Petrova (eds.), op. cit., p. 134.

32 Cf. in German El Lissitzky and Sophie Lissitzky-Küppers, *El Lissitzky: Maler, Architekt, Typograf, Fotograf. Erinnerungen, Briefe, Schriften*, Dresden: VEB Verlag der Kunst, 1967, p. 48.

33 Cf. in Russian Vakar and Mikhienko, op. cit., vol. I, p. 216.

34 Boris A. Uspenskij, "The Influence of Language on Religious Consciousness", *Semiotica*, vol. X, 1974, pp. 177–189.

35 Mudrak, op. cit., pp. 69–70.

36 Vakar and Mikhienko, op. cit., vol.II, p. 163.

37 Ibid., 161.

38 Erwin Panofsky, *Meaning in the Visual Arts*, Chicago: The University of Chicago Press, 1955, pp. 16–17.

39 Panofsky, ibid., p. 31, emphasis added.

40 Nicoletta Misler and John E. Bowlt, "The 'New Barbarians'", in Yevgenia Petrova (ed.), *Origins of the Russian Avant-Garde: Celebrating the 300th Anniversary of St. Petersburg*, St. Petersburg: Palace Editions, 2003, p. 33.

41 Panofsky, op. cit, p. 32.

42 Yve-Alain Bois, *Painting as Model*, Cambridge, MA: MIT Press, 1993, pp. xxvii–xxviii.

4 Anthropomorphism and Presence

(Non)referentiality in the Abstraction of Objecthood

Blaženka Perica

It is noteworthy that some distinguished theoreticians of visual studies tend to imply that intentions and subjectivity are features of artworks. This is evident from the insights of W.J.T. Mitchell, who speculates on the "lives of images" and poses the question "What do pictures want?".[1] Gottfried Boehm reveals to us "how icons produce meaning",[2] Georges Didi-Huberman establishes that "what we see returns the gaze to us",[3] and Hans Belting and his anthropologically oriented image science—in a somewhat different and less direct personalization of the image—directs us to the "challenges of images" and their "new power" which proves itself in our "exchange of glances with images".[4] Moreover, Isabel Graw sees the image as an "invaluable quasi-subject", on the trait of Louis Marin and Hubert Damisch who consider a painting to be a "thinking subject".[5]

Latent subjectivity and the anthropomorphic character of artworks present in the mentioned approaches is a positive and productive feature, a boost to contemporary art theory. None of these are expected to be able to get around the fact that anthropomorphism—though in its negative connotation—has defined one of the key debates in the second half of the sixties, in the discourse of the abstraction of *objecthood*, anti-referentiality and *literalness* of Minimal Art. It is one of the first (and probably most famous) negative assessments concerning that kind of art, laid out by Michael Fried in the text "Art and Objecthood".[6] He argued against anthropomorphism and *theatricality*, which he considered to be immanent to minimalist objects, despite foundationally opposing postulates set by artists associated with Minimal Art. While these artists were inaugurating three-dimensional, *literal* objects, "neither painting nor sculpture", and affirming a new, medium-wise unspecific, anti-referential and anti-anthropomorphic category of art, for Michael Fried these aspirations were everything that widespread abstract expressionism tended to eliminate as non-art, i.e., *objecthood* and the object that leaves an unsettling impression of "the silent presence of another person".

In the context of the theme "iconology of abstraction"—which is deserving of a special insight with regard to the thesis presented by the founder of iconology, Panofsky, who did not include abstract art into his reflections on the meaning of an artwork—it seems interesting to pose a question about the differences and their causes in the apprehension of the term "(non)referentiality" and the role of geometric abstraction in the perspective of Minimal Art's *objecthood*, focusing on the referential point of anthropomorphism.

4.1 From Modernist Formalism to "Art Is Something You Look At"

Minimalism is a kind of art characterized by a high discursivity brought about by the writings and theories of the artists themselves in the first place. With their radical demand for non-referentiality, these artists encouraged increasingly numerous and divergent interpretations of critics, who contended that Minimal Art was considered to be the peak and conclusion of late modernism's program in opposition to those who considered Minimal Art as the turning point of modern art toward postmodernism. On the other hand, Minimalism manifested itself through a very simple formal appearance of artifacts; abstract geometrical objects to which artists disproved any kind of representational or connotative relations and references to reality.

Disregarding partial differences between individual oeuvres and slight deviations from artist's stances in their *statements*, minimalists almost unanimously emphasize non-referentiality, which includes banal and literal concreteness and formal *literalness* of artworks. Simultaneously, however, they also articulate the rhetoric of the "aesthetic of tautology", a perception that states that "what you see is what you see",[7] as said by Frank Stella in an interview with Bruce Glaser. In the same conversation, Donald Judd makes a point: "Art is something you look at". In the text "Specific Objects",[8] which is a source of argumentation and essential basis for all subsequent significant interpretations of Minimal Art, right from the first sentence Judd states that all, or at least half, of the best new art is "neither painting, nor sculpture", provoking the most sacred foundations of the ruling high modernist theory, whose founder Clement Greenberg[9] saw the tasks of art in the historical progress of abstract expression. According to this theory, art had to operate in such a way as to gradually and more clearly separate itself from the real world to become purely autonomous (Figure 4.1). Additionally, the mentioned goal was to be aided by the restriction of artistic media that were supposed to deal exclusively with their respective formal expressive characteristics in a way that painting and sculpture were strictly defined as disciplines, separated from each other and reduced to their essence, to their formal specificities, i.e., to a two-dimensional surface in painting and to a three-dimensional space in sculpture. These main ideas of formalist modernist theory, as well as the *essence and purity* of artistic media dogmas, as they were postulated by Greenberg, defined the artistic practice of American abstract expressionism, whose victorious rise to the leading position on the global art scene during the fifties was followed by certain ideological and political circumstances[10] that conditioned a patriotic, overtly anti-European competitive rhetoric.

The theme of discussions was differences and developments in what was regarded as genuine American art in contrast to European art in whole, but the focus was set on the affirmation of American abstraction. "Advantages" for American abstract expressionists were formulated by Greenberg, whose theory, summed up as "from physicality to opticality", i.e., from the illusion of realism to optical illusion, oscillated over time as well. In some early texts, Greenberg anticipated a logical development of Constructivism that will lead to the end of painting in three-dimensional sculpture, but later he mostly overlooked Russian avant-garde and completely neglected that line of thought in favor of "pure *concept of opticality*, a bodiless, literally dematerialised and totally autonomous sculpture".[11] This is how one of the several turns in the history of abstraction was marked since its first appearance in the beginning of the 20th century. How did the minimalist concept of visual tautology and the literalness of material objects approach these existing circumstances?

Figure 4.1 Donald Judd, *Untitled*, 1977, Münster, Germany; photo: Florian Adler. Reproduced under terms: CC BY-SA 3.0.

4.2 Donald Judd's *Specific Object* as Opposed to *Abstraction*

Minimalists claimed for a long time that European forerunners of abstraction were not familiar with it at all and were extremely critical toward art in their immediate surroundings. Their decision to choose geometry over expression in continuation of the abstract art vocabulary was dually coded: on the one hand, they made it easier for themselves to get included in the dialogue with the current art scene and formalism, if not using the same "related tongue". Also, in their demands for anti-referentiality, they did not have to master the convention of "abstraction against figuration" from the start but could turn their criticism toward present achievements and simultaneously rigidify late modernist formalism. On the other hand, through the use of abstraction, minimalists justified their shift toward the "new art of objects" in the manner of an avant-gardist rebellion, by opposing already institutionalized emphatic subjectivism, wherein the object's concept is the most suitable category to use to perform criticism of Greenberg's *opticality* and still start a new order of seeing and visualizing. The status of simultaneous continuity and breakdown with the tradition of the avant-garde modern art is in the core of every minimalist *aporia* and therefore neither minimalist abstraction nor its anti-referentiality fit the original or previous meanings of these terms anymore. Where can this be recognized?

Judd's 1965 text, in which there is no mention of the label "Minimal Art" (at that time there were dozens of titles where the same was the case, until Richard Wollheim

published an essay entitled *Minimal Art* that same year), lucidly marked the events in art from the beginning of the sixties on the New York scene, not as parts of a new movement but as a group of radically new phenomena, whose common themes were *specific objects*—works that were non-referential, non-relational, anti-illusionist and anti-anthropomorphist, above all three-dimensional objects: literal physical things present here and now in real space, "an object, a whole, a single thing, and that which is open and extended, more or less environmental",[12] with its main feature being "neither painting nor sculpture". From a modernist standpoint, these qualities meant an attack on art in general.

Relegating their initiative to a negative connotation of the term "objecthood" from the very start, in the title of his text, Fried claims that it is an art of "ideological nature" (i.e., too theoretical) and analyzes several key terms in great detail (for instance, *literalness*, *non-relational art*, *presence*, *experience*), in order to demonstrate how Judd's complaints on illusionism in modernist painting and sculpture, as well as his and Robert Morris's advocacy for anti-anthropomorphic object art, are theoretically fragile, even worthless. To make such an analysis, it was first important to relativize the critiques of minimalists directed toward American abstract expressionism.

Judd's main objection to painting, and modernist painting in particular, was spatial (pictorial) illusionism of the painted surface which he considered inevitable, because "Anything on a surface has space behind it. Two colors on the same surface almost always lie on different depths",[13] and therefore an abstract expressionist painting is "nearly an entity, one thing, and not the indefinable sum of a group of entities and references",[14] characterized by a lack of *unity*, *singleness of form* or *wholeness*, the same qualities Morris singles out while describing his *autonomous and self-contained unitary forms*.[15] Modernist sculpture received similar criticism: both Judd and Morris thought that most sculptures were anthropomorphic and that even abstract ones made "part-by-part" possessed "relational" character. Additionally, they imitate gestures of expressive painting. These would be negative features as they result in an anachronous *anthropomorphism*, because "the parts and the space are allusive, descriptive and somewhat naturalistic".[16] In order to eliminate the illusion of spatial depth in paintings, Judd created a specific object that has its own, real space, which—though it is "neither painting nor sculpture"—"obviously resembles sculpture more than it does painting, but it is nearer to painting".[17]

Morris, who sticks with the term "sculpture" in his advocacy for a new art of objects, also believed that his *unitary forms* demand "its own, literal space". While Judd and Morris consider literalness, spatiality and inter-medial features of the object to be the qualities of specificity, for Fried they represent the evidence of non-specificity, a sufficient enough reason for them to be "characterized as corrupted or perverted by theatre",[18] enabling him to see them beyond the zone of autonomous "high" art and qualify them as not-art.

4.3 Abstraction without Reduction

"They are resolutely abstract", David Batchelor wrote in his overview of Minimal Art, in which he dealt with five artists individually (Morris, Judd, Andre, Flavin (Figure 4.2), and Sol LeWitt). These are the artists present in all of the many classifications of this art, which is one of the reasons that led Batchelor to state that the

Figure 4.2 Dan Flavin, *Untitled*, 1970, installation at Dia: Beacon Gallery, New York, 2016; photo: Mauritius Images GmbH/Alamy Stock Photo.

main problem of this art is that it never really existed at all.[19] That what remains unquestionable is that minimalism belongs to the tradition of abstraction that, since its beginning, implied freedom and enthusiasm of modern and avant-garde art in the fight against representation, realism and illusionism toward which later generations assumed a stance marked by various degrees of "distrust". Artists associated with abstract expressionism followed Greenberg's narrative of "homeless representation",[20] accomplishments of *all-over* and *color field paintings* as the ultimate results of abstract art's progress. In the American abstract expressionism of the fifties, which assumed heterogeneous achievements from its European roots, abstraction became an "official, global" art language with the hypothesis that conventional conflicts between abstraction-figuration had been dealt with, and so the focus of interest moved on to the differentiation of art media by means of reducing them to their formal specificities. The transformation of the meaning of non-referentiality, based on the procedures of reduction that can be traced here, is oriented differently in Minimal Art.

Donald Judd, although being in favor of a minimal number of elements and relations in works with the goal of making an inseparable, wholesome object—*non-relational and non-compositional object*—in an interview with Bruce Glaser said: "I object to the whole reduction idea". In "Specific Objects", he added, "there always seems to be a reduction, since only old attributes are counted and these are always fewer. But obviously new things are more".[21] Morris, who, contrary to Judd, thought that "only relations between sensations can have objective validity",[22] and who did not abandon the term "sculpture", although he preferred the term *unitary forms* and forced the significance of the terms *gestalt* and *shape*, also believed that sculpture demands "literal space, one with three, not two coordinates".[23] Though from another perspective, he also spoke about reduction: "Unitary forms do not reduce relationships. They order them".[24] Additionally, he considered the new situation with objects to be "more complex and extended".[25]

Therefore we are talking about a non-referential abstraction that does not begin with a conventional reduction (in spite of extreme physical simplicity of objects) and results in objects that are more than existing artifacts, that does not reduce relations but puts them in order (despite the fact that there are fewer) and that dictates a new complex and broader situation (usually found in art that possesses a larger number of attributes). In what measure then are specific objects art objects, contextualized into real space—not just another kind of abstraction but a "specific attack" on the autonomy of art? And in what way are they distinguishable from real objects and able to realize their artistic identity?

Although deviating from Judd's attitudes toward *non-relational* composition and disagreeing with him on the question of anti-illusionism (since he thought sculpture never had that problem), Morris insisted on specificities of *objecthood*. When he supported "the autonomous and literal nature of sculpture [...] that it has its own, equally literal space" and attempted to affirm his *unitary forms* with the key designation of comprehensive *shape*, in that obviously awkward formulation, Morris momentarily lost sight of the fact that autonomy is a key term of Greenberg's modernism that he, Judd and other artists of Minimal Art wanted to overcome with the category of *literal object*. In other words, Morris actually defined modernist sculpture using minimalist terms (*that it be literal*) on the one hand, while on the other, he defined the minimalist category of object in modernist terms (*autonomous*).

In further deliberation on Morris's position, Hal Foster cites the following sentence by Morris: "The magnification of the single most important sculptural value [...] established both a new limit and a new freedom for sculpture".[26] Foster thinks that the paradoxical nature of this attitude suggests tension from which he concludes that "minimalism is both a contraction of sculpture to the modernist pure object and an expansion of sculpture beyond recognition".[27] Foster's conclusion is surely an important contribution to explaining the non-reductive character of minimalist geometric abstraction, but it does not encompass its inherent aspect of changes in the hierarchy of visibility. If we add to Morris's constant suggestions that the surrounding space became a constitutive element of an artwork and to Judd's demand for *real object in real space*, then a certain incompatibility of the object's materiality in relation to "what you see is what you see" becomes somewhat more clear: formalist rhetoric with regard to the tautology of vision that transforms itself in a spatial experience of the observer could not be fully consequent.

Despite the statement concerning objects that there "isn't as great a difference in their nature as in their appearance",[28] there has to be a great difference if we estimate observers' reactions to first minimalist exhibitions. The visitors, partially ironical and partially with serious intentions, found in the literalness of objects a number of possible references to, for example, Bauhaus design, modern architectural forms, office furniture or useable objects of the time in general, and therefore some of Judd's work had been labeled as "Letter Box", "Bleachers", "Harp" or "Lifeboat".[29]

Following these allusions, some theoreticians later talked about a certain "illusion of function",[30] while suggestions of the connection between specific objects and impersonal industrial production, standardized industrial materials and construction elements or global mass production in a highly developed capitalism, which had already involved abstract vocabulary and communicational patterns, became one of the key places in the referential reception of Minimal Art.[31] As opposed to interpretations on the level of similarities with quotidian things, there are other referential interpretations of minimal objects that concern the manner of their origin, and these draw onto the principles of *seriality*, both in the context of production processes as well as the patterns of *repetition*, effective in advertisement industry and consumption. That kind of production resulted not only in a specific aesthetic of repetition in minimalism but also in the dethronement of modernist myths talking about the original and the artist as genius, i.e., in the shift of art from modernist autonomy into the world of social reality, simultaneously transforming progression into transgression.[32]

All the described reactions and interpretations of Minimal Art after Fried's condemnation of something that could not ever exist in real objects in the first place, i.e., anthropomorphism and theatricality, today are sufficient reasons that the referentiality of Minimal Art—regardless of artists' theories that claimed differently—has been in no need of special proof since a long time ago. This is all the more so because the recent interpretations of (non)referentiality of abstraction rely mostly on Fried's analyses of Minimal Art's anthropomorphism.

4.4 From Fried to Intersubjectivity: Why Non-theatrical Art Does Not Exist

The statement "what you see is what you see" and the demand for *literalness of the objects* are not as simple as they seem to be in their relationship: objects provoke

creation of meaning but, simultaneously, that what the observer really observes negates the existence of any meaning. Yves-Alain Bois[33] drew attention to the contradictions between "discursive features" and material qualities with a precise description of a "fascinating play between negative and positive space" in Judd's works, noticing how works often refute the artist's statements, while the substantial relationship of minimal objects and *literal space* as a spatial extension of the object, in which the observer-subject operates, becomes essential in interpreting Minimal Art as to emphasize the role of the observer. However, Robert Morris already warned that "simplicity of objects is not the same as the simplicity of experience".[34]

To Morris's explanation that his earlier work was seen strictly with regard to what was localized in/on it, while eventually it is an experience "of *an object in a situation—* one that, virtually by definition, includes the beholder"—Fried replied that the entire situation means the inclusion of the beholder's body "as part of the situation in which […] objecthood is established" and that objecthood "at least partly depends" on this inclusion of the beholder's body.[35] The feature of "an object in a situation", depending on the observer, is related to the quality of the term "presence", which leads Fried to additional complaints whence the whole discourse of Minimal Art's anthropomorphism stems from. His objection that "the apparent hollowness of most literalist work—the quality of having an *inside*—is almost blatantly anthropomorphic"[36] changes when he explores that this phenomenon of "obvious emptiness" includes the subject's "experience of being distanced by such objects […] or crowded, by the silent presence of another person" that can ultimately be "strongly, if momentarily, disquieting".[37]

As if he did not notice to have being affected himself by the "unsettling experience", Fried basically proves the existence of the experience he previously negated as an aesthetic element when he talked about the anthropomorphism of objects. It was not just Fried who was contradicting his opinions. Some mentioned that Morris's formulations, as well as Judd's statements—for instance "the order is not rationalistic but is simply order, like that of continuity, one thing after another"— are ambiguous.[38] They are neither in accord with the formal logic of objects nor with the rest of the sentence where he inscribes phenomenological qualities to objects: "specific, aggressive and powerful".

Inspired by these dissonances, Briony Fer[39] approaches the original duality of abstraction—between materiality and transcendence, seen and unseen, presence and absence—which she writes about in the series of seven thematically connected essays, featuring the examples of abstract artists' work (from Malevich to Mondrian, Eva Hesse's post-minimalism, to Gerhard Richter and Rachel Whiteread). Among those is the chapter devoted to Judd and "Specific Objects", which Fer confronts to Yves Klein's monochromes in the sense of "erotic objects", where formal questions of abstract art without "subject matter" are in some way neglected in favor of the oppositions of the psychoanalytic terms "anxiety" and "pleasure", as well as *uncanny*.

Briony Fer expands the circle of referential reading of Judd's and abstract works in general through a phenomenological approach, using terms such as "post-Freudian psychoanalysis", involving in her reading chosen interpretations of Lacan's term "the Real", Bataille's anti-aesthetic and partial stances of Melanie Klein, Julia Kristeva or Rosalind Krauss. She achieves an important turn in her approaches to abstraction (by that the object art of minimalism as well), not by using the psychoanalytic *instrumentarium* in the sense of psychobiography; she is instead focused on researching the objects—not subjects-makers of artworks—and explains the ways in which art can form meanings

that are in harmony with the deepest structures of human subjectivity and operations that stem from the observer's subconsciousness. Aporias of abstraction in diverse production of works appear in relations and tensions between "formal vocabulary and rhetoric of abstraction that are here confronted with meanings of unconscious—objects that materially determine the way in which the abstract art of the objects can influence our deep, most often, unarticulated fears, fantasies and wishes". In other words, "Fer tries to exclude elements in the work that manifest the unconscious, that unconscious which is suggested by the insight into contradictions of abstract art, them being symptoms".[40] Minimal Art's *Presence*, condemned by Fried (while elevating modernist abstraction in his statement "Presentness is grace"), benefits such views.

"A kind of stage presence"[41] that was, according to him, first analyzed by Clement Greenberg, led Fried to criticize Minimal Art because of the effect of theatricality he assigned to minimalist objects to the measure that he attributes to them the fictional status of actors on stage. Fried, however, is fully aware that his objection to the anthropomorphism of minimalist objects is not founded on actually existing iconic relations, and so he draws the following conclusion: "what is wrong with literalist work is not that it is anthropomorphic but that the meaning and, equally, the hiddenness of its anthropomorphism are incurably theatrical". He continues: "a kind of latent or hidden naturalism, indeed anthropomorphism, lies at the core of literalist theory and practice".[42]

The real cause of hidden anthropomorphism, the trait of the living in the non-living, is therefore not what is really present in the geometric-abstract forms of the objects but in the (unsettling) hypothesis of some secret interior of things in general. Fried's objection to theatricality is located by Juliane Rebentisch[43] somewhere in between literalness and meaning, in a *twofold presence of the object—as a thing and as a sign*. "Stage presence", used by Fried to describe the minimalist object, according to Rebentisch is a figure of ambivalence and an especially important element of theatrical experience. Stage actors simultaneously show themselves and something else, someone else's character. This is their presence on stage that necessarily provokes "perception of tension between the presenter and that which is presented".[44] In experiencing minimalist objects, the theatricality is also a question of their doubling into a thing and a sign. Therefore they can be interpreted only in their dichotomy and in the way that they interchangeably direct toward one another, becoming stronger and negating themselves simultaneously. In the moment in which it seems that minimalist objects gained anthropological meaning in the eyes of the beholder, it is clear at the same time that nothing inside of them justifies it: *production of meaning becomes a projection of meaning*, as Rebentisch points out. The observer is returned to the factuality of the material, whose alleged identification also seems to be unstable, as if contaminated by the latency of meaning. That very duality is the source of Fried's description of the unsettling theatrical quality of minimalist objects. However, Fried does not take into consideration that tensions between things and signs are the foundational feature of all art, as Rebentisch compellingly proves and draws the conclusion that completely non-theatrical art does not exist at all.[45]

4.5 That Which Does (Not) Observe Us

The minimalist overstepping of the limits—in one case, the disregard for the limitations of media specificity (neither painting nor sculpture), in the other, the erasure of

boundaries between high art and profane reality (objects are *real things* like any other real thing)—is the cause that the criticisms by Greenberg and Fried may be read as opinions concerning *the lack of difference*, *distinction*, differentialities of minimalist "objects in situation", their non-separateness from common surrounding objects and from the subject-observer that encounters these objects in the same space, like other objects or persons.

Krešimir Purgar draws attention to the oppositions and paradigmatic meaning of two points in the "construction of visible reality": the first one is offered by Gottfried Boehm in his concept of *iconic difference* as the "fundamental *possibility* of distinguishing between images and non-images"[46] and the second one is Oliver Grau's concept of *immersion*, established on the "basic *impossibility* of that differentiation".[47] While Boehm sees the image as a distinctive object, Grau is in favor of the image being a phenomenological fact, where the observer becomes "mentally absorbed", which in some cases "leads to the belief of the observer that what happens in images or visual installations is actually true".[48] Minimalist objects are not on either poles of these two positions; however, they point to non-distinctness (the status of a mere object in its surroundings) but their presence (like another person), experienced by the observing subject, encourages constructions of meaning and demands corporal exclusion and distance. The term "iconic simultaneity" suggested by Purgar refers to a mutual relationship between *difference* and *immersion*, that is, existing in a natural space but feeling as almost being inside the screen.[49] Although that concept is not directly applicable to the perception of *material* objects in real space—for in iconic simultaneity they would appear as images on screen—minimalist "objects in situation", as described in this chapter, assume the same kind of spatial ambivalence proposed by Purgar—as "not-representation-anymore and not-yet-immersion".[50]

As three-dimensional objects are not only present in space and take space but are real space—their abstractness is a fundamentally different category than pictorial abstraction. Abstract-geometric appearance of objects is not (cannot be) a consequence of conventional reduction of abstracting objects from reality, because that kind of object which specific objects would refer to does not exist in reality at all. Guaranteeing the autonomy of art in separation from reality (exclusion) therefore is not a result of the process of abstraction of these objects, but it becomes a method of expanding the field of art's competence beyond the autonomy defined by modernism into the spatial continuum of perception (inclusion); by surpassing media specificities, the questions of their attributes are not reduced to *essence* and *purity*, but they are *compressed* into a medium-wise unspecific whole, a hybrid object demanding *presence* and *place*. Minimizing material constituents of volume and surrounding space, which it encompasses as its own interior, has a paradoxical effect of *maximizing* the visibility of the whole work (as the essential otherness), by which the distance is emphasized between the presence of the volume of the object/work and place which is occupied during the visual experience by the observer present in the same—institutional—but real space, nevertheless.

Didi-Huberman interprets the distance dictated by minimalist objects during the observing experience as double bind,[51] in the sense of corporally present "empty volumes" that define place within space; however, it is empty as well, which provokes the "dilemma of the visible",[52] since that which we look at always includes also that which is missing—emptiness—in a scene that reversely encourages the incurrence of some referential construction in the observer. That situation breeds a paradox concerning

the referential character of these objects, which was, according to Didi-Huberman, uncovered by Michael Fried, with the additional explanation that "this paradox is not only theoretical, but also immediate, visually comprehensible paradox",[53] which lies on the internal contradiction of Minimal Art, between the tautological conception of perception (what you see is what you see) and the necessary opaqueness of inter-subjective experience encouraged by Minimal Art exhibitions. That which does *not observe us*—a simple Minimal Art object—"that which is just there before us […] a compact volume (*single, specific*)",[54] which can be seen clearly and which, in its formal determinism does not allow a thought about any kind of illusionism or anthropomor-phism—by pointing to that which is missing in itself (emptiness) is still returning the gaze, *is observing us.*

The key difference in relation to the conclusion made by Didi-Huberman is present in Juliane Rebentisch's aforementioned critique. In the implied humanism of the mod-ern aesthetics (Adorno), she saw a mistake that brought about the false understanding of "separation of art" and reality. Fried's reservations toward anthropomorphism, hypotheses concerning "art drowning in reality", as well as contemporary views of works of art as quasi-subjects are, according to Rebentisch, principally the result of the false understanding and consideration of the "dictate" of the observer as the deci-sive factor in aesthetical experience. An artwork never actually causes its meaning—the meaning only appears in/on the work, and therefore subjects-observers are simply dependent on their own production of semantic relations (projections). The perspec-tive of the actual autonomy of an aesthetic object (exclusively in the mode of object relations!) therefore would be in that autonomy is not negated and does not lose itself in our semantic projections, but that both object and we (in confrontation with the objects) withdraw before those projections. Only in that way the object would stop being the simple cause of aesthetic experience, and the experience itself would not anymore be reduced only to the capability of self-reflection of abstract subjectivity (as in Adorno). Rebentisch confronts modernist subjectivity with the concrete empirical subjectivity of recipients who are not transcendent, but reflect themselves in a specific way during the confrontation with the artwork (object of aesthetic observation).[55] They do not transcend or lose themselves in that experience but reflexively distance themselves.[56]

The post-humanist approach to the abstraction of Minimal Art suggested by Rebentisch pleads for an autonomy that is compatible neither with the modernist aes-thetic nor with the contemporary concept of differentiation of art and non-art via quasi-subject. Although her interpretation of Minimal Art's objecthood is partially similar to Didi-Huberman's conception of metapsychology of the image and the anthropology of form, Juliane Rebentisch draws an opposite conclusion with regard to their mutual starting point—Fried's negative appraisal of Minimal Art's anthropomorphism—since she does not, like Didi-Huberman, only correct this standpoint in the direction of positive orientation but totally discards it. She is opting instead for de-ethicizing the moment of aesthetic pleasure that happens between objects and subjects, that is, against the anthropomorphization of these relations, as "subjects do not experience the aesthetical using the capabilities they already possess beyond the aesthetical, but in those accomplishments that are only possible through aesthetic experience".[57] We will use this interpretation to distance ourselves from the objections to anthropomorphism and get closer to minimalists' demands for an art comprising non-referential objects in the status of *literal*, *real things* that could lead to a special discussion concerning

reality, cognitive potentials and the ontological dimension of art, in which theoretical-artistic and aesthetic reasons would probably remain insufficient.

There is still an unsolved question concerning the term "reality" (especially with regard to art) and what it actually implies. Lacan's Real, defined as everything that remains outside and does not enter the register of the Symbolic and Imaginary, already found its place as a model of interpretation in recent analyses of abstraction and Minimal Art. The Real is deemed acceptable in newer philosophical orientations that consider "realism"—all the reality that exists outside and independently of our subjective knowledge and consciousness—to be the term that celebrates its return in the form of "speculative realism"[58] and in the interpretation of the object close to the postulates of minimalists. In what measure can that be a guide to new possibilities of looking into abstraction and Minimal Art in today's significantly changed conditions of visibility and visuality—in an age when Martin Seel's *Aesthetics of Appearing*, characterized by the twofold focus on "art of perception and perception in art",[59] grows in importance—only time will tell.

Notes

1 Cf. W.J.T. Mitchell, *What Do Pictures Want? The Lives and Loves of Images*, Chicago: The University of Chicago Press, 2005.
2 Cf. Gottfried Boehm, *Wie Bilder Sinn erzeugen. Die Macht des Zeigens*, Berlin: Berlin University Press, 2007.
3 Cf. Georges Didi-Huberman, *Was wir sehen blickt uns an. Zur Metapsychologie des Bildes*, München: Wilhelm Fink Verlag, 1999. (Orig. *Ce que nous voyons, ce qui nous regarde*, Paris: Minuit, 1992).
4 Several titles of Hans Belting's text, i.e., "Die Herausforderung der Bilder" (The Challenge of Images) and "Blickwechsel mit Bilder" (Exchange of Glances with Images) published in: Hans Belting (ed.), *Bilderfragen*, München: Wilhelm Fink Verlag, 2007.
5 Cf. Isabelle Graw & Peter Geimer, *Über Malerei*, Köln: Walther König Verlag, 2012. In his reply to Isabelle Graw's thesis, Peter Geimer assumes a critical stance toward the personalization of artworks in the same publication. He condemns the widespread practice in texts that manifests itself in theoreticians' use of self-explanatory terms and expressions; i.e., the term "self-reflexivity" often refers to the attributes of artworks but can signify human capability of thinking.
6 Michael Fried, "Art and Objecthood", in Charles Harrison & Paul Wood (eds.), *Art in Theory 1900-1990. An Anthology of Changing Ideas*, Oxford and Cambridge: Blackwell Publishers, 1992, pp. 822–834.
7 Frank Stella in an interview with Bruce Glaser (Bruce Glaser, "Questions to Stella and Judd" (interview), in Gregory Battcock (ed.), *Minimal Art: A Critical Anthology*, Oakland: University of California Press, 1995, pp. 150–164, first published in New York: E.P. Dutton, 1968. This discussion was broadcast on WBAI-FM, New York, February, 1964, as "New Nihilism or New Art?" It was one of the program series produced by Bruce Glaser. The material of the broadcast was subsequently edited by Lucy R. Lippard and was published in *Art News*, September, 1966.
8 Donald Judd, "Specific Objects", 1965, in Donald Judd (ed.), *Complete Writings 1959-1975*, Halifax: The Press of the Nova Scotia College of Art and Design, 1975, pp. 181–189: 187. According to Judd, the text was written in 1964, but was published for the first time in *Arts Yearbook 8*, 1965.
9 Clement Greenberg, "Towards a Newer Laocoön", *Partisan Review* 7(4) (1940), pp. 296–310.
10 Cf. Serge Guilbaut, *How New York Stolen the Idea of Modern Art*, Chicago: The University of Chicago Press, 1983.
11 Benjamin Buchloh wrote about the changes in Greenberg's theory ("Cold War Constructivism", in Serge Guilbaut (ed.), *Reconstructing Modernism*, Cambridge/London,

1990, pp. 85–113), comparing Greenberg's text ("The New Sculpture" from 1949, *Partisan Review*, vol. June 16, 1949, pp. 637–642) to its revised version from 1961 (in: C. Greenberg, *Art and Culture*, Boston, 1961, pp. 139–145).

12 Judd, "Specific Objects", in *Complete Writings 1959-1975*, p. 183.

13 Op. cit., p. 182.

14 Ibid.

15 Robert Morris, "Notes on Sculpture", Part 1, in *Artforum*, February, 1966. Here cited after Gregory Battcock, *Minimal Art: A Critical Anthology*, Oakland: University of California Press, 1995, pp. 222–235, 234.

16 Judd, op. cit., p. 183.

17 Ibid., p. 182.

18 Michael Fried, "Art and Objecthood", in Harrison & Wood (eds.), op. cit., pp. 822–834: 829.

19 David Batchelor, *Minimalism*, London: Tate Gallery Publishing, 1997, p. 11. David Batchelor's doubt in the existence of this art is supported by the unwillingness of the artists to be a part of any group, let alone the one labeled Minimal Art. Along with that, although there are many similarities between individual stances and the very objects, there are significant divergences. A complete overview of Minimal Art's history which would comprise at least its beginnings still does not exist. There is a stumbling block concerning potential classification in view of increasingly numerous later productions—from Turrell's dematerialized, geometric luminosculptures to massive Land Art works, Richard Serra's sculptures or more recent minimalist tendencies in art.

20 Clement Greenberg, "After Abstract Expressionism", *Art International*, vol. October 8, 1962, pp. 24–32.

21 Judd, op. cit., p. 189.

22 Robert Morris, "Notes on Sculpture", Part 1, in Battcock, p. 225.

23 Ibid., p. 224.

24 Ibid., p. 228.

25 Ibid., p. 235.

26 Ibid., p. 228.

27 Hal Foster, "The Crux of Minimalism", in Hal Foster (ed.), *The Return of the Real*, Cambridge, MA and London: The MIT Press, 1996, pp. 35–68: 47.

28 Judd, op. cit., p. 183.

29 James Meyer, *Minimalism, Art and Polemics in the Sixties*, New Haven and London: Yale University Press, 2002. Cf. also Kirk Varnedoe, "Why Abstract Art?", in Maria Lind (ed.), *Abstraction. Documents of Contemporary Art*, London and Cambridge, MA: Whitechapel Gallery and The MIT Press, 2016 (2006), pp. 48–64: note 10, p. 64.

30 Alongside the analysis of the "illusion of function" in her book *Minimal Art: The Critical Perspective* (UMI Research Press, 1990) Frances Colpitt reminds of Rosalind Krauss's text "Allusion and Illusion in Donald Judd" (*Artforum*, vol. IV, no. May 9, 1966, p. 24), and the comparison of the structure of Judd's works with architectonic modules, for instance, Brunelleschi's Pazzi Chapel. Additionally, Colpitt compares Judd's *boxes*, *stacks* and *progressions* with Shaker's furniture. She also mentions several situations in which visitors placed drinking glasses and other objects on the artworks, thinking they were part of the furniture.

31 Cf. Benjamin Buchloh, *Neo-Avantgarde and Culture Industry*, Cambridge, MA: The MIT Press, 2003.

32 Boehm, op. cit., p. 172.

33 Yves-Alain Bois, "L'Inflexion", in *Donald Judd*, exib. cat., Paris: Lelong Gallery, 1991.

34 Robert Morris, "Notes on Sculpture", Part 1, in Battcock, p. 228.

35 Fried, in *Art in Theory*, p. 826.

36 Ibid., p. 827.

37 Ibid., p. 826.

38 Judd, "Specific Objects", in *Complete Writings 1959-1975*, p. 184.

39 Briony Fer, *On Abstract Art*, New Haven/London: Yale University Press, 1997, pp. 131–151.

40 Abigail Solomon-Godeau, "Dreaming in the Abstract", in *Art in America*, May 1998; pp. 37–41: 39. Fer seeks out elements in the work that manifest its unconscious, the

unconscious suggested by the consideration of abstract's art contradictions as, precisely, symptoms.

41 Fried, op. cit., pp. 822–834: 826.
42 Ibid., p. 827.
43 Juliane Rebentisch, "Autonomie? Autonomie! Ästhetische Erfarung heute", in: *Sonderforschungsbericht 626* (ed.), *Ästhetische Erfahrung: Gegenstände, Konzepte, Geschichtlichkeit*, Berlin, 2006 and www.sfb626.de/veroefentlichungen/aesth_erfahrung/aufsaetze/rebentisch.pdf
44 Ibid.
45 Ibid.
46 Krešimir Purgar, *Pictorial Appearing. Image Theory after Representation*, Bielefeld: Transcript, 2019, p. 34.
47 Ibid.
48 Ibid.
49 Ibid., pp. 46–52.
50 Ibid., p. 40.
51 Didi-Huberman, op. cit., p. 127.
52 Ibid., p. 45.
53 Ibid., p. 55–56.
54 Ibid., p. 44.
55 Rebentisch, op. cit., p. 10, paragraph 15.
56 Ibid., paragraph 16.
57 Ibid., p. 11, paragraph 17.
58 Dieter Mersch, "Objektorientierte Ontologien und andere spekulative Realismen", in Dieter Mersch and Magdalena Marszałek (eds.), *Seien wir realistisch. Neue Realismen und Dokumentarismen in Philosophie und Kunst*, Zürich-Berlin: Diaphanes, 2016.
59 Gerhard Gramm, review of Martin Seel book *Ästhetik des Erscheinens* (München: Carl Hanser Verlag, 2000) in *Die Zeit*, 10/19/2000.

5 Representational Abstract Pictures

Regina-Nino Mion

Abstract pictures are distinguished from depictive pictures in that no visibly recognizable objects can be seen in them. Abstract pictures are thus non-depictive and non-figurative. The question still remains, however, if abstract pictures can be representations. The aim of this chapter is to defend the view that abstract pictures can be representational and therefore have content or subject matter. It will be shown that there are at least three ways to understand what the subject matter of abstract pictures can be: it is either abstracted from figurative content, it is spiritual or the subject matter is produced.

The aim is not to provide a comprehensive analysis of what could be the subject matter of abstract pictures. Also, it is not claimed that *all* abstract pictures are representational. It is well known that various theorists and abstract artists promote the opposite idea according to which abstract pictures should not have any subject matter. Just to give a few examples: Clement Greenberg writes that "subject matter or content becomes something to be avoided like a plague"[1] and Kazimir Malevich writes: "Painters should abandon subject and objects if they wish to be pure painters".[2] It must be noted, however, that these statements often say nothing more than that abstract pictures do not (or should not) have *depictive* subject matter. In other words, the claim that abstract pictures do not represent is based on the understanding that to represent is to depict, and to be a representation is to have a depictive or figurative content or subject matter. But one could also take depiction to be a subcategory of representation and understand "subject matter" more broadly, e.g., "Depiction is a distinctive form of representation, characteristic of figurative paintings, drawings, and photographs".[3] Thus, in order to talk about the subject matter of abstract pictures one has to accept the idea that representation is not equal to depiction or figuration.

Richard Wollheim has famously distinguished the representational and figurative content of a painting. According to him, abstract paintings have no figurative content but most of them have representational content, and that allows us to treat them as representations. It should also be noted that figuration is definitely a subcategory of representation according to Wollheim:

> we must not confuse the *representational* content of a painting with its *figurative* content. The idea of representational content is much broader than that of figurative content. The representational content of a painting derives from what can be seen in it. The figurative content derives from what can be seen in it *and* can be brought under non-abstract concepts, such as table, map, window, woman.[4]

Thus, the content or subject matter does not have to be figurative. But it could be abstracted or reduced from figurative content and this will be explained in the following section.

5.1 Abstracted Subject Matter

John H. Brown distinguishes two subcategories of the term "abstract" used in visual art: first, schematizing abstraction, that is, varieties of figurative representation that strongly schematize, and second, completely non-figurative or non-objective abstraction. The division characterizes two opposite ways of *doing* abstract picture. Either one starts with a natural motif and moves gradually toward the removal of any descriptive content or one starts with lines, forms, textures and colors, "which are then worked up into aesthetically self-sufficient totalities".[5] Thus, the process of moving from depiction to abstraction is called "schematizing abstraction"[6] and characteristic to this are pictures of Analytic and Synthetic Cubism.

There is no doubt that Pablo Picasso, for instance, did not lose the reference to figurative objects and the term "schematizing abstraction" certainly fits with his description of doing art. As he writes:

> There is no abstract art. You must always start with something. Afterward you can remove all traces of reality. [...] Nor is there any "figurative" and "nonfigurative" art. Everything appears to us in the guise of a "figure". [...] See how ridiculous it is then to think of painting without "figuration". [...] Do you think it concerns me that a particular picture of mine represents two people? Though these two people once existed for me, they exist no longer. The "vision" of them gave me a preliminary emotion; then little by little their actual presences became blurred; they developed into a fiction and then disappeared altogether, or rather they were transformed into all kinds of problems. They are no longer two people, you see, but forms and colors: forms and colors that have taken on, meanwhile, the idea of two people and preserve the vibration of their life.[7]

Thus one can agree with Michel Henry that the abstraction of Cubism belongs to the figurative project.[8] Now, what about purely abstract pictures? Lambert Wiesing, for instance, suggests that abstract pictures are also abstractions from figuration. In his book *The Visibility of the Image*, he argues that the abstract image [*das abstrakte Bild*], from a genetic perspective, has come from a reduction of the objective image [*das gegenständliches Bild*],[9] an image that refers to objects beyond the image. Since an abstract image is derived from an objective image, it retains some conceivable relation to it. This is why Wiesing sees the abstract image to be a *part of an absent whole*[10]; it is a constituent part of an (absent) objective image.[11]

Because of this relation to the objective image, the abstract picture is not only a representation but a unique kind of *sign*, according to Wiesing. He follows the definition of a sign according to which "A sign is an object that stands for something else and that therefore refers to this other thing".[12] The objective image is a pictorial sign for it refers to an object (through resemblance). The abstract image is a sign as well but a unique kind of sign. As Wiesing puts it, "The abstract image is not a sign for an object, but [...] only a possible sign that is not completely realized. It is a sign for another sign, an image about the way an objective image could be structured".[13]

In case of varieties of figurative representations, such as cubist pictures, the content is an object, a figure. The content of an abstract picture, according to Wiesing, is not an object or even a possible object but a possible figurative picture. As Elisa Caldarola summarizes Wiesing's point: "This also means that abstract pictures are intrinsically a *parasitic phenomenon*, because they depend on pictures that have an object in order to be understood as pictures".[14] Wiesing furthermore explains in *Artificial Presence* that

> the structures in an abstract picture thus understood cannot be merely ornamental forms because they do indeed have meaning: even though they do not refer to objects, they yet can be used to refer to the structure of other possible photographs that display objects.[15]

In other words, "the abstract photo presents itself as a potential figurative photo".[16]

Following Wiesing's arguments, the abstract picture could be defined as being *more* than an ornament but *less* than a figurative depiction. How to distinguish the abstract picture from mere decoration, ornamentation or visual pattern seems to be one of the central questions in discussing abstract art and is also pertinent here. Of course, to call abstract art as "mere decorative" clearly expresses a derogative attitude toward abstract pictures. E.H. Gombrich's text on abstract art clearly expresses that attitude. To quote him: "But when I seriously compare my reactions to the best 'abstract' canvas with some work of great music that has meant something to me, it fades into the sphere of the merely decorative".[17] However, I believe that a more important reason for the need of a clear distinction between abstract pictures and decorations is that decoration is not representation. It means that if one wants to defend the view that abstract pictures are representational then he or she needs to explain how they are not mere decorations, or that they are more than decorations. I do not argue against the view that abstract pictures could be experienced as mere decorations. All I want to point out is that one cannot take abstract pictures to be mere decorations and representations at the same time. And it does not contradict to the idea that abstract pictures can be seen as borderline cases or quasi-decorative, that is, that these are pictorial representations *and* have decorative character.[18]

Wiesing believes that "an abstract image can only avoid being an ornament by standing in some conceivable relation to an objective image".[19] Moshe Barasch claims that an abstract painting is not a decoration because it is not arbitrarily made—the combination of forms and colors is determined by the subject matter. He says of this:

> Both Mondrian [...] and Kandinsky stressed that the "pure shaping" (*reine Gestaltung*) which they saw as art's ultimate goal was not mere "decoration". By "decoration" they meant a free, arbitrary play with forms, and the experimental combination and recombination of shapes and shades. The ultimate purpose of these experiments was to please the spectator's eye. Decoration could not be true art precisely because of its arbitrariness.[20]

It should be noted that the subject matter Barasch is referring to is neither a natural object in the real world nor an objective image—it is *spiritual*. This takes us to the next account of the possible subject matter of abstract pictures.

5.2 Spiritual Subject Matter

Charles Harrison in his historical and theoretical analysis of Abstract Expressionism emphasizes two art movements that had an influence on abstract painters: Cubism and Surrealism.[21] The inheritance of Cubism to abstractionism has been discussed in the previous section. Surrealism, according to Harrison, brought along the idea of the liberation of the spirit and the "revolution of consciousness";[22] it involved the combination of "automatic" techniques and an interest in primitive and "archetypal" subject matter.[23] This could be seen as one source for the emergence of the spiritual subject matter in American abstract painting.

It is well known that the early abstract painters had a strong interest in spiritual matters, e.g., Wassily Kandinsky's interest in theosophy.[24] In his book *On the Spiritual in Art*, he praises artists who were seeking "the internal in the world of the external".[25] Moshe Barasch describes it as the belief in *a purely spiritual subject matter*.[26] More precisely, Barasch argues that in the doctrine of abstract painting we find two types or two categories of subject matter. The first type was rejected and the second one promoted by the abstract painters. The idea that paintings must represent "natural objects", or anything that has to do with the material reality surrounding us, was rejected. Art must be liberated from such kind of subject matter and become "nonobjective".[27] The second kind of subject matter was, however, more difficult to define and not so easy to grasp. It was believed that there exists a hidden reality that was part of an "inner nature". As Barasch puts it, "It belonged to a level of reality that not everybody could directly experience, and that occasionally eluded even the select few".[28] The hidden reality was considered to be more "real" than the reality. This explains Kandinsky's concern about the term "abstract art" that he thinks is too confusing and should be replaced with "real art". In the text from 1936, he writes:

> The expression "Abstract Art" is not popular. And rightly so, since it says little, or at least has a confusing effect. [...] For a long time now, people have been trying (as I, too, did before the war) to replace "abstract" with "absolute". In fact, scarcely an improvement. In my view, the best name would be "real art", because this kind of art puts a new artistic world, spiritual in nature, alongside the external world. A world that can be brought about only through art. A real world. The old term "abstract art" has, however, by now become firmly entrenched.[29]

The main idea behind the "real art" is that every phenomenon can be experienced in two ways: externally and internally.[30] The external mode of appearance is visible, and the internal mode is invisible. Michel Henry in *Seeing the Invisible: On Kandinsky* advocates the view that abstract art seeks to represent the invisible reality. To quote Henry: "Pictorial activity no longer seeks to represent the world and its objects, when paradoxically, *it ceases to be the painting of the visible*. What, then, can it paint? It paints the invisible, or what Kandinsky calls the 'Internal'".[31] The internal reality is thus the content or the subject matter of abstract pictures. Henry's summary of Kandinsky's main thesis is the following:

> All of Kandinsky's creative activities [...] seek to promote and illustrate the essential truth contained in *On the Spiritual in Art*. This truth is that the true reality is invisible, that our radical subjectivity is this reality, that this reality constitutes the sole content of art and that art seeks to express this abstract content.[32]

Apart from being invisible, it remains open and not strictly defined by the abstract artists and theorists as to what the "internal reality" exactly involves. Jackson Pollock says that the modern artist "is working and expressing an inner world—in other words—expressing the energy, the motion, and other inner forces".[33] Kandinsky calls it "the totality of 'life' in the most general sense" that will emerge with full force.[34] Henry writes that instead of depicting the world, abstract art expresses Life.[35] The main idea is still that the abstract picture is not *abstracted from the world*. And we should not think that the geometrical forms are abstract because "they are constructed through a purification of sensible forms".[36]

The idea that the abstract picture represents spiritual subject matter clearly has some advantages. For one thing, many abstract artists themselves have expressed that view; it corresponds to what the abstract artists themselves, especially Kandinsky, wanted to achieve. Also, it avoids being a negative description of abstract art. It is quite clear that when the abstract picture is considered to be *less* than figuration, it unavoidably receives a negative characteristic. See, for instance, Henry's criticism of the process of abstraction that "marks an impoverishment and extenuation".[37] Having said this, I still believe that these two accounts of the subject matter of abstract pictures—either abstracted or spiritual—are similar. There are at least two characteristics in common: first, in both cases the abstract picture is a representation, and second, the subject matter remains *external*. I will explain it in more detail.

The differentiation of "internal" and "external" content, made by Kandinsky and Henry, does not change anything with respect to whether a picture is a representation or nonrepresentation. Even if the content is the invisible Life, an abstract picture remains a *representation of* the invisible Life. To quote Henry:

> After having represented the world of things, painting, like music, would henceforth seek to simulate the only world that truly matters: the invisible world of Desire and its history. One referent would give way to another one—the External to the Internal—but in both cases *the structure of art would remain the same: it would be a referential structure*. Through its reference to something other than itself—in the one case the world and in the other case Life—art would be the "expression" of a foreign reality, a means. That is, it would be a means for expressing a content with which it would enter into agreement.[38]

In a word, the content remains external in both cases—when the painting refers to the physical reality or to the internal reality. In fact, Henry himself explicitly says that the internal remains external: "Art would be a means—the means include sounds, colours, forms, movements, etc.—in the service of a different content, a content whose meaning is *external* to it: our life, our soul" (emphasis added).[39] In the following section, I propose a reading of abstract pictures in which the content is internal. I would like to claim that a picture that has a produced subject matter is an example of truly inner representation.

5.3 Produced Subject Matter

To begin with, I give a few examples of philosophical texts on pictorial representation that refer to the possibility to experience a produced subject matter. In *Artificial Presence*, Wiesing asks what could "abstract photography" be if the term "abstract" means that no objects are displayed? He proposes three possible answers: first, the abstract photography is a *sign* in which the infrastructure of the photograph (forms

and colors) is being thematized; second, it is an *image object*, an object of pure visibility; and third, it is a *nonrepresentation*, a work of art (a concrete object) that is not an image. In other words, the three possibilities are abstraction for the sake of *structures of visibility* [*Sichtweise*]; abstraction for the sake of *visibility* [*Sichtbarkeit*]; and abstraction for the sake of *object art* [*Objektkunst*].[40] The second possibility is of particular interest to me. In this case, we use the photograph to construct or generate an artificial object that bears no resemblance to real things. It is a new object of pure visibility.[41] Also, it is not reproduced but produced [*produzieren*]. To quote Wiesing: "If we understand abstract photography in this sense, then the medium of photography is not used for picturing [*abbilden*] or visibly reproducing something but for forming [*bilden*] and visibly producing something".[42]

Claudio Rozzoni presents a similar idea in his article "From *Abbild* to *Bild*?". He argues for the possibility that some artistic images produce their own subject, giving an example of the *Portrait of Denis Diderot* painted by Louis-Michel Van Loo in 1767 and a quotation from Denis Diderot's text in which the philosopher is unable to recognize himself in the portrait. Hence, Rozzoni claims that this is a case of *failed recognition* and therefore "what we see is an image *subject* expressed and *produced* by images differing from the *subject* they are supposed or claim to depict".[43] He suggests that a picture can have a subject declared but also a subject produced which would be the case of a creative or expressive depiction.[44]

I would like to claim that a picture that has a produced subject matter is an example of truly inner representation. A picture's internal content is the content that only that particular picture can have. It is produced by the picture itself and, in this sense, is truly *pictorial* content. It is also unique. No reference to the external material world is made, neither to the internal invisible world. The internal reality may not be acceptable to everyone, as Moshe Barasch pointed out, but it is still *one* that could be depicted by various modes, that is, different pictures can refer to the same internal reality. But the produced subject matter is unique.

Now, coming back to Richard Wollheim's distinction between the representational and the figurative content, one could wonder whether seeing the three-dimensional space in abstract pictures (the representational content) is also an experience of produced subject matter? My contention is that if we are to accept that abstract pictures are representations because they involve an awareness of depth,[45] which is the minimal requirement for being a representation according to Wollheim,[46] then it seems plausible to claim that the space or the three-dimensionality we see in abstract pictures—the content of abstract pictures—is *pictorial* and *unique*. It is because what we see in a picture depends on the pictorial surface—the forms and colors. As Wollheim describes the twofold experience of seeing-in: "whenever we look at a surface marked to any degree of complexity, we shall, while continuing to observe the marks on the surface, at the same time see one thing in front of, or behind, another".[47] Wollheim also points out that if we were to construct a three-dimensional model of what can be seen in the surface of a picture and if we would call it the *form* of the picture, then we must see that this three-dimensional form is *unique*: "Two paintings would have the same form only in marginal cases: such as where one painting is a copy of another".[48]

In my view the three-dimensional space seen in the abstract pictures is also *produced* because, firstly, it does not claim to depict any real space in the reality, and secondly, it is not a representation of the inner reality, because the invisible inner reality does not (or at least, should not) have the characteristics of the visible reality, such

as three-dimensionality. The first point—that three-dimensional space does not depict any real space—has already been expressed by various theorists. John H. Brown writes that the key concept behind non-figurative or non-objective abstraction "is that of a design which conveys no implication of actual (physical or 'tactile') space, though it is optional how strictly one applies this criterion".[49] In this respect, Charles Harisson's description of some early modern paintings that have *enclosed space* is relevant here:

> [T]he space is either entirely filled by forms and planes (as in the Leger), or it refers to an actual box-like space (as in the Picasso and Miró interiors) or it is identified with the canvas surface itself—and is thus prevented from functioning in reference to a particular "real" space—through the application of an all-over soft but opaque painted ground (as in the Matisse and in many Mirós of the twenties and thirties).[50]

The three-dimensional space seen in the abstract picture might accidentally have some resemblance to some real space out there, but to my mind it has no importance. If we take the experience of space or depth to be induced by the picture surface, it remains irrelevant that it might also accidentally have some similarity to a real space. Of course, to understand what "space" is, one must have *external* knowledge of it. One must have seen objects in real space. But I think it does not prevent one from seeing a unique space in a picture that depends solely on the visible aspects of the picture, and, in this sense is *produced* by the picture. What can be seen in the picture depends on what is marked on the picture's surface. I believe this idea is very close to what Wiesing had in mind when referring to the *pure visibility*.[51]

5.4 Concluding Remarks

In this chapter I have presented three accounts of how abstract pictures can be representational. The aim was not to give a comprehensive analysis of the "abstract picture". For instance, I have not discussed the question whether the content of abstract pictures is in some way especially *general*[52] or whether abstract pictures represent only *kinds* and *properties*.[53] The focus has been on the distinction between the "internal" and the "external" content of the abstract picture. No one would probably object that the content or subject matter has external characteristic when the abstract picture is considered to be schematizing abstraction or abstraction from the real world or just not a complete figurative representation. What might have received less attention is that even if the spiritual subject matter represents the invisible *internal* world, the subject matter is still *external* to the picture. I have endeavored to show that the truly *internal* content is a *pictorial* content that is *produced* and has no reference to the real or spiritual world. I have suggested that a good example of produced subject matter, in case of abstract pictures, would be seeing the three-dimensionality in the pictures.

Finally, I would like to point out that the three accounts of the subject matters of abstract pictures all share one positive aspect. Namely, all these theories emphasize that abstract pictures reveal something essential about pictures and images in general. For instance, Lambert Wiesing takes the abstract image to be a form of meta-imagery because it tries "to make visible the conditions under which an image can represent something".[54] Michel Henry claims that *all painting is abstract* in the sense that "the eternal essence of life is the principle behind all art and painting",[55] and it is our own

fault if we are unable to see it. Also, to some extent, all pictures *produce* their subject matter because seeing something in a picture is never like seeing the object itself. The strictly pictorial content will always depend on the forms and colors (the infrastructure) of the picture and is therefore always, to some extent, unique. As Claudio Rozzoni admits: "the image object is always 'condemned' to *produce* a subject".[56]

Notes

1 Clement Greenberg, "Avant-Garde and Kitsch", in Charles Harrison and Paul Wood (eds.), *Art in Theory 1900–1990: An Anthology of Changing Ideas* (529–41), Oxford and Cambridge: Blackwell, 1993, p. 531.
2 Kazimir Malevich, "From Cubism and Futurism to Suprematism: The New Realism in Painting", in *Art in Theory*, ibid., p. 173.
3 Catharine Abell and Katerina Bantinaki, "Introduction", in Abell and Bantinaki (eds.), *Philosophical Perspectives on Depiction* (1–24), Oxford: Oxford University Press, 2010, p. 1.
4 Richard Wollheim, "On Formalism and Pictorial Organization", *The Journal of Aesthetics and Art Criticism*, 59/2, 2001, p. 131.
5 John H. Brown, "Abstract Art", in Edward Craig (ed.), *Routledge Encyclopedia of Philosophy* (448–52), London and New York: Routledge, 1998, p. 449.
6 Ibid.
7 Pablo Picasso, "Conversation with Picasso", in *Art in Theory 1900–1990: An Anthology of Changing Ideas* (498–502), Oxford and Cambridge: Blackwell, 1993, pp. 499–500.
8 Michel Henry, *Seeing the Invisible: On Kandinsky*, translated by Scott Davidson, New York: Continuum, 2009, p. 13.
9 Lambert Wiesing, *The Visibility of the Image: History and Perspectives of Formal Aesthetics*, translated by Nancy Ann Roth, London and New York: Bloomsbury Academic, 2016, p. 174.
10 Ibid., 175.
11 Ibid., 176.
12 Ibid., 179.
13 Ibid., 176.
14 Elisa Caldarola, *Pictorial Representation and Abstract Pictures*, Padova: Università degli Studi di Padova, 2011, p. 149.
15 Lambert Wiesing, *Artificial Presence: Philosophical Studies in Image Theory*, translated by Nils F. Schott, Stanford: Stanford University Press, 2010, p. 72.
16 Ibid.
17 E.H. Gombrich, "The Vogue of Abstract Art", in id. *Meditations on a Hobby Horse and Other Essays on the Theory of Art* (143–50), London: Phaidon Press, 1963, p. 148.
18 Caldarola, op. cit., pp. 165–74.
19 Wiesing, *The Visibility of the Image*, p. 176.
20 Moshe Barasch, *The Subject Matter of Abstract Painting*, the chapter, "Modern Theories of Art 2: From Impressionism to Kandinsky" (309–19), New York: NYU Press, 1998, p. 314.
21 Charles Harrison, "Abstract Expressionism", in Nikos Stangos (ed.), *Concepts of Modern Art: From Fauvism to Postmodernism* (169–211), London: Thames & Hudson, 1994, p. 170.
22 Ibid., p. 170.
23 Ibid., p. 174.
24 Wassily Kandinsky, "On the Spiritual in Art", in Kenneth C. Lindsay and Peter Vergo (eds.), *Kandinsky: Complete Writings on Art* (114–219), New York: Da Capo Press, 1994, p. 117.
25 Ibid., 151.
26 Barasch, op. cit., p. 313.
27 Ibid., pp. 312–13.
28 Ibid., p. 313.

29 Wassily Kandinsky, "Abstract Painting", in Kenneth C. Lindsay and Peter Vergo (eds.), *Kandinsky: Complete Writings on Art* (784–789), New York: Da Capo Press, 1994, p. 785.
30 Wassily Kandinsky, "Point and Line to Plane", in Kenneth C. Lindsay and Peter Vergo (eds.), *Kandinsky: Complete Writings on Art* (524–699), New York: Da Capo Press, 1994, p. 532.
31 Michel Henry, *Seeing the Invisible: On Kandinsky*, p. 8.
32 Ibid., p. 21.
33 Jackson Pollock, "Interview with William Wright", in *Art in Theory 1900–1990: An Anthology of Changing Ideas* (574–78), Oxford and Cambridge: Blackwell, 1993, p. 576.
34 Wassily Kandinsky, "Abstract Art", in Kenneth C. Lindsay and Peter Vergo (eds.), *Kandinsky: Complete Writings on Art* (511–18), New York: Da Capo Press, 1994, p. 512.
35 Michel Henry, *Seeing the Invisible: On Kandinsky*, p. 117.
36 Ibid., p. 13.
37 Ibid., p. 12.
38 Ibid., p. 118.
39 Ibid.
40 Wiesing, *Artificial Presence*, pp. 71–79.
41 Ibid., p. 75.
42 ibid., p. 74.
43 Claudio Rozzoni, "From *Abbild* to *Bild*? Depiction and Resemblance in Husserl's Phenomenology", *Aisthesis*, no. 10/1, 2017, p. 121.
44 Ibid., p. 122.
45 Richard Wollheim, *Painting as an Art*, London: Thames and Hudson, 1998, p. 62.
46 Richard Wollheim, "On Formalism and Pictorial Organization", *The Journal of Aesthetics and Art Criticism*, no. 59/2, 2001, p. 131.
47 Ibid.
48 Ibid., p. 132.
49 Brown, "Abstract Art", p. 450.
50 Charles Harrison, "Abstract Expressionism", in Nikos Stangos (ed.), *Concepts of Modern Art: From Fauvism to Postmodernism* (169–211). London: Thames & Hudson, 1994, pp. 171–72.
51 Wiesing, *Artificial Presence*, p. 75.
52 Kendal L. Walton, "What Is Abstract about the Art of Music?", *The Journal of Aesthetics and Art Criticism*, no. 46/3, 1988, p. 356.
53 Michael Newall, *What Is a Picture?: Depiction, Realism, Abstraction*, Basingstoke: Palgrave Macmillan, 2011, p. 177.
54 Wiesing, *The Visibility of the Image*, p. 175.
55 Michel Henry, *Seeing the Invisible: On Kandinsky*, p. 126.
56 Rozzoni, "From *Abbild* to *Bild*?", p. 122.

Part II
Philosophy of Abstraction

6 What is Abstraction in Photography?[1]

Diarmuid Costello

6.1 The Problem

There seems to be confusion about what counts as abstract photography: a cursory survey of the kinds of images classed as abstract photographs turns up a bewildering variety of cases, and it is not clear that all could be considered abstract according to a single definition. In philosophy, the problem is compounded by the fact that there has been little work on abstraction by philosophers of depiction, and (almost) nothing on abstraction in photography. There is a literature on abstract photography among art theorists and critics, but it tends either to presuppose that, since we already know what abstraction is, it is not necessary to define it, resulting in indiscriminate applications of the term, or to verge on the overly programmatic or prescriptive, with normative commitments being passed off as descriptive accounts.[2] Given this lack of sustained attention to the term's intension, it is hardly surprising that the examples given often betray confusion as to its extension, at times appearing overly permissive and at other times overly restrictive.

To make a start on rectifying this, I try to answer two questions here: "What is Abstraction?" and "What is Abstraction in Photography?" In order to address the second, I also have to say something about a third: "What is Photography?" This is necessary if the account of abstract photography given is not to be undermined in advance by a poor general theory of photography—a live possibility when common assumptions about the nature of photography can still give rise (at least in philosophy) to the impression that there is something inherently problematic about the very idea of abstraction in photography, the documentary art par excellence. I argue that this stems from unreflectively internalizing a tendentious folk theory of photography—a theory that is benign so long as it is correctly perceived as local, but prejudicial as soon as it is mistaken for global.[3]

By way of an answer to my target question, "What is Abstraction in Photography?", I consider the most notable rival account, before outlining a schematic and non-exhaustive typology of various kinds of work generically typed as "abstract" in order to bring out some basic distinctions between them. To this end, I distinguish *proto*, *faux*, *constructed faux*, *weak*, *strong*, *constructed* and *concrete* abstraction, although the differences between them are not always clear-cut, and there is scope for debate about borderline cases. My goal is not to resolve all such cases here but to show: (i) that there is a range of broadly identifiable kinds of abstraction in photography; (ii) that images may be abstract in a variety of ways and for a variety of reasons that can very often be distinguished; and (iii) why some images, though widely regarded as

such, are not in fact abstract. The resulting typology is descriptive: it is meant to draw attention to some ways in which images generically typed as abstract may differ, not to imply any normative judgments as to their respective merits, or lack thereof, as art.

6.2 What is Abstraction?

In art theory, "abstract" tends to be used as a contrast category to "figurative" and means essentially non-depictive. A picture is abstract when one can no longer see any recognizably three-dimensional objects in it.[4] Pictures that are abstract in this sense may still trigger a perception of depth (as when one shape or color seems to float in front of, or recede behind, or be seen through, another) but cannot prompt us to see three-dimensional objects in their surfaces, on the pain of collapsing back into depiction. Precisely when a picture is abstract, in this sense, need not always be clear-cut: some figure-ground relations seem to hover indeterminately between the two.

Clement Greenberg was the leading theorist of this way of understanding abstraction in art theory. In Greenberg's terms, an abstract picture permits "optical" depth but not "trompe-l'oeil" or "modeling in the round". On his historical account, which I shall largely bracket here, abstraction in painting is the outcome of a process of gradual "silting up" of pictorial space, from the latter third of the 19th century onward. What Greenberg calls "optical" illusion survives this development; the depiction of objects in three-dimensional space does not.[5] But note that it is not the depiction of recognizable objects per se, so much as the depiction of the kind of space that such objects inhabit, that precludes abstraction for Greenberg. Recognition of everyday three-dimensional objects is sufficient to cue perception of such space and is as such incompatible with abstraction proper.[6]

Major philosophers of depiction, by contrast, have had surprisingly little to say about abstraction, despite its centrality to the art in the 20th century. Setting aside his psychoanalytically inspired interpretation of Willem de Kooning, Richard Wollheim includes a single page on the idea of abstraction in *Painting as an Art*. And Kendall Walton devotes just three pages to the extension of his account of imagined seeing to abstract pictures in *Mimesis as Make Believe*. Given the history of 20th-century art this is remarkable: yet, between them, Wollheim and Walton remain responsible for many of the current debates in the philosophy of depiction.

On Wollheim's mature theory, perception of pictures is "twofold": it involves simultaneous awareness of a picture's "configurational" and "recognitional" aspects.[7] When one appreciates a picture aesthetically, one is simultaneously aware of its design properties—the colors, shapes, forms and marks arrayed across its surface—and what may be seen in the surface so configured.[8] On Wollheim's theory, these are "two folds" of a single, dual-aspect experience, not a simultaneous awareness of two distinct phenomena.[9]

Given that nothing recognizable can be made out in the surface of an abstract picture, one might expect twofoldness to be ruled out in principle on this account, leaving one's experience of the configurational aspects of the marked surface as the sole focus of appreciative attention. But this would be too quick: both figurative and abstract paintings are twofold, and hence representational, for Wollheim. Not only do both have marked surfaces, but something can be seen in the marked surfaces of both. Where they differ is with respect to *what* can be seen in them. Wollheim distinguishes between them on the basis of the kind of concepts one would need to pick this out:

in the former case, we might speak of seeing a dancer, street scene or vase of flowers (identifications that make use of "figurative" concepts); in the latter, we might speak of seeing an irregular solid, or overlapping rectangles in space (identifications that make use of "abstract" concepts). Appealing to the very distinction at issue in this way renders Wollheim's own explanation more circular than informative, but it is not my goal to press this criticism here. Suffice to say that "abstract" and "figurative", however these might be non-circularly redefined, is a distinction *within* representational art and not a distinction *between* representational and nonrepresentational art. We remain aware of both the marked surface and what may be seen in that surface, in all but the limit cases of the uninflected monochrome and (notoriously) the trompe-l'oeil still life.[10]

Walton concurs with this: because an abstract painting continues to mandate "imagined seeing", it continues to count as a representational art. Simply in virtue of prescribing imaginings about figure-ground relations, almost all non-figurative paintings continue to function as "props" in games of make-believe. Take the perception of one colored shape as lying in front of, and thereby occluding, another solid shape in Malevich's *Suprematist Painting* (1915), despite the fact that its surface is flat and is made up of shapes notched into one another, rather than lying one in front of another in three-dimensional space.[11] Just as the distinction between figurative and abstract should not be mistaken for that between representational and nonrepresentational in Wollheim, so it should not be mistaken for that between supporting and not supporting imagined seeing in Walton. Rather, as it is a distinction between the *kinds* of entity that may be seen in the surfaces of different pictures for Wollheim, so it is a distinction between the *kinds* of entity we are mandated to imagine seeing when looking at different pictures for Walton. In the case of abstract pictures, we are prescribed to imagine various things about features of the paintings themselves, such as the spatial relations that obtain between the colored rectangles in the Malevich. In the case of figurative pictures, we are prescribed to imagine various things about what those pictures depict, hence about something other than the picture, even if these imaginings are occasioned by looking at the picture itself.

Wollheim and Walton discuss abstraction in passing; Michael Newall is the first philosopher of depiction in the analytic tradition to give it sustained attention. Newall characterizes the view that abstract pictures may facilitate an experience of seeing relations of depth, overlap and transparency that are not literally present (but not everyday objects) as "non-veridical seeing without recognition of volumetric form". Perception of volumetric form, so construed, would mark the difference, in Wollheim's terms, between "abstract" and "figurative" seeing-in.[12]

So far so consistent with the accounts already surveyed, what distinguishes Newall's approach is that it is grounded in the premises of vision science. Because human vision evolved for recognitional purposes—to detect objects, properties and kinds in our immediate environment—it is well equipped to detect features (such as edges, color, texture) that subtend such recognition.[13] Given this starting point, Newall's account of abstraction must meet two conditions: first, it should allow that abstract images can depict properties and kinds, but not objects, on pain of collapsing back into depiction; second, it should allow only properties and kinds of a certain sort—the kinds comprising two-dimensional shapes, lines and marks depicted in shallow space as parallel or near-parallel to the picture plane, and the properties that such kinds can take on when depicted in a two-dimensional surface, such as being seen non-veridically as

overlapping, transparent, interpenetrating and so on. So understood, abstract painting, despite frustrating the volumetric form recognition to which vision is attuned, continues to engage our recognitional abilities nonetheless: it occasions non-veridical seeing of a range of properties and kinds, but excludes recognition of volumetric form.[14]

Terminological differences aside, Greenberg, Wollheim, Newall and Walton are committed to essentially the same conception of abstraction in painting. Abstract painting is twofold in a distinctive sense; it permits limited perception of depth and spatial relations between forms, planes and lines—in Walton's terms, it serves as a prop in a game of make-believe that spectators are mandated to play with the picture—but rules out the perception of three-dimensional objects on pain of collapsing back into figuration. On the shared account of pictorial abstraction that emerges, a picture is abstract if and only if it is "two-fold" (Wollheim) in a distinctive sense: (a) it permits "non-veridical" (Newall) perception of depth and spatial relations between lines, forms and plains in a shallow space (or what Greenberg would call "optical illusion" and Walton "imagined seeing"); but (b) rules out the perception of three-dimensional objects in space (or what Newall would call "volumetric form") on pain of collapsing back into depiction.

6.3 What is Photography?

So much for pictorial abstraction in general, what about abstraction in photography? The only philosopher to have engaged seriously with this question to date is Lambert Wiesing, but I shall hold off considering his account until I have tabled my preferred theory of photography. Before we can ask about abstraction in photography we must be explicit about our conception of the latter if we want to head off assumptions that can make the very idea of abstract photography seem problematic.

Until recently, philosophical consensus conceived photography as an automatic image-rendering process, in which a mechanical apparatus (the camera) generates images that depend causally and counterfactually on what they depict. What I call "Orthodoxy" presents a powerful and intuitively appealing, if rather simplistic, explanation of photography's oft-noted epistemic advantage over other, handmade ("manugraphic") forms of depiction: it is because photographic imaging mechanizes out the fallibility of human beings as recording agents that we accord its products the evidential weight that we do. But the theory has weaknesses as well as strengths, and the two are internally related: if bracketing the photographer's subjectivity explains photography's epistemic advantage, it also implies its aesthetic disadvantage. For it is not implausible to suppose that we look to art for just those traces of subjectivity, as revealed by what a given artist chooses to thematize or suppress, and how she goes about doing so, that automatic image-rendering is meant to bracket. It is the particular artist's vision of the world, and not the world simpliciter, that draws us to the work of individual artists. This holds for photography as much as it does for any other art. Yet this is precisely what automatic imaging is supposed to bypass.

This trade-off between epistemic and aesthetic capacity has motivated a new generation of philosophers to develop an alternative theory. What makes the new theory new is, above all, how it marks the difference between photographic and non-photographic forms of imaging. This no longer turns on a contrast between machine and handmade images: rather than being differentiated by the mechanical nature of its apparatus, the automaticity of its process or the natural counterfactual dependence of the resulting images on their sources, photographic imaging is henceforth identified by whether or not

it implicates a "photographic event" in its causal history—that is, an event of recording information from a passing state of a light image formed in real time on a light sensitive surface. This can, but need not be, the camera's film plane or sensor; it might equally be a piece of photographic paper or film exposed directly to a light source. What matters, as the term "photography" implies, is the role of light in generating the image.

This, one might think, is hardly news. In fact, the new theory is not so much new as a reminder of what we already know. It can be traced back to Patrick Maynard's characterization of photography as a "branching family of technologies, with different uses, whose common stem is simply the physical marking of surfaces through the agency of light and other radiations".[15] This description is notable chiefly for the many things it does not say: there is no mention of automatic recording, mechanical apparatus, machine-made images, belief-independence or natural counterfactual dependency—the backbone of all orthodox accounts. Rather than focusing on what is special about a photograph's relation to what it is of, Maynard's account directs our attention to what is distinctive about photography as a process for making images. This is significant because any account that *begins* by trying to isolate what is special about a photograph's relation to its source builds in, without argument, a commitment to reference that the theory then has to make sense of. On Maynard's account, by contrast, what is distinctive about photography is not some special relation between a photograph and what it is of, but the nature of the photographic process—specifically, the role of light in the production of the image. Because he does not assume from the outset that all photographs have referents, only some of the resulting images need be pictures, and only some of those pictures need be of anything. As a result, his account builds in no commitments to realism, resemblance or even reference—no requirement that a photograph should have an object (something that it depicts or causally refers back to) in order to count as such. The relevance of such an account to thinking about abstract photography will be obvious.

So much for the historical roots of a new theory: the emergence of a new theory proper can be traced to Dawn Wilson's use of this approach to target the assumption, common to folk theory and orthodoxy alike, that photographs come into existence at the moment of exposure.[16] This turns out to be false in both the analog and digital cases. In the analog case, exposing the film to light creates a latent image, but the film needs to be processed before that image becomes visible and, if the film is negative or color reversal, it also needs to be printed before it can be appreciated. In the digital case, exposing the camera's CCD (Charge Coupled Device) sensor to light causes the capacitors that make up its surface to transmit electrical charges, but the charged or uncharged state of those capacitors not only has to be recorded, the resulting code has to be passed through several stages of digital processing before it can generate a visible image. This process, though too quick to be humanly detected, nonetheless consists of stages that can be distinguished, both functionally and conceptually: output the same code through a different set of algorithms and it need not even generate an image file. Processed differently, it might be output as sound, and this shows there is a distinction to be drawn between the information stored and the algorithms required to output that information in visual form.

In neither the analog nor the digital case, then, are photographs produced simply by exposing a light-sensitive surface. More is required, but precisely what more varies between theorists. These differences need not detain us here; it is what they have in common that is important.[17] Whereas for orthodox theorists the recording of information from an image focused onto a light-sensitive surface is sufficient, for new theorists it is merely necessary. And this means that any further stages of image processing,

without which there could be no visual image to appreciate, must be part of photography proper. If there cannot be a visually appreciable image without such stages, they can hardly be dismissed as incidental. Such stages *can*, but *need not*, be automated, and in many cases, both historical and contemporary, they have not been automated. This includes everything from minor darkroom adjustments to compensate for poor contrast, exposure and the like to elaborate combination printing in analog photography and their digital equivalents. Such examples cannot be ruled out simply because they conflict with photography's presumed mind-independence or natural counterfactual dependence on its sources, for that would be to assume the truth of orthodox premises, when it is precisely the truth of such premises that is in question.[18]

What differentiates photography from painting, on the new theory, is not mind-independence, automatism, mechanism or natural counterfactual dependence, but the fact that some images are made using photographic technologies and others are not. So the real question is: what makes a technology photographic? What makes a process photographic is that it implicates a photographic event in its causal history. Because traditional darkroom techniques in analog photography, such as dodging and burning, double-exposure and the use of multiple enlargers all implicate such events, as do the manipulation of hue, contrast, saturation and gradient mapping in digital photography, all still count as photographic according to the new theory—*irrespective* of whether they preserve belief-independence. On Dominic McIver Lopes's formulation:

> an item is a photograph if and only if it is an image that is a product of a photographic process, where a photographic process includes (1) a photographic event as well as (2) processes for the production of images.[19]

Lopes's definition consists of two independent clauses and it is their independence that is crucial: because the first secures the distinction with non-photographic images, the second need no longer discharge this burden. This frees up the processes used to create photographic images to be anything photographers want them to be—so long as they continue to implicate an event of photographic recording. Photography need no longer be belief-independent, nor does it require a contrast class of belief-dependent, intentionally mediated images. From an orthodox perspective, this will seem far too permissive, and the obvious solution would be to build back in something like natural counterfactual dependency:

> "An item is a photograph if and only if it is an image that is a product of (1) a photo-graphic event and (2) processes for the production of images that (3) ensure belief-independent feature-tracking".

Less resolute, second-generation orthodox theorists, and perhaps also less permissive new theorists than Lopes himself, may want to qualify this:

> "An item is a photograph if and only if it is an image that is a product of (1) a photographic event and (2) processes for the production of images that (3*) *generally* ensure belief-independent feature-tracking".[20]

Lopes might even agree. But from his perspective, the question will be: What forces the concession? Whether (3) or (3*) obtains will depend on the social institutions that a given form of photography serves, not any general features of photography. Medical, scientific, diagnostic, forensic and legal practices are all "knowledge-oriented" and

this imposes *additional* constraints on the legitimate uses of photography within these domains: notably, that they do not misrepresent the relevant facts and thereby encourage false beliefs about the domain in question. But such restrictions are not constitutive features of photography per se. If they were, they could not be broken, yet they very often are. Orthodoxy conflates what is true of a highly visible, and socially very important, *subset* of photographic practices with what is true of photography per se. This is why it has difficulty accommodating photographic art in general, and abstract photography in particular. For new theory, by contrast, neither presents a problem: a photograph is a visual image, the causal history of which necessarily implicates an event of recording information from a light image. Whatever further restrictions need be invoked to explain a given stretch of photography will be institutional in nature, not features of photography in general.

6.4 What is Abstraction in Photography?

Pause to consider what we have seen so far. "Abstraction" is not the absence of depiction, but a restricted form of the same, in which one has the experience of seeing spatial relations—notably, relations of depth between planes, colors or lines—in a flat surface, but not volumetric forms or everyday objects. "Photography" is a wide array of practices, subtending diverse institutions, for creating, storing and displaying "photographs", where the latter are understood as images that necessarily implicate an event of recording information from a light image in their causal history, but require further imaging processes—which may, but need not, be photographic—to make that information available in a form that can be visually appreciated. Given a sufficiently determinate notion of abstraction, and a sufficiently broad conception of photography, such as these, there is no problem in principle with the idea of abstract photography.

Lambert Wiesing concurs in "What Could 'Abstract Photography' Be?" the most serious engagement with abstract photography by a philosopher to date. Wiesing distinguishes the empirical question of what abstract photography is and has been, from the conceptual question of what the idea of abstract photography permits, noting that since what is *actual* need not exhaust what is *possible*, and one cannot get to the latter simply by enumerating the former. This is why surveying the field of abstract photography, as is done in exhibition catalogs and the like, cannot yield a philosophically satisfying answer. For this reason, Wiesing focuses solely on what he takes to be the properly philosophical, conceptual question. But it bears noting that both approaches to the question—the empirical and the philosophical—presuppose some conception of both abstraction and photography: the former to identify which entities fall within the domain; the latter to say what the concept at issue permits in principle.

In terms of the alternatives presented here, it is not clear where Wiesing stands: some of what he says suggests new theory, some orthodoxy and some is ambiguous between the two. On what he calls a "wide" definition of photography, for example, "photographically produced products are always traces that can be explained physically and chemically. Photographs are what they are on the basis of relations of cause and effect: they are the permanently visible result of manipulated radiation".[21] This is wide by comparison to a narrower definition of photography as the "technical production of figurative images [that resemble their sources] by means of optical transformation and conservation of traces of light".[22] While the narrow definition clearly implicates orthodoxy, a resolute new theorist will likely find Wiesing's wide definition

still too narrow. For photography cannot be *exhaustively* explained in non-agential physical and chemical terms alone: this is what orthodoxy maintains, and it does not yet build in enough to account for an image that can be visually appreciated. Reference to "manipulated radiation" might build in what is required but it depends on what "manipulation" permits, and Wiesing declines to say.

Wiesing has much less to say about the idea of abstraction itself, beyond distinguishing a wide philosophical notion of abstraction, understood as the absence of implication for other concepts, from a narrow art theoretical notion, construed as a lack of figuration: "a picture is abstract, in this [latter] sense, when no visible object can be discerned in it".[23] This is consistent, so far as it goes, with what I have said here, but unpacking what it might mean for a photograph, given its means of generation, to preclude perception of "visible objects" turns out to be harder than one might think. The taxonomy that follows shows that difficulties arise for the more obvious answers. Wiesing himself defers to the champion and practitioner of "Concrete Photography", Gottfried Jäger, on such questions, by presenting photographic abstraction, in broadly modernist terms, as a reduction to essence.[24] Thus, in terms of process, "abstraction" can mean abstracting from camera and lens in favor of directly "preserv[ing] as visible traces the action of light on substances sensitive to light".[25] Further abstraction may involve reducing out the negative in photograms, the object that occludes the flow of light in luminograms, right through to the borderline case of seeming (but only seeming) to dispense with light itself—in favor of directly manipulating chemicals on a sensitive surface. In fact, as Wiesing points out, fixing light remains central to chemigrams and, if it did not, they would not count as photographs. This is a point on which Wiesing, Jäger and new theorists from Maynard onwards can agree.

But his broader theory remains too dependent on Jäger's practice and self-understanding to capture much that is in the domain. To show this, I now turn to the breadth of photographic abstraction, which comes in a wide variety of shades and strengths. Even philosophers would do well to pay attention to empirical matters—if they want their definitions to be adequate to the domains under discussion. Faced with such diversity, Wiesing could deny that much of it is abstraction, thereby vitiating one constraint on empirically informed and critically sensitive philosophizing, or broaden his own account's scope, albeit at the expense of its dependence on Jäger's.

6.4.1 Proto Abstraction

What I call *proto abstraction* can, as the name implies, be considered a way-stage on the road to abstraction proper. It typically depicts recognizable objects, but framed or lit in such a way as to draw attention, when photographed, to the resulting image's design properties. This is achieved by a combination of bold and simplified gestalts, unusual points of view, strong lighting, close ups and other crops that direct attention to visual patterning in the image. Given, however, that this still involves recognition of everyday objects, it clearly cannot count as abstract on the forgoing account. It is formalist, rather than abstract proper.

Proto abstraction was common among photographers attracted to abstraction in the other arts, but unable or unwilling to forgo the depiction of recognizable objects altogether for the sake of full-blown photographic abstraction. Examples include Paul Strand's *Abstraction, Twin Lakes Connecticut* (1916) and some of his early cityscapes, and Edward Weston's 1936 series of *Sand Dunes Oceano*, all of which depend on an

interplay of framing and strong, natural light. Other examples depend on dramatically "tipped up" or vertiginous points of view (Strand's *View from the Viaduct, New York* (1916), László Moholy-Nagy's *Berlin Radio Tower* (1928) or André Kertész's images of Washington Square in the snow (1954)).

The fact that photography proved slower than many other arts to embrace abstraction in its full-blown form may not be surprising, given how widespread the idea that photography is at bottom an art of documenting how the world was and still is. Strand himself celebrated photography's supposed "absolute, unqualified objectivity", despite the fact that both his own work and the terms in which he celebrated that of others show how misleading a characterization this is for the kind of distinctive personal vision he had in mind.[26] Meanwhile, leading theorists of modernism, both within and without photography, took an orthodox conception of photography more or less for granted—despite modernism's inbuilt telos toward abstraction.[27]

6.4.2 *Faux Abstraction*

Faux abstraction is a close cousin of proto abstraction and the two can be hard to distinguish in some cases. It consists chiefly of various strategies of estrangement and defamiliarization that isolate objects from their everyday environments or frame them in such a way as to delay or frustrate recognition of what one is looking at. What is especially interesting about faux abstraction in this context is that it depends, for its dramatic effect, on leveraging the orthodox assumptions of viewers. Photographs in this vein occasion such delight largely *because* it is widely assumed that photographs necessarily show us how some corner of the world looked at some moment of time. Set aside whether such assumptions are true; were they not in play, these works could not carry the charge that they do.

Jaromir Funke's *Abstract Fotos* (1927–1929) of complicated shadow patterns is one obvious example; Minor White's land and seascapes employing points of view (such as *Bullet Holes (Middle Canyon, Capitol Reef, Utah)* (1961) and *Stony Brook State Park, New York* (1960)) that make it hard to be sure what one is looking at— though it is clear that one is looking at something—are others. It is hard to overstate how widespread faux abstract and related tendencies are in photography. The act of cutting away the rest of the world with the image edge, fundamental to much (if not all) of photography, often works to estrange and abstract simultaneously.

This overlap between proto and faux abstraction explains why it is not always clear how to characterize certain images. Take Moholy-Nagy's *Radio Tower Berlin*: Is this proto abstract in virtue of formal design or faux abstract in virtue of a strange point of view—or both? If the latter, it falls in the space where two overlap. Note, however, that such an overlap is not complete. One can estrange by photographing something at an angle or speed or from a distance that frustrates recognition of what one is looking at, without this entailing that the result appears abstract. Conversely, one can abstract, by foregrounding a composition's formal design properties, without thereby estranging. So the two remain in principle distinct, even if some images do both.

6.4.3 *Constructed Faux Abstraction*

Constructed faux abstraction is, as the name suggests, a variant of faux abstraction. Unlike faux abstraction, which works by alienating or estranging a scene that would

otherwise be easily recognizable, constructed faux abstraction comprises works in which the photographer constructs a scene that can be photographed so as to give rise to an image that seems (but only seems) to be abstract. There are numerous examples in recent photographic art. Barbara Kasten's *Studio Constructs* (2007–2011) depicting arrangements of glass panes, lit and framed in such a way as to make their complex play of reflections and shadows difficult to resolve, is one obvious example. Richard Caldicott's seemingly abstract images made by photographing colored light filtered through semi-transparent Tupperware boxes (such as *Untitled #179* (2000)) is another.

James Welling's work from the late 1970s and early 1980s provides a rich seam of examples: here some simple, everyday material such as aluminum foil, filo pastry, gelatin or tiles is photographed in such a way as to make it hard to figure out what one is seeing. Though colloquially known as *Foils*, *Filo*, *Gelatin*, *Tiles* (etc.), the works are officially *Untitled*, so as not to give the game away. Like faux abstraction, the fact that one is seeing something is typically clear, as is the fact that it exhibits volumetric form, even if precisely what one is seeing remains much less so. Welling's images of sheets or fragments of filo pastry, for example, could be mistaken for paper, crisp linen sheets or shards of ice; the *Foils* might be harshly lit lunar surfaces, ravines or dense foliage, and so on. Like faux abstraction, such images work to delay or frustrate recognition of what one is seeing, but do so by virtue of the photographer constructing the scene before the camera for that very purpose. But because they still involve the experience of perceiving objects and scenes, even if we cannot always say what, they cannot be counted as abstract *stricto sensu*.

6.4.4 Weak Abstraction

Weak abstraction, by contrast, records the world in such a way as to no longer give rise to a clear experience of seeing figurative content or volumetric form. Weakly abstract photographs home in on some corner of the world, an alignment of edges or surfaces that can, when isolated by the viewfinder of a camera, be photographed in such a way as to generate an abstract or quasi-abstract composition. We may not be sure that we are seeing some corner of the world, or be able to make out what it is if we do, though we always are. The art consists in the photographer's ability to find, isolate and record the alignment in question. Like faux abstraction, weak abstraction is pervasive; once again, photography's ability to isolate and excerpt a fragment from a wider field of view seems to invite it. Like proto abstraction, purists will see weak abstraction as a stop on the road to abstraction proper, albeit one considerably closer to the terminus.

Examples include Aaron Siskind's well known images of walls of peeling paint, ripped fly posters and crumbling plaster surfaces (such as *Chicago 30* (1949), *New York 2* (1947) or *Bahia 148* (date unknown)). These are routinely included in surveys of abstract photography despite the fact that it is generally clear what such images depict. Bert Danckaert's *Horizon* series (2014–2016) offers a more recent example in a similar vein: quiet, beautifully composed photographs focusing on junctures where two or more wall surfaces or finishes in the same plane abut one another or overlap, or where a wall meets a pavement, road or grass verge at ninety degrees, but framed so that this is not immediately apparent (*Horizon #019 (Guangzhou)* (2014), *Horizon #017 (Lodz)* (2014)).

Absent the act of framing that brings their disparate entities into dialogue, what such images show would remain mere details in an undefined, unbounded field. In the

resulting images one sees planes in shallow space rather than volumetric forms, even if those planes are the faces of real objects. That one recognizes worldly objects such as walls and other planar surfaces photographed parallel to the picture plane, rather than just planes of colors, shapes or lines is what makes such images only weakly abstract. It also shows that recognizing three-dimensional objects *need not* involve the perception of volumetric form.[28]

6.4.5 Strong Abstraction

Like weak abstraction, *strong abstraction* involves straight recording of the world. Unlike weak abstraction, it records the world in such a way as to no longer give rise to an experience, even an ambiguous or liminal one, of seeing everyday objects. The difference between weak and strong abstraction can be as minimal as how an image is cropped. It is possible to take a weakly abstract work and render it strongly abstract simply by cropping away those parts of the image, such as wall edges, that enable us to recognize objects in its surface.

This will naturally give rise to the worry that weak and strong abstraction cannot be kept apart on principled grounds. A more pressing worry, however, may be that weak abstraction collapses back into proto abstraction. For it would seem that in so far as one can make out either volumetric form or everyday objects in an image, it will count, indeterminately, as proto and/or weakly abstract and, in so far as one cannot, it will count as strongly abstract. But this would be too quick: the difference between proto and weak abstraction lies between recognizing everyday objects exhibiting volumetric form and being able to make out everyday objects, such as wall surfaces or edges, even in the absence of such form.

With strong abstraction, it may seem that we have finally reached the terminus. But note that whether or not strongly abstract works count as "abstraction proper" will depend in part on prior methodological commitments. If one's theory pivots on what a suitable viewer perceives in an image—in this case a non-volumetric formal array— such works will count as abstraction proper. But, if one's theory pivots not on what such a viewer should experience but on whether or not an image does in fact record the world, even strongly abstract photographs will count as fully representational— irrespective of whether the viewer recognizes this.

Orthodox and new theorists are likely to differ with respect to such cases. Orthodox theorists will be obliged to take the latter route on pain of refusing, in the face of all evidence to the contrary, that strongly abstract works count as photographs *stricto sensu*. New theorists, by contrast, need not. Taking the latter route is the only option open to orthodox theorists because such images do in fact record the world, even if they do so in such a way that we are unable to say what they depict. Because new theorists are not wedded to a background theory of photography as a recording medium, they will feel no pressure to withhold the epithet "abstraction" from such cases—irrespective of whether or not they straightforwardly record the world.

6.4.6 Constructed Abstraction

By contrast to both weak and strong abstraction, *constructed abstraction* involves the construction of an image from scratch: no straight recording of the world, if that is understood to be of a prior, camera-independent reality, is involved. And, by contrast

to the constructed variant of faux abstraction, no construction of a scene is involved either; instead it is the image itself that is now constructed from the ground up. Such images nonetheless count as photographs for new theorists because they implicate a photographic event in their causal history. Orthodox theorists, by contrast, will have to refuse to so count them, given that they are neither belief-independent nor causally and counterfactually dependent on some prior object or scene. Lopes calls such work "Lyrical Photography", noting that it cannot be photography if orthodoxy is true. One might equally call it "Material photography", insofar as it turns its attention inwards, onto the material processes and procedures of photography itself.

Examples include works by Wolfgang Tillmans, Walead Beshty and James Welling, among others. Tillmans's *Freischwimmer* series comprises sumptuous abstractions punctuated by clusters of black gestural swirls often on a scale to rival mid-century gestural abstract painting. Generated from scratch in the darkroom, and despite suggesting chemical flows, these images are made through an entirely dry process that involves manipulating the projection of light onto sheets of light-sensitive photographic paper with various baffles and light-emitting tools, and then enlarging the results. Beshty's "multiple-sided" images are made by exposing different facets of three-dimensional constructions made out of light-sensitive photographic paper to different colored lights in total darkness. The constructions are then unfolded, and the paper is developed in the normal way. This results in images that call to mind crumpled paper, but in which the paper itself seems to be rendered directly from colored light.[29] Though they retain some passages of volumetric form, taken as a whole, the works seem clearly abstract. Finally, James Welling's *Fluid Dynamics* series (which, like Tillmans, is reminiscent of gestural abstraction but, unlike Tillmans, is made using an entirely wet process) serves to make visible a prior, semi-liquid state of the very surface one is looking at when one looks at the image. Made by prolonged soaking of chromogenic paper in water so as to mobilize the dyes in the paper surface, the paper is removed from the water and exposed to light. This fixes an image of the dyes' disposition across the paper's surface. One sees these flows when one looks at the resulting image.

6.4.7 Concrete Abstraction

What I call constructed abstraction may initially seem close to what the Gottfried Jäger calls "Concrete Photography". On Jäger's account, this foregrounds artifacts of photographic processes or events, but has no denotative content. It takes the medium, processes, materials and mechanisms of photography as both the means and end. So understood, concrete photography is the late flowering of modernism in photography.[30]

But not only does concrete photography, so understood, not exhaust the domain of abstract photography, it cannot be straightforwardly identified with abstraction more generally. Abstraction in art is typically *eliminative* or *reductive*: it removes features deemed inessential to something's continued existence as an entity of a given kind. Piet Mondrian's transformation from landscape painter to abstract painter through a process of reduction, simplification and gradual elimination of the motif is a classic example. Mondrian dispensed with the depiction of everyday objects and volumetric form, but did not in so doing dispense with painting, thereby demonstrating that neither could be essential to painting. Concrete art and constructive abstraction, by contrast, are typically *additive*: they generate an image from scratch rather than arriving at it by a process of elimination.

This is one reason constructed abstraction cannot be identified with strong abstraction: where the former constructs an image from scratch, the latter generates its images by framing pre-existing scenes in such a way as to remove any depictive cues. But a more substantive reason is that it is in principle possible to construct an image from scratch in such a way as to give rise to an experience of non-veridically seeing volumetric form. Some of the Beshtys and Tillmans do just this. Anything that gives rise to an experience of non-veridically perceiving volumetric form in this way fails the test of strong abstraction, despite being entirely constructed. This shows that constructed and strong abstraction are distinct; though what is constructed is often also strong, it need not be.

These points of convergence between constructed abstraction and concrete photography should not, however, be allowed to obscure their differences. On the typology I have developed, constructed abstraction has a much less programmatic significance than concrete photography does in Jäger's account. As a corollary, it generates no pressure to endorse Jäger's claims for the kinds of photography he both practices and champions. Neither concrete photography nor constructed abstraction should be seen as the only pure form of photography—in some honorific sense of "pure". And simply taking photography's means and processes as one's focus is not enough to rule out subject matter or association. One of the goals of my typology is to show that what is often generically typed as "abstract photography" is a complex, multifaceted phenomenon that comes in many forms. Holding up any one such form as its telos is indefensibly reductive. And even if, contrary to fact, all works of constructed abstraction or concrete photography did renounce subject matter, this would still not suffice to show that they have no external content or referent. At the very least, such works index actions—indeed, often complex iterated processes—suggesting they may take a certain kind of performance as their subject matter. All the works by Beshty, Tillmans and Welling discussed thematize the labor of their own making and thereby comment on the (generally underplayed) labor of photography itself.

So far as abstraction in photography goes, new theory implies not only that it is possible, but that it comes in various strands or strengths that warrant the term on various grounds, sometimes to do with differences in how images appear and at other times to do with how they are made. No one such strand can be non-normatively privileged, and critical or participant preferences make a poor foundation for theory-building. But all such photography explores the space of photographic possibility, a space that turns out to be much more capacious than orthodoxy ever imagined.[31]

Notes

1 First published in *British Journal of Aesthetics*, Vol. 58, nr. 4, October 2018, pp. 385–400. Published by Oxford University Press on behalf of the British Society of Aesthetics.

2 See Lyle Rexer, *The Edge of Vision: The Rise of Abstraction in Photography*, New York: Aperture, 2013, and Gottfried Jäger, "Concrete Photography", in Gottfried Jäger, Rolf H. Krauss and Beate Reese (eds.), *Concrete Photography/Konkrete Fotografie*, Bielefeld: Kerber, 2005, respectively.

3 Cf. Diarmuid Costello, "Foundational Intuitions and Folk Theory", *On Photography: A Philosophical Inquiry*, London: Routledge, 2018.

4 For the purposes of this chapter, I assume an experiential, viewer-focused approach to abstraction—any picture is abstract in that it is correctly experienced as such by a viewer—rather than, say, an intentionalist, artist-centered theory of abstraction—any picture is abstract that the artist intends as such.

5 Clement Greenberg, "Modernist Painting", in John O'Brian (ed.), *The Collected Essays and Criticism*, Vol. 4, Chicago: The University of Chicago Press, 1993, p. 90.

6 Ibid., p. 87.

7 Richard Wollheim, *Painting as an Art*, London: Thames & Hudson, 1987, pp. 21, 73.

8 Ibid., p. 75. See also Wollheim, "Seeing as, Seeing-in and Pictorial Representation", in id. *Art and Its Objects*, 2nd edition, Cambridge: Cambridge University Press, 1980, pp. 212–214.

9 Wollheim, *Painting as an Art*, pp. 46–47.

10 Wollheim, ibid., p. 62.

11 Kendall Walton, *Mimesis as Make Believe; On the Foundations of the Representational Arts*, Cambridge: Harvard University Press, 1990, pp. 55–57.

12 Michael Newall, "Abstraction", in id. *What Is a Picture? Depiction, Realism and Abstraction*, Basingstoke: Palgrave Macmillan, 2011, p. 173.

13 Ibid, p. 177ff.

14 Ibid, p. 178.

15 Patrick Maynard, *The Engine of Visualization: Thinking through Photography*, Ithaca: Cornell University Press, 1997, p. 3.

16 Dawn M. Wilson (née Phillips), "Responding to Scruton's Scepticism", *British Journal of Aesthetics*, Vol. 49, nr. 4, 2009, pp. 335–340.

17 On these differences see Costello, "What's So New about the 'New' Theory of Photography?", *Journal of Aesthetics and Art Criticism*, Vol. 75, nr. 4, Fall 2017, pp. 439–452 and *On Photography: A Philosophical Inquiry*, chapter 2.

18 Cf. Paloma Atencia-Linares, "Fiction, Nonfiction and Deceptive Pictorial Representation", *Journal of Aesthetics and Art Criticism*, Vol. 70, nr. 1, Winter 2012, pp. 22–24.

19 Dominic McIver Lopes, "Jetz sind wir alle Künstler", in Julian Nida-Rümelin and Jakob Steinbrenner (eds.), *Fotographie: zwischen Inszenierung und Dokumentation*, Ostfinden: Hatje Cantz Verlag, 2012, p. 106ff.

20 By "less resolute" orthodox theorists I have in mind Catherine Abell and Robert Hopkins. By "less permissive" new theorists, Paloma Atencia-Linares and (perhaps) Dawn Wilson. Cf. Costello, *On Photography: A Philosophical Inquiry*, chapters 2–3.

21 Lambert Wiesing, "What Could 'Abstract Photography' Be?", in Wiesing (ed.), *Artificial Presence: Philosophical Studies in Image Theory*, trans. Nils F. Schott, Stanford: Stanford University Press, 2010, p. 62.

22 Ibid.

23 Ibid., p. 63.

24 Ibid., pp. 71–79.

25 Ibid., p. 64.

26 Paul Strand, "Photography", in Alan Trachtenberg (ed.), *Classic Essays on Photography*, New Haven, CT: Leete's Island Books, 1980, pp. 141–142. For a discussion, see Costello, *On Photography: A Philosophical Inquiry*, pp. 24–29.

27 Clement Greenberg, "The Camera's Glass Eye: Review of an Exhibition by Edward Weston", in John O'Brian (ed.), *The Collected Essays and Criticism*, Vol. 2., Chicago: The University of Chicago Press, 1986; Siegfried Kracauer "Photography", in id. *Theory of Film: The Redemption of Reality*, Oxford: Oxford University Press, 1960; and John Szarkowski, preface to *The Photographer's Eye*, New York: MOMA, 2007.

28 The same is true of photograms that allow viewers to recognize everyday objects in their surfaces by means of their silhouettes, while eliciting perception of neither volumetric form nor the three-dimensional space such objects might inhabit.

29 Work titles (e.g., *Six-Sided Picture (RGBCMY), January 11, 2007, Valencia, California, Fujicolor Crystal Archive* [2007]) document the process of construction, colors projected (here red, green, blue, cyan, magenta and yellow), paper used and place and date of creation.

30 Concrete Photography, as Jäger presents it, is the point at which Concrete Art, as defined in Theo van Doesburg's "Manifesto of Concrete Art" (1930), and Abstract Photography overlap. See "Concrete Photography", in Jäger (et al.) *Concrete Photography/Konkrete Fotografie*, also available here: www.gottfried-jaeger.de/articles%23categoryArticle s?id=97.

31 I would like to thank Jason Gaiger, Dominic Lopes, Bence Nanay and Michael Newall for comments on this chapter in draft, and the audiences of "The Problem of Form: Symposium on Minimalism and Abstraction in Photography", FotoMuseum, Antwerp, September 2016; "Art or Evidence: What Is Photography" workshop, University of Kent, November 2016, and the European Society of Aesthetics Annual Conference, Freie Universität, Berlin, May 2017.

7 Abstraction and Transperceptual Space

Paul Crowther

By abstract art, we mean works without recognizable figurative content, or with a figurative content that is mainly subsumed within some broader non-figurative structural configuration (emphasizing features such as shape, color, line, texture, volume and mass). As a practice, abstract art has been in existence for over a hundred years. Its diversity is such that, in itself, this might appear to rule out the possibility of any general theory of meaning for it.[1] However, this belief is unfounded. In previous studies, this author has formulated such a theory in detail, and this chapter takes this further.[2] It shows how the phenomenon of optical illusion on a plane surface enables the construction of a general theory of meaning for abstraction. Section 7.1 presents the ground-theory in detail, focusing on the relation between allusive meaning and the concept of transperceptual space. In Section 7.2, levels of transperceptual space with particular relevance to abstract art are described, and examples are provided. In Section 7.3, the theory is defended against a number of objections.

7.1 Between *allusive meaning* and *transperceptual space*

Abstract art has not developed *ex nihilo*. From the beginning, formats and presentational contexts shared with figuration have actively determined our orientation toward abstraction. This takes the form of a cultural convention, which we shall call the *presumption of virtuality*. The presumption holds that abstract works are "about" something over and above the mere fact of their physical presence. Of course, tendencies such as Minimal Art were often created with the intention of affirming no more than the physical presence of the work, but this affirmation can be of virtual significance in itself. In such cases, the works are *about* physicality, and how objects occupy space in relation to the spectator (as well as evoking the spectator's own mobility in relation to the object). The object/space relation is, in effect, thematized, even if it is not explicitly represented.

This leads to the key point, no matter how bare or minimal an abstract work may be, (and no matter what its creator's intentions are) once the work is presented as art in an appropriate display context, then none of its visible properties are virtually inert or neutral. This is because both figurative and abstract works share a common ground in *optical illusion*.[3] The very placing of a mark on a plane surface creates optical relations, whereby the mark appears to push from the surface or, by suggesting a puncture, pulls the gaze beneath it. In this way, the basics of pictorial space are created as the outcome of optical push/pull effects. An important cognitive factor is also involved. The retinal image is two-dimensional, but our cognitive processes resolve it into three-dimensional

structure. Given, accordingly, a plane surface, it is only to be expected that vision will seek to interpret any configurations upon it in three-dimensional terms, even if we are dealing with no more than lines and /or dots, and the like.

It follows, then, that the presumption of virtuality is both determined by social convention and by the basic trajectory of visual perception itself, from the two-dimensional to the three-dimensional. The need to see things in three-dimensional terms is a basic cognitive instinct. Now, it might seem that the existence of hyper-minimal works such as blank canvases or simple uniform monochrome surfaces offer a counter example to these points. Actually, they do not. In such cases, the physical boundaries of the work define an empty space, and, by defining it, make it into something very active, indeed, in optical terms. They lead us to see features such as emptiness, blankness, uniformity and related effects. These have strong psychological associations, especially when presented in direct visual terms, rather than as a factor bound up with some broader "real life" context. In some artworks, indeed, such as Yves Kline's blue monochromes, the intense color of the empty space creates a dialectical reversal—it becomes a space that is not empty but saturated with emotionally significant color, suggesting even the possibility of infinite depth.

Given that optical illusion in abstract works involves representation, the question arises as to what kind? The answer is—not pictorial representation but rather pictorial *allusion*. Allusion involves meaning where an object or circumstance in some external context is referred to indirectly. In such cases, the recipient of the reference has to make the connection on the basis of guesswork. But, of course, whilst allusion is a perfectly intelligible concept in communication generally, how can it get a purchase in relation to abstract art? To put it bluntly, what on earth can abstract works be taken as alluding to?

To answer this query, we must consider a key feature of visual perception itself. The basis of ordinary cognition is singular identification—we see an x, or a y, or f doing g, or x in relation to y, or whatever. Such recognition is highly selective. Our perception of individual visible material bodies and states of affairs emerges from a vast network of background visual relations and textural details. In recognizing anything, our basic orientation is synoptic and is based on the body's orientation and directed cognitive capacities. Normal perception omits such things as the multitudinous *parte-extra-parte* details of the things it perceives, or how their internal states might appear if we opened them up, or how the things might appear if swathed in mist, etc. If we did not shut out these more detailed features, or the looser associations, perception would be overwhelmed by the immediate stimuli.

However, that being said, there are times when we do consider such details, e.g., when looking at some specific aspect of a thing independently of its place in the whole of which it is a part. And we sometimes do, in the course of our dealing with visible things, have to open them up to see what they're like inside, or act on the assumption that they have such and such internal character, even though we cannot perceive it. The orientation involved in all this draws on the accumulating whole of embodied experience. As Merleau-Ponty puts it:

> the life of consciousness—cognitive life, the life of desire or perceptual life—is subtended by an "intentional arc" which projects round about us our past, our future, our human setting, our physical, ideological and moral situation, or rather which results in us being situated in all these respects.[4]

A key feature of this intentional arc is imagination, the mental capacity to represent—in quasi-sensory terms—what items and states of affairs (not immediately present to perception) might be like. The importance of this is brilliantly summarized by Nigel J.T. Thomas:

> Imagination [...] makes perception more than the mere physical stimulation of sense organs. It [...] produces mental imagery, visual and otherwise, which is what makes it possible for us to think outside the confines of our present perceptual reality, to consider memories of the past and possibilities for the future, and to weigh alternatives against one another. Thus, imagination makes possible all our thinking about what is, what has been, and, perhaps most important, what might be.[5]

Imagination is subject to the will, and most importantly, it works very powerfully by association. In many situations, features of the situation suggest things we have previously experienced, or provoke sensations—sometimes very vague—of related phenomena, many of which will be purely imaginary. These associations are not mere distractions to cognition. They are central to how we become orientated (perceptually and psychologically) to things. They help us make ourselves at home in the world—filling what is given with associations that help us make them familiar to us.

The key point, then, is that the perceptual only exists insofar as it selectively orientates us toward what we shall call the *transperceptual*. The transperceptual consists of the aforementioned background details relevant to immediate perception, and those memories, imaginings, and related associations which go beyond the immediately given, but contextualize it. These factors can emerge from the transperceptual to become objects of perception in their own right, just as things previously perceived can recede into it. However, the key point is that, since the transperceptual background *is* a background, it must transcend immediate awareness. Without such transcendence, perception in the human sense would not be possible. For, as we have already seen, in order to negotiate the contents of space, the embodied subject must be highly selective in the features it attends to. We know the transperceptual dimension is present and sense something of its importance, but our knowledge of it is mainly intuitive—an aspect of our perceptual orientation.

Now, Merleau-Ponty has, in effect, linked the transperceptual to the concept of painting as such, through his notion of the "invisible". We are told of the painter, for example, that

> Light, lighting, shadows, reflections, colour, all the objects of his quest are not altogether real objects; like ghosts, they have only virtual existence. In fact, they exist only at the threshold of profane vision; they are not seen by everyone. The painter's gaze asks them what they do to suddenly cause something to be and to be this thing, what they do to compose this worldly talisman and to make us see the visible.[6]

For Merleau-Ponty, then, painting discloses that texture and network of visual relations that are constitutive of how a particular item or state of affairs appears to us, but which are usually "invisible". These are details of a momentary appearance of the painting's subject matter, and the artistic style through which it is rendered. Whilst

Merleau-Ponty does not explain the specific significance of abstract works in any detail, it is reasonable to assume that, for him, such works capture the details of their own being as a unified configuration of marks upon a canvas, rendered in such and such a style.

Now the term "invisible" is somewhat limited in this context.[7] This is because the relevant features extend far beyond normally unnoticed details of appearance, and this is especially the case with abstract works. The notion of the *transperceptual* is far more appropriate. This is because it describes all the aforementioned features that subtend perception and is particularly apt in evoking those involved in abstract art. For, as we have seen, as well as having unnoticed aspects, perceived phenomena create waves of imaginative association that take us beyond the given. These are based on what the phenomena suggest imaginatively and on their relation to our own experience of the relevant individual or the kind of thing. To use our key term, perceived phenomena *allude*. And when suitable circumstances are present, this allusive potential will begin to be realized.

The circumstances in question here arise especially when we see something that is intended to mean something, but we cannot immediately identify what. Mainly this arises in relation to practical problems in life, but, in the case of abstract works, it arises in its purest form. The presentational context and optical illusion seem intelligible but without definite reference. This stimulates us to find allusions in the transperceptual realm that might make this intelligibility more specific. This need not be done explicitly; it is simply a kind of default process, when, faced with forms that are not familiar objects or states of affairs, we are led to the transperceptual, so as to interpret them.

Given all these considerations, it is reasonable to conclude, provisionally, that abstract art is artistically meaningful by alluding to transperceptual possibilities. Abstraction's optical illusion suggests virtual space, but the character of its configuration stimulates us to make its meaning more specific. However, the transperceptual realm is vast. It is impossible to map it out exhaustively, insofar as with each embodied subject, it changes from moment to moment in correlation with his or her movements through the perceptual field and the widening "intentional arc" that informs and responds to these movements. It is accordingly only feasible to give a general indication of some of the major relevant levels of transperceptuality (and even these, can, doubtless, be subdivided further). It is to this task we now turn.

7.2 The levels of transperceptual space

The following seem especially relevant as sources of allusive meaning in abstract art. We will explain them and offer an illustrative example for each.

i) *Spatial items, relations or states of affairs not accessible to perception under normal circumstances or that are presented incompletely, or (ironically) taken for granted so as to not to be noticed, usually.* This encompasses such things as hidden (but potentially visible) aspects of things, forms on the margins of the immediate visual field, small or microscopic structures or life-forms, internal states of a body or state of affairs (as might be seen in a cross-section, or through electronic scanning devices) and unusual perceptual perspectives (such as aerial ones). This level might also include aspects or details of particular visual appearances viewed

independently of the whole of which they are a part. Gestures and facial expressions, for example, are normally recognized as features of the embodied beings who carry them out, but aspects of such gestures and expression can also stick in memory or be imagined simply through salient details.

Consider, for example, Kandinsky's *Composition VII* of 1913 (Tretyakov Gallery). The palette of yellows, reds and (to some extent) blues creates a carefree composition using a host of different forms. There are many irregular ovoids, segments and squares, all rendered with little sense of shadowing. There may be suggestions of waves, or of netting and other linear structures. But the key point is that even though the work seems to be striving to represent objects, it does not. All that we have are shapes that suggest parts that have disconnected from their wholes or vague details glimpsed at the periphery of perception; Kandinsky is able to present these as a visual rhythm—of substances on the brink of taking on form.

ii) *Possible visual items, relations, states of affairs or life-forms as might appear under different perceptual conditions from the normal ones in which they are encountered.* This might take the form of unusual atmospheric conditions, things seen in sub-aquatic or subterranean environments, things reshaped through catastrophic physical events, dream-content or even imagined environments populated by extra-terrestrial objects or states of affairs. Such possibilities can also encompass life-forms, objects or artifacts that are simply alien in the sense of being totally unfamiliar.

Much "biomorphic" and "action-painting" type abstraction operates at this level, especially Jackson Pollock's work after 1945. A different example is Amy Ellingson's *Variation (red-orange, black, pink)*, of 2018.[8] The painting is in oil and encaustic. Its effect arises mainly from the stream of orange/red forms that cover a differentiated background (visible only intermittently). Whilst these elongated streaks of encaustic form a covering stream, they do not actually flow. Rather the encaustic's visual palpability creates an arrested structure—one that seems to have been in motion, but has now stopped. It may be protecting what is behind, it may be trying to absorb it, or it may simply have coated it. The allusions here could relate to subterranean or sub-aquatic chemical processes or to some dense atmosphere populated by unknown entities in an extra-terrestrial world.

iii) *Visual forms that seem to be loose variations on kinds of things and/or their relations and spatial contexts.* Examples are apparent distortions or fragmentations of the thing or state of affairs, configurations that suggest something specific without offering enough familiar aspects to clinch our recognition of it as such and such a thing. This tendency begins—albeit with contrasting emphases—in aspects of hermetic and Synthetic Cubism and in Kandinsky's work after 1910. A classic example is Mondrian's series of tree paintings done between 1911 and 1913, where the artist gradually abstracts away from recognizable branching trees to present works where the tree schema is scarcely discernible any more. Indeed, in *The Tree A* c. 1913 (Tate Gallery), the trunk and branches have been abstracted down to an inverted triangular structure where the branches are evoked through loosely patterned trellises of vertically extended plate-like forms. At this point, the work only alludes to the tree. It no longer depicts it.[9]

iv) *Idealized variations on basic features of perceptual space.* These include traditional primary qualities of mass, volume, density, shape and positional relations such as "in front of" or "behind". They also include variations upon the hue,

density and differentiation of color areas. In abstract works, the aforementioned features are presented (individually, or in combination) as foci of attention for their own sake, rather than as factors encountered simply as aspects of our everyday practical dealings with the world. Again, this tendency begins with hermetic and Synthetic Cubism, Mondrian, Malevich and then becomes a recurrent factor in the widespread modernist tendency toward geometrical abstraction.

In this respect, let us consider Malevich's *White on White* of 1918 (Museum of Modern Art, New York).[10] The work consists of a white square painted on canvas. In the upper right quadrant, there is another square, painted in grey-shaded white and tilted at an oblique angle. Its lower right corner extends downward into the last fifth of the background square, whilst its top left and top right corners almost touch the top side and the right side of the background square. However, they do not quite touch. And this is important. For the empty space between the corners of the tilted square and the edges of the background one creates the possibility of notional virtual movement. Malevich himself felt that relations between planes had a metaphysical significance.[11] However, associations of that kind depend on what planar relations achieve in terms of the relation between real and pictorial space. In this respect, an observation by Hans Hofmann is instructive:

> The line originates in the meeting place of two planes. The course of a space line always touches a number of space-planes. […] The line divides, combines, flows. The line and the plane are the vehicles of free, searching effects.[12]

Now, whether one agrees with this or not, it is quite clear that the plane is a fundamental feature of both pictorial and abstract art. As we saw earlier, as soon as one puts a mark on a plane surface, it creates other planes. Pictorial space—figurative or abstract—arises from this. This means that Malevich's affirmation of figures, such as squares and crosses as vehicles for planar creation, is conceptually sound. Hence, it is hardly surprising that so much modernist art has had a strong planar emphasis and that sculptural tendencies such as minimalism have explored it three-dimensionally. Planar structure is a key way in which artists deal with the creation of space as such. The aforementioned abstract tendencies all allude to space-formation as an activity.

v) *Visual correlates of the emotions and related states of mind.* Specific kinds of shape and color—and, of course, their interrelations—carry strong, emotional connotations. These arise from both natural factors and a shared cultural stock of relevant connotations. Given the presumption of virtuality, it is likely that emotional correlation in abstract works involves the mediation of other transperceptual levels. For example, shapes found threatening or relaxing may have this effect by alluding to specific qualities of gesture (and especially, facial expression), through which we normally recognize threatening or friendly behavior. However, in these cases, we are not given the whole body or face—just some salient visual features that suggest the relevant emotional characterization.

In this respect, it is interesting to consider Franz Kline's work.[13] He favored black and white structures with a calligraphic feel to them. Sometimes these are supplemented by delicate greys or other colors that substantialize the black and white forms, through the suggestion of cast shadow. In all these works, the gestural feature is to

the fore—but in a way that is ragged and uncertain. The restricted color schemes and the raggedness of form project a great existential frailty simply through the associative emotional power of the colors and shapes in question. It should be emphasized that this frailty is a strength insofar as it centers on Kline's mastery of a specific formal vocabulary.

Now which transperceptual levels are dominant in any specific cognitive situation depends on the kind of item or state of affairs involved, and the basis of our interest in it. More than one level can be engaged, allusively, on the basis of the configuration's specific visual character. Indeed, this is one of the great strengths of abstract art. What we find in it, allusively speaking, can involve different levels of the transperceptual simultaneously, and thence augment its enigmatic quality.

Consider, for example, *Ordo 170X*, a digital abstraction by Charles Csuri, from 2018.[14] This work involves a network of narrow ribbons, and even finer thread sequences of different kinds of wire-like form. Both ribbons and wires are extremely taut and tonally modeled in such a way as to suggest colored metallic strands. They suggest some artifacts of unknown origin. However, they could just as well be features of some physical processes at a microscopic level or a strange life-form of extra-terrestrial origin. At the same time—in the work's emphasis on threading—the work also emphasizes pictorial space as something constructed, in this case, on a linear basis. The arrangements of ribbons and wires also have emotionally satisfying formal value in their own right. They create rhythms of line and color that appear both artfully choreographed, and yet spontaneous. In this example, therefore, we find possible allusions to all the levels of transperceptual space mentioned earlier.

We now arrive at the decisive point. In scrutinizing abstract art, we draw, intuitively on our experiences of transperceptual space, taking the configuration as alluding to some possible configuration there. Meaning in abstract art is founded on this. To justify the claim, requires, of course, that the connection between abstract art and the transperceptual can now be shown to be compelling, rather than a mere interpretative possibility. This can be established by refuting some specific objections to the proposed theory.

7.3 Dealing with objections to the theory of transperceptual space

A first objection is that most people (including artists themselves) have no concept of the transperceptual, and, second, even if they do, there is no necessary reason why this should be linked to abstraction's optical illusion. The only terms that must be applied to such illusion are descriptive ones—such as "this spot of color looks to be in front of that one", or "this shape seems to be in motion", or "that volume appears to be heavy", or whatever.

However, in terms of the first objection, we have already seen in detail how the transperceptual is intrinsic to perception and that there is cognitive propensity to make unfamiliar things intelligible by referring them allusively to our experience of the transperceptual—even though we may have no specific concept of it. *The transperceptual is something we exist in.* We form a sense of it through problem-solving, and, very often, through arbitrary imaginary transformations of how things appear, or what they might hide (a mindset that is very familiar through daydreaming, and other forms of reverie.) Given these propensities, it is only natural that, when we see abstract art, we interpret its optical content in terms of allusions to transperceptual phenomena.

These points refute the second objection also. Bare literal descriptions of optical allusion in such works are no more than that. They do not explain why these features are able to engage us imaginatively, and aesthetically. An explanation might seem to be found in the formalist idea of significant form and the expressive values of line and shape as such. But this raises the question of why form becomes significant and of expressive value in the first place. If one says "because form is aesthetically satisfying", this invites the question, "why"? If the answer is to involve anything more than simple decorative meaning, then the abstract configurations must be significant in some deeper sense. There *must* be an active visual factor in abstract pictorial creation which takes the work to deeper levels of aesthetic meaning.

The only real contender here is the allusive link between optical illusion and transperceptual space. Allusions to transperceptual possibilities have a special spiritual significance in that they employ sophisticated cognitive propensities that are central to embodied subjectivity but are usually taken for granted (and thence not noticed) in our normal practical engagements with the world. It is precisely these propensities that abstract works solicit through their optical illusion. In doing so, they express the depth of how we exist in the phenomenal world and our extraordinary capacity to project possible states of affairs other than those currently present to perception. These projections are like steps to different possible visual worlds. They celebrate the creative range of the human spirit.

Another objection might be raised, namely, that the approach taken here is a distortion of abstract art insofar as such works can only be understood correctly through historical investigation. Their meaning is a function of the particular circumstances under which they were produced, the specific conditions of their reception and the character of their subsequent historical transmissions. Any attempts to form a general theory of meaning for abstract works will suppress vital differences between them and end up as "ahistorical" distortions.

However, this "social history of art" approach involves a key contradiction. Abstract art is not locked into tight little historic and geographic communities. It has been culturally transmitted. The nature of its origins and transmissions are worthy of the deepest historical investigation including, of course, social history of art approaches. But the problem, then, is to explain why abstract is the sort of thing that can be culturally transmitted as an object of enduring interest across so many different times and places. This is not a question of empirical history; rather it is a question about how such history is even possible.

In this respect, it is worth considering an important philosophical point. Donald Davidson notes that

> We can make sense of differences all right, but only against a background of shared belief. What is shared does not in general call for comment; it is too dull, trite, or familiar to stand notice. But without a vast common ground, there is no place for disputants to have their quarrel.[15]

And Ernst Cassirer observes that "All human works arise under particular historical and sociological conditions. But we could never understand these special conditions unless we were able to understand the general structural principles underlying these works".[16]

The point is that, in order for a cultural practice to be historically transmissible, it must have flexible constant features that enable it to be intelligible to practitioners

and audiences across historical and geographical distances. There must be a core of shared beliefs and structural principles involved—a basis of meaning. An artist might intend his or her work to be about the ninth dimension of space, or plastic reality, the unconscious, or the Absolute, or whatever, but in order to create these meanings, he or she has to deal with marks on a plane surface, and, as soon as that relation is established, we are dealing with an optical illusion. Such a space can be used as a vehicle for personally and historically specific intentions and ideas (of the ambitious kind just noted), but it has a more universal dimension of allusive meaning that exceeds these particularities. This dimension provides the shared beliefs and general structural principle that enables abstract art to have a history.

However, this leads to a final objection. Surely, it might be remarked, whilst abstract works have optical illusion, and whilst this might allude to transperceptual possibilities, these are no more than simply personal associations. In effect, what the purported theory of meaning for abstract works comes down to is the fact that such works mean whatever one wants to read into them.

Actually, there is much more to it than that. Certainly, *qua* abstract, a work cannot simply be a picture of such and such a definite thing or state of affairs. There must be some ambiguity. Indeed, it is very often the case that a range of different transperceptual possibilities are allusively consistent with the same work. However, the decisive term here is *consistent*. The key is to allow one's imagination to be guided by the actual details of the configuration. Suppose, for example, one claims that Barnett Newman's *Vir Heroicus Sublimis* of 1951 (a vast expanse of monochrome color with a couple of thin verticals) evokes a possible colony of ants gathering food. Doubtless, there are possible colonies of ants hidden from view in transperceptual space, but the formal structure of the work gives no visual grounds to take it as alluding to such possibilities. The point is, that where an allusive content does suggest itself, such a reading must be justified through direct reference to the work's appearance itself, and not just any play of associations it might lead to. It must be consistent with the work's appearance. Hopefully, the examples provided earlier show how this notion of consistency can be applied.

There is a related objection. It may be that one can identify all sorts of possible allusions that might be consistent with how a work appears, but what if, in creating the work, the artist did not intend any such allusion? The answer is that this is irrelevant. Artistic practice is done for personal reasons, and one can create such and such a configuration with quite specific intentions. However, the artist does not remain tied to the work when it is finished. It has a life that is indifferent to the intentions that sustained its creation. Abstraction, like all other art forms, is a social rather than a purely private practice and exists mainly as a possibility of experience for those who behold it—on the basis of what is in the work, and how traditions surrounding the relevant medium transmit it.

Finally, one might claim that there is something commonsensical about the theory of meaning proposed here. Abstract art continues to find an audience—mostly composed of people with little or no understanding of the artists' specific intentions and ideas, or of the original historical contexts in which the works were produced. Despite this, the audience still finds such works meaningful. As we now see, this goes beyond questions of "significant form" or "spiritual reality" involving ineffable meaning. The ineffable, the sacred even, can be involved, but only when we have got a purchase on the work's meaning by virtue of allusions to transperceptual possibilities. We have

proposed here a general theory of meaning for abstract art. This is not intended as a replacement for empirical historical approaches. Rather, as noted earlier, it identifies what it is that enables abstract art to have a history at all.

Notes

1 Discussions of meaning in abstract art usually focus on the aims of individual tendencies rather than meaning as such. This is the case, for example, in Herbert Read's *The Philosophy of Modern Art*, London: Faber and Faber, 1952—which actually contains hardly any philosophy.
2 The concept is discussed, at length, for example, in chapter 6 ("The Logic and Phenomenology of Abstract Art") of our *Phenomenology of the Visual Arts (Even the Frame)*, Stanford: Stanford University Press, 2009, pp. 99–119. More detailed discussion occurs throughout our book *The Phenomenology of Modern Art: Exploding Deleuze, Illuminating Style*, London and New York: Continuum, 2012. See especially pp. 201–250.
3 The only scholars who have taken optical illusion in abstract art seriously are Richard Wollheim, in *Painting as an Art*, Princeton, NJ: Princeton University Press, 1987, and Kendall Walton, in *Mimesis as Make-Believe: On the Foundations of the Representational Arts*, Cambridge, MA, and London, England: Harvard University Press, 1990. Unfortunately, Wollheim's ideas are very scattered and focus mainly on his more global notion of "seeing-in". Walton discusses optical illusion in relation to Malevich's *Suprematist Painting* (Collection Stedelijk Museum) on pp. 54–57 of his book. However, he seems to regard such illusion as having no application beyond the limits of the particular abstract work in which it occurs. Our position in contrast holds that such illusion also works allusively by engaging with transperceptual space.
4 Maurice Merleau-Ponty, *Phenomenology of Perception*, trans. Colin Smith with revisions by Forrest Williams. London: Routledge Kegan-Paul, 1974, p. 136.
5 This was formerly the main opening remark on Thomas's impressive website: www.imagery-imagination.com/ (last accessed 2013-05-07). The website now appears to have gone.
6 Merleau-Ponty's "Eye and Mind", included in Galen A. Johnson (ed.), *The Merleau-Ponty Aesthetics Reader: Philosophy and Painting*, Evanston, IL: Northwestern University Press, 1993, pp. 121–150. This reference, p. 128.
7 Merleau-Ponty's use of the visible/invisible pairing is actually not just about vision. It is a metonym for issues concerning the body's and the world's mutual immersion in one another. However, this raises difficulties in its own right. We have addressed these in a paper entitled "The Poetry of Flesh or the Reality of Perception? Merleau-Ponty's Fundamental Error", *International Journal of Philosophical Studies* Volume 23 (2015), Issue 2, pp. 255–278.
8 Ellingson's work can be seen at www.amyellingson.com/2017-works/ (accessed May 24, 2018).
9 Mondrian's *The Tree A* can be seen online at www.tate.org.uk/art/artworks/mondrian-the-tree-a-t02211 (accessed 24/05/2018).
10 Malevich's *White on White* can be seen online at www.moma.org/collection/works/80385 (accessed 24/05/2018).
11 We have considered these theories in detail in "Malevich, Schopenhauer, and Non-Objectivity"—chapter 4 of *The Language of Twentieth-Century Art: A Conceptual History*, New Haven and London: Yale University Press, 1997, pp. 71–86.
12 Cf. James Yohe (ed.), *Hans Hoffmann*, New York: Rizzoli, 2002, p. 42.
13 A selection of Kline's work can be seen online at www.moma.org/artists/3148 (accessed 24/05/2018).
14 *Ordo 261 X* can be seen online at charlescsuri.tumblr.com (accessed 25/05/2018).
15 Donald Davidson, "The Method of Truth in Metaphysics", included in his *Inquiries into Truth and Meaning*, Oxford: Clarendon Press, 1984, pp. 199–214. This reference, pp. 199–200.
16 Ernst Cassirer, *An Essay on Man*, New Haven: Yale University Press, 1944, p. 69.

8 The Visualization of Temporality in the Abstract Paintings of Barnett Newman[1]

Claude Cernuschi

Given the tortuous difficulties his audiences encountered while attempting to interpret his reductive, abstract canvases, the American painter Barnett Newman provided the following, albeit brief and nebulous, hint to his public. Looking at his images, he asserted, should be "a single experience", one comparable to "the single encounter that one has with a person, a living being".[2] Coming, as it did, from the artist himself, this account commands a certain authority and has, justifiably, fed the speculation that the vertical beams in Newman's paintings (or "zips" as he liked to call them) stand for abstracted, schematic versions of a human being. Not a human being's external appearance, of course, but the intensity of what the artist termed a person's "presence", i.e., the force of its personality, or the way it affects those in its vicinity. In this regard, presence does not mean literal existence, but a sense of contemplative or existential self-awareness. Newman described the creative act in similar terms: "One is in the presence of a kind of presence: oneself. One feels present at a moment which is very real".[3] For Newman, the term "presence" thus encapsulated both his own creative attitude and the one with which a spectator should peruse his art. After visiting Indian mounds in Ohio, the artist—obviously deeply moved—recalled:

> Looking at the site you feel, Here I am, *here* [...] and out beyond there [...] there is chaos, nature rivers, landscapes. [...] But here you get a sense of your own presence. [...] I became involved with the idea of making the viewer present: the idea that "Man is Present".[4]

Expanding upon these experiences, Newman injected yet another layer of complexity into an already intricate idea. The sensation of presence, he insisted,

> is the sensation of time—and all other multiple feelings vanish like the outside landscape. [...] Only time can be felt in private. Space is a common property. Only time is personal, a private experience. That's was makes it so personal, so important. Each person must feel it for himself. [...] The concern with space bores me. I insist on my experiences of sensations in time—not the *sense* of time but the physical *sensation* of time.[5]

In a draft for the same statement, Newman wrote: "The greatest, most profound feelings of the human spirit never arise inside a frame of space. They always arise around the concept of time".[6]

Since they echo the upright posture and bilateral symmetry of a human being, Newman's vertical beams can easily be associated with the idea of a human presence. More problematic is connecting these schematic images with the notion of time, especially as painting is a static rather than kinetic idiom. What, then, could Newman have possibly meant by "physical sensations of time"? It is, of course, impossible to know for certain, but the term "presence" itself provides a clue. "Presence", after all, does not simply designate a spatial position (e.g., "I was present at the meeting"); it also designates a state of existence in the *chronological* "present". And because it is a difficult experience to verbalize literally, time is often described, metaphorically, in more concrete, spatial terms. The past is "behind" you; the future "ahead" of you; and the present is "here", where you are located at this moment.[7] These idiomatic expressions reveal how readily we conceptualize time and space as if they were interchangeable: remembering is "looking backwards", anticipating is "looking forwards", and when we are told to "look here", we pay attention to what is being expressed *now*. We speak of a "near future", of a "distant past", and say that "time is short" or that it has been "too long" since we have seen close friends. Asked how far Boston is from New York, we answer "three and half hours" just as easily as "approximately two hundred miles".[8] And it has been found that the degree of precision with which languages express space and time is internally consistent (i.e., languages that tend to be precise or imprecise with one are also with the other).[9] Moreover, many of the linguistic prepositions and descriptors we employ to designate space are equally applicable to time. In English, for instance, we find expressions such as he came "*on* time", "*around* noon", "at the *top* of the hour", "*in* July", "in the *middle* of the week", "*under* an hour", "*over* the allotted time", "*within* a day", "*inside* of a minute", etc. We can "have our *down* time", or "take time *off*", be "*ahead* of schedule", "*behind* the times", or even "at the nick of time". Not surprisingly, John O'Keefe speculates that temporal prepositions "are similar to (diachronically borrowed from?) their homophonic spatial counterparts".[10]

Accordingly, Newman might have conceptualized the expanses of his canvases to evoke, not just space (the "hereness" versus "thereness" of experience), but something akin to a time-line (another example of construing time and space in tandem). If single beams represent solitary human beings or presences, then multiple beams could represent multiple human beings or presences. Alternatively, given Newman's intent to devise visual analogs for physical sensations of time, the zips might also represent the same individual presence at different moments along a temporal continuum, evoking the way memory throws us back toward our past, or how anticipation projects us toward the future. Compellingly, Peter De Bolla wrote that, in Newman's work, the zips "introduce time to the look, and help temporalize the experience of viewing". "In effect", De Bolla writes, "the zips keep time".[11] These observations are suggestive. But to be more specific, we may conjecture that standing, say, at the center of a symmetrical painting punctuated by stripes on the left and right, we might—in conformity with the directionality of our writing system—interpret the stripes to our left as "behind" us, belonging to the past, and those to our right as "ahead" of us, belonging to the future. If any stripes were placed dead center, those would be equivalent to the "now". This possibility reinforces the suggestion that, when perusing a Newman, our gaze is not just frontal, but lateral, that we peruse not just the stripes, but scan the entire canvas,[12] just as, for William James, our experience of time is analogous to standing on a ship with a bow and a stern, "a rearward- and forward-looking end".[13]

But time remains a tricky dimension, one whose passage, though divided into codified increments (hours, minutes, seconds), is affected by subjective factors and therefore difficult to gauge accurately. Even professional athletes and professors, who engage in the same activity week after week, need to monitor the game clock, or must glance at their watches, to know when the bell will ring. "We experience time", Stefan Klein writes, "exclusively against the backdrop of events".[14] The beams along a Newman canvas, therefore, might be construed, not as designating regular chronological intervals, but as marking particularly significant moments in the stream of time. Additionally, their placement at specific points along the canvas will elicit different responses depending on the spectator's perspective. Mark Johnson and George Lakoff, for example, have identified how verbal expressions betray different conceptualizations of time,[15] some of which may be directly relevant to interpreting Newman's work. When we employ expressions such as "time flies when you're having fun", "this experience is finally behind me", or "I don't know where the time has gone", the impression is that we are immobile in the present, while the past moves behind and the future approaches ahead of us. Lakoff and Johnson call this conceptualization the "time-as-moving-object" metaphor, because human subjects feel as though they stand still while time is continuously in motion. Intriguingly, it is also possible to conceive of temporality in exactly the opposite way. Whenever we use expressions such as "we just passed the deadline", "we're halfway through the holidays" or "we're coming to the end of game", the assumption is that time remains stationary, while the human subject acts as the dynamic element moving through its continuum. These two discrete ways of conceptualizing time are directly extrapolated on our own physical experience: just as we can describe a room from a stationary position (a "gaze tour") or as if we were literally moving through it (a "walking tour"), we can describe time in either of those two ways.[16]

To this classification, Lera Boroditsky contributes the analogous distinction between time-as-a-procession and time-as-a-landscape, which dovetails nicely with Lakoff and Johnson's categories.[17] In the idea of time-as-procession, the evaluation is ego-centric insofar as observers use themselves as the main, stationary reference point by which time figuratively passes. In the time-as-landscape metaphor, by contrast, the reference points are established by time itself, in whose dimension *we* are continuously moving. Although we can use both modes to refer to time, the two are actually incompatible. We can say "I am getting used to this as time goes by" (time-as-moving-object) or "we'll cross that bridge when we get to it" (time-as-landscape), but we cannot say "we'll cross that bridge as time goes by". These modes of conceptualizing time are mutually exclusive, most likely because they hinge on completely different physical experiences to communicate their point. Either we stand still and time moves or we move and time stands still, but we cannot both be moving or standing still at the "same time".

Newman, arguably, availed himself of both alternatives, though, given their incongruence, not in the same paintings. Smaller pieces with symmetrical compositions—*Onement*, for instance—will encourage spectators to stand relatively motionless at their very center and to take themselves as the frame of reference, mirrored by the frame of reference provided by the painting: the left of the painting is also to their left (Figure 8.1). In which case, in line with the time-as-moving-object metaphor, the central stripe will stand for the spectator existing in the present, with the left and right halves of the painting as signifying the past and future, respectively. In other words,

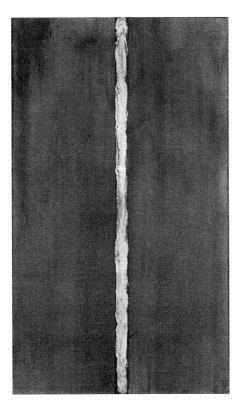

Figure 8.1 Barnett Newman, *Onement I*, 1948, oil on canvas and masking tape, 69 × 41 cm, Museum of Modern Art, New York, Gift of Annalee Newman, photo: fair use.

Onement could be seen as provoking an experience equivalent to "a gaze tour", with a static observer and time as a moving object. That temporality can be mapped onto space in this way should hardly be surprising; Bernard Comrie posits that the employment of past and future tenses in language depends—conceptually—on remarkably similar diagrammatic representations, thus drawing yet another connection between language and space.[18] On this account, canvases such as *Onement*, by virtue of the beam's central placement, and their strict adherence to bilateral symmetry, compel us to focus on the center zip as a visual analog for a human presence in the "now".

Conversely, larger paintings with multiple stripes, such as *Vir Heroicus Sublimis*, will encourage the spectator to stand at different points before the picture surface, not simply because the large scale of the piece resists any attempt to grasp it in its entirety,[19] but also because the center, normally an ideal position from which to peruse a work of art, is bereft of any incident. Confronted with this void, spectators will tend to wander, most likely stopping before each of the beams longer than before empty spaces, injecting discrepancies between their bodily center and the center of the canvas. In this case, their propensity to move could be interpreted as more consistent with the time-as-landscape rather than the time-as-moving-object metaphor and would therefore trigger an experience equivalent to a "walking tour" rather than a "gaze tour". Indeed, during real-life situations, the temporal present is a difficult sensation

to appreciate. If we were asked to concentrate exclusively on the "now", to focus only on the present, our minds will soon wander, remembering what happened yesterday or planning for what may happen tomorrow.[20]

It merits mentioning, equally, that, even if the center of a composition remains empty, prompting observers to attend to the stripes at either side, that center will still exert a certain pull, just as "the present", even if it cannot hold our attention consistently, supplies the only point around which "the past" and "the future" can be calibrated. "No language", Steven Pinker writes, "has a tense that refers to the entirety of time other than the 'now'". This means that the now "intrudes between the past and the future with no detour around it, ineluctably dividing time into two noncontiguous regions".[21] In the same way, we insert arbitrary events to "divide" the stream of time. In the West, the birth of Christ marks the time before and after the "Common Era", and, in our own individual lives, special occasions establish chronological frames of references: births, graduations, weddings, retirements, etc. Newman's zips function analogously. A canvas with beams at the left and right of an empty center could thus correspond—analogically—to a sentence such as "between recruitment and retirement I plan to do the following", when persons, still employed, are looking back to their date of hire and looking forward to their farewell party. In effect, past or future events, though they function as quasi-autonomous reference points, are always triangulated against a perpetual present: just as "left" and "right" would be meaningless without a concept of "center", "before" and "after" are no less so without the "now". Even if an empty center invites us to peruse the stripes Newman placed at its periphery, we will remain instinctively cognizant of that center no less than of the beams at a distance. By virtue of that center, the zips on the left will be read as belonging to the past, those on the right to the future, and our moving along (or even scanning) the painting laterally as somehow equivalent to moving through time, with the middlemost void as a recalcitrant but centripetal median.

The imaginary sensation of moving through time as through a landscape, however, should not violate an undeniable aspect of human experience, namely, that time is irreversibly *uni*-directional, i.e., that it moves "forward", not "back". Additionally, for mortals at least, time is also limited. If our existence in space is confined to the literal boundaries of our own bodies (e.g., we exist "inside" and not "outside" our corporeal envelopes), our existence in time is also restricted to our chronological lifespan (another physical boundary, as it were). This may or may not explain Newman's cryptic statement about hoping to spark physical sensations of time, but, if this ambition went hand-in-hand with his desire to trigger our awareness of our own presence, then it stands to reason that time and presence are related. Namely, that a sense of our own presence also entails an awareness of where we are *now*, at this present moment, as well as how we are affected by remembering the past and by anticipating the future—a future that is finite.

Inasmuch as being "here" means not being anywhere else, existing in the "now" means the past is beyond our power to change and the future beyond ours to predict. Those who are self-aware also understand that time is brief and that they are confined to a fleeting chronological "while", during which they are only temporarily permitted to linger. By marking the beginning and the end of our existence, birth and death thus demarcate the limits of "our" individual time—an additional way, arguably, of interpreting what Newman may have meant by *physical* sensations of time, sensations that are "personal" and "private". When the artist ascribed, instructively, the title

Moment to one of his paintings, it was, ostensibly, because the sensations sparked by the painting suggested, at least to him, a visual "equivalent" to a transient but *distinct* "instant" in time (no different than the way time-lines also demarcate chronological distinctions by means of spatial columns or stratifications). In its intensity, the yellow band in the middle of *Moment* stands out dramatically against the darker, more gestural background—again evoking something coming into presence within physical boundaries. The clarity with which the yellow area is defined and segregated also suggests that the moment is of special import. Against the vertical strokes behind it, the beam almost looks as if it were expanding laterally, increasing in intensity. As was already mentioned, Newman once related that, during the creative act, he felt "present at a *moment* which is very real [italics mine]".[22] It is the "reality" of this "moment" that the stark color contrasts and spatial differentiations convey: the moment is short-lasting yet intense; it has a beginning and an end, like any physical entity.

The symmetrical *Moment* thus invites comparison to, because it generates an effect so unlike, the asymmetrical *L'Errance*—whose title refers, most likely, to the act of straying or mistaking (as in expressions such as "to err" or "to go astray"). With an empty chasm at its center, *L'Errance* (which was also called *The Wandering*) induces a disconcerting impression, forcing us to direct our attention first to one beam at the extreme left, then to the other, at the extreme right, preventing our gaze from resting comfortably on any single spot. Again, we seem to be confronting the distinction between a gaze tour (*Moment*) versus a walking tour (*L'Errance*). In the latter painting, the disparity in hue, dark blue versus intense red, also accentuates the difference, even incommensurability, of the disparate beams. The painting thus appears both literally and figuratively bipolar: as if visualizing two potential alternatives about which a self, uncertain and confused, cannot decide. The effect is strikingly different from the one visualized in *Moment*. Instead of confronting a centrally, well-defined image, we are unsure where to fix our attention and feel "out of kilter". Instead of being brought back to ourselves, during a moment that, however brief, brings focus and resolution, we feel distracted, disoriented and "out of place". The artist, in fact, commented specifically on this potential dichotomy: "you put something in the middle of the canvas and there it is. That's focus. Or you put something in each corner and you leave the middle empty. That's something else".[23] The desire to have "the painting be asymmetrical", he stated elsewhere, "create[s] a space different from any I had ever done, sort of—off balance".[24]

From this perspective, Newman's concerns with presence, place and time were intimately related, as were his compositional choices, of necessity, determined by the physical sensations and emotional overtones he hoped they would elicit. In this regard, *Outcry* also rewards close attention, particularly, because the image transcribes Newman's response to suffering a heart attack, his confrontation with death and distress over the curtailment of his potential. The extreme narrowness of the canvas confines the human presence almost to the very edge of its own physical, bodily contours, severely restricting any possibilities still before it. The gestural execution also induces a high degree of visual tension with the strict rectilinearity of the frame, as if the human presence fights or rebels against its constriction, against being forced to relinquish any of its unfulfilled potential. With death, of course, all future possibilities vanish, and human existence returns to a literal spatiality no different than that of any piece of inert matter. This may explain Newman's objections to adding frames to his works, on account, in his own words, of their "restricting content".[25] If his works might generate sensations of freedom

or containment, Newman, it seems, hoped that these would result from formal elements he had created and placed himself, not ones extrinsic to the piece, or contingent upon another person's decisions. Even so, the literal edge of the canvas, like a frame, also halts any sensation of lateral expansion. Capping that expansion by "termination" points (a stripe or the edge of the canvas) might therefore signify a form of limitation, or the human presence's inability to explore additional possibilities. If the end of the canvas stands for the end of existence, it would mean that, for the human presence contained in *Outcry*, "time will soon be up".

If so, how would the edge of the picture frame affect the spectator in larger, asymmetrical paintings? At first sight, *The Third*'s composition is remarkably similar to *L'Errance*, but the orange coloration gives the painting a far less foreboding effect (Figure 8.2). The first beam, in bright yellow, a possible reference to an awakening presence, emerges from an irregular, chaotic area at the extreme left. The suggestion, arguably, is not so much of physical birth but of original existential awareness. The second beam, no less bright, but now closer to the right edge, seems more delicate due to its frayed lines, the surrounding orange having bled into the yellow zip. The sense of

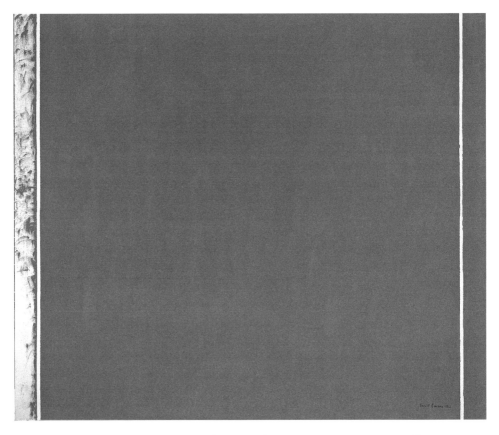

Figure 8.2 Barnett Newman, *The Third*, 1962, oil on canvas, 86 × 103 cm, Walker Art Center Minneapolis, Gift of Judy and Kenneth Dayton, photo: fair use.

presence is still active, yet somehow more fragile and brittle, less self-assured—owing, additionally, to the looming termination of the canvas nearby, a hint, perhaps, at mortality and its accompanying denial of potential. Again, we might be confronting two human presences, or the same presence at different moments in time: at the left, when all its possibilities are "ahead" of it, and, at the right, when all of its possibilities are "behind" it (which might account for the effect of vulnerability created by the second beam). Regardless, we posit that the two zips represent the first and second elements referenced in the title *The Third*. The last "third", so to say, is symbolized by the empty, yet surprisingly poignant, visual field located at the very center of the painting, which, because of its bright orange coloration, may be interpreted as the realm of possibility itself (again, a recalcitrant but conceptual center without which there is no left or right, before or after). Conceivably, Newman might be insinuating that we come into presence, not when we are born, but when we become self-aware (in fact, he identified the creation of *Onement I* as the "beginning" of his "present life"[26]), and inevitably, we will confront the end of our existence and our very person will return to nothingness. The fundamental question remains: what do we do with the time that has been allotted to us *in between*? How shall we seize the possibilities that are available? The possibilities are there and remain—where else?—in that *space* and within that *time*—between self-awareness and death—where the meaning of our existence, our potential, may be allowed to unfold.

On this account, the emptiness at the center is not a literal emptiness, as much as a "stretch of time" awaiting to be filled (like a vessel with liquid) with our deeds and actions, so long as we commit to "fulfilling" our potential. Still, if the empty center of *The Third* suggests a realm of possibility available to mindful and resolute individuals, the remarkably minimalist *Yellow Edge* provokes a radically different effect. The spectator is confronted with a monochromatically black canvas, animated only by a yellow zip flush at the right edge of the painting. Placing the brightest portion of the work at the extreme right—at its "termination" rather than "starting" point—arguably compensates for the foreboding, ominous impression induced by the dark coloration, and the disorienting imbalance caused by the asymmetrical composition. Although the empty space now looks more like a chasm or void than a realm of possibility, the yellow edge, quite literally, allows the work to end, so to say, on a positive note. Figuratively, the yellow zip may be interpreted as a moment of profound, life-changing insight; yet its placement at the extreme right of the piece suggests that it came at the very "last moment". But no matter how late, no matter how close to the moment of death, that insight, Newman seems to be intimating, is intense and powerful enough, even to redeem a protracted, thoughtless existence.

Thus, by manipulating placement and color, Newman sought to imbue a relatively limited visual vocabulary (the zips and the spaces that form between them) with a surprisingly wide expressive range. If vast, Newman's canvases evoke the idea of possibility that a human being is a not-yet, with all of its potential awaiting tangible realization; if narrow, the constraints on our existence, the closing off of our possibilities (the making of a "not-yet" into a "never-more"). The placement of the beams on the left or right side of an image also has distinct implications. *Shimmer Bright* of 1968, to give another example, connotes the solidarity of two human presences determined to confront the vicissitudes of life in tandem. Rarely for him, Newman assigned the same color to two distinct beams—bright blue, in this case—indicating the camaraderie

between the two human presences. Intriguingly, the zips in *Shimmer Bright* are located toward the extreme left of the canvas, as if the human presences have "time before" them. No less significant, the vast expanse of space to their right bears no evidence of agitation or travails "ahead". What shimmers bright, as the title insinuates, is a future trajectory of immense and infinite possibility, as when we say "these two have a bright future ahead of them". This does not mean that everything is open (the pedestrian cliché that "anything is possible"), only that, at all times, as long as life exists, so do possibilities. Only in death will our possibilities vanish. That such experiences of time, as Newman intimated, are personal and private is, in many ways, self-evident. No one, after all, can experience *our* past or *our* own potential for us.

Until now, we have interpreted Newman's physical sensations of time as triggered primarily by the lateral expansions of his canvases, as if spatial extension stood, metaphorically, for a chronological continuum, a continuum interrupted, so to say, by zips denoting the position of human presences at different points within its duration. But Newman also found a way to relate the relative brightness or darkness of the beams (and how dramatically they stand out from their backgrounds) to the idea of presence and time. Newman, for example, frequently made references to light in his titles—e.g., *Shinning Forth, Anna's Light, Profile of Light, Shimmer Bright, Primordial Light*— opening the possibility that, for him, illumination was yet another way of evoking potentiality and self-awareness. One thinks of the verbal expressions such as "her face just *lit* up", "he *beamed* as he heard the news" or the one previously mentioned: "they have a bright future ahead of them". Intriguingly, while discussing the works of his friend and fellow abstract expressionist Adolph Gottlieb, Newman sharpened what he meant by illumination by citing Heraclitus. "It is gratuitous", Newman wrote, "to put into a sentence the stirring that takes place in these pictures. But no one has a better right than the ancient Greek philosopher Heraclitus".

> The perfect soul is a dry light
> Which flies out of the body as
> Lightning breaks from a cloud.[27]

One suspects, however, as is so often the case with Newman, that he had his own paintings in mind, rather than Gottlieb's, when he referenced Heraclitus. The image of lightning breaking from a cloud, after all, and its association with a human presence, sounds remarkably close to Newman's description of his own work. When asked about the potential meaning of the stripes or "zips", he replied: "I thought of them as streaks of light".[28]

Using his experience in Ohio as a reference point, we can surmise that, for Newman, humanity's difference from nature sparked its sense of presence and place. As it stands apart from a world that is alien, material and unthinking, humanity comes to ponder its own history, the way its existence is restricted by chronological as well as physical constraints, an awareness that also makes it uniquely "present" in a temporal as well as spatial way. A human being, in effect, can be present in a way an animal or material object cannot, and illumination can be interpreted, metaphorically speaking, as a manifestation of this uniquely human form of existence. If the beams indeed stand for streaks of light, however, another layer of complexity animates the artist's version of the time-as-space metaphor. As already insinuated, we tend to read time sequentially

as a path moving from left to right. Yet connecting the beam with lightning strikes will make us think of the beam as moving "downwards". If so, that occurrence, however brisk, also unfolds in time, as it does for any object rapidly falling under gravity. Revealingly, although we tend to associate left with "past" and right with "future" in conformity with the direction of our writing system, the Chinese often speak of the past as "up" and the future as "down", in conformity with theirs.[29] And since gravity, like time, is also uni-directional, most objects fall far more easily and with greater velocity than they rise. Accordingly, we assume that objects moving downward do so with greater speed and momentum than those moving upward or even laterally.

The very term Newman preferred to designate the beams, "zip",[30] connotes this faster velocity. Unfortunately, the word is somewhat inelegant, accounting for its infrequent use in these pages, but Newman's choice reinforces the analogy being proposed here—as Steven Pinker put it: "Long words may be used for things that are big and coarse, staccato words for things that are sharp and quick".[31] In which case, Newman hoped his canvases would trigger two separate sensations of time: a slower lateral motion and a faster downward thrust (analogous, say, to a person ambulating slowly while an object falls directly in its path). As the directions are different, so are the velocities. Yet unlike the time-as-procession versus time-as-landscape metaphors, these two conceptions are actually compatible. Though we cannot say "we'll cross that bridge as time goes by", we can say "I was walking down the street when, suddenly, it hit me". Newman could easily have capitalized on these associations in order to differentiate two different temporal and existential situations. The leisurely ambulation through a medium that offers a certain degree of resistance may appropriately evoke the slower tempo of remembering or anticipating, while the rapid descent, lightning-strike of the zip, conversely, evokes an energetic moment of insight, or, better yet, a "flash of inspiration".

As if connecting his abstractions with metaphysical notions such as presence and place were not difficult enough, Newman's ambition to suggest "physical sensations of time" posed an additional interpretive challenge for art historians. Even so, it is the contention of this essay that, just as metaphorical expressions draw equivalences between time and space, Newman equated the spatial relationships in his abstract paintings with physical sensations of time. If verbal expressions betray how temporality is conceived in ways that are extrapolated from different physical experiences ("time-as-procession" or "time-as-landscape"), these finer distinctions, in turn, help differentiate the various sensations triggered by Newman's symmetrical versus asymmetrical compositions and how these sensations provide a basis for the construction of meaning. It still needs to be said, however, that, during the act of interpretation, these intellectual concepts need to be applied with special sensitivity to the visual nuances exhibited by the individual paintings themselves, none of which elicit exactly the same kinds of reactions as the next. Newman's awareness of mortality and of the brevity of time also motivated him to expand or contract the literal size of his canvases, using broadness and expansiveness to convey potential and possibility, or narrowness and constriction to convey the lack of it. The relative brightness or darkness of the beams, moreover, whether they are singular or plural, how close or far their positions are from the framing edge and how much they stand out against or blend with their backgrounds, are elements no less meaningful and open to interpretation, as was the use

of the beam as a streak of light: a metaphor for how insight and inspiration strike as quickly as bolts of lightning.

Since the majority of New York School artists insisted that their abstractions were intended to convey meaning, but were unwilling to say exactly how, their works have frustrated many a would-be observer. Newman was perhaps among the most notorious in this regard; even some of his own colleagues harbored deep suspicions about the reductive geometry of his art. And no less a philosopher than Jean-François Lyotard admitted that, while perusing a Newman, "There is almost nothing to 'consume', or if there is, I do not know what it is".[32] Whether the interpretations proposed in this chapter—which, admittedly, remain purely speculative—would have persuaded Lyotard and others that Newman's abstractions are indeed meaningful, and meaningful in the manner argued therein, is, of course, not for this author to judge. That verdict must be returned by his readers, of whom much indulgence is asked. But if one were permitted, in all humility, to give Lyotard some direction, one might say, first, that the expectation of "consuming something" may not be the most appropriate attitude with which to approach a work of art—whether abstract or representational—and second, that perhaps Lyotard needed to pause, contemplate a while longer, and simply give Newman's canvases more time.

Notes

1 I dedicate this essay, with great affection, to my late mother-in-law, Doris Forster.
2 Barnett Newman interviewed by Emile de Antonio, 1970, transcript, p. 22, Barnett Newman Foundation Archives.
3 Barnett Newman interviewed by Karlis Osis, 1963, transcript, p. 20, Barnett Newman Foundation Archives.
4 Richard Shiff (ed.), *Barnett Newman: Selected Writings and Interviews*, New York: Knopf, 1990, p. 174 (hereafter referred to as *SWI*).
5 *SWI*, p. 175.
6 Barnett Newman, draft of the statement "Ohio, 1949", Barnett Newman Foundation Archives.
7 Stefan, Klein, *The Secret Pulse of Time: Making Sense of Life's Scarcest Commodity*, New York: Marlowe and Company, 2007, p. xvii.
8 The idea of literally moving from one location to another also gives us a way to express the metaphorical idea of moving from one state to another: "I moved from point A to point B" underpins the concept of "things *moved* from bad to worse".
9 See Bernard Comrie, *Tense*, New York: Cambridge University Press, 1985.
10 John O'Keefe, "The Spatial Prepositions in English, Vector Grammar, and the Cognitive Map Theory", in P. Bloom, M. Peterson, L. Nadel and M.F. Garett (eds.), *Language and Space*, Cambridge: MIT Press, 1996, p. 302.
11 See Peter De Bolla, *Art Matters*, Cambridge: Harvard University Press, 2001, p. 41.
12 Yve-Alain Bois, "Newman's Laterality", in Melissa Ho (ed.), *Reconsidering Barnett Newman*, Philadelphia: Philadelphia Museum of Art, 2002, p. 44.
13 William James, *The Principles of Psychology*, New York: Dover, 1950, p. 21.
14 Klein, *The Secret Pulse of Time*, p. 55.
15 George Lakoff and Mark Johnson, *Metaphors We Live By*, Chicago: University of Chicago Press, 1980, pp. 41ff.
16 See Barbara Tversky, "Spatial Perspective in Description", in P. Bloom, M. Peterson, L. Nadel and M.F. Garett (eds.), *Language and Space*, Cambridge: MIT Press, 1996, p. 469.
17 Lera Boroditsky, "Metaphoric Structuring: Understanding Time through Spatial Metaphors", *Cognition*, Vol. 75, 2000, pp. 1–28.
18 See Comrie, "Time and Language", in *Tense*, p. 2.

19 Renée van de Vall, "Silent Visions: Lyotard on the Sublime", *Art & Design*, Vol. 10, January/February 1995, p. 73.
20 Klein, *The Secret Pulse of Time*, p. 89.
21 Stephen Pinker, *The Stuff of Thought: Language as a Window into Human Nature*, New York: Viking, 2007, p. 195.
22 Barnett Newman interviewed by Karlis Osis, 1963, transcript, p. 20, Barnett Newman Foundation Archives.
23 Barnett Newman, "Picture of a Painter", *Newsweek*, March 16, 1959, p. 58.
24 *SWI*, p. 192.
25 Newman, interviewed by Jane Dillenberger, March 27, 1967, see Dillenberger, "The Stations of the Cross by Barnett Newman", in *Secular Art with Sacred Themes*, Nashville: Abingdon Press, 1969, p. 104.
26 *SWI*, p. 255.
27 *SWI*, p. 61.
28 *SWI*, p. 306.
29 Lera Boroditsky, "Does Language Shape Thought? Mandarin and English Speakers' Conceptions of Time", *Cognitive Psychology*, Vol. 43, 2001, pp. 1–22.
30 *SWI*, p. 278; see also Sarah K. Rich, "The Proper Name of Newman's Zip", in Melissa Ho (ed.) *Reconsidering Barnett Newman*, New Haven: Yale University Press, pp. 96–114.
31 Pinker, *The Stuff of Thought*, p. 300.
32 Jean-François Lyotard, "Newman: The Instant", in Andrew Benjamin (ed.), *The Lyotard Reader*, London: Basil Blackwell, 1989, pp. 241–42.

9 Rethinking Abstraction Post-phenomenologically: Michel Henry and Henri Maldiney

Bruno Lessard

There seems to be an elective affinity between French philosophers and painting. Indeed, since World War II, philosophers such as Maurice Merleau-Ponty, Michel Foucault, Jacques Derrida, Gilles Deleuze, Jean-Luc Nancy, François Wahl, Jean-François Lyotard, Jean-Luc Marion and Alain Badiou, among others, have reflected on painters ranging from Velázquez to Soulages. What is it exactly that these philosophers found captivating in painting? What could explain the enduring fascination with the ontology of the painted image in 20th-century French philosophy? Equally intriguing is the obsession with a painter such as Cézanne, who captured the imagination of an entire generation of thinkers. What could justify Cézanne's recurring presence in the writings of French philosophers? Is it the painter's singular approach to the object, which Lyotard described as a "subterranean principle of *derepresentation (déreprésentation)*",[1] that sparked an interest in Cézanne's gradual departure from representation in the first place? Or is it the general "failure of representation"[2] in philosophy foreshadowed in Cézanne's work that drew the attention of philosophers?

This chapter will further examine the multifaceted relationship between French philosophy and painting by adding to the aforementioned intellectuals the names of two neglected philosophers who published extensively on abstract painting: Michel Henry (1922–2002) and Henri Maldiney (1912–2013). In their writings, Henry and Maldiney both argue that it is imperative to rethink abstraction *post-phenomenologically*. In the following pages, I introduce these two philosophers' reflections on abstract painting, and I examine how their post-phenomenological approach could be used to reconceptualize the discourse on abstract art in both modern art history and 20th-century French philosophy.

The concepts that Henry and Maldiney create to make the case for a post-phenomenological approach to abstract painting significantly differ. In his magnum opus of 1963, *L'Essence de la manifestation*, Henry argues against the privilege accorded to intentionality in Husserlian and Heideggerian phenomenology, and he also contests Merleau-Ponty's phenomenology of perception in which all phenomena are bathed in the light of the world and are invariably made visible to the human gaze. Henry's reflections on abstract painting, and the work of Wassily Kandinsky in particular, are predicated on his post-phenomenological concepts of pathos, Life, immanence and auto-affection. For Maldiney, whose writings on painting address a number of painters including Kandinsky, thinking of abstraction post-phenomenologically signifies being attuned to sensibility, rhythm and the pathic, these three concepts also figuring as the main ones in Maldiney's philosophy. In the final analysis, Henry's and

Maldiney's writings on Kandinsky expose their divergent views on both abstraction and Kandinsky's artistic legacy.

9.1 Toward a Phenomenology of Abstraction

In numerous writings and interviews, Michel Henry often referred to his philosophy as a *material* phenomenology.[3] This qualifier points to one forgotten reality in Western philosophy according to Henry: that of the lived body and its interiority that is invisible to the human eye and, therefore, to the phenomenological gaze. One of Henry's crucial concepts is "sensibility", which, he suggests, demands a post-phenomenological perspective that would be attentive to sensibility's potential for revelation beyond what rational thought can reveal and that would question the primordial place that intentionality and the subject-object dichotomy have occupied since Husserl. In sum, Henry argues that rethinking phenomenology means paying closer attention to materiality, interiority, invisibility and sensibility, which entails disclosing the subject's immanent life and auto-affective inclinations. This revisionist philosophical program was the core of Henry's monumental work of 1963 that received little attention at the time of its publication in the heyday of French structuralism.

What is at stake in Henry's material post-phenomenology and, by extension, "material aesthetics", is uncovering the relationship between the invisibility of affects and the phenomenality that has been historically neglected in Western philosophy.[4] To be more precise, what Henry contests is the *ontological monism* at the heart of the Western tradition. As Gabrielle Dufour-Kowalska remarks on philosophy's foundational monist precepts and perennial investment in the visible:

> there exists only one type of being and authentic phenomenality, which is the being and phenomenon that are determined by the supra-sensible essence, by what the Ancients called *form* or *idea*, the Greek *eidos*, the ideal (*idéelle*) essence. Being does not possess its essence in itself, but in the knowing act that perceives it. The essence of presence lies in its representation […] Therefore, being in Western thought is essentially a *visible* reality.[5]

Predicated on Platonic ideas and forms, the Western philosophical tradition would deny sensibility the potential to disclose authentic knowledge, and it would have elevated visible representation to the rank of sole genuine reality. Henry would contest this philosophical scenario in which only *visible* evidence amounts to authentic presence and existence. As Philippe Sers has noted,[6] one of the most significant accomplishments of Kandinsky's revolution in painting is to have exchanged the Western philosophical tradition's emphasis on the externally visible for the *internally invisible* via the central notion of "internal necessity", as explained in the next section.

The radical nature of Henry's writings is to be found in his rejection of the primacy of the visible, which leads to the revelation of the invisible realm of interiority that remains inaccessible to the traditional phenomenological gaze to access the objective world. This post-phenomenological process of discovery emphasizes feeling [*sentir*] and the reflexive act, feeling oneself [*se sentir*]. This auto-affective act concerns what is found within and discloses the essence of sensibility. Interestingly, Henry uses qualifiers associated with night such as "nocturnal" to describe the "night of being" that his post-phenomenological method wishes to uncover. Developing a philosophy of the

body after Merleau-Ponty, Henry considers the body as an interior reality because its givenness is felt within first and foremost. This interior reality is invisible and immanent in Henry's work, which is to say that it does not refer to a transcendental subjectivity à la Husserl.

Privileging the ontological knowledge of the body instead of the epistemological stakes of its knowledge, Henry argues that to exist signifies to experience sensibility [*sensibilité*]. As Dufour-Kowalska defines it, "sensibility is an immediate mode of being of the affective substance of subjectivity".[7] In that sense, Henry's post-phenomenological stance amounts to more than a philosophy of the body; it is an onto-phenomenology of life itself. His philosophy of sensibility seeks to disclose the originary essence of phenomena that Husserl and his heirs failed to address according to the French philosopher. As Henry has argued, it is necessary to construct a philosophy of sensibility to make sense of the essence of art and abstraction generally speaking. It is, to borrow from Dufour-Kowalska, an "ontophenomenology of artistic experience"[8] that is at stake in Henry's writings on abstraction.

Still relatively unknown outside of France, Henri Maldiney's body of work can be considered one of the most significant in post-World War II French phenomenology alongside that of Merleau-Ponty and Henry.[9] Maldiney's first book-length publication, a collection of essays titled *Regard parole espace*, was published in 1973.[10] Collecting writings spanning the last twenty years, the book was more appreciated by psychiatrists and artists than by philosophers themselves. This is due in large part to the fact that Maldiney drew on poetry, painting and existential psychiatry to create a post-phenomenological discourse that could not be readily appropriated by the philosophical community. Gilles Deleuze was one of the first philosophers to draw attention to Maldiney's *Regard parole espace* in his publications of the early 1980s.

Maldiney's post-phenomenological approach can also be considered radical, but for reasons that differ from Henry's perspective on the phenomenological tradition. First, some of Maldiney's key concepts such as the Open [*l'Ouvert*] and Nothingness [*le Rien*] derive from the amalgamation of Western and Chinese aesthetic notions as opposed to the German phenomenological tradition per se. Second, Maldiney's main influences were Erwin Straus and Ludwig Binswanger, which is to say that Maldiney's philosophy is not a direct response to Husserl and Heidegger like Henry's, but a thorough engagement with phenomenological psychology and *Daseinsanalyse*.[11] Integrating these unlikely sources into his post-phenomenological program, Maldiney discusses both affective and aesthetic sensations, which would share a common origin in the affective dimension of existence, presence and creation. While Maldiney's work posed as radical a challenge to phenomenology as Henry's did, its philosophical orientations differ in that Maldiney's revisionist phenomenological agenda refracted his marked interest in artistic creation, art therapy and existential psychiatry, first and foremost. In this sense, Maldiney is a singular figure in the post-World War II French phenomenological landscape, because he forged his main concepts at the crossroads of phenomenological psychology and the creations of painters and poets.[12] Indeed, it is mainly in conversation with the paintings of Cézanne, Pierre Tal Coat, Jean Bazaine, Nicolas de Staël and the Chinese landscape painting of the Song dynasty[13], as well as the poetry of Francis Ponge and André du Bouchet, that Maldiney found a form of radical sensibility with which to go beyond the phenomenology of Husserl, Heidegger and Merleau-Ponty.[14]

Maldiney first put forward his post-phenomenological program predicated on aesthetics in his breakthrough *Regard parole espace*. Privileging the notion of *sensation* (rather than perception in phenomenology), Maldiney makes use of two critical concepts: "*pathic feeling*" [*le sentir pathique*] (from the Greek *pathos*: trial, suffering, sensation) and *rhythm*, which countered the overreliance on form, sign and image in art criticism. As Frédéric Jacquet has shown, Maldiney's philosophy "is an aesthetic phenomenology in the double meaning of *aisthesis*, one of which referring to art and the other to 'affective receptivity'".[15] What this distinction points to is the long-forgotten meaning of "aesthetics", which derives from *aisthesis* and pertains to both art and sensibility. Aesthetic phenomenology merges with phenomenological aesthetics in Maldiney's thought in other words.

Claiming that "Art is the truth of what can be felt (*du sensible*) because rhythm is the truth of [*aisthesis*]",[16] Maldiney goes on to suggest that the concept of form be understood *as* rhythm rather than as a fixed entity. In fact, rhythm would further qualify the notion of style because it is "the act of style",[17] and that, thus conceived, rhythm combined both the essence and existence of art before ontologists and phenomenologists separated them. As shown below, the concept of rhythm would come to determine Maldiney's definition of abstraction, which means "to extract from the arrhythmic world of action the elements capable of being moved (*s'émouvoir*) and of moving themselves rhythmically. Abstraction is not a modern bias. It is the vital act of Art".[18] The essence of abstraction would thus lie in the affective, rhythmic and pathic sensations—which are pre-objective and unintentional—that have been neglected in the phenomenological tradition favoring the subject-object dichotomy and intentional perception.

Rather than the static notion of form [*Gestalt*], Maldiney preferred to use *Gestaltung* (after Paul Klee) to highlight how form is always *in formation*, that is, form creates the space in which it takes form. This evolving, shape-shifting form, which functions as an event in Maldiney's work, is rhythm. Rhythm is not readily present, but it exists in a particular space-in-the-making that it opens up for phenomena and artistic creation in general. In the case of painting, we would experience pictorial form in its rhythm. Maldiney defines rhythm as follows:

> A form's own dimension […] is rhythm, its rhythm. A rhythm does not unfold in time and space. It generates its own space-time. It cannot be explained by it; it implies it. The advent of a rhythmic space goes hand in hand with the constitutive transformation of all the elements of a work of art in the moment of formation, in the rhythmic moment.[19]

What is most striking in Maldiney's understanding of rhythm is that it challenges the traditional definition of the word as a movement that has both cadence and presence because, as Jacquet argues, it is "the essence of manifestation"[20] itself rather than its appearance. As the philosopher argues, rhythm would precede the space-time continuum that has served to understand the cadence and presence of phenomena. Perhaps the most important concept in Maldiney's philosophical aesthetics, rhythm would thus create its own spatio-temporal environment prior to phenomena occurring. In this sense, Maldiney's philosophy was one of the first to draw attention to rhythm's "autogenesis" [*autogenèse*].[21]

The main implication of Henry's and Maldiney's post-phenomenological approaches to abstract painting is that the emphasis on intentionality and the prevalence of the subject-object correlation failed to disclose the original meaning of phenomenality itself in the foundational texts of the phenomenological tradition. Henry called this undisclosed face of phenomenality "pathetic" [*pathétique*], whereas Maldiney used the word "pathic" [*pathique*]. While "pathetic" refers to auto-affection or feeling oneself [*se sentir*], "pathic" refers to feeling [*sentir*] itself. The main difference between Henry's "pathetic" and Maldiney's "pathic" is that the latter is irreducible to the mere fact that we as humans feel ourselves. It is akin to a pre-reflexive state of being that is non-objective in nature and that precedes any intentional act of consciousness.[22] Maldiney often mentioned that this non-intentional way of being in the world is more about *how* things appear to us than *what* appears to us. For Maldiney, the pathic precipitates the blurring of the boundary between the subject and the object in light of the primordial place representation has occupied in both philosophy and art. For Henry, the phenomenological tradition, from Husserl's *Ideen* to Merleau-Ponty's *Phénoménologie de la perception*, exhausted itself in intentional acts and the description of the objective world given to sight. In other words, Henry contested the emphasis on exteriority that has figured as a *sine qua non* condition of phenomenological work since Husserl. Rather, Henry's phenomenology of life and reflections on abstract painting emphasize the primacy of auto-affection in invisible form.

9.2 The Painter of Invisible Life: Michel Henry on Kandinsky

As previously discussed, Henry's emphasis on the invisible aspects of lived experience flew in the face of phenomenology's goal to shed light on what is apparent and visible, what appears both in the world and to humans. Henry's innovative philosophical agenda could certainly have a great impact on any aesthetic theory predicated on phenomenology and the visible. It is nothing less than a philosophy of *invisible sensibility* that is proposed in Henry's work, a philosophical aesthetics whose principles are no longer founded on exteriority and transcendence but on interiority and immanence.

The hitherto unexamined relationship between the realm of invisible affects and artistic creation does depend on how one conceives of phenomena in the first place. Henry's philosophy rethinks phenomenality itself as understood in the writings of his predecessors. The phenomenality of art, for Henry, is not something that happens out there in the world; it is something that primordially unfolds within humans, in the invisible realm of interiority, immanence and auto-affection. As shown in this section, Henry's thought-provoking reflections on art posit affectivity as the core of artistic experience both in terms of creation and reception. The notion of objective, visible representation being what his philosophy vehemently contests, Henry's theory of art aligns with Kandinsky's in questioning both representation itself and the primacy of the external over the internal. In fact, Henry's philosophical tenets strikingly echo what the painter called the "principle of internal necessity (*Prinzip der inneren Notwendigkeit*)"[23] in his ground-breaking work *Über das Geistige in der Kunst* (*On the Spiritual in Art*) (1912), the notion of "internal necessity" pointing to an awareness of what makes the soul resonate and what Jean-Claude Lebensztejn has called the "unveiled being of nature as sonority".[24] Kandinsky's abstract painting would function as the aesthetic *epoché* of the visible world itself in this process. Henry adapted the spiritual, cosmic and prophetic themes in Kandinsky to argue that painting discloses

the *sensitive being* within the viewer and allows the expression of inner sounds, vibrations and resonances [*Klänge*] in the soul.

Henry's reflections on the invisible call for a post-phenomenology of the unseen and the latent in painting. Henry's material phenomenology of immanence and auto-affection expresses what he calls "Life", and his writings on abstraction convey the pulse of Life that is invisible within us. As Henry discusses at length in his writings, a post-Kantian concept of aesthetic sensibility should rely on the notion of pathos. The recourse to pathos is yet another way for Henry to signal how the invisibility of all things artistic appear in the world and are experienced as joy or suffering, both modalities of pathetic life referring to, in the realm of art, the pathos of the image in its post-phenomenological declensions of the invisible and the interior. Artistic creation becomes a conceptual laboratory in which Henry questions the power of the gaze and, therefore, the visible to account for the *invisible impact* of abstract painting. In Henry's reconceptualization, the work of art calls to mind not so much the mimetic act as immanent revelation. In this revisionist aesthetic scenario, the essence of phenomenality characterizes the invisible revelatory powers of art. Kandinsky's abstract paintings and avant-garde writings are the ideal site to further examine Henry's philosophical aesthetics.

Published in 1988, *Voir l'invisible. Sur Kandinsky* occupies a singular place in Henry's oeuvre.[25] Indeed, it is the only book-length study of an artist, and it seeks to found on philosophical soil key intuitions and reflections on creation in Kandinsky's writings, many of which concerning sensibility.[26] There is no doubt that Henry found in Kandinsky the artist whose writings came closest to what he had expressed in his publications up to that point. Working alongside Kandinsky's revolutionary pictorial and theoretical oeuvre, Henry was able to fully develop a post-phenomenological approach to painting predicated on interiority, invisibility and auto-affection. Attentively studying Kandinsky's publications, for Henry, meant not so much being influenced by the painter, or merely applying his philosophical concepts to the paintings, as encountering the work in a unique meeting of the minds between painter and philosopher.[27] In fact, Henry mentioned in an interview that he found in Kandinsky's theoretical writings the very concepts and categories he had created in his "own phenomenological analysis".[28]

Freeing painting from figuration, Kandinsky was, according to Henry, the first painter to both reveal sensibility and auto-affection in his paintings and theorize them in his writings. What is of particular interest to Henry is Kandinsky's profound "understanding of the essence of painting",[29] and how Kandinsky's reflections on the ontology of painting relate to an innovative phenomenological program. In his book, Henry reconstructs the phenomenological tenets of the *aesthetic epoché* that is implicitly theorized in the writings of the artist who was Husserl's contemporary.[30] In words evoking his own philosophical agenda, Henry argues that Kandinsky gave a "phenomenological analysis"[31] of abstract painting, and that the philosophical foundation of the painter's publications is a "phenomenology of bodily sensibility".[32]

Henry's passion for Kandinsky's paintings and writings discloses the elective affinity between the painter's theory of abstraction and the concepts that Henry used to erect his post-phenomenological edifice over the years. Reading the monograph on Kandinsky, one is struck by the undeniable convergences between the philosopher's concepts and the painter's ideas. For example, Kandinsky explains in the opening pages of the Bauhaus-period *Punkt und Linie zu Fläche* (*Point and Line to Plane*) (1926) that phenomena can be experienced either *internally* or *externally*,[33] a remark that is

of crucial importance to Henry's philosophy in general. As Henry explains at length, post-Husserlian phenomenology lost itself in exteriority and forgot the "pathetic" aspect of life, which is to say the internal, invisible life within us. Abstraction would express the invisible content of affectivity, and this is the new theme that Kandinsky explored according to Henry.[34]

It is worth dwelling on Henry's thesis, which he states midway through the Kandinsky book: "abstract painting defines the essence of all painting".[35] It is because the abstract content of this type of painting reveals the *pathos of life* itself that it would define the essence of painting. Underlying Kandinsky's theory of abstraction, according to Henry, is the desire to show the invisible life that animates us all. The essence of painting can only be expressed by the painter of invisible life: the highest principle of aesthetic creation would lie in the painting of the pathos of (invisible) life itself. Instead of representing the world, Henry argues, Kandinsky chose to express the *invisible being of life*. As the philosopher points out, life is not an object to be represented: its content must be abstract and invisible to fully express it. Henry has famously said: "art does not represent anything",[36] and the ingenuity of Kandinsky's practice was to express the unrepresentable: life's pathetic element.[37]

The preceding summary of Henry's views on Kandinsky's achievements as a painter explains why his abstract paintings would offer a "counter-perception".[38] The goal of many abstract painters such as Kandinsky was to challenge the reference to the objective world to which the figurative artwork had referred for centuries. In fact, in the case of Kandinsky, the idea was to eliminate it altogether. Kandinsky's counter-perceptive act also wished to do away with intentionality in the rapport between the creative mind and what was found on his canvas. In this scenario, color and line became autonomous entities, spiritual beings whose relationship to mimesis and figuration is denied to serve the affirmation of life in the form of the unveiling of affective tonalities. This is supported by one of Henry's most thought-provoking claims, which states that color is not only a visible, external, and objective entity but also a phenomenon with an invisible affective charge. This statement—colors have an *invisible* life of their own that evokes affective tonalities—might seem puzzling at first, but it does echo the claim about the invisible auto-affection of life, and it vividly illustrates the counter-perceptive act that Henry ascribed to abstract painting.

The reader familiar with Kandinsky's writings might think that Henry's post-phenomenology of art reflects several ideas found in Kandinsky's publications themselves. This is no surprise, as Henry's philosophical musings on aesthetics derive from years of closely examining Kandinsky's paintings and studying his publications. For instance, Kandinsky's theory of art strives to go beyond the realm of the visual to address the spiritual experience in both art and nature, which refers to the pathetic content of art discussed by the philosopher. Kandinsky also strived in his theoretical writings to convey the idea that colors do exist and possess an *internal* reality, which explains why the painter spoke of the *being* of colors. Henry's monograph on Kandinsky could be said to have sought to make more manifest some of the philosophical stakes that remain undeveloped in *On the Spiritual in Art*. As Henry's reflections reveal, Kandinsky's abstract artwork unveils the manifestation of pathetic life instead of simply representing the world. Abstract art manifests the invisible; its goal is the manifestation of self-affected presence rather than its representation.

Reading Kandinsky's writings and Henry's book on the artist, it is difficult not to come to the conclusion that *abstraction* would denote not only the genre of painting

but also the essential condition of art under the regime of invisible auto-affection; it would function as the hidden, undisclosed truth of art in other words. Abstraction would be, to use Dufour-Kowalska's expression, "the archetype of all art".[39] That said, Henry's is not a theory of modern art per se, nor is it a traditional exegesis of Kandinsky's visual work and publications for that matter. It is a general theory of art predicated on philosophical principles that think art after Heidegger with the help of post-phenomenological tools. In fact, Henry's theory of art could not be more different than Heidegger's actually: the unveiling act does not seek to disclose a long-forgotten truth about Being. Rather, the abstract work of art would make visible what has escaped phenomenological thought for so long: the invisible essence of art. This invisible reality *is* the interiority and auto-affectivity generated by the contemplation of artistic phenomena and abstract art in particular. It is this invisible reality that Henry wishes to disclose first and foremost in his writings on Kandinsky.

In Henry's revisionist narrative, abstraction cannot be reduced to another artistic movement or genre; its ultimate function is to reveal the essence of painting and artistic creation. It is the revelation of invisible, internal tonalities that takes precedence in Kandinsky's writings, which entails a reconceptualized notion of phenomenality that eschews the perceptible aspects of the world and its relationship to light and vision to emphasize pathos as feeling. It is this "feeling oneself" [*se sentir*] that, according to Henry, Kandinsky's paintings disclosed for the first time. Abstract art would thus allow us to see what is invisible, that is, the life within us.

9.3 Critique of Pure Abstraction: Henri Maldiney on Kandinsky

Henry's reflections on Kandinsky require a post-phenomenological discourse on abstraction that would both reinvent the notion of phenomenological reduction [*epoché*] and rehabilitate the pathetic dimension of feeling. Art would occupy a central place in this because it would be the royal road to a revised phenomenological reduction. Abstraction would thus play a larger role in contemporary debates on art, which would correspond to Henry's wish for abstract art generally speaking. Maldiney would have supported this view. As he states in a 1953 essay titled "The False Dilemma of Painting: Abstraction or Reality", abstraction is "the vital act of Art".[40] Several decades later, in his last book, Maldiney would write: "Art is the truth of feeling (*sentir*) because it does not allow the reduction of the real to the objective. That is why it begins in abstraction".[41] Abstraction would be the suspension of the reduction of the world to the objectivist, positivist stance. As discussed in this section, in his late period, Maldiney went beyond the phenomenology of art to explore a *philosophy of abstraction* itself. Maldiney's philosophy of abstraction posits that feeling [*sentir*] precedes perception and is irreducible to intentionality as objective perception. Applied to painting, abstraction can be said to function as a reduction of perception toward the pathic [*pathique*] aspect of human existence. The aesthetic reduction that is proposed through abstract painting brings us back to the revelation of the essence of manifestation and phenomenality explored in the work of Michel Henry, but with significantly different emphasis because Maldiney's philosophy of abstraction would make us see the *rhythm of appearance* itself rather than the invisible life within and auto-affection.

In the chapter titled "Form and Informal Art" in *Regard parole espace*, Maldiney introduces the issues at the heart of Kandinsky's practice and highlights what he calls the painter's "veritable aesthetic Euclidism".[42] In this early piece, Maldiney discusses

the elements in Kandinsky's aesthetic system and emphasizes how his paintings acted as a watershed in the history of the medium. Maldiney asks the question: "What does the new formal painting that appeared around 1910 mean?"[43] The answer is "not an inversion of the function of forms, but a passage to the limit that surreptitiously transforms its nature".[44] The question of form is Maldiney's focus in these pages, where he addresses the radical nature of the event that was abstract painting in the early 20th century. Maldiney writes:

> The abstract form, which is tension, constitutes a being that, however entirely abstract it may be, lives, acts, and influences because of its internal sonority, which the external (its objective delimitation) manifested but concealed. The artist's goal is to free this internal sonority, to express it freely, by wresting the form from its indicative function as an object, in order that it refer only to itself.[45]

In such early passages where form and internal sonority are discussed, one must admit that Maldiney does not make significantly insightful remarks on Kandinsky's practice the way that Henry did in his monograph on the painter. Henry's analysis of the paintings and writings enter into productive dialogue with his philosophical concepts, whereas Maldiney's early discussion of Kandinsky limits itself to *idées reçues* in modern art criticism. Maldiney's later work on the painter, however, would build on his own philosophical concepts to offer a radical critique of abstraction as practiced in Kandinsky's late period.

In his last book-length publication *Ouvrir le rien, l'art nu* (2000), Maldiney proposes one of the most sustained analyses of abstraction ever written. In a long section titled "Creative Abstraction" focusing on Kandinsky, Jawlensky, Delaunay and Mondrian, Maldiney examines abstraction in general and the singular practices of the aforementioned artists, touching on abstraction in Chinese painting as well. The 2000 publication elaborates on Maldiney's writings of the preceding decades, as it moves into new critical territory using his own philosophical concepts. What emerges from Maldiney's general theory of abstraction is that the notions of space and rhythm are inseparable from the issue of abstraction in painting. As Anne Boissière notes,[46] where Maldiney's work departs from Henry's is that, for Henry, the notion of space—and one should add the equally important notion of rhythm—does not emerge as a key concept to explore in abstraction, as Henry privileged life and auto-affection.

Maldiney defines abstraction as follows:

> Abstraction isolates in thought that which cannot be in representation. However, what is impossible in everyday experience, not only has art the possibility to do it, but also is it art only because of it. Art makes exist separately (*subsister à part*) what thought isolates in abstraction.[47]

Opposing what he calls "pure abstraction" to Impressionism and Cubism, Maldiney goes on to claim that

> the artists of pure abstraction neither go to the object, nor do they depart from it. They want the space of the work [...] they intend to open a space where to be open to the openness of being. Being open means opening Nothingness (*le Rien*).[48]

Maldiney echoes Henry when he claims that "the issue of abstraction not only concerns a particular art form. [...] It is that of art itself. Art and work coincide in the being-work (*l'être-oeuvre*) in one advent".[49] Maldiney describes the advent as the act of "opening Nothingness".[50] As the reader may have realized, Maldiney's thoughts on abstraction are abstract themselves: they open up a space for thought that challenges traditional conceptions of what abstract art is and what abstract artists do.

Comparing and contrasting the comments made on Kandinsky in "Form and Informal Art", in the 1960s, with those in *Ouvrir le rien, l'art nu*, published close to four decades later, is quite an enlightening exercise. What emerges from this comparison is the damning verdict in Maldiney's last book-length publication, which suggests that Kandinsky's abstract painting would have failed to measure up to the philosopher's understanding of what abstraction should be.[51] One of Maldiney's criticisms has to do with the claim that Kandinsky's "thought and, increasingly, work feature a residual objectivism, which can be called an objectivism of essences".[52] The problem for Maldiney is that Kandinsky's essentialist stance—his "metaphysical objectivism"[53]— would nullify the key intention in *On the Spiritual in Art*: listening to the internal sounds and voices of forms and colors. Rather, Kandinsky would have unwittingly revived the intentional perceptive act in his return to the object in geometrical form and what Annegret Hoberg has described as "biomorphic configurations of shapes".[54]

Furthermore, the issue of color in Kandinsky's geometrical forms is of central importance in Maldiney's critique. One of Maldiney's major concepts is rhythm, and it surfaces in the critical discussion of color. Maldiney states that "Colour is form where it is rhythm",[55] and that "Colour is rhythm where, moving itself, it moves space. It is in such a space that the coloured rhythms and linear rhythms communicate *without being subordinated to each other*".[56] Maldiney notes that, after 1914, Kandinsky's "rhythms of colours are constrained".[57] The main issue for Maldiney is that the internal sounds discussed in Kandinsky's *On the Spiritual in Art* seem to be limited by the painter's definition of form as the delimitation of a surface. A form's auto-constitutive dimension would be incompatible with this limitation. The fate of Kandinsky's painting would lie in this tension between the definition of form as the delimitation of a surface and a form's auto-constitutive, rhythmic dimension.

Another of Maldiney's criticisms concerns the colors in Kandinsky's post-1914 paintings, which would lose "their transparency and their mobility".[58] Diffusive surfaces also disappeared with the loss of transparency, mobility and their "rhythmic coexistence that involved a simultaneity of depth, which is space itself".[59] According to Maldiney, what is to be deplored in Kandinsky's paintings after 1914 is that "a circulation of coloured fluxes *in* space" has replaced the "self-transforming, rhythmic auto-movement *of* space".[60] This change would signal, according to Maldiney, a type of representation that "is to the figurative what a geometrical figure is to a human figure: the figural, that is to say, objecthood (*l'objectité*) in its raw form".[61] The problem, for Maldiney, is that eliminating figuration to rely on the figural does not solve the problem of abstraction. In fact, Maldiney adds, the figural is a "signifying representation".[62] As Maldiney's aesthetics rejects signification per se, the philosopher comes to the conclusion that "An aesthetic form cannot be signified. In coming into being, it opens up the sphere of signification, as the Open (*l'Ouvert*) opens itself up in it".[63] The implication is that Kandinsky does reject representation in its figurative form, but that he would retain its intentional objective aim in the figural: "Freed from the figurative, the *figural* structures a work in its constructed state whose function is to

be representative of itself".[64] Forms would cease to be "events-advents (*événements-avènements*) opening and integrating, to the rhythm of the constitutive transformation they are when taking form, the ecstatic space(-time) of their apparition".[65] Maldiney's conclusion is that Kandinsky's art would display an internal logic that ossified itself in his late period (1933–1944). Each painting would become a "choreography of delimited forms".[66] On Maldiney's account, Kandinsky seemed to have lost his way in the pursuit of stationary forms. It is what Maldiney had in mind when he used the term "figural" to address Kandinsky's late work: the painter had abandoned pure abstraction to return to the figural image of geometry.

9.4 A Missed Encounter and a *Rapprochement*

Even though Henry and Maldiney held divergent views on Kandinsky's artistic legacy, one finds in their writings common concerns that make their work a fruitful site for comparative analysis. In a rare analysis of both philosophers, Philippe Grosos argues that one can discern two common theses with regard to the post-phenomenological perspective they adopted: the "radical critique of intentionality" and the "radical affirmation of the reality of feeling (*sentir*) and its irreducibility to the question of Being".[67] Indeed, what is particularly striking in their writings is that Henry and Maldiney both challenged the primordial role of intentionality in the founding documents of phenomenology that are Husserl's *Ideen* and Heidegger's *Sein und Zeit*, and they both rehabilitated feeling [*sentir*] in the world of art without ever addressing each other's publications in print. Most significantly, Maldiney's silence on Henry's Kandinsky book raises important questions given the crucial analyses at the heart of the 1988 publication on the painter and the influence it has had. It is difficult to believe that Maldiney was not familiar with Henry's study of Kandinsky, and his reluctance to engage Henry's work on the painter in *Ouvrir le rien, l'art nu* leaves a number of questions unanswered.

Notwithstanding this missed encounter between the two philosophers, one can certainly appreciate the remarkable connection they made between their post-phenomenological program, abstract painting and the *aesthetic epoché* that Kandinsky's work of the early 1910s first revealed. In his last book, Maldiney would further qualify Kandinsky's *aesthetic epoché* and the practice of abstraction itself. He writes: "Abstraction is neither a system nor a method. It is [...] a manner of existence (*façon de l'existence*)".[68] Conceived as a powerful form of thought in practice, abstract painting provides the post-phenomenological foundation for thinking abstraction as the "manner of existence" that both Henry and Maldiney sought in their common rehabilitation of feeling [*sentir*] via Kandinsky's oeuvre. Henry's and Maldiney's philosophical agenda to rethink phenomenology by bypassing the notion of intentionality and exploring the non-intentional character of embodied materiality is their original contribution to the unwritten study of 20th-century French philosophy's relationship to abstract painting.

Notes

1 Jean-François Lyotard, *Des Dispositifs pulsionnels*, Paris: Union Générale d'Editions, 1973, p. 80.
2 Gilles Deleuze, *Difference and Repetition*, trans. Paul Patton, London: Continuum, 2004, p. xvii.

3 Cf. "Phénoménologie hylétique et phénoménologie matérielle", in Michel Henry, *Phénoménologie* matérielle, Paris: PUF, 1990, pp. 13–59.

4 For an introduction to Michel Henry's philosophy in English, see Michael O'Sullivan, *Michel Henry: Incarnation, Barbarism and Belief*, Bern: Peter Lang, 2006. In other languages, one finds the monographs of Rolf Kühn, who has published both studies of Henry's philosophy (Rolf Kühn, *Leiblichkeit als Lebendigkeit. Michel Henrys Lebensphänomenologie absoluter Subjektivität als Affektivität*, Freiburg/Munich: Verlag Karl Alber, 1992, and Rolf Kühn, *Wie das Leben spricht: Narrativität als radikale Lebensphilosophie. Neuere Studien zu Michel Henry*, Dordrecht: Springer, 2015), and his own Henry-inspired philosophy named "radical phenomenology". On the latter, see Rolf Kühn, *Radicalité et passibilité. Pour une phénoménologie pratique*, Paris: L'Harmattan, 2003; Rolf Kühn, *Individuation et vie culturelle. Pour une phénoménologie radicale dans la perspective de Michel Henry*, Leuven: Editions Peeters, 2012; Sébastien Laoureux, *L'Immanence à la limite*, Paris: Editions du Cerf, 2005; and Grégori Jean, *Force et temps. Essai sur le "vitalisme phénoménologique" de Michel Henry*, Paris: Hermann, 2015. For a collection of essays specifically devoted to Henry's aesthetics, see Adnen Jdey and Rolf Kühn (eds.), *Michel Henry et l'affect de l'art. Recherches sur l'esthétique de la phénoménologie matérielle*, Leiden: Brill, 2012.

5 Gabrielle Dufour-Kowalska, *L'art et la sensibilité. De Kant à Michel Henry*, Paris: Vrin, 1996, pp. 8–9, emphases in original.

6 Philippe Sers, *Kandinsky—philosophie de l'art abstrait*, Paris: Hazan, 2016, p. 267.

7 Dufour-Kowalska, *L'art et la sensibilité*, p. 170.

8 Ibid., p. 11.

9 In the absence of English translations, Maldiney's work has not received much critical attention in the Anglophone sphere. However, his publications have been widely discussed in France, where they have been the subject of numerous colloquia and collections of essays. For a short introduction in English, see Éliane Escoubas, "Henri Maldiney", in Hans Rainer Sepp and Lester Embree (eds.), *Handbook of Phenomenological Aesthetics*, Dordrecht: Springer, 2010, pp. 193–195. Escoubas has published extensively on Maldiney. See Éliane Escoubas, "Du pathique et du rythme: singularité de Maldiney dans l'histoire de la philosophie", in Chris Younès and Olivier Frérot (eds.), *À l'épreuve d'exister avec Henri Maldiney. Philosophie—art—psychiatrie*, Paris: Hermann, 2016, pp. 117–125; Éliane Escoubas, *L'Esthétique*, Paris: Ellipses, 2017, pp. 217–228; Éliane Escoubas, "Le phénomène et le rythme: l'esthétique d'Henri Maldiney", in Éliane Escoubas, *L'Invention de l'art*, Brussels: La Part de L'Œil, 2019, pp. 199–209; and Éliane Escoubas, "Du sentir à l'œuvre: Maldiney et l'endurance de la peinture", in Éliane Escoubas, *L'Invention de l'art*, Brussels: La Part de L'Œil, 2019, pp. 211–235. Escoubas has also examined painting through the lens of Maldiney's post-phenomenology, including Kandinsky. See Éliane Escoubas, *L'Espace pictural*, La Versanne: Encre Marine, 2011, pp. 125–151.

10 Maldiney taught at the Université de Lyon for most of his career. Publishing the fruits of his teaching came later in life, in 1973, when Maldiney was sixty-one years old. The following decades would see the publication of several key works in philosophical aesthetics.

11 An influential publication on Maldiney was Erwin Straus's *Vom Sinn der Sinne. Ein Beitrag zur Grundlegung der Psychologie* (1935), where the French philosopher found the crucial notion of *Empfinden* (*sentir* [feeling]).

12 Maldiney thought that Cézanne's paintings truly revealed what *feeling* meant, going so far as to speak of a "Cézannian phenomenology" in which the painter would perform an aesthetic *epoché* showing the painted objects' primordial manifestation in the gradual ruin of representation.

13 A particularity of Maldiney's post-phenomenological aesthetics is that, throughout his career, the philosopher appropriated concepts from Chinese landscape painting to create his own. Although there is no space to discuss the issue here, Maldiney's recourse to the tradition of Chinese aesthetics and the landscape painting of the Song would deserve a closer look, as it does present essentialist tendencies.

14 Generally speaking, Maldiney's publications tend to focus on French poets and painters. See Henri Maldiney, *Le Legs des choses dans l'œuvre de Francis Ponge*, Paris: Cerf, 2012; Henri Maldiney, *L'Art, l'éclair de l'être*, Paris: Cerf, 2012; and Henri Maldiney, *Aux Déserts que l'histoire accable. L'art de Tal Coat*, Paris: Cerf, 2013.

15 Frédéric Jacquet, *La Transpassibilité et l'événement. Essai sur la philosophie de Maldiney*, Paris: Grasset, 2017, p. 41.
16 Henri Maldiney, *Regard parole espace*, Paris: Cerf, 2012, p. 208.
17 Ibid., p. 229.
18 Ibid., p. 50.
19 Henri Maldiney, "Notes sur le rythme", in Jean-Pierre Charcosset (ed.), *Henri Maldiney: penser plus avant … Actes du colloque de Lyon (13 et 14 novembre 2010)*, Chatou: Editions de La Transparence, 2012, p. 20.
20 Jacquet, *La Transpassibilité et l'événement*, p. 109.
21 Henri Maldiney, *Art et existence*, Paris: Klincksieck, 2017, p. 15.
22 The notion of *affect* in Anglophone scholarship approximates Maldiney's notion of *sentir*.
23 Wassily Kandinsky, *Complete Writings on Art*, Kenneth C. Lyndsay and Peter Vergo (ed.), New York: Da Capo Press, 1994, p. 165.
24 Jean-Claude Lebensztejn, "Passage: Note on the Ideology of Early Abstraction", in Terence Maloon (ed.), *Paths to Abstraction 1867–1917*, Sydney: Art Gallery of New South Wales, 2010, p. 38.
25 Michel Henry, *Voir l'invisible. Sur Kandinsky*, Paris: François Bourin, 1988.
26 For analyses of Henry's Kandinsky monograph, see Jérôme De Gramont, "Critique de la peinture pure", *Cahiers philosophiques* 65, 1995, pp. 23–37; Pierre Rodrigo, *L'Intentionnalité créatrice. Problèmes de phénoménologie et d'esthétique*, Paris: Vrin, 2009, pp. 266–285; Yannick Courtel, "L'invisible du visible. Notes sur l'esthétique de Michel Henry", *Cahiers philosophiques de Strasbourg* 30, 2011, pp. 235–248; and Pierre Rodrigo, "'La vie à l'oeuvre': le Kandinsky de Michel Henry", in Grégori Jean and Jean Leclercq (eds.), *Lectures de Michel Henry. Enjeux et perspectives*, Louvain: Presses universitaires de Louvain, 2014, pp. 211–227. In addition to his *Kandinsky*, Henry devoted three publications to the painter, which are collected in Michel Henry, *Phénoménologie de la vie. Tome III. De l'art et du politique*, Paris: PUF, 2004, as well as a lecture given one year after the publication of his book on the painter: Michel Henry, "Peindre l'invisible", in Adnen Jdey and Rolf Kühn (eds.), *Michel Henry et l'affect de l'art. Recherches sur l'esthétique de la phénoménologie matérielle*, Leiden: Brill, 2012, pp. xxv–xlii.
27 Rodrigo, *L'Intentionnalité créatrice*, p. 271.
28 "Art et phénoménologie de la vie", in Michel Henry, *Auto-donation. Entretiens et conférences*, Paris: Beauchesne, 2004, p. 202.
29 Michel Henry, *Seeing the Invisible: On Kandinsky*, trans. Scott Davidson, London: Bloomsbury, 2009, p. 2.
30 Hans Rainer Sepp and Rolf Kühn have examined the phenomenological *epoché* in the context of Kandinsky and abstract painting. See Hans Rainer Sepp, "Riduzione fenomenologica e arte concreta. Sull'affinità tra fenomenologia e pittura moderna: Husserl e Kandinsky", in Gabriele Scaramuzza (ed.), *La fenomenologia e le arti*, Milan: Edizioni Unicopli, 1991, pp. 113–135, and Rolf Kühn, "Kunst als verfleischlichte Leiblichkeit. Kulturelles Bedürfen und Ästhetik", *Zeitschrift für Ästhetik und allgemeine Kunstwissenschaft* 38 no. 2, 1993, pp. 155–183.
31 Henry, *Seeing the Invisible*, p. 26.
32 Ibid., p. 112.
33 Kandinsky, *Complete Writings on Art*, p. 532.
34 Henry, *Seeing the Invisible*, p. 10.
35 Ibid., p. 59.
36 Ibid., p. 121.
37 Ibid., pp. 121–122.
38 Ibid., p. 28.
39 Dufour-Kowalska, *L'art et la sensibilité*, p. 195.
40 Maldiney, *Regard parole espace*, p. 50.
41 Henri Maldiney, *Ouvrir le rien, l'art nu*, La Versanne: Encre Marine, 2000, p. 204.
42 Maldiney, *Regard parole espace*, p. 157.
43 Ibid., p. 155.
44 Ibid.
45 Ibid., p. 156.

46 Anne Boissière, "Henry Maldiney et l'art: une pensée intempestive. L'œuvre d'art en présence", 2018. Philopsis. www.philopsis.fr/spip.php?article400.
47 Maldiney, *Ouvrir le rien, l'art nu*, p. 166.
48 Ibid., p. 172.
49 Ibid., p. 173.
50 Ibid.
51 Giuseppe Santonocito provides a rare look at Maldiney's criticisms of Kandinsky in *L'Esperienza estetica. La fenomenologia di Henri Maldiney*, Milan: Mimesis, 2008, pp. 148–149.
52 Maldiney, *Ouvrir le rien, l'art nu*, p. 180.
53 Ibid., p. 180.
54 Annegret Hoberg, "Vasily Kandinsky—Abstract. Absolute. Concrete", in Helmut Friedel (ed.), *Kandinsky—Absolute Abstract*, Munich: Prestel, 2008, p. 212.
55 Maldiney, *Ouvrir le rien, l'art nu*, p. 182.
56 Ibid., p. 183, emphasis in original.
57 Ibid., p. 184.
58 Ibid., p. 185.
59 Ibid., p. 186.
60 Ibid., p. 185, emphasis in original.
61 Ibid., p. 185.
62 Ibid., p. 186.
63 Ibid.
64 Ibid.
65 Ibid.
66 Ibid., p. 187.
67 Philippe Grosos, "Henri Maldiney, Michel Henry et la critique de la phénoménologie", in Jérôme de Gramont and Philippe Grosos (eds.), *Henri Maldiney. Phénoménologie, psychiatrie, esthétique*, Rennes: Presses universitaires de Rennes, 2014, p. 15.
68 Maldiney, *Ouvrir le rien, l'art nu*, p. 197.

Part III
Redefining Abstraction— Analog vs. Digital

10 Visual Music and Abstraction

From Avant-Garde Synesthesia to Digital Technesthesia

Michael Betancourt

Digital media and "glitch art" continues the tradition of abstraction known as "visual music" that is most apparent in avant-garde films and the early modern embrace of synesthetic forms as a metaphor (and model) for visualizing spiritual beliefs through the relationship of sound to color;[1] their work, "synesthetic abstraction" is sometimes identified as "kinetic abstraction".[2] The art critical use of the term "synesthetic" differs from psychology, where it has a limited and precise, technical meaning: "cross-modal sensory experience" that describes a real, physiological condition where two distinct senses (such as seeing and hearing[3]) are linked, producing simultaneous sensations from a singular experience (such as seeing colored forms while hearing music).[4] This history involves those artists working in film, painting and live performance, whose creations are unified by the attempt to render a metaphysical reality immanent by employing the rhythmic and compositional structures familiar from music visually, in painting[5] or film.[6] Instead of disrupting naturalism in the name of autonomy for art,[7] this type of abstract art, influenced by the 19th-century Romanticism, cultivates hybrids and transfers between media.[8] This model of abstraction identifies a withdrawal from the realm of everyday appearances in an attempt to present the noumenal, a metaphysical reality: in visual music it identifies a specific concern with developing analogies between sound and image which identifies this aesthetic history.[9] The avant-garde took these subjective experiences as an inspiration for their work, no less an explicit statement in Wassily Kandinsky's theorization *Concerning the Spiritual in Art*[10] than an implicit dimension of filmmaker Stan Brakhage's argument about "closed-eye vision" in *Metaphors on Vision*,[11] while the esoteric paintings of Hilma af Klint make the link between abstraction and spiritualism explicit.[12] Recognitions of the continuities between early abstract art (such as painting or the visual music film), the productions of the mid-20th-century film avant-garde and the contemporary abstractions generated by digital processes are not new.[13] The contemporary phenomenon of "glitch art" extends this history of synesthetic abstraction into the present.

10.1 Synaesthetic Foundations of Abstraction

Synaesthesia is a foundational concept in the invention of abstraction, appearing through the metaphor of "visual music" that has had a lasting influence on art,[14] apparent in abstract painting, avant-garde film, video art and computer art.[15] This nexus of ideas about sound, color, form and realism first converged in the years immediately prior to World War I. Formalist art critic Roger Fry predicted the transition from recognizable forms to abstract shapes and colors arranged on the canvas in 1912,

using the established abstraction of music to explain the on-coming shift away from representation in visual art:

> [These painters] do not seek to imitate form, but to create form; not to imitate life, but to find and equivalent to life. By that I mean that they wish to make images which by the clearness of their logical structure, and by their closely-knit unity of texture, shall appeal to our disinterested and contemplative imagination with something of the same vividness as the things of actual life appeal to our practical activities. In fact, they aim not at illusion but at reality. The logical extreme of such a method would undoubtedly be the attempt to give up all resemblance to natural form, and to create a purely abstract language of form—a visual music.[16]

The metaphor that Fry uses to explain these aesthetics, "visual music", is common to artists and writers addressing the development of abstraction. His review of paintings by Henri Matisse, Pablo Picasso, André Derain, Auguste Herbin, Jean Marchand and André L'Hote makes the connections between abstraction and the earlier "color music" an immediately apparent part of how he explains these works of near-abstraction. Music is the first model for abstraction because it is free from representational links that subjugate painting to the world of sensory experience and its organization in the form of everyday objects.[17] His analysis denies the representation's immediate, recognizable forms of everyday life to argue for the presentation of an unseen, transcendent reality that is otherwise invisible to perception. What he theorizes as the "logical extreme" was being achieved as he wrote his review, first appearing in the abstractions produced by painters František Kupka and Wassily Kandinsky. The harmonious arrangement of colored forms that Fry discerns in the *near*-abstraction of Matisse's or Derain's paintings will rapidly become devoid of familiar appearances with the invention of abstraction over the course of the decade following his review. His discussion anticipates these "novel" aesthetic developments: in the 1910s, both the expressionist and constructivist strands of abstract painting, such as Kazimir Malevich's *Suprematism*,[18] attempt to create what Fry proposes—a "purely abstract language of form". These paintings by Kupka, Malevich and Kandinsky present a "deeper realism" born of the mind, visualized as a realm of pure geometry and color arranged in an analog to music.[19]

Their innovations established a specific iconography that reproduced the same "synesthetic form constants" seen by color-sound synesthetes.[20] These graphic patterns (Figure 10.1) were empirically classified by German psychologist Heinrich Klüver in his study "Mescal and Mechanisms of Hallucination", published in 1932: (a) grating, lattice, fretwork, filigree, honeycomb or chessboard; (b) cobweb; (c) tunnel, funnel, alley, cone or vessel; (d) spiral.[21] These hallucinatory forms describe the visual character of abstract art generally[22]; they are common formal descriptions of abstraction throughout the 20th century. These aesthetic constants are also obvious in abstract film, video art and digital art, masking the alienation and disruption that all new media potentially offer by converting novelty into familiarity and rendering the unfamiliar mundane.[23] Recapitulation of the established and familiar iconography of historical abstraction is a factor in the development and acknowledgment of new media such as "glitch art" that rely on the generative processes of computers: the artifacts generated by computer *mis*function (and occasional *mal*function) produce a wide range of graphics that resemble Klüver's "synesthetic form constants"—especially the

Figure 10.1 Diagram showing a collection of "synesthetic form constants" described by Heinrich Klüver in *Mescal and Mechanisms of Hallucination*, 1932, photo: courtesy of the author; Artists Rights Society (ARS).

highly geometric gratings, lattices and chessboards—enabling the aesthetic continuation of familiar iconography (synesthetic abstraction) in a new medium. This association is simultaneously startling and predictable: familiar and already-established aesthetics from historical media and art are prioritized in the art made with new technology, maintaining the stability of traditional aesthetics.[24]

Moving between live performance, motion pictures and abstract painting,[25] early practitioners of visual music in film typically worked both as painters and as animators because they wanted to abandon static compositions for the direct presentation of real movement and the synesthetic potentials afforded by the new technical art. The apparatus that made this transfer possible, a cardinal invention of this age—the motion picture camera and its projector—was a fusion of 19th-century technologies (photography, electricity and the incandescent lamp) that allowed a modern realization of a much older aspiration[26] to demonstrate a transcendental link[27] between light and sound.[28] Futurists Bruno Corra and Arnaldo Ginna explicitly connected synaesthesia to abstraction; their development is typical of later artists, who often shift/divide their efforts between painting or film and the construction of a live performance instrument or "color organ".[29] Corra and Ginna created the first avant-garde films as direct animations drawn on clear film stock between 1909 and 1912, explaining

their now-lost films in the manifesto, "Abstract Cinema—Chromatic Music".[30] Their discussion and experiments with live performance and direct animation link the 19th-century conception of an immobile framework of the "color organ" that demonstrates "color music" (via an assignment of colors to notes in an attempt to demonstrate the pseudo-scientific belief that "light and sound are similar"[31]), to the invention of abstract film.[32] The fluid movement by artists between these activities is not unusual; the change of medium was neither a failure of aesthetics nor a conceptual deficiency, but a technological one because their "color organ" apparatus, an electrified piano, was incapable of producing the desired effects.[33] These visual music animations fulfilled an ambition to illustrate the "true nature" of the world: this concern has directed avant-garde film from its beginning.

The formal arrangement, timing, and design of the audio-visual synchronization in motion pictures descends from the first abstract animations that were all variously innovations, inventions and experiments with producing a kinetic analog to the then-recent developments in avant-garde painting.[34] The histories of abstraction on film and in avant-garde painting are not simply parallel evolutions—visual music and early abstract painting intersect and share the influence of Theosophy.[35] Anne Besant and Charles Leadbetter's theosophical treatise *Thought Forms* (first published in 1901) gives the synesthetic form constants that Klüver will describe in the 1930s a specifically transcendent meaning as visual projections of mental/emotional activity.[36] These transfers between Theosophy and abstraction are especially obvious in the "absolute films"[37] made in Germany in the 1920s by Walther Ruttmann.[38] His animations used increasingly geometric imagery in each of the *Lichtspiel: Opus I–IV* (1921–1925) series, develop a non-narrative and nonrepresentational style: the brushy, expressionist forms in *Opus I* become sharp-edged kinetic bands and curves in *Opus IV*, revealing the emergent influence of Constructivism in the 1920s and the direct connection between painting and these earliest surviving "visual music" motion pictures.[39] The central relationship between the work of painting and that of abstraction in film was of both practical and theoretical concern to these artists, as Ruttmann's statement on his work, *Malerei mit Zeit* (*Painting with Time*), from 1919 attests:

> An art meant for our eyes, one differing from painting in that it has a temporal dimension (like music), and in that its artistic foci are not to be found (as in the picture) in the rendition of a (real or stylized) moment in an event or fact, but rather precisely in the temporal unfolding of its form. [...] This new art form will give rise to a totally new kind of artist, one whose existence has been only latent up to now, one who will more or less occupy a middle ground between painting and music.[40]

His rejection of a "rendition of a (real or stylized) moment" to visualize the unseen, "true nature of reality" demonstrates the spiritual concerns of *Thought Forms*, rendering the imagery that appears in that book the same as his animations on-screen (Figure 10.2). That these visuals are conceived as belonging to the "middle ground between painting and music" is obvious from the title *Lichtspiel—Opus I* (Lightplay: Opus I). Ruttmann's films are typical of fellow "absolute" filmmakers Viking Eggeling,[41] Hans Richter[42] and Oskar Fischinger[43]; the same use of "synesthetic form constants" and the established imagery of painterly abstraction connects all their visual music films.[44] The synesthetic is part of all these developments through the translation of

Figure 10.2 (Upper row) Annie Besant and C.W. Leadbeater, "Illustrative Thought-Forms" as shown in plates 19, 23, and 27 from *Thought Forms*, 1901; (middle and lower row) Walther Ruttmann, selected stills from *Lichtspiel—Opus I* [Lightplay: Opus I], 1922 (Eva Riehl reconstruction), photos: public domain.

non-visual into visual—in the link of sound::image—initially through musical scores composed to be performed live in a synchronized counterpoint and (later) in organization by the recorded and synthetic soundtrack.[45] However, what matters for later visual music works in these initial films is the concern with making an unseen order immanent through synesthetic form.

10.2 Making the Metaphysical Reality Perceptually Immanent

These attempts to render a metaphysical order that lies *outside* perception in an immanent form that can be perceived and considered—thus presenting a "reality of the mind"—are essential to understanding abstraction as having a metaphysical significance. Visual music attempts to illustrate this immaterial realm in an "attempt to give up all resemblance to natural form, and to create a purely abstract language of form" by reducing and eliminating familiar details. The results are understood as a refinement that presents what the German Idealist philosopher Georg Wilhelm Friedrich Hegel described in the *Phenomenology of Mind*:

> The simple ultimate spiritual reality (*Wesen*), which, by coming at the same time to consciousness, is the real substance, into which preceding forms return and in

which they find their ground, so that they are, with reference to the latter, merely particular moments of its process of coming into being, moments which indeed break loose and appear as forms on their own account, but have in fact only existence and actuality when borne and supported by it, and only retain their truth in so far as they are and remain in it.[46]

The "spiritual" meaning associated with visual music and abstract art generally derives from an aspiration to make a transcendent, metaphysical reality perceptually immanent: the "absolute knowledge of the world" that becomes evident in these works provides an insight into the "first principle of the world"[47] that then becomes an elevation of humanity toward a similar level of spiritual consciousness. The metaphor of "insight" is not coincidence. Hegel understands this shift as the transformation of the external reality into an internal, mental order that challenges mere appearances (perception) of the everyday world: it requires a qualitative change to become the *universal* reason apart from the normal resemblances of familiar reality. His approach to the "realism of the mind" through a process of advancement toward an essential purity became increasingly important to abstraction in the 20th century.[48]

Hegel's assertion of knowledge through vision is an ordering of the world that implicitly demands specifically *visual* proof.[49] Abstraction provides this demonstration through the identification of the cross-modal experience of sound–color synaesthesia as presenting a metaphysical experience. This directive gives the transfer of the characteristic, hallucinatory visual forms of synesthetic perception into abstract visual art its characteristic "spiritual" meaning as a material description of the hidden nature of "the real". The abstract expressionist painter Hans Hoffman described this shift as "surreal" in his article "The Search for 'the Real' in the Visual Arts":

> Although these forces are surreal (that is, their nature is something beyond physical reality), they, nevertheless, depend on a physical carrier. The physical carrier (commonly painting or sculpture) is the medium of expression of the surreal. Thus, an idea is communicable only when the surreal is converted into material terms. The artist's problem is how to transform the material with which he works back into the sphere of the spirit.[50]

Hoffman identifies "spiritual significance" as an intangible factor of art that only impacts its audience when it becomes immanent in the work, i.e., when it is demonstrated in material terms as a fact. This "surreal" dimension is not precisely that of the French avant-garde movement.[51] Hoffman's term is consistently supernatural, a transfer from the metaphysical interpretation into immanence that places the appearances of the work within the realm of realism, not only as physical objects, but as works whose understanding is connected to reality rather than merely to depiction. These historical interrelationships between synaesthesia and abstract art are complex and identify a specific variety of abstraction predicated on an analogy between visual form and sound/music that emerges in the 19th-century Romantic analogy between imagery and music, which understands the *experience* of synaesthesia as a merging of "subjective" and "objective" encounters with reality.[52] This view of cross-modal experiences, understood them as escaping the predetermined, mechanical world of empirical science and behaviorist psychology,[53] illustrates the links between the transcendence of synaesthesia and the universal, utopian aspirations that inform Hoffman's argument

about *transcendent* realism. This utopia/decay dialectic frames the meaning of abstraction in an opposition between a transcendent state visualized by Klüver's synesthetic form constants and the rationality of materialist science that transforms them into everyday appearances.[54] This opposition between physicality and transcendence enables the subjective understanding of the world offered by abstraction as an objective "fact": visual music thus becomes a revelation of higher levels of reality than those normally available in the mere appearances of the world. These conceptions of a metaphysical and spiritual realm visualized through abstraction provide not only a foundational framework of imagery, but a semantic lexicon of meanings for those images, distinguishing these synesthetic compositions from simple decorative patterning via their semiosis.

10.3 "Noise" in Early Computer Graphics

The graphic nature of Klüver's "synesthetic form constants" makes their translation into the flat geometries of abstraction an easily understood application of these forms, one which gives the resulting iconography an immediately recognizable meaning for audiences familiar with the synesthetic tradition of visual music. The nexus of convergence between the physiological process of synesthetic sound–color perception and the articulation of spirituality in painting and visual art are a formal heritage that is immediately obvious in the graphics and imagery generated by digital computers. This relationship between the forms of historical abstraction and computationally generated imagery was initially noted at Bell Labs in Murray Hill, New Jersey, by computer scientist A. Michael Noll.[55] The generative nature of early computer graphics reflected the limitations of computational power—both in terms of resolution and in the initial constraint on imagery as patterns of geometric forms.[56] The limitations on digital imagery that Noll described are readily apparent in the graphics produced by Kenneth Knowlton in his film *A Computer Technique for the Production of Animated Movies* (1964) made at Bell Labs using BEFLIX, an animation programming language that expanded on commands and structures in FORTRAN. The low resolution of the imagery, 252 by 184 pixels, with six levels of gray anchored by pure black and white for a total of eight values meant that both the pixels and their arrangement on-screen necessarily became features of their aesthetic form.[57]

The patterns that are easily generated by computers have the same repeating graphic patterns of Klüver's form constants, but at the same time suggest circuit boards, anticipating the postmodern paintings by Neo-Geo artists such as Peter Halley in the 1980s.[58] Artist Lillian Schwartz, during her time as an artist-in-residence at Bell Labs, identified the formal connections between early abstraction and flat, geometric graphics of computer imagery as the direct inheritor of this tradition that becomes immediately apparent in her work as kinetic, flowing patterns that change shape and spread across the screen in her abstract, computer-generated films such as *Pixillation* (1970), *U.F.O.s* (1971), or *Olympiad* (1973). The tension between recognizable "runner" in *Olympiad* and its decomposition into abstract geometry creates fields of repeating graphics across the screen, leaving traces of its motion-path readily visible. The limitations of computer graphics in the 1970s are evident in the ways these restrictions became a part of the "grammar" of media art. Sheldon Brown, Director of the Center for Research in Computing and the Arts at the University of California, San Diego,

noted their prominent role as a revelation of the "substance" of these electronic, generative images:

> Bit-depth, gamma range, object edges and noise were some of the new compositional elements that analog and digital signal processing made apparent. Over the following decades this new semantics permeated image culture at large, becoming the *de facto* material basis by which media is produced.[59]

These formal elements that Brown identifies are immediately apparent in how Schwartz's earliest films incorporate non-digital elements. Her first computer film, *Pixillation* (1970), employs extended montages that contrast geometric patterns painted in live action photography, with the same types of forms generated by a computer, making the differences between these types of imagery fully apparent. The opposition this intercutting sets up between analog and digital is also a transformation of the same imagery: a concentric, rectangular pattern familiar from Klüver's research. These "synesthetic form constants" are an immanent feature of this film, one which reappears in her later films as well—they are especially obvious in *U.F.O.s* and *Olympiad*. The repeating concentric shapes—what are initially squares in *Pixillation* become increasingly "organic" blobs—have the same, distinctly serial nature as the repeating geometric patterns of the first glitch video *Digital TV Dinner* (1978/1979). Figure 10.3 shows the patterns produced by Jamie Fenton's physical assault on the *Bally Astrocade: The Professional*

Figure 10.3 Jamie Fenton, selected stills from *Digital TV Dinner*, 1978/79, photo: courtesy of the artist.

Arcade Expandable Computer System. These glitches were generated by striking the machine hard enough to cause the game cartridge to pop out. What appears on-screen are the visual results of a partial system crash that happened while the machine was drawing the on-screen menu.[60] These images are the instrumental products of a partially (in)complete mechanical operation; they are potentially present at all times for these devices, but are rarely acknowledged or identified as anything other than a momentary breakdown that can be readily fixed. What Brown describes as "noise" *is* and *is not* the particular affect of the patterns generated by the breakdowns that Fenton instigated: these eruptive patterns replace the familiar, comprehensible image/text with abstraction, a repeating series of regular forms whose organization converges on the same linearity of Lillian Schwartz's films made at Bell Labs with the BEFLIX and EXPLOR animation languages. What matters in Brown's conception of "signal processing" is its essentialism: the understanding of these technical artifacts as a presentation that reveals the ontology of the media, its material basis, which then becomes the starting point for aesthetic expression, stressing materiality-as-process that constructs each art from the particular characteristics of the medium.[61] These semantics express a desire for a fixity of signification which ontological concerns only seem to provide by allowing the confusion of the representation for the thing itself, an ironic development since what is signified in these abstractions is a transcendence of the everyday appearances of the physical world. This transformation is an instrumental attempt to realize Hegel's "ultimate spiritual reality" as immanent in/to abstract art.

This ontological concern—the "thingness" of the medium itself that noise reveals[62]—creates the self-reinforcing concern with the technical specifics of each medium identified by Brown. This basis gives his collection of features their currency, "bit-depth, gamma range, object edges and noise", which are all specific to (analog and digital) systems, reflecting the material dimensions of electronic imaging. This list for electronic media specifically parallels the collection of features P. Adams Sitney identified for analog motion pictures as the "Structural Film": fixed camera position (fixed frame from the viewer's perspective), the flicker effect, loop printing and rephotography off the screen all attend to the materiality of celluloid motion picture technology, drawing attention to the opticality of photography–projection.[63] This concern with the materiality of media unveils the paradox at the heart of these abstractions: that they are an attempt to render the unseen "universals" of human experience visible.[64] This network of relationships between abstraction, synaesthesia and technology are more than just a set of congruencies.[65] A concern with them as a literal *material* that crystalizes the invisible has been a part of their aesthetics since the 1920s,[66] a recurring aspect of how artists have addressed the technologies of motion pictures, video art and computer graphics.

10.4 Digital "Glitches" and the Reality of Machines

The pixelated, sampled media that produces digital glitches continues this heritage. The banality of these technical failures as transient surface flaws indicative of the materiality of the digital technology also leads to their uncritical dismissal as insignificant, as philosopher Jacques Attali explains about non-musical "noise" generally:

> Everywhere codes analyze, mark, restrain, train, repress and channel the primitive sounds of language, of the body, of tools, of objects, of the relations to self and

others. [...] Clamor, Melody, Dissonance, harmony; when it is fashioned by man with specific tools, when it invades man's time, when it becomes sound, noise is the source of purpose and power, of the dream—music.[67]

The translation of these concerns with order and expression into a visual form yields "visual music" as Roger Fry suggested in 1912. The progression and connection of these ideological concerns to the technical elaboration and materiality of media is a logical consequence of this recurrent desire to visualize what cannot be seen and which gives this formalist attention to the material dimensions of media its particular currency in media art. The differentiation between "signal" and the interruptions of "noise" is an imposition of a familiar order. The designation "noise" is nothing less than a labeling of those elements that are *not relevant* for interpretation and can then be ignored.[68] In the anthology *Postdigital Aesthetics*, historians Christiane Paul and Malcom Levy explain the meaning of these transient failures' emergence for the procedural basis of digital media, as they begin to signify rather than interrupt:

> The terms "glitch" and "corruption artifacts" in the broadest sense refer to images and objects that have been tampered with; their creation relates to the core of the media apparatuses used to store, produce and relay information. These corrupted images can be created by adjusting or manipulating the normal physical or virtual composition of the machine or software itself, or by using machines or digital tools in methods different from their normative modalities.[69]

The materiality of "noise" presents a specific collection of artifacts and forms that circumscribes the physical exhibition of digital media, whether audio or visual. The place of aliasing, crashes, distortion and errors[70] in the semantics of digital culture is not simply a product of their material nature. They embrace also a reflection of how these visual breakdowns recreate the same set of synesthetic forms described by Klüver in a complex way: the levels of order displayed by the images in Figure 10.4 betrays discrete structures common to historical abstraction, but arrayed in novel ways. These stills from two very different glitch videos each contain the same formal element—a grating, lattice or checkerboard structure—obvious in the grids of squares that recur. These modular units simultaneously contain additional, noticeably linear and graphic elements which combine to form other, repeating patterns that fill the image, providing a second level of organization apart from the grid. Digital glitches reconfigure the older iconography developed in painting and animation, facilitating an imaginary transfer between electronic imaging and human perception that sustains the continuity of historical meaning for these visuals that serve to elide the novelty of new technology by asserting its familiarity.[71] This conception of what appears on-screen as a surrogate for human vision has a particular place in the theorization of naturalistic cinema by film theorist André Bazin,[72] who argued that the ontology of photography creates a direct link (the "presentation effect" of motion pictures[73]) between what appears on-screen and the recorded profilmic events that are the source, discursively functioning as a revelation of a socially defined reality.[74] It is the same ontological concern that leads to the materialist engagement with media—the desire to link the representation to the represented in a way that defeats the artifice of realism by turning it into reality.[75]

Figure 10.4 Michael Betancourt, selected stills showing digital glitches from *Malfunction*, 2000, Artists Rights Society (ARS); photo: courtesy of the author.

The presentation on-screen thus serves as an articulation of this ontological reality for the audience, a revelation of a world on-screen that enables a consideration of the "conditions of reality"—the way the actual world is organized.[76] This illusionistic understanding of media imagery entails a seeing-through that transforms the display on-screen into an illusory space "in" which events occur[77]; the rupture of that illusion then functions as an intrusion of reality.[78] The continuity between the graphic breakdowns of glitches, abstraction, and visual music gives these interruptions their particular metaphysical significance as a revelation of an unseen reality. These relationships are circular, continuously returning to the same transcendent meaning for synesthetic abstraction as a revelation of an unseen, hidden order. The importance of this ontological conception of materiality in media comes into focus as the demand that it not be simply a representation of this experience, contingent and thus artificial,[79] but instead be a realization interchangeable with the experience itself, *being* rather than *signifying*—reality rather than mere representation.[80] This assertion for the ontology of motion pictures is a product of the same search for "the real" that Hans Hoffman expounded upon for mid-century abstract painting.

The convergence of visual music with glitch is obvious from these metonymic repetitions and their implicit meaning as a transcendent presentation. The resulting appearances "flirt" with disaster without actually becoming real failures.[81] Digital

facture (performed by software) employs instructions (digital file) to create an abundance of new works on demand and thus hides the operations of the device: everything "inside" the computer exists as numerically encoded data that when "replayed" for a human audience appears continuous.[82] Glitches develop the difference between *being* failure, *representing* failure (as the use of visual glitches in a dramatic, narrative work) and the *semiosis* of failure-as-aesthetic (its role as an artifact presented and used for aesthetic purposes) common to digital materiality.[83] The unstable character of these works draws attention to the audience as the crucial mediator of meaning.[84] Without past experience and prior knowledge, abstraction can easily collapse into a decorative pattern—the audience that asks *but what is it?* is not addressed by the work.[85] The generative nature of digital media becomes obvious in the understanding of glitches as artifacts of automated processes that reiterates the apparent facticity of photography: the glitch appears automatically, as a product of typical machine operation that is nevertheless aberrant,[86] giving its correspondence to synesthetic forms an aspect of "reality", not normally present in abstract imagery which leads to claims for its criticality.[87]

Unlike the patterns and forms appearing in traditional visual music animations which must be planned and executed to appear at all, the digital glitch is a product of the machine's normal operations behaving in unexpected ways (if the machine were to completely breakdown, there would be nothing rendered for the audience).[88] The materialist understanding of glitches depends on this autonomy, while its convergence with the established iconography of abstraction is of peripheral acknowledgment: instead, the hypothetical *perfect reproduction* is reified as the "norm" for digital reproduction[89]—identifying anything produced by the machine as "glitch" (as a "failure") is *only* possible because its audience recognizes it as different from both the *anticipated* imperfections of the immanent work *and* what they expect the ideal form to be; the glitch shows the *reality* of the machinic processes themselves, rather than an ambiguous result of a stoppage that demands human consideration.[90] This emphasis on the materiality of media as a revelation of their underlying reality as a physical product of machinic operations becomes a simultaneous presentation of that which is not normally apparent to everyday sensation. The assumption dominating discussions of aesthetic synaesthesia in relation to any technical apparatus is that an analogous transfer of iconography and procedures following a human-determined and controlled paradigm based in perception results in a technical approximation of those perceptions—in the case of synesthetic abstraction, this product is "synaesthesia". Glitches provide this logical analogy for synesthetic form within a technical matrix, a *technesthesia*,[91] where the comparison is more than coincidence: occasional mis-attribution of digital files and their consequent mis-interpretation through the "wrong" software generates valid-yet-aberrant results.[92] *Technesthesia* is a metaphor for this misfunction and misdirection of autonomous processes; however, to understand it as a literal overlap with the human synesthetic experience would be a fundamental category mistake,[93] a confusion of the media work understood as a diagram of consciousness or a model of "the real",[94] with the reality being modeled. This instability is precisely the purpose of those aesthetics understood as *transcendent*—the convergence of representation with the represented is an essential goal of *all* realist arts[95]—that makes the ontological claims for media especially important: the assertion of their significance as a function of their ontology short-circuits the difference between the reality and the model allowing them to be interchangeable.

10.5 Conclusion

Synesthetic abstraction and its heritage as simultaneously *expressing* and *being* a transcendent revelation of an underlying or metaphysical reality becomes immanent in the duality of meanings ascribed to the technical misfunctions and short-circuits that create glitches in analog and digital systems. The visual forms autonomously generated in these technical failures coincidentally converge with the historical iconography of abstraction, allowing and then authorizing them as the continuation of an aesthetic tradition that sought to demonstrate subjective experiences in the immanence of art. The autonomy of digital systems' generation of these familiar iconographies gives them their currency as the perpetuation of this approach to abstraction and its significance. The contemporary embrace of these digital images derives from this recapitulation of encultured significances established for earlier abstract art, thus asserting the cultural continuity between modern, postmodern, and contemporary works which are otherwise dissimilar in production, exhibition and distribution.[96] The viewer's ability to conceptualize and interpret abstraction across these differences is dependent upon their familiarity with the varied aesthetic traditions and contexts of abstraction, much as the understanding of language and culture requires past experience to effectively navigate their subtleties of expression, depending precisely on assignments of value that begin as the differentiation between "noise" and "signal/music". The avant-gardist tendency to expand and breakdown these distinctions continues with the transformation of technical failures into art.[97] The recognition of "visual music" abstractions, whether in traditional art or contemporary digital media, depends on the audience's attentiveness to the iconography of synaesthesia as much as to the relationships of audio-visual synchronization. These images and movies are understood as a visual, graphic parallel to the formal designs that create musical order. The synesthetic experience and its hallucinatory imagery lie at the foundations of this visual music tradition—a connection between subjective experience and aesthetic form documented by the graphic patterns and structures recognized by Klüver's form constants. Their presence and recurrence throughout this history are neither surprising nor unusual. It is the evidence for the continuity of this tradition, independently of its means of production.

Notes

1 Maurice Tuchman, "Hidden Meanings in Abstract Art", in Maurice Tuchman (ed.), *The Spiritual in Art: Abstract Painting, 1890–1985*, New York: Abbeville, 1985, pp. 17–62.
2 Frank Malina, *Kinetic Art*, New York: Dover, 1974.
3 Laura Marks, "On Colored-Hearing Synaesthesia: Cross-Modal Translations of Sensory Dimensions", in Simon Baron-Cohen and John E. Harrison (eds.), *Synaesthesia: Classic and Contemporary Readings*, Cambridge: Blackwell, 1997, pp. 49–98.
4 Bulat Galeyev, "Open Letter on Synaesthesia", *Leonardo*, vol. 34, no. 4, 2001, pp. 362–363.
5 William H. Wright, *The Future of Painting*, New York: B.W. Huebsch, Inc., 1923, pp. 47–50.
6 William Moritz, "Visual Music and Film-as-an-Art before 1950", in Paul J. Karlstrom (ed.), *On the Edge of America: California Modernist Art, 1900–1950*, Berkeley: University of California Press, 1996, p. 224.
7 Clement Greenberg, "After Abstract Expressionism", in John O'Brian (ed.), *The Collected Essays and Criticism: Vol. 4*, Chicago: The University of Chicago Press, 1995, p. 131.
8 Kevin Dann, *Bright Colors Falsely Seen*, New Haven: Yale, 1998, pp. 94–95.

9 Jeffrey Schnapp, "Bad Dada (Evola)", in Leah Dickerman and Matthew S. Witkowski (ed.), *The Dada Seminars*, Washington, DC: National Gallery of Art/DAP, 2005, pp. 50–51.

10 Wassily Kandinsky, *Concerning the Spiritual in Art*, New York: Dover, 1977, p. 31.

11 Stan Brakhage, *Metaphors on Vision*, P. Adams Sitney (ed.), New York: Anthology Film Archives/Light Industry, 2017.

12 Tracey Bashkoff, *Hilma af Klint: Paintings for the Future*, New York: Guggenheim Museum Publications, 2018.

13 William C. Wees, *Light Moving in Time: Studies in the Visual Aesthetics of Avant-Garde Film*, Berkeley: University of California Press, 1992, pp. 137–146.

14 Peter Vergo, *The Music of Painting*, London: Phaidon, 2010, pp. 254–309.

15 Lillian Schwartz, *The Computer Artist's Handbook*, New York: Norton, 1992, pp. 151–152.

16 Roger Fry, "The French Post-Impressionists (preface to catalog for the Second Post-Impressionist exhibition, 1912)", *Vision and Design*, London: Pelican Books, 1937, pp. 195–196.

17 Claude Levi-Strauss, *The Raw and the Cooked*, Chicago: The University of Chicago Press, 1983, p. 22.

18 Patricia Railing, *Malevich on Suprematism—Six Essays: 1915 to 1926*, Iowa City: University of Iowa Museum of Art, 1999.

19 Thomas McEvilley, *Art and Discontent*, New York: Documentext, 1993, pp. 29–35.

20 Michael Betancourt, "A Taxonomy of Abstract Form Using Studies of Synaesthesia and Hallucinations", *Leonardo*, vol. 40, no. 1, 2007, pp. 59–65.

21 Heinrich Klüver, *Mescal and Mechanisms of Hallucinations*, Chicago: The University of Chicago Press, 1966, p. 66.

22 Cretien van Campen, "Synesthesia and Artistic Experimentation", *Psyche*, vol. 3, no. 6, November 1997, np.

23 Umberto Eco, "Interpreting Serials", in ibid., *The Limits of Interpretation*, Bloomington: Indiana University Press, 1994, pp. 98–100.

24 Cynthia Goodman, *Digital Visions: Computers and Art*, New York: Abrams, 1987, pp. 156–158.

25 Martin F. Norden, "The Avant-Garde Cinema of the 1920s: Connections to Futurism, Precisionism and Suprematism", *Leonardo*, vol. 17, no. 2, 1984, p. 112.

26 Eleanor Selfridge-Field, "The Invention of the Fortepiano as Intellectual History", *Early Music*, vol. 33, no. 1, February 2005, pp. 81–94.

27 Athanasius Kircher, "Liber III, Caput XIII, SII: De Genere Chromatico", in *Musurgia Universalis (Facsimile Edition)*, New York: George Olms Verlag, 1970, p. 240.

28 Thomas Hankins, "The Ocular Harpsichord of Louis-Bertrand Castel; or, The Instrument That Wasn't", *Osiris*, no. 9, 1994, pp. 141–151.

29 William Moritz, "Visual Music and Film-as-an-Art before 1950", in Paul J. Karlstrom (ed.), *On the Edge of America: California Modernist Art, 1900–1950*, Berkeley: University of California Press, 1996.

30 Bruno Corra, "Abstract Cinema—Chromatic Music", in Umbro Apollonio (ed.), *Futurist Manifestos*, New York: Art works, 2001, pp. 66–69.

31 Hankins, op. cit., pp. 141–151.

32 Corra, op. cit., pp. 66–68.

33 Ibid.

34 Standish Lawder, *The Cubist Cinema*, New York: Anthology Film Archives, 1980.

35 Zoe Alderton, "Colour, Shape, and Music: The Presence of Thought Forms in Abstract Art", *Literature & Aesthetics*, vol. 21, no. 1, 2011, pp. 236–258.

36 Bulat Galeyev, "Open Letter on Synaesthesia", *Leonardo*, vol. 34, no. 4, 2001, pp. 362–363.

37 The designation of the German abstract and visual music animations as "absolute films" began with the filmmakers themselves. The Novembergruppe exhibition of May 3, 1925 (a program which included Ruttmann, Richter and Eggeling's films) was titled "Der Absolute Film".

38 Walther Ruttmann, "Painting with the Medium of Light", in Angelika Leitner and Uwe Nitschke (eds.), *The German Avant-Garde Film of the 1920s*, Munich: Goethe Institute, 1989, pp. 103–104.

39 Patrick de Haas, "Cinema: The Manipulation of Materials", in *Dada-Constructivism*, exhibition catalogue, London: Annely Juda Fine Art, 1984, np.

40 Ruttmann, op. cit., p.104.

41 Gösta Werner and Bengt Edlund, *Viking Eggeling Diagonalsymfonin: Spjutspets I Återvändsgränd*, Lund: NovaPress, 1997. See also Gösta Werner, "Spearhead in a Blind Alley: Viking Eggeling's *Diagonal Symphonyi*", in John Fullerton and Jan Olsson (eds.), *Nordic Explorations: Film before 1930*, Sydney: John Libbey & Co, 1999, pp. 232–235.

42 Hans Richter, "My Experience with Movement in Painting and in Film", in György Kepes (ed.), *The Nature and Art of Motion*, New York: George Brazillier, 1965, p. 144.

43 William Moritz, *Optical Poetry: The Life and Work of Oscar Fischinger*, Eastleigh: John Libbey Publishing, 2004.

44 Malcolm Le Grice, *Abstract Film and Beyond*, Cambridge, MA: MIT Press, 1981, pp. 19–31. See also W. Schobert, *The German Avant-Garde Film of the 1920s*, Munich: Deutsches Filmmuseum, 1989.

45 Aimee Mollaghan, *The Visual Music Film*, New York: Palgrave, 2015, pp. 97–139.

46 G.F.W. Hegel, *The Phenomenology of Mind*, trans. J.B. Baillie. New York: MacMillan, 1910, p. 340.

47 W.T. Harris, *Hegel's Logic*, Chicago: Griggs and Company, 1890, p. 120.

48 Renato Poggioli, *The Theory of the Avant-Garde*, Cambridge: Harvard University Press, 1968.

49 Michel Foucault, *The Birth of the Clinic*, New York, Routledge, 1976, p. xiii.

50 Hans Hoffman, "The Search for 'The Real' in the Visual Arts", in Sara T. Weeks and Bartlet H. Hayes Jr. (eds.), *Search for "The Real"*, Cambridge, MA: MIT Press, 1967, p. 40.

51 Dawn Ades, *Dalí's Optical Illusions*, Hartford: Yale University Press, 2000, p. 12.

52 Amy Ione and Christopher Tyler, "Is F-Sharp Colored Violet?", *Journal of the History of the Neuroscience*, vol. 13, no. 1, 2004, pp. 62–64.

53 Klüver, op. cit., p. 93.

54 Kevin Dann, *Bright Colors Falsely Seen*, New Haven: Yale, 1998, p. 91.

55 A. Michael Noll, "Human or Machine: A Subjective Comparison of Piet Mondrian's *Composition with Lines* (1917) and a Computer-Generated Picture", *Psychological Record*, vol. 16, no. 1, 1966, pp. 1–10.

56 A. Michael Noll, "The Digital Computer as a Creative Medium", *IEEE Spectrum*, vol. 4, no 10, 1967, pp. 89–95.

57 Jasia Reichardt, *The Computer in Art*, New York: Van Norstrand Reinhold, 1971, pp. 77–78.

58 Peter Halley, "The Crisis in Geometry", in *Peter Halley: Collected Essays, 1981–87*, New York: Sonnabend Gallery, 1991, pp. 75–105.

59 Sheldon Brown, "Introduction" *Synthesis: Processing and Collaboration*, San Diego: The Gallery@Calit2, 2011, p. 5.

60 "Jamie Fenton's" biography webpage on her personal website: www.fentonia.com/bio (accessed February 4, 2014). Also, the quote is from a private email, February 7, 2015: "I was the lead software engineer on the *Arcade* project. I had two engineers helping me. Part of my role was to make sure that the hardware guys created a good design. Jeff Frederiksen was the lead hardware guy—he was and is brilliant (and a little difficult to work with, since he could change a design on a moment's notice). Right now Jeff is working at Apple on the *iPhone*. All this means I can point-out where in the code things went wrong".

61 Malcolm Le Grice, *Experimental Cinema in the Digital Age*, London: BFI Publishing, 2006, p. 275.

62 Jacques Attali, *Noise: The Political Economy of Music*, Minneapolis: University of Minnesota Press, 1985, pp. 6–9.

63 P. Adams Sitney, *Visionary Film: The American Avant-Garde 1943–1978 (Second Edition)*, New York: Oxford University Press, 1979, p. 370.

64 John Hanhardt, "The Medium Viewed: The American Avant-Garde Film", *A History of the American Avant-Garde Cinema*, New York: The American Federation of the Arts, 1976, p. 22.

65 Jackie Hatfield, "Expanded Cinema and Narrative", *Millennium Film Journal*, 2003, nos. 39–40, pp. 63–64.

66 Jacques Donguy, "Machine Head: Raoul Hausmann and the Optophone", *Leonardo*, vol. 34, no. 3, 2001, pp. 217–220.

67 Attali, op. cit., p. 6.

68 Douglas Kahn, *Noise, Water, Meat*, Cambridge, MA: The MIT Press, 1999, p.25.

69 Christiane Paul and Malcolm Levy, "Genealogies of the New Aesthetic", in David M. Berry and Michael Dieter (eds.), *Postdigital Aesthetics: Art, Computation and Design*, New York: Palgrave Macmillan, 2015, p. 31.

70 Kim Cascone, "The Aesthetics of Failure: 'Post-Digital' Tendencies in Contemporary Computer Music", *Computer Music Journal*, vol. 24, no. 4, 2000, p. 3.

71 Umberto Eco, "Interpreting Serials", in ibid., *The Limits of Interpretation*, Bloomington: University of Indiana Press, 1994, pp. 83–100.

72 André Bazin, *What Is Cinema?*, trans. Timothy Barnard. Montreal: Caboose, 2009, pp. 8–9.

73 Gilles Deleuze, *Cinema 1: The Movement-Image*, Minneapolis: The University of Minnesota Press, 1986, pp. 70–71.

74 Richard Rushton, *The Reality of Film: Theories of Filmic Reality*, Manchester: University of Manchester Press, 2011, pp. 44–47.

75 Julian Hochberg and Virginia Brooks, "Movies in the Mind's Eye", in David Bordwell and Noël Carroll (eds.), *Post Theory*, Madison: University of Wisconsin Press, 1996, pp. 368–369.

76 Christoper Williams, *Realism and the Cinema: A Reader*, London: Routledge, 1980, p. 36.

77 Christian Metz, *Film Language*, New York: Oxford University Press, 1974, p. 98.

78 Peter Gidal, *Materialist Film*, London: Routledge, 1989, pp. 15–16.

79 Daniel Barnett, *Movement as Meaning in Experimental Film*, New York: Rodopi, 2008, pp. 16–17.

80 Michel Foucault, *This Is Not a Pipe*, Berkeley: University of California Press, 1982, p. 44.

81 Gregory Zinman, "Getting Messy: Chance and Glitch in Contemporary Video Art", in Gabrielle Jennings (ed.), *Abstract Video: The Moving Image in Contemporary Art*, Oakland: University of California Press, 2015, pp. 98–115.

82 Hugh Manon and Daniel Temkin, "Notes on Glitch", *World Picture 6: WRONG*, http://worldpicturejournal.com/WP_6/Manon.html, 2011, par. 29.

83 Rosa Menkman, *Network Notebooks 4: The Glitch Moment(um)*, Amsterdam: Institute of Network Cultures, 2011, p. 35.

84 Michael Betancourt, "Critical Glitches and Glitch Art", in *Harmonia: Glitch, Movies and Visual Art*, Cabin John: Wildside Press, 2014, pp. 149–172.

85 Umberto Eco, *The Limits of Interpretation*, op. cit., pp. 83–100.

86 Sylvère Lotringer and Paul Virilio, *The Accident of Art*, New York: Semiotext(e), 2005, p. 74.

87 Hugh Manon and Daniel Temkin, "Notes on Glitch", *World Picture 6: WRONG* (2011), http://worldpicturejournal.com/WP_6/Manon.html, par. 25.

88 Kim Cascone, "The Aesthetics of Failure: 'Post-Digital' Tendencies in Contemporary Computer Music", *Computer Music Journal*, vol. 24, no. 4, 2000, p. 12–13.

89 Michael Betancourt, *The Critique of Digital Capitalism*, Brooklyn: Punctum, 2016, pp. 61–74.

90 Michael Betancourt, *Glitch Art in Theory and Practice*, New York: Routledge, 2015, pp. 21–48.

91 Michael Betancourt, "Technesthesia and Synaesthesia", in *Harmonia: Glitch, Movies and Visual Art*, Cabin John: Wildside Press, 2018, pp. 145–148.

92 Vendela Grundell, *Flow and Friction: On the Tactical Potential of Interfacing with Glitch Art*, Stockholm: Art and Theory, 2016, pp. 28–30.

93 Michel Foucault, *The Archaeology of Knowledge*, New York: Pantheon, 1972, p. 90.
94 Thomas McEvilley, *Art and Discontent*, New York: Documentext, 1993, p. 29.
95 Linda Nochlin, *Realism*, New York: Penguin Books, 1975, pp. 13–23.
96 Frances Colpitt, "Systems of Opinion: Abstract Painting Since 1959", in *Abstract Art in the Late Twentieth Century*, New York: Cambridge University Press, pp. 153–203.
97 Eero Tarasti, *Theory of Musical Semiotics*, Bloomington: Indiana University Press, 1994, pp. 73–76.

11 Ecology and Climatology in Modern Abstract Art

Linn Burchert

11.1 Art and Climatology[1]

In the context of the life reform movements in Europe around 1900 and beyond, discussions about the intersection of human society and its relationship to nature reached a crescendo: How did the climate influence the human body? What types of life forces did nature provide, and how were they channeled into human life?[2] These questions were not only crucial for reformers hoping to improve society in general, but also played a key role in emerging concepts of modern abstraction in art. Atmospheric and climatic qualities such as temperature, light and humidity were of interest not only to the impressionists and the neo-impressionists, but also to artists making non-figurative images such as Robert Delaunay and Yves Klein in France or Wassily Kandinsky, Paul Klee and Johannes Itten at the German Bauhaus school. According to these artists' theories, images should not primarily aim to represent natural phenomena, but rather to envelope the observer within an atmospheric space—equivalent to a natural environment or a climate. As this chapter reveals, in contrast to the impressionist and neo-impressionist concept of nature, abstract artists were not interested in fugitive meteorological and atmospheric changes, but rather in phenomena of climate and the natural environment, more generally. They used visual abstraction to make *effective* equivalents to natural powers otherwise represented in the form of diagrams.[3] Therefore, they drew from naturopathy as well as scientific knowledge of the time in order to consolidate the concept of the artwork as a natural power.

The birth of ecology as a modern discipline is usually dated back to German scientist Ernst Haeckel's (1834–1919) definition, first published in his 1866 text *Generelle Morphologie der Organismen* (*General Morphology of Organisms*). It includes "climate" as part of the anorganic conditions of life:

> The inorganic conditions of existence to which each organism must adapt first include the physical and chemical characteristics of its living space, the climate (light, heat, humidity and electricity conditions of the atmosphere), the inorganic food, the nature of the water and the soil etc.[4]

Just a few years earlier, the German natural philosopher and explorer Alexander von Humboldt (1769–1859) had published his definition of climate in the first volume of his unfinished large-scale project *Kosmos—Entwurf einer physischen Weltbeschreibung* (*Cosmos—A Sketch of a Physical Description of the Universe*) (1845):

The term climate in its most general sense encompasses all the changes in the atmosphere which significantly affect our organs: the temperature, the humidity, the changes in the barometric pressure, the calm air or the effect of different winds, the magnitude of the electric tension, the purity of the air or its mixture with more or less harmful exhalations, finally the degree of general transparency and cheerfulness of the sky, which is not only important for the increased thermal radiation of the soil, the organic development of the plants and the ripeness of the fruits, but also for the feelings and people's overall sentiment of the soul.[5]

Temperature, humidity, changes in the atmospheric pressure, wind, electrical charge, the overall quality of air—all these factors were thought to not only impact the human body, but also affect the soul and psyche. Yet since all of these factors are genuinely non-optical, one might well ask how such qualities were supposed to manifest themselves in the visual arts and in images in particular?

As the following examples will show, artists claimed that through color, contrast and rhythm, they could actually produce climatic qualities such as temperature and humidity through their works. Climatic qualities were referred to not merely metaphorically, but in the sense of a substantial effect of the image. This chapter argues that the practice of "abstraction" is crucial to these artists' concepts in two senses and will thus serve as an umbrella term: first of all, climate in its contemporary definition is itself an abstraction, "an average of weather conditions over a given number of years" which cannot be perceived per se, but only "sensed as a given form of weather".[6] The early German environmental psychologist Willy Hellpach (1877–1955) also stressed the aspect of climate as the average of weather conditions in *Die geopsychischen Erscheinungen (Geopsyche)*, published in 1911. His book enjoyed widespread popularity and went through several editions all the way through the 1950s. It was referred to by Bauhaus architect Siegfried Ebeling (1894–1963)[7] as well as by Bauhaus student and later Folkwang teacher Max Burchartz (1887–1961).[8] Hellpach described climate as *Witterungscharakter* (*characteristic weather*) in a certain zone—based on long-term observation and regularity.[9] Among other things, he names the characteristics of the seasonal cycle and the characteristic rhythm of day and night as examples of elements that create a specific climate.[10]

The second argument for my use of the term "abstraction" (besides the abstract nature of "climate" as a concept) is that in referring to "climate", artists articulated a specific stance on what they understood to be the relationship between "art" and "reality". They did not make pictorial abstractions from visible objects, which they then translated into non-figurative images. Instead, they used "abstraction" to designate a *non-visual* but sensed "reality", accessible to the lived body as sensations of warmth and cold, tension, calm, excitation, etc. In this sense, "abstraction" refers to that which was *in the world*, but which could be felt rather than seen. Artworks based on this notion, therefore, sought to render the sensory effects of abstraction in a visual format, which itself was abstract like the effects it sought to (re)produce.

The most prominent image concept that these artists proposed can generally be described with recourse to the figure of the "organism" as an overarching model. This model can be found in artists' statements such as those by Wassily Kandinsky who described his artworks as "vital wholes".[11] As an extension to that concept, I propose understanding their artworks in terms of producing an environment or living space for the observer.[12] Their images do not only reflect the world's "vitality", but are also

life-giving themselves. They were not thought of as equivalent to the human body, but rather as being connected to anorganic, climatic living conditions.

11.2 Robert Delaunay and the Image as a Sun-Like Presence

French artist Robert Delaunay placed one crucial condition for organic life on earth at the heart of his concept of artistic abstraction. In 1913 he wrote to his colleague August Macke in Germany: "I am in the country now, working a great deal, my last picture *is* the sun. It shines more and more brightly the more I work on it".[13] The *Soleil* series contains at least seven works, and the artist continued to develop the theme subsequently in numerous versions of *Formes Circulaires*. Delaunay equated his *Soleils* to the radiation of the sun, and, as becomes clear in his writings, he intended these images to directly affect the observer with "harmonic energies" and a kind of *élan vital*.[14] Delaunay wanted not only to represent the sun's optical effect in a given environment or a certain atmosphere (as was of interest to the impressionists and neo-impressionists), but also to create a presence equivalent to pure sunlight that would have an effect as vitalizing for the observer's soul as the sun itself.[15] Around 1938/1940 Delaunay wrote: "[T]he more a painting shines, the more life it contains within itself, the more its conception and its creation assure and impose its presence".[16]

Delaunay's strategy to create a sun-like presence relies on the use of simultaneous chromatic contrasts as explored and expounded upon by French chemist Michel Eugène Chevreul (1786–1889) in *De la loi du contraste simultané des couleurs et de l'assortiment des objets colorés* (1839). Taking Chevreul's findings as the point of departure, Delaunay experimented with how to combine colors in ways that enhance their luminosity using contrasts of light and dark, complementary colors (green–red, blue–orange) as well as contrasts in saturation (Figure 11.1). Delaunay's *Soleils* do not resemble the sun mimetically; they aim instead to recreate the sun's effects through a manipulation of color and form in ways that marry visual effects with the types of conceptual abstractions described above in relation to the concept of climate.

As pointed out before, Delaunay, as many other abstract artists, described his artwork as an "organism",[17] i.e., as an undividable and living whole. Another central term the artist used to explain his approach to making work was that of "synchromy".[18] The term "synchromy" refers both to the simultaneity of colors on the canvas and to the musical symphony—in order to consolidate the concept of the image as a harmonious whole, an accord. Delaunay's concept thus aligns with the Swiss naturopath Maximilian Bircher-Benner's (1867–1939) concept of nature and his ideas about the healing power of the sun in the context of his *Ordnungstherapie* ("regulative therapy"): Bircher-Benner understood the sun to be a cosmic power able to regulate, organize, harmonize and unify life in all of its facets.[19] He considered life to be based on vibrations—a concept that will be discussed later with regard to the concepts of chromotherapy.[20] By calling nature a "grandiose Symphonie" built up from chords, Bircher-Benner referred to antique ideas where the order and laws of the cosmos were likened to music in the sense of a Pythagorean "harmony of the spheres".[21]

For Delaunay, this intertwining of ideas drawn from natural philosophy and aesthetic principles provided a foundational frame through which the artwork appears as a natural power and a giver of life equivalent to the sun. The visual facets of the

Figure 11.1 Robert Delaunay, *Formes Circulaires, soleil*, 1912/1913, oil on canvas, 75 × 61 cm, Museum Folkwang, Essen (work in public domain).

painting take on an atmospheric and energetic quality, he argues, that will directly affect the lives of its beholders. Two restrictions have to be made with regard to the focus of this chapter, though: first, Delaunay did not aim to create a specific climate with his images, which are meant to channel the power of pure sunlight and thus "only" one climate factor. Second and in contrast to Wassily Kandinsky and Johannes Itten, Delaunay was not interested in the direct physiological impact of the image. Instead, he was concerned with its psychic effects, i.e., the harmonizing and energizing impact on the soul. Kandinsky and Itten, however, were precisely interested in colors as equivalents of climatic phenomena and in their both psychic and physical effects on the observer.

11.3 Wassily Kandinsky, Chromotherapy and Psychophysics

In 1938, Wassily Kandinsky described the possible effects of art on the viewer or listener as follows:

> [The observer/the listener, *l.b.*] has the sensation of icy air passing through an open window in winter. And the entire body is dissatisfied.
>
> Suddenly he/she becomes hot—because the painter or the composer created "warm" artworks. […] It burns directly. Forgive me, but it really is painting and music that can (albeit it rarely) produce an aching in your body.[22]

Kandinsky here not only claims that the artwork produces a direct physical effect on the beholder but, moreover, that the image or musical composition appears as a kind of atmospheric space that contains air of a certain temperature. Kandinsky's discourse is rooted in the psychophysical knowledge of the period as well as contemporary theories and practices of "color therapy" that enjoyed increasing popularity in the 1910s.[23] While in the preceding quote the artist focused on the negative climatic effects that certain artworks could produce, the center of Kandinsky's interest in color and climate as early as 1910 lay in exploring the healing possibilities of color.[24] Both he and Johannes Itten directly addressed the methods of chromotherapy, i.e., the possibility of healing nervous diseases through colors. Kandinsky possessed a book by Andrew Osborne-Eaves titled *Die Heilkraft der Farben* (*The Healing Power of Colors*), first published in 1906, which explains the basic principles of color medicine.

In chromotherapy, sickness is attributed to a lack of certain colors in the body.[25] This approach was based on the idea that vibrations flow through and organize the human body.[26] As Douglas Howat explained in his 1938 publication *Elements of Chromotherapy. The Administration of Ultra-Violet, Infra-Red and Luminous Rays through Colour Filters*: "The electro-magnetic waves, which we refer to in general as light, are the natural means of inducing and maintaining the normal vibratory value of the living organism".[27] Thus, different colors were equated to specific vibratory values and sickness was thought to be a consequence of disharmonious vibration due to a lack of certain colors.[28]

Osborne-Eaves understood chromotherapy to be a kind of naturopathy,[29] and indeed —as will be discussed later using the example of Arnold Rikli—there are general connections between the therapeutic approaches of natural medicine and chromotherapy. Both were grounded upon the ideas of thermotherapy, i.e., healing through warmth, cold and the shifts between these temperature extremes. In chromotherapy, red light was used to vitalize, while blue light served to calm.[30] Accordingly, in his teaching notes, written between 1923 and 1933, Kandinsky left the following list:

Yellow/white: tempo: presto, pulse rate: 135, temperature: warm
Red/gray: tempo: moderate, pulse rate: 75, temperature: warm-cold
Blue/black: tempo: adagio, pulse rate: 50, temperature: cold[31]

Here it becomes evident how for Kandinsky, colors had certain thermic qualities that prompted a specific pulse rate, which the artist further likens to different tempos in music. For him, the human body's vital forces were thus closely linked to color.

Kandinsky did not buttress his ideas about the relationship between the body and color based on the theories of color therapy. He also kept abreast of the results from numerous psychophysical experiments being carried out in the early 20th century. Such experiments were most prominently conducted by Wilhelm Wundt's group in Leipzig. In his art and color theory, the former Bauhaus student Max Burchartz referred directly to such experiments, in particular those carried out by Wundt's colleague Florian Ștefănescu-Goangă. The latter exposed test subjects to the light of different colors and investigated the ways in which different colors impacted biorhythms—breath, blood pressure and pulse, as well as the psyche.[32] The notion that psychic effects could be ascertained by looking at corporeal changes lay, of course, at the core of psychophysics, which was based on the principle of isomorphism, a tenet which held that physical and psychic processes follow the same laws and patterns.[33] As Burchartz pointed out, the findings of the psychophysicists resembled Johann Wolfgang von Goethe's phenomenological observations regarding the *sinnlich-sittliche* effect of colors in the sense that red, orange, yellow and purple were thought to be arousing while green, blue, indigo and violet were considered to have soothing psychic effects.[34]

Kandinsky, who was Burchartz's teacher at the Bauhaus, borrowed from the phenomenology of Goethe, the more esoteric tenets of color therapy and also the empiric and quantitative methods of psychophysics in order to consolidate and strengthen his concepts about thermic qualities and the potentially vitalizing power of colors. These, in turn, were the preconditions for developing his idea of the image as environment. Kandinsky theorizes the image as a space that encloses the viewer: discussing the

Figure 11.2 Wassily Kandinsky, *Yellow-Red-Blue*, 1925, oil on canvas, 128 × 201.5 cm, Musée National d'Art Moderne, Centre Georges Pompidou, Paris (work in public domain).

painting *Yellow-Red-Blue* from 1925, Kandinsky states that the colors are "neither on the surface of the canvas, nor on any ideal surface. They are rather suspended in the air and appear like steam"[35] (Figure 11.2). More than ten years earlier, he similarly compared *Composition VI* to a steam bath:

> Such an absence of the surface and indeterminacy of distance can be observed, for example, in a Russian steam bath. The man standing in the steam is neither near nor far; he is *somewhere*. This "somewhere" of the main center determines the inner tone of the whole picture.[36]

Like color therapy, the steam bath is a mechanism for healing, purifying. Kandinsky assigned a similar power to the image. According to him, the image provides a certain climate, which directly influences the beholder's biorhythmic body functions (i.e., the pulse rate). Kandinsky's colleague at the Weimar Bauhaus, Johannes Itten, took a similar approach. While Kandinsky's *climates* were rather detached from the actual natural environment, Itten focused more directly on the natural cycle of the seasons in order to demonstrate his concept of art as a natural power.

11.4 Johannes Itten's Seasonal Cycle

Quite late in his career, in 1963, Johannes Itten made a series of paintings dedicated to the four seasons. Like Kandinsky, Itten was a teacher at the Bauhaus in Weimar, Germany, between 1919 and 1923. The four images titled "Spring", "Summer", "Autumn" and "Winter" are non-figurative; the seasons are represented by colored rectangles on rather large format canvases, each measuring 150 × 100 cm. The rectangles and their disposition on the canvas represent not only the colors, but also the specific rhythm of each season (Figure 11.3). Itten, however, did not describe his images as mere representations, but as "Kraftfelder" ("force fields").[37] According to him, artists were able to "create life" and their artworks had the potential to *give* life to the viewer through color and rhythm.[38] Comparable to Robert Delaunay and Kandinsky, Itten likened the image to "an organic world, a closed, self-contained world".[39] The image thus appears as a kind of environment into which the observer can enter and become completely absorbed.[40] Colors were accordingly defined as "radiating powers, energies" that have positive or negative effects on the observer.[41] The qualities that Itten ascribed to colors include "shadowy–sunny", "calming–exciting", "airy–earthly" and "wet–dry".[42] These can all be identified in the seasonal cycle from 1963.

The series may well be understood as presenting a kind of natural life cycle that represents life by providing powers that are a vital part of life itself. As previously mentioned, it was not the fugitive principles of atmospheric events that were of interest to abstract artists like Itten, but the more general processes; in this case, Itten extends these processes over a timespan: the entire year. According to the artist, the light colors and the vibrating rhythm of "Spring" represent "becoming" in nature.[43] He attributed a *sun-like radiating power* to orange[44] and stressed its warmth as a precondition of life and growth.[45] "Spring" is full of not only *sunny* colors but also *wet* colors such as green. "Summer", too, is characterized by a balance of such warm, dry colors as well as of fresh, wet green tones. The colors here are much more saturated, which is why Itten regarded "Summer" as the most energetic of the four images color-wise.[46] With

Figure 11.3 Johannes Itten, *Spring* (up) and *Summer* (down), 1919–1923, oil on canvas, 100 × 150 cm each, Museum Würth, Künzelsau (work in public domain).

regard to the rhythmicity of the color forms, however, "Spring" is more dynamic. In contrast to "Spring" and "Summer", "Autumn" is characterized by fewer color changes, and by darker, dry and warm colors: brown and violet are, according to Itten, the colors of decomposition and decay although they still provide a *dry warmth*.[47] "Winter" is composed of even less shifts in color, which form a calming rhythm fortified by blue, green and brown pastel shades.

Itten further mentioned that red-orange light is not only supposed to increase plant growth, but also to enhance the "organic functions" of the viewer's body, for instance, its circulatory systems.[48] This corresponds to the ideas prevalent in color therapy and psychophysics whereby red is considered to stimulate the circulation, as seen in the example of Kandinsky in the previous section. In Itten's "Summer", stimulation is associated with a high saturation, especially in comparison to "Spring". Like "Spring", "Winter" features lighter colors; however, the colors are colder and can be likened to a clear, transparent air that Itten contrasts with black and brown rectangles. Light and dark, warm and cold, intense and mild, pure and cloudy and radiating and transparent colors are thus the main chromatic contrasts in Itten's cycle. Itten connected the shift from warm to cold to naturopathic knowledge: "Through coldness and warmth (ice blue and vermillion-orange), intense life is created. (Compresses with boiling water and subsequent treatment with ice have a similar effect on man.)".[49] Rhythm and movement in conjunction with the different qualities of colors are thus especially important to Itten's concept of the vitalizing image where movement is regarded as a precondition of life.[50]

In methods of natural medicine—as popularized by the Swiss healer Arnold Rikli (1823–1926) in the course of the second half of the 19th century—variation in environmental influences such as warmth and cold, or lightness and darkness, is necessary in order to keep the nervous system and the body lively and healthy, i.e., to keep everything flowing.[51] Rikli adapted his healing method from antique concepts of nature and health, comparable to those of Maximilian Bircher-Benner discussed in the section on Robert Delaunay. According to the Hippocratic and Galenic tradition, it was the right mixture, the *eucrasia*, of the elements and the humors, of warm, cold, dry and wet, that would ensure health.[52] Accordingly, environmental psychologist Willy Hellpach spoke about the "Wechselbest", i.e., the rhythmic optimum, assuming that periodic shifts between light and dark and pure and turbid weather were important preconditions of good health.[53]

Itten's cycle pictorializes the rhythmic shifts that were regarded as a natural order of life since antiquity—a natural rhythm of growth and decay that manifests itself in color.[54] He held that decay was necessary for the creation of new life as winter served as an interlude essential to growth and blooming in spring.[55] The seasonal cycle was meant to offer a vitalizing variation of natural rhythms and forces between excitement and relaxation and between physical and intellectual life: Consequently, Itten described the passing of the seasons as *Atemzug*—"gasp of air"—where winter appears as a time of intellectual inhalation and summer as a time of physical exhalation.[56] In that sense, not only the overall seasonal cycle but also the rhythm of each image is crucial. It develops from a vibrant, vitalizing rhythm in "Spring" and "Summer" to a calming rhythm in "Autumn" and "Winter". Itten demanded that viewers should give themselves up completely as individuals and feel that they are totally a function of the image.[57] He posited that the life forces of the viewer who is moved by the rhythm of the image would flow in a harmonic, natural rhythm.

11.5 Paul Klee and the Image as a "Villeggiatura"

The idea that an artwork constitutes a healthy, energizing environment can also be found in Bauhaus artist Paul Klee's concept of art, which was informed by ideas borrowed from naturopathy as well. In 1920, Klee described artwork as a *villeggiatura* that provided the opportunity to "change air", "enter a world that offers a reinforcement" and "fill the vessels of the soul with new juice".[58] In the same text, he compared the observer of art to a "grazing animal".[59]

Klee's use of the term "juices" again refers to the Galenic concept of the four humors as discussed previously. His overall interest in naturopathy cannot simply be attributed to a general spirit of time infused by an interest in *Lebensreform*, but was also motivated specifically by his son Felix Klee, who underwent several naturopathic treatments early in life. Klee's letters are filled with remarks on naturopathy and healthy climates in particular, describing the islands of Porquerolles and Sicily as well as other "healthy" places and resorts near the Mediterranean Sea.[60] Klee's reference to the Italian term *villeggiatura* has to be understood in a broad sense as a revitalizing summer stay in a comforting climate on the one hand. At the same time, it denotes premodern villa architecture as conceptualized by Leon Battista Alberti and, most famously, Andrea Palladio.[61] Alberti and Palladio both believed architecture to be a means of improving and supporting dwellers' health.[62] What Klee called a "change of air" was of utmost importance in this tradition: Palladio regarded the combination of warm and dry rooms with colder and fresh rooms as a precondition for healthy living; thus, facilitating a rhythmic shift between these temperature zones played a key role in his design strategies—an idea that the modern natural healer Arnold Rikli also stressed.[63]

The balance between warmth and cold (i.e., a mild climate) is fundamental to Klee's ideal state of nature and the climate of his images. In his lessons at the Bauhaus, he declared that colors could be too hot or too cold, and that counterbalancing extremes was crucial to both a harmonious and a vibrant composition.[64] In *Polyphony* (1932) (Figure 11.4), colors appear to shape an immaterial atmosphere, comparable to Wassily Kandinsky's compositions. They do not remain on the surface but appear detached from the canvas like air and particles. Moreover, they are mild and comforting to the eye. Klee uses a variation of a pointillist method to apply his pigments reminiscent of the neo-impressionist style. Like Kandinsky and Johannes Itten, as well as the impressionists and neo-impressionists, Klee was fascinated by the idea of painting with pure light and dematerializing the image so that it would become a transparent space filled with air and radiation that enclosed the beholder.[65]

While on the one hand Klee developed a concept of the image as a mild and gentle Mediterranean climate zone, which is neither too hot nor too cold, he also thought of images as manifesting a healthy *Reizklima*, i.e., a *stimulating* climate.[66] This concept was connected to the idea of the image as a living and breathing space constituted by strong color contrasts. We can discern how this concept appeared visually in Klee's work, for example, in *Blooming* (1935), which corresponds to his idea of the image being a breathing organism: "A great range from pole to pole provides the action with a deep breathing in and breathing out that can change to a panting gasp. A limited range lowers the breathing".[67] By "action" Klee meant the interaction between different colors on the scale from light to dark which is to stimulate the observer: in *Blooming*, there is a shift from dark and turbid colors in the outer frame to lighter

Figure 11.4 Paul Klee, *Polyphony*, 1932, oil on canvas, 66.5 × 106 cm, Öffentliche Kunst-
sammlung, Basel; photo: fair use.

and more saturated colors in the center. This color change is accompanied by the accu-
mulation of smaller forms toward the center, which thus appears much more vibrant.
Moreover, the colored rectangles shaping the composition are not based on geometri-
cal but on freehand drawings, evoking the impression of a fluent, "breathing" move-
ment through space: as light colors appear to come forth while darker colors strive
back, they are reminiscent of the principle of both in- and out-breaths—expansion and
contraction—as well as shifts between a calm, slow and a faster, more agitated breath-
ing rhythm. Klee thus was not only interested in an airy, atmospheric quality of images,
but also in the figure of breath as a vitalizing principle which affects the observer.

11.6 Yves Klein's Concepts of the Pictorial Climate and
the Architecture of Air

The term "climate" itself was not used explicitly by the artists discussed so far. The
term thus remains implicit, embodied in their artworks and theories of the image. In
addition to Josef Albers,[68] French artist Yves Klein appears to be among the first artists
to have applied this term to color and artwork. In the late 1950s, Klein defined the
goal of his art as "the creation of an environment, of a real pictorial climate".[69] The
health resort in Nice, France, was crucial to the development of his image concept, as
he wrote: "As an adolescent, I wrote my name on the back of the sky in a fantastic
realistic-imaginary journey, stretched out on a beach one day in Nice".[70] He further
described the sky above Nice as his "greatest and most beautiful work".[71] For Klein,
blue was the most "immaterial" and thus a truly atmospheric color.[72] It was meant

to reach the observers of his blue monochromes as "pure energy".[73] Like Johannes Itten, Klein described the effect of his images as the "radiation" of forces[74] containing "radiant life",[75] and also compared it with air humidity to stress its atmospheric quality.[76] The observers of his works were to be impregnated with this blue energy soaked through like the sponges Klein used to create his paintings as "portraits of the 'readers' of [his] monochromes".[77]

In his 1958 exhibition *Le Vide* at the Iris Clert Gallery in Paris, Klein completely dematerialized this blue life energy, entering his "pneumatic period", as he called it.[78] By painting the walls white and letting the visitors step into the space through a blue baldachin, welcoming them with a blue cocktail, and tempering the room with blue light—blue as pure energy and immaterial (nearly invisible) presence is released. Klein spoke of an "autonomous, and stabilized pictorial climate".[79] Later in his career, Klein developed an architectural utopia, together with the German architect Werner Ruhnau (1922–2015). They wanted to create a "technical Eden" or "paradise" through technical apparatuses as well as ceilings of air and using "elements" such as fire and water but also electrical and magnetic powers in order to create a mild climate in which people could live together naked and in peace:[80]

> [M]y original goal being an attempt to reconstruct the legend of the lost Eden. This project has been directed towards the habitable surface of the Earth by the climatization of the great geographical expanses through an absolute control over the thermic and atmospheric situations in their relation to our morphological and psychic conditions.[81]

Thus, the ideal of the mild climate which was part of Paul Klee's image concept can be found in Klein's ideas, too. His collaborator Ruhnau also grounded his ideas on contemporary biometeorology and medicine, as well as the architectural tradition of the Bauhaus and the ecological architecture of Richard Neutra (1892–1970).[82] Klein's and Ruhnau's cooperation was brought to an end due to the fact that Ruhnau came to the conclusion that this project was unrealizable.[83] Another crucial factor for Klein's focus on climate might have been Klein's interest in the esoteric philosophy of the Rosicrucians, which he directly linked to his architectural phantasies.[84] Among other things, Klein argued that physical laws such as gravity should be suspended in exchange for new, purely spiritual powers as described by the Rosicrucians.[85]

It is ironic that the only artist who explicitly refers to the term "climate" in his art practice uses it in a way that is not genuinely modern—although the traditions Klein referred to were certainly virulently present and relevant to early 20th-century modernists. This orientation toward antique ideas becomes evident in the fact that Klein referred to the Greek concept of Pneuma, meaning "breath and spirit, air and wind", ranging "between a material and a spiritual element".[86] While the other artists discussed in this chapter were also interested in the spiritual and especially psychic impacts of respectively the climate and colors on the individual, they were also mostly keen to claim a physical efficacy of art on the beholder.

11.7 Closing Remarks

There are many more examples demonstrating the hitherto neglected role that climatic concepts played in abstract modern art, e.g., Max Burchartz, who was mentioned

several times in this chapter, but also Czech artist František Kupka who lived in France from 1906 and developed concepts of luminosity and healing effects of art comparable to those of Robert Delaunay (whom he may even have inspired). In the broader Bauhaus context in Germany, Otto Nebel ought to be mentioned, an artist who was supported by Wassily Kandinsky and worked alongside Paul Klee.[87]

All these approaches, especially that of Yves Klein, can also be seen as precursors to later installations and architectures such as Olafur Elíasson's *Weather Project* at the London Tate Modern in 2003. For that project, Elíasson and his team built an artificial atmosphere consisting of light, air, fog and clouds in which the observer was completely enveloped. However, it could be argued that Elíasson was not as much interested in *climatology* as he was in *meteorology* (hence the installation's title): he was not interested in the average of weather conditions in an overall climate zone, but in a particular weather condition. The concepts discussed throughout the chapter are characterized not only by abstraction on a formal level, but also with respect to content. Climate is an abstraction and cannot be perceived at once but rather only in time. It is not a brief atmospheric moment but rather a compression and generalization of atmospheric features that were of interest to abstract modern artists. These include the shift between warm and cold (Kandinsky), an orientation toward the Mediterranean climate (Klee) and the seasonal cycle of central Europe (Itten).

Notes

1 This chapter is based on my finished dissertation project, which is published in German under the following title: Linn Burchert, *Das Bild als Lebensraum. Ökologische Wirkungskonzepte in der abstrakten Kunst, 1910–1960*, Bielefeld: Transcript, 2019.
2 For a general introduction to the European life reform movements, see: Bernd Wedemeyer-Kolwe, *Aufbruch: Die Lebensreform in Deutschland*, Darmstadt: Philipp von Zabern, 2017; Michael Hau, *The Cult of Health and Beauty: A Social History, 1890–1930*, Chicago: The University of Chicago Press, 2003.
3 Birgit Schneider, *Klimabilder. Eine Genealogie globaler Bildpolitiken von Klima und Klimawandel*, Berlin: Matthes & Seitz, 2018.
4 Ernst Hawckel, *Generelle Morphologie der Organismen. Allgemeine Entwickelungsgeschichte der Organismen*, vol. 2, Berlin: Reimer, 1866, p. 286 (my translation).
5 Alexander von Humboldt, *Kosmos. Entwurf einer physischen Weltbeschreibung*, vol. 1, Stuttgart: Cotta, 1945, p. 340 (my translation).
6 Julien Knebusch, "Art and Climate (Change) Perception: Outline of a Phenomenology of Climate", in S. Kagan & V. Kirchberg (eds.), *Sustainability: A New Frontier for the Arts and Cultures*, Frankfurt am Main: VAS, 2008, p. 245.
7 Siegfried Ebeling, *Der Raum als Membran*, Dessau: Dünnhaupt, 1926, pp. 9, 17.
8 Max Burchartz, *Schule des Schauens*, Munich: Prestel, 1962, p. 86.
9 Willy Hellpach, *Geopsyche. Die Menschenseele unterm Einfluß von Wetter und Klima, Boden und Landschaft*, 4th edn, Leipzig: Engelmann, 1935, p. 100.
10 Hellpach, *Geopsyche*, p. 126.
11 Claudia Blümle & Armin Schäfer, "Organismus und Kunstwerk. Zur Einführung", in: C. Blümle & A. Schäfer (eds.), *Struktur, Figur, Kontur. Abstraktion in Kunst und Lebenswissenschaften*, Berlin & Zurich: Diaphanes, 2007, pp. 9–25; Reinhard Zimmermann, "Das Kunstwerk als Wirk-Organismus. Zur Bildtheorie der Abstraktion", in Ulrich Pfisterer & Anja Zimmermann (eds.), *Animationen/Transgressionen. Das Kunstwerk als Lebewesen*, Berlin: Akademie-Verlag, 2005, pp. 247–264.
12 Burchert, *Das Bild als Lebensraum*.
13 Virginia Spate, *Orphism. The Evolution of Non-figurative Painting in Paris 1910–1914*, Oxford: Clarendon Press, 1979, p. 209.

14 Robert Delaunay, *Zur Malerei der reinen Farbe. Schriften von 1912 bis 1940*, Hajo Düchting (ed.), München: Verlag Silke Schreiber, 1983, p. 38.

15 Arthur A. Cohen (ed.), *The New Art of Color. The Writings of Robert and Sonia Delaunay*, New York: The Viking Press, 1978, p. 92.

16 Ibid., p. 163.

17 Ibid., pp. 163–164.

18 Cf. Spate, *Orphism*, p. 209 and Pierre Francastel & Guy Habasque (eds.), *Robert Delaunay—du cubisme à l'art abstrait*, Paris: S.E.V.P.E.N, 1957, p. 117.

19 Uwe Heyll, *Wasser, Fasten, Luft und Licht. Die Geschichte der Naturheilkunde in Deutschland*, Frankfurt am Main/New York: Campus Verlag, 2006, p. 199.

20 Cf. Heyll, *Wasser, Fasten, Luft und Licht* and Robert Michael Brain, *The Pulse of Modernism. Physiological Aesthetics in Fin-de-Siècle Europe*, Seattle/London: University of Washington Press, 2015, pp. xxviii–xxix.

21 Max Bircher-Benner, *Fragen des Lebens und der Gesundheit: Vorträge aus der Sommerakademie 1935 der Zürcher Kulturgesellschaft*, Zurich/Leipzig/Wien: Wendepunkt-Verlag, 1937, p. 17; Jamie James, *The Music of the Spheres. Music, Science, and the Natural Order of the Universe*, New York: Grove Press, 1993, pp. 30–78.

22 Max Bill (ed.), *Wassily Kandinsky: Essays über Kunst und Künstler*, Bern: Benteli, 1963, p. 219 (my translation).

23 Frances Gage, *Painting as Medicine in Early Modern Rome*, University Park, PA: The Pennsylvania State University Press, 2016, p. 81 (my translation).

24 Helmut Friedel, *Wassily Kandinsky. Gesammelte Schriften 1889–1916. Farbensprache, Kompositionslehre und andere unveröffentlichte Texte*, Munich: Prestel, 2007, p. 417; Angelika Weißbach (ed.), *Unterricht am Bauhaus 1923–1933. Vorträge, Seminare, Übungen*, Berlin: Mann, 2015, p. 506.

25 Albert Osborne-Eaves, *Die Heilkraft der Farben*, Dresden: Rudolph, 1931 (1906), p. 6.

26 Anthony Enns & Shelley Trower, "Introduction", in A. Enns & S. Trower (eds.), *Vibratory Modernism*, Basingstoke: Palgrave Macmillan, 2013, pp. 5–6.

27 R. Douglas Howat, *Elements of Chromotherapy. The Administration of Ultra-Violet, Infra-Red and Luminous Rays through Colour Filters*, London: Actinic Press, 1938, p. 11.

28 Osborne-Eaves, *Heilkraft der Farben*, p. 43.

29 Ibid., p. 4.

30 Ibid., p. 7.

31 Weißbach, *Unterricht am Bauhaus*, p. 204 (my translation).

32 Glorian Ştefănescu-Goangă, *Experimentelle Untersuchungen zur Gefühlsbetonung der Farben*, Leipzig: Engelmann, 1911, pp. 3–32.

33 Robert Michael Brain, *Pulse of Modernism*, op. cit., pp. 53–57; Cf. Stanley Smith Stevens, *Psychophysics: Introduction to Its Perceptual, Neural, and Social Prospects*, New York: John Wiley & Sons, 1975, pp. 1–36.

34 Max Burchartz, *Gleichnis der Harmonie. Gesetz und Gestaltung der bildenden Künste*, Munich: Prestel, 1949, p. 34.

35 Clark V. Poling, *Kandinsky-Unterricht am Bauhaus. Farbenseminar und analytisches Zeichnen dargestellt am Beispiel der Sammlung des Bauhaus-Archivs Berlin*, Weingarten: Kunstverlag Weingarten, 1982, p. 264.

36 Wassily Kandinsky, *Rückblicke*, 3rd edn, Bern: Bentili, 1977, p. 41 (my translation).

37 Johannes Itten & Willy Rotzler (eds.), *Johannes Itten. Werke und Schriften*, Zurich: Orell Füssli, 1972; Erich Haeckel, *Generelle Morphologie der Organismen. Allgemeine Entwickelungsgeschichte der Organismen*, vol. 2, Berlin: Reimer, 1866, p. 78.

38 Eva Badura-Triska (ed.), *Johannes Itten: Tagebücher. Stuttgart 1913–1916, Wien 1916–1919. Abbildung und Transkription*, Wien: Löcker, 1990, p. 227.

39 Rotzler & Itten, op. cit., p. 211.

40 Ibid., pp. 50, 59.

41 Johannes Itten, *Kunst der Farbe. Subjektives und objektives Erkennen als Wege der Kunst*, Ravensburg: Maier, 1961, p. 16.

42 Itten, op. cit., p. 64.

43 Ibid., p. 131.

44 Ibid., p. 136.

45 Rotzler & Itten, op. cit., p. 234.
46 Itten, op. cit., pp. 131–132.
47 Ibid., 132.
48 Ibid., p. 134. Itten does not specify here what he means with "organic function". As becomes clear from his interest in the Mazdaznan health doctrine, Itten was especially concerned about the function of heart, lung and digestion; see Eva Streit, *Die Itten-Schule Berlin. Geschichte und Dokumente einer privaten Kunstschule neben dem Bauhaus*, Berlin: Gebr. Mann Verlag, 2015, p. 111.
49 Itten & Rotzler, op. cit., p. 67 (my translation).
50 Ibid., p. 63.
51 Arnold Rikli, *Die Grundlehren der Naturheilkunde einschließlich Die atmosphärische Cur "Es werde Licht"*, Leipzig: Fernau, 1895, p. 11.
52 Frances Gage, *Painting as Medicine...*, op. cit., p. 48; Jacques Jouanna, *Greek Medicine from Hippocrates to Galen. Selected Papers*, Leiden/Boston: Brill, 2012, pp. 335–359.
53 Hellpach, *Geopsyche*, p. 59.
54 Itten & Rotzler, *Johannes Itten*, op. cit., p. 101.
55 Ibid., p. 84.
56 Itten, *Kunst der Farbe*, op. cit., p. 132.
57 Itten & Rotzler, op. cit., p. 59.
58 Paul Klee, "Schöpferische Konfession", in Kazimir Edschmid (ed.), *Schöpferische Konfession* (Tribüne der Kunst und Zeit, 13), Berlin: Reiß, 1920, pp. 28–40, p. 39–40.
59 Klee, "Schöpferische Konfession", p. 40.
60 Felix Klee, *Paul Klee: Briefe an die Familie, 1907–1940*, 2nd. vol, Cologne: DuMont, 1979, pp. 996–997, 1048–1056.
61 Winfried Moewes, *Grundfragen der Lebensraumgestaltung. Raum und Mensch, Prognose, "offene" Planung und Leitbild*, Berlin/New York: de Gruyter, 1980, p. 650.
62 Klaus Bergdolt, *Leib und Seele. Eine Kulturgeschichte des gesunden Lebens*, Munich: Beck, 1999, pp. 183, 207.
63 Bergdolt, ibid., p. 183.
64 Paul Klee, *Bildnerische Form- und Gestaltungslehre*, Bern: Zentrum Paul Klee, 2011. Available from: www.kleegestaltungslehre.zpk.org (August 30, 2018), BF/158 (November 28, 1922).
65 P. Klee, ibid., BF/158.
66 Hermann Trenkle, *Klima und Krankheit*, Darmstadt: Wissenschaftliche Buchgesellschaft, 1992, p. 15.
67 P. Klee, ibid., BG 1.2/104-105, January 15, 1924.
68 Hans Joachim Albrecht, "Von malerischer Freiheit in konstruktiver Kunst am Beispiel von Josef Albers und Richard Paul Lohse", in C. Wagner & G. Leistner (eds.), *Vision Farbe. Adolf Hölzel und die Moderne*), Paderborn: Fink, 2015, pp. 219–243, p. 234.
69 Klaus Ottmann (ed.), *Overcoming the Problematics of Art. The Writings of Yves Klein*, Putnam: Spring Publications, 2007, p. 48.
70 Ottmann, ibid., p. 158.
71 Ibid., p. 183.
72 Ibid., p. 158.
73 Cf. Ottmann, ibid., p. 146; and Linn Burchert, "Identität und Differenz in Yves Kleins monochromen Vorschlägen", in V. Krieger & S. Stang (eds.), *Wiederholungstäter—die Selbstwiederholung als künstlerische Praxis in der Moderne*, Vienna: Cologne & Weimar Böhlau, 2017, pp. 195–207, 201, 205–206.
74 Ottmann, *Overcoming*, p. 48.
75 Ibid., p. 158.
76 Ibid., p. 19.
77 Ibid., p. 23.
78 Ibid., p. 419.
79 Ibid., p. 51.
80 Ibid., pp. 62–66, 189–190.
81 Didier Semin & Marie-Anne Sichère (eds.), *Yves Klein: Le dépassement de la problématique de l'art et autres écrits*, Paris: Ecole Nationale Supérieure des Beaux-Arts, 2003, p. 291.

82 Dorothee Lehmann-Kopp & Museum für Architektur und Ingenieurkunst NRW Gel-senkirchen (eds.), *Werner Ruhnau: Der Raum, das Spiel und die Künste*, Berlin: Jovis Verlag, 2007, pp. 21, 35, 50.

83 Lehmann-Kopp, *Werner Ruhnau*, p. 54.

84 Burchert, *Das Bild als Lebensraum*, pp. 252–260; Sidra Stich, *Yves Klein*, Stuttgart: Cantz, 1994, p. 18.

85 Semin & Sichère, *Yves Klein*, p. 105.

86 Vlad Ionescu, *Pneumatology. An Inquiry into the Representation of Wind, Air and Breath*, Brussels: Academic & Scientific Publishers, 2017, p. 9.

87 Cf. Burchert, *Das Bild als Lebensraum*, pp. 116–129, 312–317.

12 Digital Abstraction

Interface between Electronic Media Art and Data Visualization

Birgit Mersmann

The paradigm of abstraction has expanded beyond the domain of visual art and formal aesthetics. Within cultural, social and media studies, it is acknowledged as a major symptom of the computerized information and network society and its globalizing economic, social and political effects. In his 1991 essay "Abstraction and Culture", Peter Halley regards abstract art as "nothing other than the reality of the abstract world". In his view, "abstraction in art is simply one manifestation of a universal impetus toward the concept of abstraction that has dominated twentieth-century thought".[1] In *Living with Abstraction* (2008), Sven Lütticken stresses that abstraction has pervaded every aspect of how we live as a result of radical financial capitalism combined with high technology. With reference to Adorno, Baudrillard, Flusser and Osborne he seeks to demonstrate how abstraction is implemented universally through capitalism, drawing connections between the abstraction of social and economic conditions and those mechanisms that turn abstract concepts into code. His main argument is that we are all living within abstraction, and that this mode of living generates a thoroughly concrete experience: "In the past decades, the two 'real abstractions' of finance and technology have increasingly converged and penetrated society to an unprecedented degree, forming what I have called a regime of *concrete abstraction*".[2] The new concreteness of this "embodied" abstraction as experienced by humans particularly challenges the modern concepts of formal abstraction and utopianism that have long dominated the discourse of (artistic) abstraction. Augmented by digital means, abstraction is reconcretized into virtual reality by modeling and mapping practices that serve to reduce complexity. How, then, do the experiences of real "lived" abstraction and the virtual reality experience of data abstraction relate to each other? How does contemporary software abstraction work its way from complexity to abstraction, and, vice versa, in a transcoding loop, from abstraction to complexity?

The use of digital media by visual artists, paralleled by the application of new methods of data visualization in the social, information and life sciences, medical research, statistics and nanotechnology, has shifted the modern analog forms, languages and methods of visual abstraction into the digital realm. Transformed into a computer-based code, abstraction has experienced manifold reinvigorations as a universal language of information visualization, one that is specific to the global information and network society of the 21st century.[3] In recent decades, the application of scientific visualization practices by contemporary artists and designers has sparked investigations into the complex role that digital visual representation plays in the forms and functions of abstraction. The growth in digitally native information visualization has led to a greater use of abstraction techniques to dynamically visualize large data sets in order

to better navigate the complexities of life and knowledge-processing.[4] Many aspects of artistic visualization overlap with the study of science and technology, sharing a common use of computational abstraction. Meanwhile, such visualizations are recognized not only as products of knowledge-producing technology, but also as expressions of art and design—in sum, as cultural artifacts. This transdisciplinary nature makes it possible and even necessary to look more closely at the practice and meaning of digital abstraction at this interface between digital art and data visualization.

Although the modern and postmodern legacy of visual (artistic) abstraction has permeated the digital world, no theory of digital abstraction as a visual practice and visualization concept in art and information design on a larger scale has been formulated.[5] So far, digital abstraction has almost exclusively been discussed in the technical sciences, and within that, primarily in the interdisciplinary border areas between electrical engineering and computer science, such as digital system engineering and digital system design.[6] By drawing on a historical, media-related distinction between analog forms of modern abstraction and digitally native contemporary forms of abstraction, this chapter seeks to trace the new interrelations of digitally mediated art and information visualization.

12.1 Abstraction and Information Aesthetics: From Oscillographic to Computer Graphic Abstraction

By now, it is a commonly accepted fact that the history of digital abstraction in the visual arts begins with computer art in the 1960s. Electronic abstraction constitutes an important transitional link between modern analog abstraction and contemporary digital abstraction in the visual arts. The *oscillons*, electronic abstractions created by the mathematician and artist Ben F. Laposky, were among the pioneering works of computer art to interweave art, design and science by means of electronic data visualization:

> Oscillons are [...] an excellent example of the possibility of employing modern technology in art and of demonstrating the relationship between science and art. They are also manifestations of some of the basic invisible aspects of nature, such as the movement of electrons and energy fields. The non-figurative art forms of *Oscillons* represent the reality of various intricate combinations of electricity and magnetism, such as fields, frequencies, phases, voltages, and currents. Their composition from electrical vibrations is in accord with the waveform character of light, atomic interactions, sound and other phenomena of nature.[7]

As the name indicates, the electronic abstractions are created by the oscilloscope, a scientific instrument used to study electrical wave-forms, voltages and currents. Since "the circuits within an oscilloscope itself would produce only a very limited variety of wave shapes, so other electrical circuits are connected to it to create the almost infinite variety of forms it will display as electronic abstractions".[8] In order to increase aesthetic variation, Laposky used different forms of waves, such as sine waves, sawtooth waves, square waves, triangular waves and others in various combinations, modulations, envelopes and sweeps. Color compositions were produced by employing special filter combinations. The abstract art form results of these oscillographic experiments were displayed in different types of presentation—as kinetic images on the screen of

the cathode-ray oscilloscope, in light-boxes and on movie screens or as still images of photo-recordings taken with a high-speed camera lens on film.[9] In exhibition catalogs and academic publications, Laposky categorized them decisively as creative art forms[10] and an aesthetically pleasing "kind of 'visual music'".[11] The oscillographic abstractions are related to computer art and forms of analog computational abstraction in "that the basic waveforms are analogue curves, of the type used in analogue computer systems".[12] In a letter to the video artist Woody Vasulka, Laposky even characterized his oscillons as forerunners of computer art, also proposing them as precursors of video (synthesizer) art.[13] From that point in the genealogy, it was only a small step to convert abstract electronic art into computer art. The credit for this move goes first to John C. Mott-Smith, chief of the Image Processing Branch at the Data Sciences Laboratories in Bredford, Massachusetts, who, by connecting an oscilloscope to a computer, created color computer oscillograms of experimental aesthetic value.[14] Second, it goes to the Californian computer graphic engineer John Whitney who completely transformed the art of electronic oscillographic abstraction into computer-generated abstraction by programming oscillograms using analog computing methods. This revolutionary invention finally paved the way for computer graphic animation, a pioneering field of motion graphics.

The first computer graphic abstractions generated by means of a digital electronic computer were produced by Frieder Nake and Georg Nees in the academic environment of the Computer Institute of the Stuttgart Polytech in Germany. In 1963, the mathematician, informatician and artist Frieder Nake used the *Graphomat Z64*, the legendary drawing machine created by the computer inventor Konrad Zuse and controlled by punch tape,[15] to produce abstract computer graphics. Creating drawings digitally involved a three-stage process: (1) the setting up of a program for the computer that was intended to generate a certain "artistic" variation of predefined patterns; (2) the automatic feeding of the program into the computer; and (3) the automatic conversion of the information, i.e., its transposition into line drawings. *Rectangular Hatchings* was Nake's first series of computer graphics produced by means of digital computer programming. The program for this abstract image series was created with the aim of producing a "class of drawings consisting of rectangular-shaped hatchings parallel to the borders of the illustrations".[16] The plotter images, the final results of the program, show horizontally and vertically shaded rectangles partially overlapping each other. In their composition, they echo geometric abstract art. Given this feature of programmed visualization, it comes as no surprise that modern abstract art, which reduces figures to simple forms and basic graphic elements, became a source of inspiration for early experiments with digitally programmed computer graphics. In 1965, Nake created the computer drawing *Homage to Paul Klee* as a free graphic adaptation of Klee's painting *High Road and Byroads* of 1929 and several related drawings by the modern artist from the same period. It has become one of the most frequently cited icons for the emergence of computer art in the mid-1960s and is even used as an illustration of early experiments in artificial intelligence (AI).[17] Explorations of proportions and relationships between horizontal and vertical lines in the abstract work of Klee became the point of departure for writing a computer algorithm in machine language. Random variables were intentionally included in the program in order to allow choices within a fixed number of options.[18] The visual differences between Nake's abstract computer graphic *Homage to Paul Klee* and Klee's abstract painting *High Road and Byroads*— Nake's image is horizontally oriented and includes circular forms—make clear that

the explorative digital programming of Klee's abstract visual language is conceived of and performed as an operation of artistic invention and reinterpretation, and not as a digital simulation of the original artistic work. It presents itself not as a digital copy, but as an independent creative digital abstraction of modern-art analog abstraction, one that seeks to establish a new, artistically autonomous form of digital abstraction in computer graphics. In this respect, Nake's *Homage to Paul Klee* can be identified as the first artistic work in which digital abstraction features as both the method *and* the result of data visualization.

From today's digital media culture viewpoint, computer graphics and digital abstraction seem to be naturally connected. In the pioneering phase of computer art, however, "digital abstraction" was not considered as a topic and concept. Nobody used this exact term to describe and define the new computer-generated forms and practices of graphic abstraction. Other terms and concepts dominated the debate, which was headed by mathematicians and computer scientists. The focus was on cybernetics, info-aesthetics and programming. Abstraction as a still-dominant visual language of the 1960s seemed to fuse easily with the first artistic computer experiments. The abstraction of abstract art was translated (and transcoded) into the cybernetic language of the computer, resulting in abstract visualizations. In view of the context of media and science at this point, it would be appropriate to call these early forms of computer-generated abstraction *cybernetic abstractions*.

The exhibition *Cybernetic Serendipity. The Computer and the Arts*—advised by Max Bense, the guiding thinker and founder of info-aesthetics, and displayed by the Institute of Contemporary Art in London in 1968 under the curatorial guidance of Jasia Reichardt—provides evidence for this causal relationship. The aim of the exhibition was

> to present an area of activity which manifests artists' involvement with science, and the scientists' involvement with the arts; also, to show the links between the random systems employed by artists, composers and poets, and those involved with the making and the use of cybernetic devices.[19]

Exhibits in the show were either produced using a cybernetic device (computer) or were themselves cybernetic devices. They reacted to something in the environment, either human or machine, and in response produced sound, light or movement, thus taking the first steps toward interactive art. Examples of Frieder Nake's and Georg Nees's computer graphics were also included in this legendary computer art exhibition alongside computer-generated film, music and poetry.

Interest in the founding of info-aesthetics was the main motivation behind the early cybernetic experiments with computer graphics. The information aesthetics movement surfaced as an innovative and influential approach in Europe in the 1960s; it orbited around two central figures—the philosopher Max Bense and the physicist and psychologist Abraham A. Moles. Rooted in semiotics, communication science and the concept of information as defined by Shannon and Weaver,[20] the foundation of information aesthetics began with the assumption that a work (of art) is a complex sign; it

> is structured in a multitude of ways and can be analyzed in terms of subsigns, and subsigns of subsigns, continuing down to a lowest level (granularity). [...] The concept of information is taken up as the central notion for an aesthetics that is oriented towards numeric values.[21]

It is this numeric redefinition and recodification of aesthetics that paves the way for digital data aesthetics, including data visualization. The difference between the information aesthetics of the 1960s and its reinvigorated contemporary form[22] can be characterized as a move from an analytic and generative aesthetics of complex sign processing to that of complex data processing and navigating. As Nake observed, "'Information Aesthetics' today is about the display of huge quantities of data (erroneously called 'information'), and 'generative design' is now about running a program on a computer with complex parameter settings".[23] Although in retrospect Nake criticizes the rational, object- and measurement-centric foundation of Bense's information aesthetics, he adheres to a semiotic understanding of computer programming and processing and accordingly advocates a digital aesthetics as an algorithmic semiosis.[24]

It is remarkable that the term "information aesthetics" was coined before the computer revolution took hold, and that the introduction of digital machine computation seemed to provide an apt instrument and method to implement and promote it. In a study of 2008, Lev Manovich adapted the term "info-aesthetics" and reconceptualized it as a new paradigm for understanding our contemporary culture. According to his definition, info-aesthetics "refers to those contemporary practices that can best be understood as responses to the new priorities of information society; making sense of information, working with information, producing knowledge from information".[25] Interested in the form and shape of information, he raises aesthetic and image- and design-related questions: "Has the arrival of information society been accompanied by a new vocabulary of forms, new design aesthetics, new iconologies? Can there be forms specific to information society, given that software and computer networks redefine the very concept of form?".[26]

Information design in the global informational network society is shaped by new forms (and functions) of digital abstraction. In the following section, I will explore how contemporary information aesthetics, as connected to data visualization, is determined by the paradigm, method and practice of digital abstraction.

12.2 Digital Abstraction and Data Aesthetics

The digital has surfaced as a new aesthetic condition and category in the context of media art; digital media were discovered as artistic tools, and the term "digital art"[27] became the norm, partly replacing the older and broader term "computer art". From a science-historical point of view, it was the discourse on the digital and digitality, combined with the emergence of visualization as a new digital technology of computer graphics, that largely impacted and reinvigorated the research on the principles, paradigms and practices of abstraction as a computer-coded language and data-aesthetic form of visualization. Meanwhile, a variety of new abstraction concepts such as *algorithmic abstraction*, *software abstraction* and *digital abstraction* began circulating. Clear differentiations between these digital-driven redefinitions of abstraction are yet to emerge, and even a historical periodization of digital forms and features of abstraction has not yet been undertaken. The introduction of the World Wide Web, for instance, has catapulted digital abstraction into a new infosphere of global communication. Against this background, there is a need to analyze digital abstraction in relation to the technical functions, conditions and possibilities of each (historical) web epoch and its versions, such as web 1.0, 2.0, 3.0 (semantic web) and 4.0 (AI web)—a huge terrain for future research on the technical history of digitality and abstraction.

It is obvious that the nature and meaning of abstraction has changed through digitally native technologies and cultures. To understand the particularity of digital abstraction at the interface of visual art and data visualization, it is important to look at the digital transformation of artistic, cultural and media informational processes of abstraction in relation to reality, be it a physical or virtual reality. Three issues appear to be crucial to resituating abstraction in the digital contemporary: (1) the historical differences and relations, continuities and discontinuities between the paradigms of (modern) analog and (contemporary) digital abstraction; (2) the relation between abstraction, representation and concretization; and (3) the relation between reality and visual abstraction with regard to the digital machine, that is, the computer.

What differentiates between modern analog and contemporary, digitally native abstraction? Is it the loss of belief in the universalism of non-objective, non-representational art? The metaphysical endeavor and exercise of abstraction as creation/ism? The self-referentiality of modern abstraction as a triumph of autonomous art? How is the autonomy of modern abstract art distinct from the self-generational processes and self-organizational patterns of digital art?

According to the media theoretician Lev Manovich, modern abstraction was informed by the modern scientific paradigm of atomization and universalization, whereas digital abstraction is guided by the new network paradigm of complexity-reduction:

> If modernist art followed modern science in reducing the media of art—as well as our sensorial experiences and ontological and epistemological models of reality—to basic elements and simple structures, contemporary software abstraction instead recognizes the essential complexity of the world.[28]

In data visualization, Manovich recognizes a genuinely new cultural form of abstraction linking art, science and computer graphic design. Computer visualizations transform quantified data, which by themselves are not visual, into visual representations. They are closely related to the concept and practice of mapping, forming "a particular subset of mapping in which a data set is mapped into an image".[29] According to Manovich, modern visual artists and contemporary visualization artists are bound together by their desire and motivation to map the invisible, ungraspable and infinite:

> Just as in the first decades of the twentieth century modernist artists mapped the visual chaos of the metropolitan experiences into simple geometric image, data visualization artists transform the informational chaos of data packets moving through the network into clear and orderly forms.[30]

Data visualization as a form of digital abstraction makes it possible "to see patterns and structures behind the vast and seemingly random data sets".[31] Turned into an art form, it should, if the aesthetic component of information visualization is considered seriously, not only "map some abstract and impersonal data into something meaningful and beautiful" but also "represent the personal subjective experience of a person living in a data society".[32]

The data visualization work of the Paris-based Japanese visual and sound artist Ryoji Ikeda illustrates this new "data-subjectivity" as human immersion into data-driven digital abstraction. Since Ikeda engages in synchronizing the visualization and sonification of data, it would be more appropriate to speak of data audiovisualization

as a specific artistic technique of data design. The artist works with diverse data from digital and analog sources (among them texts, numbers, images, sounds, etc.) as the visible and invisible material that constitutes our world and living environment. By applying a pure and minimalist data aesthetics, he creates audiovisual artworks of "abstract beauty that have a virtually hypnotic effect on the viewer".[33] The composition of immersive datascapes out of flows and columns of data is featured in different artistic genres and mediation formats, such as installations, audiovisual performances, concerts and sonic albums. The complexity of data information freely floating in cyberspace is captured and condensed by means of digital algorithmic abstraction, resulting in dynamic and interactive data abstractions that flicker, pulsate, transform and dance across large-screen environments. The artist's specifically designed software algorithms represent an important computer-technical prerequisite for processing, fragmenting and recomposing the data material into visually perceptible and aesthetically pleasing forms.

The reliance upon digital abstraction as a methodological tool of data processing and visualization is most clearly reflected in Ikeda's art project *Datamatics* (2006–ongoing), whose major aim is to explore the "potential to perceive the invisible multi-substance of data that permeates our world".[34] Massive sets of raw data derived from diverse scientific fields such as astronomic mapping, DNA sequencing, proteomics and graphic geometry are algorithmically abstracted into computer-generated sound-images. Projected on walls or screened as part of audiovisual concert performances and installations (Figure 12.1), they rhythmically flicker in black and white with intermittent color accents, assembling computer graphic structures and outlines that remind the viewer of bar codes and diagrams, test images, records and interference patterns—even of a predigital electronic era. The datamatic experiments are acted out in four dimensions:

Figure 12.1 Ryoji Ikeda, exhibition view of the installation *datamatics*, 2017; photo: courtesy of Ryoji Ikeda Studio.

From 2D sequences of patterns derived from hard drive errors and studies of software code, the imagery transforms into dramatic rotating views of the universe in 3D, whilst in the final scenes four-dimensional mathematical processing opens up spectacular and seemingly infinite vistas. A powerful and hypnotic soundtrack reflects the imagery through a meticulous layering of sonic components to produce immense and apparently boundless acoustic spaces.[35]

A key element in Ikeda's digital synesthetics is the vast immersiveness of the data experience. The synchronization of image and sound is "artistically orchestrated as a whole symphony, which brings 'total sensory experiences' to visitors".[36]

This absorbing type of surround audience experience on the individual and collective human level is also characteristic of the screening of other data artwork by Ikeda. The audiovisual work *test pattern* (2008–ongoing), for instance, presents "intense flickering black and white imagery which floats and convulses in darkness to a stark, powerful and highly synchronised soundtrack".[37] It is entirely composed of abstract barcode and binary patterns of 0s and 1s that are digitally converted from any form of data (text, sound, photos and movies) through a real-time computer program. "The velocity of the moving images is ultra-fast, some hundreds of frames per second, so that the work provides a performance test for the audio and visual devices, as well as a response test for the audience's perceptions".[38] It made it possible to collectively experience the abstraction of visual perception through the pulsating acceleration of data streams, be it at its 100 m installation version in the Kraftzentrale Duisburg at the Ruhrtriennale, Germany, in 2013 where visitors could walk on the datascapes of the moving barcodes like zebra crossings, or in a public urban space such as when the *test pattern* was staged as an audiovisual "live" concert in Times Square, New York, on October 16, 2014 (Figure 12.2). This art performance in New York was promoted as a "public/private silent concert"[39] and staged as an urban mega event. Fifteen digital screens in Times Square were selected for the projection of the *test pattern*. At precisely midnight, the gathered human crowd was able to listen to a six-minute soundscape and view the corresponding flickering screen shifts of the barcode stripes and binary patterns. With his fast-track audiovisualization, the artist attempted to test the limits of not only human visual perception of abstract data visualization patterns, but also media reception and recording of data synchronizations. Although the invisible and inaudible flow of data can be made visible and audible through digital data visualization and sonification techniques, their sensory perception by humans remains a challenge, not to mention their cognitive processing. In this respect, digital abstraction can also be connected to the reduction of conscious perception of data and the principle of the limitation of receptive capacities through data information overload.

The artist's intention to push the limits of human perception in relation to the unrepresentability and abstractness of complex data worlds is continued in the audiovisual performance *superposition*, an art project ongoing since 2012 which finds its installation counterpart in the work *supersymmetry*. In line with an earlier artwork, the performance *superposition* draws upon diverse material such as images (still and moving), language, sound, documents about physical phenomena and mathematical concepts for the purposes of superimposing data information in synchronizations of image and sound. According to the exhibition reviewer Joo Youn Lee, who participated in one of the performances of *superposition*, the artist turned "the theater into a constantly transforming soundscape by composing sounds ranging from droning,

Figure 12.2 Ryoji Ikeda, *Test Pattern*, every night on Times Square, New York, 11:57 pm to
 0:00 am (for three minutes), from October 1–31, 2014; photo: courtesy of Ryoji
 Ikeda Studio.

glitchy rhythms and white noise to high-frequency sine waves at a precisely calibrated
pace and intensity".[40] To date, the audiovisual performance *superposition* has been
staged twice for a public art audience: in 2012 at the Centre Pompidou in Paris and
in 2014 at the Metropolitan Museum in New York. For these performances, the artist
included real human performers for the first time—the female and male performers
Amélie Grould and Stéphane Garin who enacted various data operations "on stage"—
including the tapping of Morse codes to generate words and messages in order to cre-
ate powerful data audiovisualizations that were projected onto an immersive screen
environment.[41] By adding human actions as an operating component to the data
screening, Ikeda emphasized the human relation to digital data compositions.

The creation of *superposition* was motivated by the desire to visualize the non-
perceivable and non-graspable. The title of the work refers to "that state of superim-
position of '0 and 1' in quantum mechanics, suggesting a state of things that even the
best scientists cannot describe, and that no-one is able to perceive".[42] The so-called
qubit, i.e., quantum binary digit, represents a superposed state of 0 and 1. As opposed
to the *bit* as the smallest data unit that computers we are using in daily life work with,
the unit the quantum computer operates with is called *qubit* (quantum bit). The qubit
represents not "0 or 1", but a superposition state of "0 and 1 at the same time". It is
said that this makes cryptanalysis and other complex calculations that cannot be done
with conventional computers possible.[43]

Although *superposition* was not created and performed with a quantum computer
but with a classical digital computer, it provides glimpses into a new era and dimension

of computational abstraction: that of quantum abstraction blurring the dichotomy between the material and the immaterial, physical and informational, presence and absence, existence and non-existence, all at the same time. Qubit-based abstraction lies beyond digital abstraction; it reconnects to the analog: "Bit is digital. QUBIT is analog—analogous to nature. Bit is discrete. QUBIT is continuous—continuum. Quantum computing is to read how subatomic particles behave by means of the language of QUBIT; i.e. Nature computes. We decipher it".[44] When nature itself computes, there is no artificial intelligence involved, but only the intelligibility of nature "at work". With quantum computational abstraction emerging as a form of nature concretization, the media and art history of data visualization enters a new, as yet undiscovered stage.

12.3 Visualizations of the Abstract Computing Machine

The definition of art as an "abstract machine", by now regarded as an almost classic topos of mechanical modernity, turns out to be another important aspect of approaching digital abstraction between electronic media arts and data visualization. It urges us to approach abstraction not only formally, but on a phenomenological and ontological level. The construction of a new reality is intertwined with the production of abstraction. Following the philosophy of Deleuze and Guattari in *A Thousand Plateaus* (1980/1988), the "abstract machine [of art; note BM] does not function to represent, even something real, but rather constructs a real that is yet to come, a new type of reality".[45] Today, art and visual design (which I would include here) function and (inter) act as a digital abstract machine. This type of machine serves no function other than the "unfolding of complexity, a fractal engineering inseparable from life, a blooming of multiplicity".[46] Its abstraction process shapes how it becomes; the existence of the digital machine is the creative becoming. For this reason, "constructing an abstract machine is to construct construction itself".[47] And here, we return to cybernetics, since, according to William Ross Ashby, it includes the study of all possible machines.[48]

Bill Seaman, artist, computer scientist and visual studies scholar at Duke University, has explored the AI potential of a robotic entity with human sentience, i.e., the capacity to feel, perceive and experience subjectivity. He has devised a new type of abstract digital machine that functions as an "engine of engines", one that is able to "abstract abstraction" and "employ informed 'reciprocity'—mutual exchanges and relational inter-actions as a central aspect of our and its 'coming to be'".[49] The machine, called Neosentient,[50] is created via the embodiment of a series of specific algorithms on a parallel computing platform. It is an electrochemical computer that functions in conjunction with a robot and a related sensing system. With this Neosentient machine, the artist "seeks to abstract abstraction as an ongoing process of ultra-complexity, and articulate a topology of relationalities or better a relationality of relationalities in the service of insight production, technological creativity and ongoing human self-reflection".[51] In order to develop the "Insight Engine" tool, Seaman transforms the body's natural computational processes into a mixed analog and digital system. In creating networked AI systems that are "bio-mimetic and bio-relational, mixing both analogue and digital processes",[52] he acknowledges the future of computing. This perspective makes us aware that analog abstraction is not an outdated process, but rather that it can be productively combined with and even embedded into digital abstraction, in particular when considering human–machine interaction.

One groundbreaking artistic research project that explores the digital visualization of the abstract machine of computational data processing from the perspective of knowledge design is *AI Senses* by Kim Albrecht (Figure 12.3). It was developed in 2017 in collaboration with the research group MetaLab@Harvard, a laboratory at Harvard University dedicated to exploring the human dimensions of artificial intelligence, including the psychological and philosophical conditions of electronic systems, by means of artistic experiments at the interface between information science, network design and the humanities. Kim Albrecht has joined the group as a knowledge designer and aesthetic researcher. He is an expert in the visualization of complex information and knowledge networks, spanning from mathematical, medical and biological through social and ecological networks to the networks of the universe (see his project *Cosmic Web*[53]). Among his best-known projects is *Trump Connections*, the visualization of Trump's personal and business connections with individuals and organizations all over the world,[54] and *Science Paths*, the visualization of the evolution of individual scientific impact using citations of over 10,000 scientists from seven different research fields as its basis.[55] The data designer Kim Albrecht even created a meta-visualization of his own projects, affiliations, exhibitions, writings and media appearances. Accessible on his homepage,[56] the visualization project reflects the visual language of mind mapping, network graphics and info-aesthetics.

The visualization project *Artificial Senses*, alternatively termed *AI Senses*,[57] which was presented in the form of an exhibition at the Harvard Art Museums in 2017 and is now accessible as a web-native experience on the homepage of Kim Albrecht, is interested in tracing the mechanisms and limitations of digital abstraction. Based on the reality of binary digits, the computing machine is considered to be an abstract(ion) machine that reaches beyond our human perception and cognitive capacities.[58] The velocity and complexity of machinic data processing is considered responsible for digital abstraction and its excessive demands on human perception. Disorientation and disfiguration occur as a consequence, even though all kinds of data are ultimately human-generated data, representing a certain human relationality to their production source.[59] The project description highlights that

> the machine's reality departs from our own. With many of its sensors [...] the machine is operating in a timescale that is too fast to understand; the orientation sensor returns data up to 300 times per second. This is not only too quick to manage to draw each of these values on the screen, but also too quick for us to comprehend. In most cases, to make these visualizations, the machine had to be tamed and slowed down for us to perceive this experience.[60]

In *AI Senses* the computer device displays its own noticing, registration and monitoring of sense perception and input processing. It monitors "how the machines look at the world and how different their way of seeing and feeling is, compared to ours".[61] Contrary to the human relation to the computer as an inclusive media and communication machine, the relation of abstract data to the real human world (of its users) takes center stage. Raw sensory data are reimagined as animated data visualizations. These provide explorations—or should we speak of visual data representations?—of how the machine of the digital computing devices perceives and processes the senses of our human world. The invisible AI technology hidden in the

Figure 12.3 Kim Albrecht, *AI Senses*, "Locating" (up) and "Touching" (down) (software, computer, screen), 2017; photo: courtesy of the artist.

machine is made visually perceivable. Accordingly, the project series *AI Senses* pro-vides visualizations of sensory processes, activities and interactions that are central functions of digital information services such as seeing, hearing, locating, moving, touching and orienting. It captures visual data from the camera, frequency data from the microphone, geolocation data, touching data, motion data and gyro-sensor data from digital devices. Mappings of sensor data from smart phones and personal com-puters form the basis for the visualization of the above-mentioned artificial digital senses. In the beautifully striped visualization image *Touching*, for example,

> each vertical row represents the vertical and horizontal position of the finger on the screen of the device compared against the total height and width of the screen. [...] The width of each drawn line depends on the time between two incoming signals.[62]

In the visualization image *Locating*

> each vertical line represents one request of the latitudinal and longitudinal geolo-cation of the device. Rather than displaying the two numbers that are returned the visualization displays every digit of those numbers individually. [...] Each digit of the latitude and longitude values are represented by saturation of blue and magenta. Both created patterns are overlaid: the difference between the bottom layer and the top layer is calculated and represented as a positive value.[63]

One major result of this visualization research is that "the device can know its position to an accuracy of a few centimeters/inches", and that "on every request, the location of the instrument, even when it is not in motion, is constantly changing".[64] This means that the data visualizations are variable depending on environmental influences, move-ment and technical changes. The use of different machines and web browsers even produces different visualization results. Although the final images of the *AI Senses* vis-ualizations are distinct from each other in terms of color and compositional structure, they show remarkable similarities with regard to their basic patterns. This observation demonstrates the aesthetic homogenization of distinct sensory experiences through their processing by the abstract(ing) digital machine.

In view of the aesthetic features of the data visualization output, the animated images can be considered concrete art expressions of the abstract digital machine. To the human viewer, they provide insight into how the abstract machine "under-stands" in terms of sensory coding and (re)cognition. They represent the abstract machine view of human-produced data rather than the human view of data. For this reason, Albrecht remarks that these "graphics might not be entirely readable for humans but give a sense of how the machine depicts reality and how that differs to our experience".[65] As a kind of visual database of human-induced machine record-ing, *AI Senses* opens immediate and online access to humanness in digital computer abstraction: "the closer you inspect the machine, the more you realize how human it is. All sensors are created, made by humans. The entire construction of the computer is human, and the closer you get the more this becomes visible".[66] With this state-ment, the visualization researcher Albrecht emphasizes the perception of artificial intelligence as human and points to the centrality of understanding human sentience in AI research.

12.4 The Changing Paradigm: Concretizations of Digital Abstraction

Visualizations in the field of electronic media art and data design aim at senso-rial concretizations of digital abstraction processes. They algorithmically transform the invisibility of complex and ultra-fast data flows into visible patterns, thereby enabling a multisensory and immersive experience of digital abstraction processes. In the overall picture, this case study–based media-historical account has shown that digital abstraction appears on two distinct, yet interconnected levels: It is employed as a visual(ization) practice of complexity-reduction and shaped as a media-specific information- and data-aesthetic visual form. The findings indicate a close connec-tion between the artistic language of digital abstraction and the technical conditions of digital data representation. Digital visual abstractions freely experiment with the graphic syntax of information and knowledge visualization, spanning from bar charts to network mappings.[67] Contrary to Manovich,[68] I would argue that through data-mapping, visualizations can generate a new digital sublime. This is particu-larly proven by the data visualization work of Ryoji Ikeda, in which the viewer is overwhelmed by the immersive sensorial experience of abstract data information streaming.[69]

This short journey through the art, design and science history of electronic abstraction from the early 1960s to the present reveals that a differentiation needs to be made between the electronic forms of computational abstraction according to their technical conditions and operating principles. The oscillographic abstractions created by Ben F. Laposky are among the electronic abstractions of the predigital age. Even though they initiated a turn toward computer and video art, they were still anchored in the iconic logic of modernist analog abstraction. The computer graphic abstractions by Frieder Nake and Georg Nees were—contrary to their mod-ern abstract imagery—identified as (among the first) digital abstractions, since they were programmed by a digital computer. Taken together, the works of early com-puter art and contemporary data visualization art demonstrate that digital abstrac-tion can arise from both analog and digital data processing. The key criterion for defining abstraction as a natively digital visual code and visualization practice is that the technical process of abstraction has to be performed digitally. With quantum computational abstraction involving the superposition of binary digits, a new era of postdigital electronic abstraction is appearing on the horizon. This is what the data visualization work of Ryoji Ikeda suggests. Machinic abstraction, if generated by the 'abstract machine' of a digital device, represents another operational dimension of digital abstraction. AI researchers in the domain of visual electronic arts and data visualization, such as Bill Seaman and Kim Albrecht, attempt to understand this type of machine abstraction; they recognize in it a new form of reality construction. Digital machine abstraction can serve to visualize natural human intelligence in the robot, as Seaman's design of the Neosentient demonstrates, or visualize the artificial intelligence of sensory processing in the computer machine, as Albrecht's explora-tions of *AI Senses* prove. In both cases, the human dimensions of digitally pro-grammed artificial intelligence are laid bare, resulting in animated visualizations of the seeing, feeling, hearing, touching, locating and orienting functions of the abstract digital machine. During this process, the abstractness of sensor data input is concre-tized, and the operational mode of digital abstraction traced back to abstract sensa-tions. In digital visualization contexts, we ultimately encounter a new virtual sense

regime of *concrete abstraction* that installs a data-representational human power of abstraction. Through this move, the inhumanness inherent in digital abstraction processes is humanized, and the numerical abstractness of digital data is transcoded into perceptual realizations.

Notes

1 Peter Halley, "Abstraction and Culture" (1991), in Maria Lind (ed.) *Abstraction*, Cambridge, MA/London: MIT Press, 2013, p. 138.
2 Sven Lütticken, "Living with Abstraction" (2008), in Lind, *Abstraction*, p. 148.
3 See Louis Albrechts, Seymour L. Mandelbaum, eds., *The Network Society*, New York/London: Routledge, 2005; Manuel Castells, *The Rise of the Network Society: Economy, Society and Culture*, Volume I (Information Age Series), Oxford: Blackwell Publishers, 1996; Manuel Castells, *The Power of Identity: The Information Age: Economy, Society, and Culture*, Volume II (Information Age Series), Oxford: Wiley-Blackwell, 2009; Frank Webster, *Theories of Information Society*, New York: Routledge, 2014.
4 See Colin Ware, *Information Visualization. Perception for Design*, Waltham: Morgan Kaufmann, 2012; Robert Spence, *Information Visualization. An Introduction*, Cham: Springer, 2014; Andy Kirk, *Data Visualisation. A Handbook for Data Driven Design*, London: SAGE, 2016; Andy Kirk, Simon Timms, *Data Visualization: Representing Information on Modern Web*, Birmingham: Packt, 2016; Grzegorz Osinski, Veslava Osinska, *Information Visualization Techniques in the Social Sciences and Humanities*, Hershey: IGI Global, 2018.
5 The artistic research project "Digital Abstractions" conducted by the Basel School of Design in Switzerland was one of the first to investigate digital abstractions as new paradigmatic image forms of the digital information society. Its goal was to extend the history of the abstract image into the digital era, from the first experiments in computer graphics of the 1960s and 1970s through digital animations and sound visualizations to interactive web art and game projects of the 1990s and artistic apps for smart phones and tablet computers. In 2016, an exhibition of the research project was organized at the House of Electronic Arts in Basel (see www.hek.ch/en/program/events-en/event/digitale-abstrakt ionen.html) [February 26, 2019].
6 See William J. Dally, John W. Poulton, *Digital Systems Engineering*, Cambridge: Cambridge University Press, 1998; Anant Agarwal, Jeffrey Lang, *Foundations of Analog and Digital Electronic Circuits*, Amsterdam: Morgan Kaufmann, 2005.
7 Ben F. Laposky, "Oscillons: Electronic Abstractions", *Leonardo*, vol. 2, no. 4, 1969, p. 353.
8 Ben F. Laposky, *Oscillons. Electronic Abstractions. A New Approach to Design*, self-published by Laposky, Cherokee, Iowa, 1953, p. 2.
9 Laposky, *Oscillons*, 1953, p. 14.
10 Laposky, "Oscillons", 1969, p. 345.
11 Laposky, *Oscillons*, 1953, p. 14.
12 Ben F. Laposky, *Oscillons: Electronic Abstractions*, 1975. Available from: www.atari-archives.org/artist/sec6.php [February 23, 2019]. When Laposky discovered the field of computer art, he described it as a form of oscillography, thereby emphasizing the close connection between electronic abstract art and computer art.
13 Laposky, *Oscillons*, 1953.
14 They were included in the London exhibition *Cybernetic Serendipity. The Computer and the Arts* of 1968.
15 The drawing machine was equipped with "a drawing head guiding four pens, fed by Indian ink of different colours with nibs of varying thickness" (Frieder Nake, "Notes on the Programming of Computer Graphics", in Jasia Reichardt (ed.) *Cybernetic Serendipity. The Computer and the Arts*, London/New York: Studio International, 1968, p. 77).
16 Nake, "Notes", p. 77.
17 Cp. Lev Manovich, *AI Aesthetics*, Moscow: Strelka, 2018.
18 The variegating options programmed by Nake were the following: "Change of original width of the horizontal bands (at the left boundary): The 'buckling' of the horizontal bands

as they extend from left to right, but so that they never intersect; for each quadrilateral that is generated as part of one horizontal band, a random decision is made: it is left empty, or filled by vertical lines, or by triangles; the number of signs per quadrilateral (vertical lines or triangles); positions of those signs per quadrilateral; additionally, the number of circles; position of each circle; size (radius) of the circles" (http://dada.compart-bremen.de/item/artwork/414) [February 26, 2019].

19 Reichardt, *Cybernetic Serendipity*, p. 5.
20 Claude E. Shannon, Warren Weaver, *The Mathematical Theory of Communication*, Champaign: University of Illinois Press, 1963.
21 Frieder Nake, "Information Aesthetics: An Heroic Experiment", *Journal of Mathematics and the Arts*, vol. 6, no. 2–3, 2013, p. 68.
22 See Stephen Wilson, *Information Arts. Intersections of Art, Science, and Technology*, Cambridge/London: MIT Press, 2001; Lev Manovich, *Info Aesthetics*, New York: Bloomsbury, 2010.
23 Nake, "Information Aesthetics", p. 65.
24 Frieder Nake, "Art in the Time of the Artificial", *Leonardo*, vol. 31, no. 3, 1998, pp. 163–164.
25 Lev Manovich, *Introduction to Info-Aesthetics*, 2008, p. 6. Available from: http://manovich.net/content/04-projects/060-introduction-to-info-aesthetics/57-article-2008.pdf [February 23, 2019].
26 Manovich, op. cit., p. 6.
27 See Christiane Paul, *Digital Art* (2008), London: Thames & Hudson, 2015.
28 Lev Manovich, "Abstraction and Complexity", in Oliver Grau (ed.), *MediaArtHistories*, Cambridge, MA/London: MIT Press, 2007, p. 346.
29 Cf. Manovich, ibid.
30 Ibid.
31 Ibid.
32 Ibid.
33 Ryoji Ikeda, *Leaflet to the Exhibition*, Basel: House of Electronic Arts (HeK), 2015.
34 Cit. from www.ryojiikeda.com/project/datamatics/ [26 March 2019].
35 Ibid.
36 Ibid.
37 Cit. from www.ryojiikeda.com/project/testpattern/ [26 March 2019].
38 Ibid.
39 Joo Yun Lee, "Review Ryoji Ikeda", *Afterimage. Journal of Media Arts and Cultural Criticism*, 2015, p. 32.
40 Lee, "Review Ryoji Ikeda", p. 31.
41 In the performance of *superposition* at the Metropolitan Museum in New York, the screen environment entailed a large screen as backdrop, a long band of ten screens in the center arranged as a line and ten monitors at the front of the stage.
42 "Ryoji Ikeda. Supersymmetry", 2014, n.p. Interview with Kazunao Abe. Available from: https://special.ycam.jp/supersymmetry/en/interview/ [26 March 2019].
43 Ibid.
44 Ikeda cit. in Lee, "Review Ryoji Ikeda", p. 30.
45 Gilles Deleuze, Felix Guattari, *A Thousand Plateaus*, London: Athlone Press, 1988, p. 142.
46 Stephen Zepke, *Art as Abstract Machine: Ontology and Aesthetics in Deleuze and Guattari*, New York/London: Routledge, 2005, p. 1
47 Zepke, *Art as Abstract Machine*, p. 2.
48 See William R. Ashby, *An Introduction to Cybernetics*, Eastford: Martino Fine Books, 2015.
49 Bill Seaman, "Neosentience and the Abstraction of Abstraction", *Systems. Connecting Matter, Life, Culture and Technology*, vol. 1, no. 3, 2013, p. 51.
50 The introduction of this term is based on Bill Seaman's conversations with the theoretical physicist Otto E. Rössler. See Bill Seaman, Otto E. Rössler, *Neosentience: The Benevolence Engine*, London: Intellect, 2013.
51 Seaman, Rössler, *Neosentience*, p. 64.
52 Ibid.

53 See https://kimalbrecht.com/vis/#cosmic-web [March 26, 2019].

54 See http://trump.kimalbrecht.com/network/ [March 26, 2019].

55 See http://sciencepaths.kimalbrecht.com/ [March 26, 2019].

56 See https://kimalbrecht.com/vis/ [March 26, 2019].

57 The meta lab description of the project cites the title *AI Senses*. See https://metalabharva rd.github.io/projects/lb_aisenses/ [26 March 2019].

58 Kim Albrecht writes on machinic abstraction in *AI Senses*: "For the machine, reality is binary—a torrent of off and on. Any knowledge we accomplish through the machine about the world goes through the process of this abstraction. As we become more dependent on our machines, we need to understand these underlying boundaries of the form of abstraction that takes place" (cit. from https://artificial-senses.kimalbrecht.com/) [26 March 2019].

59 "I am trying to discover new worlds that nobody has seen so far. […] Data are generated by people, a human product. So this discovery is cultural, we are building and discovering a new cultural world" (Kim Albrecht cit. in Maddalena Mometti, "Human-Data Interaction in the Age of Industry 4.0, Part 2", 2017, n.p. Available from: http://digicult.it/news/h uman-data-interaction-age-industry-4-0-part-2/) [March 26, 2019].

60 Cit. from https://artificial-senses.kimalbrecht.com/ [March 26, 2019].

61 Ibid.

62 Ibid.

63 Ibid.

64 Ibid.

65 Cit. in Mometti, "Human-Data Interaction", n.p.

66 Ibid.

67 See Manuel Lima, *Visual Complexity. Mapping Patterns of Information*, New York: Princeton Architectural Press, 2011.

68 Lev Manovich, "Data Visualization as New Abstraction and Anti-Sublime", 2002. Available from: http://manovich.net/content/04-projects/040-data-visualisation-as-new-abstraction-and-anti-sublime/37_article_2002.pdf [March 27, 2019].

69 Cf. also Maryse Ouellet, "Par-delà le naturalisme: médiatisation du sublime dan les œuvres d'Olafur Eliasson et Ryoji Ikeda", *RACAR: revue d'art Canadienne/Canadian Art Review*, vol. 41, no. 2, 2016, pp. 105–120.

13 Toward a Transsensorial Technology of Abstraction (Ekstraction)

Clemens Finkelstein

Located in the midst of an aggressive yet subversive data-ecology in the 21st century, humans find themselves frequently transformed by the processes of generation, transfer or translation of data and the operations of media as technologized cultural techniques it facilitates. The accumulation of data poses specifically an ethical challenge that extends itself into the algorithmic implementation in artificial intelligence, machine learning and robotics. Not solely undergoing an epistemic but ontological turn, media, as Wolfgang Ernst so fittingly remarked, "becomes itself the active agent of that which generates knowledge, and the mirror stage of a realization (*Erkenntnis*), in which humans experience themselves as their other not notionally, but as a data field".[1]

The ontological and semiotic exhaustion of the contemporary condition that sets up this inquiry into the porous paradigm of *abstraction* may be linked to its vacillating instantiations within the history and theory of art and science. In an attempt to dissolve and reform the symbolically drained lexical vessel, the following will attempt to process the frayed notion in its original transitive meaning. Derived from the Latin *abstractus*, *abstrahere*, three nodes emerge that bridge its distilled definitions and become instrumental for the unfolding analysis: "to take away, separate, extract, or remove (something; a substance) by distillation"; "to move (a person or thing) away, withdraw"; "to disengage from an object, experience, or activity, usually so as to be distracted or absorbed by something else".[2]

Defining abstraction as a process rather than a fixed form or identifiable quality, its functional aspect is nonetheless entwined with *form* as it materializes and dematerializes exemplarily in the transmedial and transsensorial works of the Japanese artist Ryoji Ikeda (*1966). Active as a DJ (1980–1990) and sound artist (1990–), releasing genre-defining concept albums on cult labels such as Touch (UK) and Raster-Noton (Germany), Ikeda began in the 1990s to negotiate the radical shift of contemporary life as a member of the Japanese collective Dumb Type—critiquing the submissive formatting of the human through consumption and technology as *dumb type*. A hybrid of fine art, architecture, theater, music, dance, composition and computer programming, the artist's collective took shape as a productive paradox to the discourse it sought to attack and channel. Continuously evolving his practice through long-term research inquiries—which he often develops in collaboration with scientists and programmers—Ikeda situates himself as a drifter between liminal states. In his so-called metacompositions, he dwells in these zones with an agility provided by synchronously anchoring and expanding potent points of transmedial and interdisciplinary intersection. His practice thereby focuses on the *aestheticization* and the *perceptualization* of

mathematical theorems, physical phenomena or so-called big data sets, and is directed toward the exploration of the very liminality they inhabit.

This chapter examines Ikeda's turn to the space of particle physics and physical cosmology in *micro | macro* (2015–) through his technology of abstraction. The project was conceived during his 2014–2015 artist residency at CERN, the European Organization for Nuclear Research in Geneva, Switzerland, and the initial audiovisual installation *the planck universe [micro | macro]*[3] was commissioned and produced by the ZKM, the Center for Art and Media in Karlsruhe, Germany, in 2015 (Figure 13.1). Instrumentalizing high performance video projectors, computers and high-frequency loudspeakers to generate immersive environments that enter into dialogue with the monumental architecture of the former munitions factory in Karlsruhe, Ikeda's *sens-escape* of rhythmically dissipating sounds, vibratory haptics and visual imprints hypnotically cocoon or permeate the audience in a stream of scientific data: recorded, mapped and perceptualized.

Ikeda, thus, frequently transgresses media boundaries by algorithmically and synchronously activating varying senses and their analytic capabilities. Sketching human silhouettes against the high definition projections of minimal geometric patterns, he likewise embeds their bodies within a dense transsensorial fabric that activates visual, sonic and haptic perception simultaneously. His sound practice thereby relies on the raw material of sonic frequencies that act as psychophysiological stimulants. In this, the work becomes emblematic of what John Durham Peters, in regard to media, would delineate—after Friedrich Nietzsche—as *applied physiology*, the "psycho-technical

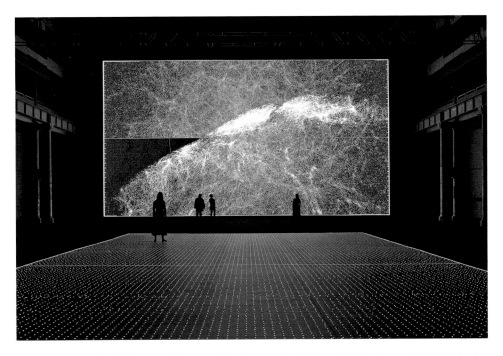

Figure 13.1 Ryoji Ikeda, *micro | macro*, Carriageworks, Sydney, 2018; photo: Zan Wimberley, courtesy of Ryoji Ikeda Studio.

practices that derive from study—and simulation—of the human sense organ".[4] Ikeda transgresses media boundaries by algorithmically and synchronously activating varying senses and their analytic capabilities through a transsensorial perceptualization of data that utilize, he claims, "the essential characteristics of sound itself and that of visuals as light by means of both mathematical precision and mathematical aesthetics".[5] The deictic dimension of *micro | macro—deixis* as both showing something and (re)presenting oneself—thereby fully hinges on the algorithmic technologies utilized by the artist, interrogating the liminal instabilities that arise from the processes of *exteriorization* (Leroi-Gourhan) and *individuation* (Simondon, Cavaillès).

Interested in said liminal onto-epistemology, this inquiry instrumentalizes the notion of cultural technique in its life rendering, cultivating dimension. Similar to Bernhard Siegert's deduction that "to investigate cultural techniques is to shift the analytic gaze from ontological distinctions to the ontic operations that gave rise to the former in the first place", Ikeda's project pushes back on the refined cultural techniques of reading, writing, listening, etc. in order to get to their sensory origin: the analytic processing of vibrations as light (electromagnetic waves, traverse, sinusoidal) and sound (pressure waves, longitudinal).[6] The attained media agency of vibration thereby ultimately provides an advanced tool for the investigation of the immersive environment of abstraction and its transsensorial and transmedial architecture. Creating immersive environments in which the audience's bodies are permeated by high-pitch sine tones and rhythmically dissipating sounds, their silhouettes sketched against the high definition projections of minimal geometric patterns, Ikeda's hypnotic synchronaesthetic process negotiates the nervousness of knowing by abstracting the distance to the physical phenomena everyone and everything is a part of, making them experienceable (in translation)—from the unfathomable subatomic particles that are the object of abstract scientific research at CERN, to the pulsating bodies of the audience whose organs oscillate reactively with the high-frequency vibrations that mediate said data, to the equally unfathomable infinity of the universe. The techno-artisan manages to generatively map and transform data into sensory events that may be phenomenally imbibed by the audience who seeks experience, not understanding. Utilizing the synchronaesthetic *contempor(e)ality* of sound, visual and tactile elements—a constant play between technical and elemental media—Ikeda's practice probes abstraction as a state rather than a concrete object that is filtered by and through the technicity of the human apparatus.

13.1 Liminal Conditions

In 1900, Max Planck (1858–1947), the German theoretical physicist, whose quantum mechanics and theory of the universe lie at the core of Ikeda's aptly titled project, instigated a break from classical physics to atomic physics. Through his paradigm shift inducing theories of quanta and black body radiation he declared that "the spatial-temporal differential equations do not suffice to exhaust the content of the events within a physical system", and stressed that "the liminal conditions must also be taken into consideration".[7] Identifying a complex dialectic between virtuality and actuality that defines this field of liminal conditions, Planck further argued that we may never "grasp the real world in its totality any more than human intelligence will ever rise into the sphere of ideal spirit: these will always remain abstractions which by their very definition lie outside actuality".[8] Inducing likewise a shift in the discipline of art history

at this moment, Planck's Austrian contemporary Alois Riegl (1858–1905) hinted at a transsensorial and transmedial inculcation of the human being through the material individuality of things and the formation of space [*Raumbildung*] in *Die Spätrömische Kunst-Industrie* (1901). Opposing the natavistic and empirical theories of perception at the same moment in which quantum mechanics ushered in a new physical world-view, Riegl asserted the transformative aspects of synthetic knowledge that, derived in the form of an epistemological drive and cultivated at the intersection of the sensorial and human thought, materialized as a form of bodily vision [*Körpersehen*].[9]

Ikeda's technology of abstraction seems to concentrate both historical threads as catalysts to erect a transsensorial architecture that sways between transparency and opacity, and in which the liminal conditions between actuality and virtuality, empirical and analytical, may be negotiated unencumbered by the need to produce concrete results. Ikeda's *micro | macro* materializes as the potentiality that is inherent to cognitive and physical exhaustion. "The data is here less important than the code itself", stressed Ikeda, "[t]he result is beyond our capacity for perception and decoding; it is a state" of abstraction, which, one may deduce, fosters liminal epistemologies.[10] The two correlative site-specific installations at the ZKM concern themselves with unfathomable scales whose extremes the techno-artisan negotiates with attention to (A) the small subatomic particles that elude human perception—in *[micro]*—and (B) the equally imperceptible vastness of the observable universe—in *[macro]*. *The planck universe [micro]*—a planar projection mapped onto the floor of the atrium—and *the planck universe [macro]*—a vertically transposed screen on the second level—are linked by a synchronized soundscape of layered drones, a staccato of micro-bleeps, white noise, deep-frequency bass pulsations and high-pitch sine tones that a-harmonically and deafeningly linger. The overwhelming density of sonic reverberations within the architectural space and enveloping human bodies created a tactile sensorial bridge between visuals and sound and the two spatial entities of building and bodies.

The paradoxical feeling of being disoriented and anchored at once manifests specifically in the immersive projection of *the planck universe [micro]*, where the bodies moving across the immense vertically oriented projection become likewise part of the surficial screen. Their organic membrane appears fused with the concrete architecture of the ZKM through the shapeshifting illumination of vertically scanning, finely drawn grids of white dots; the oscillating matrix of wave forms and their phase offset modulation; the assembling two-dimensional point-clouds, which morph into three-dimensional networks; the flashing red vectors that intersect various coordinates diagrammatically; the streams of polychromatic pulsating lines; the alphanumerical raw data; and the intermittent darkness rectangularly framed by a thin white line partitioned by hatch marks denoting values and scales. Representing the artist's engagement with quantum mechanics and the infinitesimally small scale of the Planck length (l_p), a unit of length equal to $1.616229(38) \times 10^{-35}$ m—definable from three fundamental physical constants: the speed of light in vacuum (c), the Planck constant (h) and the gravitational constant (G)—also known as the distance light travels in one unit of Planck time (t_p), *micro* negotiates the liminal condition in which quantum effects dominate and dissolve classical physical ideas of gravity and space-time.

Mirroring the move from immersion to observation in its installation, *the planck universe [macro]* creates a distance between the large rectangular screen—an architectural element stretching in height close to the three floors that delimit the large hall-like exhibition space—and the audience, whose active character as a performative

element of the graphic instantiations in *micro* has been transformed by Ikeda into that of a classical observer. The representational actualization of the unfathomably large scale of the (technologically aided) observable universe, *macro*, utilizes a similar arsenal of visuals that are paired with the synchronized soundscape: animated nebulous three-dimensional clouds in glowing red and white; superimposed geometric vectors and grids; thermal mappings in red, green and yellow; accelerating star charts complete with alphanumeric coordinates; extremely decelerated magnifications of the active surface of the sun and solar winds flaring up; psychedelic diagrams of the solar system in red to yellowish hues or chromatically inverted to light green and blue, hypnotically looped and centered; and strings of raw data that may underlie the perceptualization performed.

Nonetheless physically distanced to the projection, the large surface of the screen exceeds the peripheral vision of the observers, who gaze symptomatically upward to the representation of the cosmological vastness, losing touch with the surrounding exhibition space by being sucked into the spatio-temporal choreography unraveling before them. Instrumentalizing both the objective and subjective dimensions of his audience, Ikeda provides each viewer with the ability to explore the works from various angles, distances and perceptual impact, opening up the possibilities to experience *micro | macro* in its similarly unfathomable potential. Aided in this by the audiovisual juxtaposition, the rapid velocity at which the sequences of images appear, reappear, merge and transform into intense bursts, at times seemingly coupled to distinct, high volume sounds while increasingly deteriorating into asynchronous auditory lags, he emphasizes the fleeting presence of complex physical events and the asymmetry of the underlying data lake instrumentalized in his work.

Despite the use of data as the raw material for his transsensorial and transmedial research projects, Ikeda's practice of abstraction complicates a straightforward attribution to new media art practices such as data art or mapping art which are, stressed media theoretician Roberto Simanowski, "focused not as much on the visual pleasure of the transformation as on the disclosure of data [...] a sociological study or data architecture".[11] The nodes of abstraction earlier defined reveal themselves to be intricate elements of this performance: the distillation of a substance by subtractive processes, extracting data points and voids and then transforming them into affective components; moving the audience away from a concrete understanding, or, according to Planck, an unattainable actuality, to allow them to disengage and be absorbed by something else, the *phenomenologization* or activated technicity of their anthropic sensorial apparatus. Abstraction, here, collapses the distance between what Michael Fried had once posited as opposites: theatricality and absorption. "I need to absorb everything", Ikeda affirmed his alchemical practice of abstraction; "[t]hen I somehow filter, process and I give output" that navigates the mutual plateau of mathematics, science and philosophy in transmedial instantiations algorithmically.[12]

Distinct to intersensorial art, which includes cross-sensory explorations by artists such as Wassily Kandinsky, who formulated his own theory of synaesthesia in *Über das Geistige in der Kunst* (1910), or Piet Mondrian, who tried to visualize rhythm and time in his musical paintings such as *Composition with Gray Lines* (1918) or *Victory Boogie-Woogie* (1942–1944) (Figure 13.2), Ikeda developed a practice that coalesces in the transcending of sensory accumulation and synchronicity. He refrains from cross-sensory conception, yet works with the parameters of each expanded sense—sight, hearing, touch and proprioception (orientation in space)—in order to compose his

Figure 13.2 Piet Mondrian, *Victory Boogie-Woogie*, 1942–1944, 127 × 127 cm, oil and paper on canvas, Gemeentesmusem, The Hague (work in public domain).

total scenography. Synaesthetic perception is replaced by what may be differentiated as *synchronaesthetic* perception. The synchronaesthetic dimension differentiates from the synaesthetic in that it doesn't evoke a cross-sensory perception—hearing color or seeing sound. It rather constitutes a simultaneous perception of multisensory input by hearing sound, seeing visuals, registering visceral and haptic pressure and orienting oneself in the spatial surrounds—all synthesized and synchronized in their occurrence, thus enabling the audience to connect these aspects of perception in a transsensorial synthesis.

By weaving a transsensorial environment that is correlative to the architecture it is presented in—changing accordingly in the project's various locations and realiza- tions—, Ikeda engages the experiential dimension of the exhibition space as a musical

performer would the architectural acoustics of a concert venue.[13] A remnant, deduced Kazunao Abe, of his early activity within the avant-garde collective Dumb Type, "producing works in which performance and installation were pushed forward concurrently within an artistic conception", he has developed a "sensibility that synchronizes visual and sound elements on equal terms in order to then subvert them positively".[14] Emphasizing the important role of composition within his work, Ikeda simultaneously emerges as a liminal being, defiant to identify as either an artist or a musician but rather seeing himself as an artisan of transsensorial materials:

> My job as an artist is to compose elements. Composition is the key. So any elements, which are brushed up carefully, are the subjects to be composed. I compose sounds. I compose visuals. I compose materials. I can't put, or analyze, myself in the context of something between art and music; I am naturally doing what I am doing.[15]

This liminal condition, which Ikeda manages to traverse so intelligibly, crystallizes as an agility toward progressively creating new experimental methods to push his research projects toward the exploration of the very liminality they inhabit. Distancing his transmedial practice, however, from Greenbergian definitions of abstraction in which prevailed the distinct materiality, the purity and specificity of the artistic medium, or a Kraussian concentration on the medium as a "technical support", which carries its own potentialities and virtual agency in the creation of art, Ikeda draws from the instability of media, neither the "extensions of man" (McLuhan) nor modular "new media object" (Manovich), but systems of relations (i.e., scientific and philosophical discourses) and knowledge structures, a *dispositif*.[16]

Ikeda's practice of abstraction embodies what Daniel Albright described as *transmedial art*: "the imaginary artwork generated by the spectator through the interplay of two or more media—the transient, complex thing that is assembled in each spectator's mind through attention to the elements in different media".[17] His transmedial project, thus, not only instrumentalizes the processes of abstraction from scientific data to audiovisual installations but activates (autonomous) processes of abstraction that unfold on the side of the audience, constitutive of their individual experience and synthesized through the sensorial and analytical capabilities of their biological system. As Planck stressed:

> Natural science and the intellectual sciences cannot be rigorously separated. They form a single inter-connected system, and if they are touched at any part the effects are felt through all the ramifications of the whole, the totality of which is forthwith set in motion.[18]

Oscillations between depth and surface manifest as integral fragments of this coded performativity, in which the ecology of mediating vibrations activates the human as fragmented *dispositif*. Touching upon the undeniable phenomenological aspect of Ikeda's sensescape, depth in *micro | macro* may be described as "not a space in the conventional sense of a series of dimensions through which the movements of objects can be measured, but a place where relationships between objects as differential processes are formed".[19] Enthralled by the technology of abstraction and the abstraction of technology, Ikeda's endeavor culminates in what María Belén Sáez de Ibarra defined

regarding his practice as "a plane of immanence with neither organs nor geography [...] the pure pulse of becoming".[20]

Returning to Riegl's earlier mentioned *Körpersehen*, Mark B. N. Hansen similarly argued for a "haptic and prehodological mode of perception" that "taps into the domain of bodily potentiality (or virtuality) in order to catalyze the active embodied reconfiguring of perceptual experience (or, in other words, to 'virtualize' the body)".[21] Linking to Planck's negotiations of virtuality and actuality as a framing device for the liminal conditions navigated by Ikeda in his transmedial architecture, the reference to Hansen enables here to point to a paradoxical condition of Ikeda's work, namely, his attempt to allow one "to 'see' *with our bodies*",[22] while constructing an impermeable blind spot which disallows one to fully enter the data and its source code— feigning closeness to the actual processes of translation/transformation that cannot be transgressed by the audience. Remaining blind, neither able to influence nor fully comprehend the coded space, the audience is left to dwell in the liminal condition of abstraction, which may be emblematic of the contemporary human condition.

13.2 Contempor(e)al Iconology of Abstraction

Assembling oscillatory frequencies in time and "cooking" data synthetically, the transmedial artisan conjoins multiple threads into a metacomposition to "keep the projects alive [...] the projects start communicating with each other [...] they are constantly evolving".[23] Subsequent to distilling sine waves, white noise and pixels as his compositional raw material, the creative use of time becomes crucial for Ikeda in bonding the elements of his metacompositions. "You need a time structure, even if you think of it in rudimentary terms", he stressed.[24] Both operating within linear time and encapsulating non-linear time recursively in specific research projects (i.e., *continuum*), Ikeda instrumentalizes the *tempor(e)alities*—"technical instantiations of time(s)" generated by the time-critical media of his craft—to enforce the media agency of his transsensorial environments.[25] As Ernst has delineated in his study of time-critical media [*zeitkritische Medien*], "the essence of technical media is revealed only in the processuality of their temporal operations", and, thus, specifically the digital computer, Ikeda's main instrument, "itself does not understand time in the cultural sense; it evades the emphatic concept of time in favor of a purely signified tempor(e)ality in the form of timing and rhythm".[26] Ikeda's carefully constructed *sensescape* is dependent on its synchronicity with the pertinent *timescape* articulated by his time-critical media and the corresponding processing and sculpting of time through his technology of abstraction.

Time accordingly manifests both as the duration of the performative media works and conceptually as a physical parameter (relative space-time, etc.). These may be altered through operations of acceleration, deceleration, dilation, interruption, discontinuity, etc. and become psychophysiologically integral to the representational affectivity of Ikeda's transmedial system. Manifesting as "an elusive sedimentation", deduced Marcella Lista, "where real and represented time are put into tension", the transmedial milieu of Ikeda's research confronts the audience with their own conflictual perception of time and the asynchronous drift between the con-tempor(e)alities of the technical media that generate the audiovisual actualizations and their human, biotechnologically conditioned reality.[27]

Specifically explored in his solo exhibition *continuum* at the Centre Pompidou (June 15–August 27, 2018), time (discrete or continuous) materializes differently in

the concerts (fixed-duration) and installations (non-fixed-duration, looped). The experiential control of time is divided between himself and the audience, which may piece together pockets of time from various temporal structures by moving autonomously throughout the exhibition space. For Ikeda, "the two formats started feeding each other", eliminating borders between them: "They are not the same and yet they are deeply interconnected".[28] Even speculating with concepts of infinite time and the continuous deterioration of frequencies, some pieces such as *A [continuum]* (2018)—Ikeda reproduced the historical variations of the concert pitch note A using pure sine waves and fluctuating pitch between 376.3 Hz (1700) and 444.9 Hz (1857) for the entire duration of the exhibition—dilate the modes of abstraction to a point at which the totality of the art work is impossible to be experienced by the audience.

This strategy of the missing or logic of the suspended echoes the impermeable opacity that characterizes the code-space of Ikeda's other works, in which the existent yet imperceptible elements assume an ultimately abstract quality. Their existence is essential to the work yet generates an unbridgeable distance between the human subject and the phenomena explored, which seem "complete" through the transsensorial blur that coalesces discrete elements into a continuum. "Here is the thing", he revealed:

> on the one hand, slicing, cutting down the material makes it discrete, and on the other, when every byte is put side by side in time, they start behaving in a very elegant manner. They adopt a continuous behavior. When I orchestrate all these chords, an unexpected beauty of continuity appears. It's a little bit like in the original cinematographic medium: when the celluloid film strip runs through the projector, you don't see the twenty-four frames per second, you see a continuous image. In my case, it would be a hundred frames per second. The number of units per second is the resolution of time. How much can I divide a time unit? A lot.[29]

Only a glitch—"a short-term derivation from a correct value"[30]—may reveal the coded tempor(e)ality produced by the media technologies in Ikeda's arsenal. These artifacts, which may emerge in the sonic or visual translation/transformation of data, find their equivalent in the theory of quantum mechanics, treated by Ikeda in *the planck universe [micro | macro]* as *black noise*:

> Quantum mechanically speaking, you cannot avoid having a glitch that occurs probabilistically. What you perceive as a vacuum is not simply nothing; it is full of energy. To the point that there is no room for air, just a very high density of energy. And this energy can pop up any time: all of a sudden, something emerges from nothing.[31]

This constantly lingering potential defines Ikeda's practice of abstraction, revealed through glitches in the transsensorial and transmedial fabric that, claimed philosopher Akira Asada, may be termed the artist's "new techno version of sublimity".[32]

13.3 Ekstraction

Disinterested in framing his work as a commentary on technical media—the computers, projectors, loudspeakers or other devices that constitute his tool-kit and enable or

delimit his transmedial actualizations—Ikeda nonetheless composes a probing contin-uum that imbues abstraction with the operativity of an ecstatic technology, detached from the boundedness of specific devices and performing on the level of distilled, concrete physical elements, cultural techniques and the technicity of the human appa-ratus. The definition of technology—itself an ongoing process, intricately linked to the anthropological and temporal dimension—may thus be adapted in line with the Simondonian notion of technology as technoscientific research. Gilbert Hottois pointed to a crucial passage in Simondon's doctoral thesis *L'Individuation à la lumière des notions de forme et d'information* (Individuation in the Light of the Notions of Form and Information) (1958), in which the philosopher of technology fittingly exclaimed that "nowadays, the true technical activity is in the field of scientific research, which is oriented, because it is a research, towards objects or properties of objects that are still unknown".[33]

Similarly exploring the unknown in all of his ongoing research projects, Ikeda's main elemental media have been distilled from the physical properties of sound (sine waves and white noise) and light (pixels):

> A sine wave is the purest wave form and white noise is the opposite: it contains a dense quantity of completely random frequencies. The sine wave is totally ordered; its order repeats. [...] They're extremely pure and transparent, but not so easy to handle. White noise, on the other hand, is almost impossible to control [...] it has to contain random frequencies at the same time. If you make the comparison with light: white light contains all the colours of the spectrum, while black would be like silence, zero.[34]

Providing a potent link to physics and the quantum mechanics explored in *micro | macro*, sine waves demonstrate another key aspect of his artisanal practice, which Ikeda clearly distances from traditional notions of art: "the very notion of art is behind; it would be more precise to talk about these activities as very solid and refined artisan practices—which, to me, sounds very similar to the practice of mathematics or physics".[35]

Although imperceptible, quantum wave function (Ψ) is detectable in the smallest physical particles which emit oscillatory frequencies, comparable to acoustic modes of vibration in classical physics, and constituting the universe, everything and everyone. Whether invisible due to the light spectrum or velocity at which data sets are algorith-mically visualized, or the auditory frequency at which they unfurl, the hyper-sensorial aspect of signals that escape human perceptibility in this transmedial mode of abstrac-tion assumes functionality in the second degree.

"Not concerned with ontology but with axiology", Simondon stressed at the begin-ning of his posthumously published "Technical Mentality" (1961), furnishing an insight into the disparity between affective and cognitive values, this technical mental-ity is similarly existent in the quantum field of Ikeda's inquiry:

> the technical mentality offers a mode of knowledge *sui generis* that essentially uses the analogical transfer and the paradigm, and founds itself on the discovery of common modes of functioning—or of regime of operation—in otherwise different orders of reality that are chosen just as well from the living or the inert as from the human or the non-human.[36]

Drawing energy from this liminal condition, between virtuality and actuality, the algorithmic technology that constitutes the transsensorial and hyper-sensorial environment synchronaesthetically causes psychological and physiological effects in the audience members—an abstraction aimed at conferring a simulative experience of the infinite potential of data rather than attempting and failing to convey the underlying intellectual complexity.

Unlike other new media artists who utilize computers in conjunction with the pre-existing software, the code and algorithms that transform data in Ikeda's practice are determined by project-specific programs he has written himself (or aided by assistants): "I work straight from pure numbers. [...] There is a certain beauty in it: source code and programming".[37] The actual methodology applied by the artist varies with the medial output, from purely mathematical operations in his musical compositions to complex algorithmic processes in the transsensorial installations. Creating his representations through accurate data composition of pixels, sine waves and white noise, he contends the infinite potential of data to "render more than the existing entities", deriving an infinite amount of information from the shifting topological shapes of either light or the universe, "as well as the vibration of the matter it is composed of".[38] Ikeda further distinguishes between dynamic data (i.e., CERN's experiments in particle physics) and static data (i.e., DNA code, galactic coordinates of cosmic bodies), stressing that he only utilizes the latter in his work as manageable "crystallized facts". Although ultimately unable to instrumentalize the dynamic data that CERN—itself a hyper-mediated "abstraction machine"—had encouraged him to implement in his algorithmic creation, *micro | macro* benefited from Ikeda's exposure to the research methods of nuclear physics, implementing a few key aspects into the creation of the project:

> Firstly, that in some contexts quantity is more important than quality. Then, that the intersection of various data sets is more important than the in-depth study of one set of data. And finally, that they could cross-examine data on both a huge scale and micro scale: the scale of electrons.[39]

The technoscientific aspect of Ikeda's practice of abstraction is entangled in what Jean-Hugues Barthélémy has called the extension of Gaston Bachelard's notion of *phénoménotechnique*, meaning, argues Vincent Bontems,

> that the contemporary scientific phenomena are not only observed through technical instruments but even produced by these experimental devices as artificial actualizations of natural potentialities. [...] Techno-science is not only applied science but a fundamental technology that creates new artificial possibilities—new technological modes of existence—at all scales.[40]

According to quantum field theory, which is an intricate foundation of Ikeda's conceptual framework, the devices that aid in the observation of particles likewise disturb and alter the phenomena one is trying to detect. "The tools condition the perception of the reality they are helping to grasp", argued Ikeda, "when we observe them, they look like particles because we grasp them in a specific moment, resulting in their excitation. What we call particles is actually the state of excitation of waves".[41] Symptomatic of the artist's practice, which explores modes of intermedial and intersensorial translation

and transformation, sourcing structural compositions from the phenomena at the heart of his various research projects, "excitation"—the technical application of energy to something, or the enhanced activity of an organism—assumes a vital agency in the performative incorporation and modification of the audience's biological morphon.

This ecstatic technology is controlled by the technical settings (*ensembles*) of the transsensorial environment and the discrete media—elemental and technical—collectively applied in its construction. The "totality of sensory experience" Ikeda strives to construct is achieved by the synchronized visual, sonic and haptic *sensescape* of perceptualized data. This includes—on the side of visual perception—the flickering strobes of monochromatic or polychromatic frequencies as well as the media of light and darkness which alternate in the psychomotoric agitation of the immersed subjects (Figure 13.3). On the sonic and haptic side, these affects are complemented by the materiality of infrasound (<20 Hz) and ultrasound (>16 kHz). These simultaneously cloak the audience in a dense atmosphere and permeate their physical boundaries through the psychoacoustical properties of acousmatic sound as well as layers of harmonic distortions and intoned pitch combinations which produce altered emotional states and a disorienting proprioception by synchronously emanating from the inner ear and the exterior loudspeakers. Indebted not only to Planck but the physicist's teacher Hermann von Helmholtz, who described the analytic properties of the ear and the media apparatus of the human sensory organs as early as 1857, Ikeda exploits the immanence of sound to anchor his stratified choreography of affective states. Music— or sound (and noise) organized in time—remains the artist's most complacent medium.

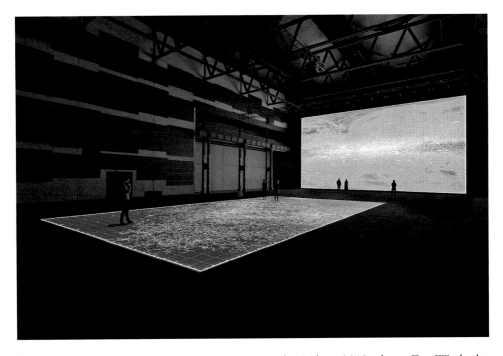

Figure 13.3 Ryoji Ikeda, *micro | macro*, Carriageworks, Sydney, 2018; photo: Zan Wimberley, courtesy of Ryoji Ikeda Studio.

The solitary mode of production, in which he can follow concrete principles and the "abstract laws of mathematics", liberates him from the somewhat stunting necessity to communicate his ideas to collaborators, assistants or curators, enabling him to tease out the complex "chain reactions" of abstraction that unfurl in his thoughts beyond verbalization.[42]

As Chus Martínez has pointed out, despite abstraction and the technologically mediated environments of the algorithmic code, Ikeda's concern remains with nature, the universe and the scale of life:

> The works he has developed over years can be seen as a whole, as one major research on cosmic apprehension, on the difficult relations between the forces, the systems and the organism that coexist in the realm of what we call life.[43]

Anchored in mathematics, which for the artisan provides a certain stability and continuum in abstraction, and physics, concerned with the material understanding of the universe and nature, he balances, she argued, "the instability that defines organic life".[44]

The discrete elements and the continuum of Ikeda's transmedial and transsensorial research series materialize a perplexing sensescape that unfolds as the *transgenesis*—a biotechnology of spatio-temporal criticality—of an instable *milieu*—a medium which constitutes the environment between two bodies while penetrating and thus situating them within it.[45] Transgenesis can be defined as a dynamic process that mediates between digital and analog, atomic and subatomic, organic and inorganic, psychological and physiological, analytical and empirical, phenomenological and ontological, by constructing immersive transsensorial spaces. Activating the potentials that lie between these absolutes, instrumentalizing data as catalytic transgenes of infinite potential, transgenesis unfolds not as a singular event but as a continuous negotiation of our contemporary condition and data as a hermeneutic circle—concurrently regulating our rendition of "life" and "human", while being invariably generated and altered by us. In an increasingly disembodied and posthuman ecology in which we question our being as a data field, Ikeda reanimates our atrophied sensory apparatus and enhances our ability of orientation amid the unfathomable scales of data and the quantum field. The technology of abstraction which excites the existential states of *ekstasis*—the standing outside of or beside oneself—thus culminates in a self-distancing and the recalibration of the onto-epistemological system as *ekstraction*.

Notes

1 Wolfgang Ernst, "Medienwissen(schaft) zeitkritisch", inaugural lecture October 21, 2003, Humboldt-Universität zu Berlin, Philosophische Fakultät III, Institut für Kultur- und Kunstwissenschaften, 7—translation my own.
2 Oxford English Dictionary, s.v. "abstract" + "abstraction".
3 Concept, composition: Ryoji Ikeda; programming, computer graphics: Norimichi Hirakawa, Tomonaga Tokuyama, Yoshito Onishi, Satoshi Hama.
4 John Durham Peters, "Helmholtz, Edison, and Sound History", in Lauren Rabinovitz and Abraham Geil (eds.), *Memory Bytes: History, Technology, and Digital Culture*, Durham: Duke University Press, 2004, pp. 177–198 (179).
5 Ryoji Ikeda, "Biography", www.ryojiikeda.com/biography/, accessed January 5, 2019.
6 Bernhard Siegert, "Cultural Techniques: Or the End of the Intellectual Postwar Era in German Media Theory", *Theory, Culture & Society*, vol. 30, no. 6, 2013, pp. 48–65 (48).

7 Max Planck, "Physics and World Philosophy", in *The Philosophy of Physics*, translated by W.H. Johnston. London: Allen and Unwin, 1936, chapter 1, pp. 30–31.

8 Ibid.

9 Alois Riegl, *Die Spätrömische Kunst-Industrie*, Vienna: Österreich. Staatsdruckerei, 1901, p. 18; *Körpersehen* [bodily vision], as a concept, appears in the—by Riegl footnoted—psychological investigation of the Austrian philosopher Carl Siegel (1872–1943) *Entwicklung der Raumvorstellung des menschlichen Bewusstseins*, Leipzig: F. Deuticke, 1899, p. 23.

10 Ryoji Ikeda, "Interview—Ryoji Ikeda with Marcella Lista", *Code Couleur* 31 (May–August, 2018), Paris: Édition du Centre Pompidou, pp. 38–41, as cited in Marcella Lista, "The Labyrinth of the Continuum", in Ryoji Ikeda, Marcella Lista, Centre national d'art et de culture Georges Pompidou (Paris) (eds.), *Ryoji Ikeda: continuum*, exhibition catalogue, Paris: Xavier Barral, 2018, pp. 8-13 (12-13).

11 Roberto Simanowski, *Digital Art and Meaning*, Minneapolis: University of Minnesota Press, 2011, p. 162.

12 Ryoji Ikeda, "Patterns of the Unknown: Interview with Marcella Lista", in Ryoji Ikeda, Marcella Lista, Centre national d'art et de culture Georges Pompidou (Paris) (eds.), *Ryoji Ikeda: continuum*, exhibition catalogue, Paris: Xavier Barral, 2018, pp. 153–170 (166).

13 For example, see his interventions at Wiener Festwochen 2018, Vienna Festival (Austria), May 23–June 17, 2018, and Carriageworks Sydney (Australia), July 4–29, 2018.

14 Kazunao Abe, "As '/'", in Ryoji Ikeda (ed.), *datamatics*, Milano: Edizioni Charta, 2012, pp. 105–112 (106).

15 Lista, "The Labyrinth of the Continuum", op.cit., p. 13.

16 Marshall McLuhan, *Understanding Media: The Extensions of Man,* Cambridge, MA: The MIT Press, 1964, p. 6; Lev Manovich, *The Language of New Media*, Cambridge, MA: The MIT Press, 2001, p. 14.

17 Daniel Albright, *Panaesthetics: On the Unity and Diversity of the Arts*, New Haven: Yale University Press, 2014, p. 209.

18 Planck, "Physics and World Philosophy", op. cit., p. 32.

19 Henry Somers-Hall, "Deleuze and Merleau-Ponty—Aesthetics of Difference", in Constantin V. Boundas (ed.), *Gilles Deleuze*, New York/London: Continuum, 2011, p. 124.

20 María Belén Sáez de Ibarra, "datamatics: Ryoji Ikeda", in Ryoji Ikeda (ed.), *datamatics*, 2012, pp. 113–120 (114).

21 Mark B.N. Hansen, "Seeing with the Body: The Digital Image in Postphotography", *Diacritics*, vol. 31, no. 4, Winter 2001, pp. 54–84 (67).

22 Ibid., emphasis in original.

23 Ikeda, "Patterns of the Unknown", op. cit., p. 159.

24 Ibid., p. 157.

25 Wolfgang Ernst, *Chronopoetics. The Temporal Being and Operativity of Technological Media*, London/New York: Rowman & Littlefield, 2016, p. vii.

26 Ibid., p. 84.

27 Lista, "The Labyrinth of the Continuum", op. cit., pp. 10–11.

28 Ikeda, "Patterns of the Unknown", op. cit., p. 159.

29 Ibid., p. 169.

30 Olga Goriunova and Alexei Shulgin, "Glitch", in Matthew Fuller (ed.), *Software Studies: A Lexicon*, Cambridge, MA: The MIT Press, 2008, p. 110.

31 Ikeda, "Patterns of the Unknown", op. cit., pp. 156–157.

32 Akira Asada, "Ryoji Ikeda on Ryoji Ikeda: Conversation with Akira Asada", in Ryoji Ikeda, Marcella Lista, Centre national d'art et de culture Georges Pompidou (Paris) (eds.), *Ryoji Ikeda: continuum*, exhibition catalogue, Paris: Xavier Barral, 2018, pp. 174–201 (191).

33 Gilbert Simondon, *L'Individuation à la lumière des notions de forme et d'information*, Paris: Millon, 2005, p. 512, as cited and translated in Vincent Bontems, "On the Current Uses of Simondon's Philosophy of Technology", in Sacha Loeve, Xavier Guchet, Bernadette Bensaude Vincent (eds.), *French Philosophy of Technology: Classical Readings and Contemporary Approaches*, New York: Springer, 2018, pp. 37–49 (39); Cf. Gilbert Hottois, *Philosophie des sciences, Philosophie des techniques*, Paris: Odile Jacob, 2004, p. 129.

34 Ikeda, "Patterns of the Unknown", op. cit., p. 156.
35 Ibid., p. 167.
36 Gilbert Simondon, "Technical Mentality", trans. Arne De Boever, *Parrhesia*, vol. 7, 2009, pp. 17–27 (17).
37 Ikeda, "Patterns of the Unknown", op. cit., p. 161.
38 Ibid., p. 162.
39 Ibid.
40 Bontems, "On the Current Uses of Simondon's Philosophy of Technology", op. cit., p. 40; Cf. Jean-Hugues Barthélémy, "Des instruments de connaissance", *Science et Avenir*, October/November, 2004, pp. 46–50; Jean-Hugues Barthélémy, *Penser la connaissance et la technique après Simondon*, Paris: L'Harmattan, 2005; Gaston Bachelard, *The New Scientific Spirit*, Boston: Beacon, 1985.
41 Ikeda, "Patterns of the Unknown", op. cit., p. 164.
42 Ibid., pp. 160, 166.
43 Chus Martínez, "The Codes of Life: Some Reflections on the Work of Ryoji Ikeda", in Ryoji Ikeda, Marcella Lista, Centre national d'art et de culture Georges Pompidou (Paris) (eds.), *Ryoji Ikeda, continuum*, exhibition catalogue, Paris: Éditions Xavier Barral, 2018, pp. 50–53 (50).
44 Ibid., p. 52.
45 Cf. Georges Canguilhem, "The Living and Its Milieu", *Grey Room*, vol. 3, Spring 2001, pp. 7–31 (8).

14 Digital Landscapes of the Internet
Glitch Art, Vaporwave, Spectacular Cyberspace

Dario Vuger

Founded in the organized and complex systems of data aided by contemporary technology, the internet of today represents a total machine of assimilation and dissemination of information through two fundamental paradigms: first, connection and communication as a producer-user unity, and, second, community of networks (or networkers).[1] The two represent the basic ontology of the network. What this ontology creates in its most far reaching consequences—and its further techno-individuation—is a "new form of aesthetic experience and illusion",[2] namely, the *technosphere*. As it became a more and more stable element of the contemporary culture, the internet as a cyberspace and a cyberculture had witnessed different stages of reception from academic theory as well as from institutional and noninstitutional art practice.[3] The same can be said of the technology in general, or, to be more precise, the turnover from the *technics* or *technique*—more or less sophisticated mechanics and other non-electric technical devices, technical objects being tools for purposes—to *technology*—electrical, digital, machinery of the code and its consequential visual representation, thus making a subtle shift from tools to means and a broader one from using to being used. Better yet, the internet as well as its method (the network)—closely connected to the basic principles of cybernetics—presents yet another stage in the development of technology itself.

The main thinker of this shift was Max Bense who was the first to systematically incorporate the concept of information and cybernetics to aesthetics as a discipline.[4] If we are to call his era a time of techno-enthusiasm that was preceded by the time of initial discovery of the potentials of new technologies, we are witnessing today a time of radical normalization of technology as it becomes not just the means or a topic of the work of art, culture and theory but rather embedded in the structure of culture and life itself, radically changing the notions of both respectively, far beyond the recent fascination of bio-technical interaction. The easiest way to describe this is the phenomena of *the internet of things* where connectivity and communication become the principles of social and technological governance over the totality of our lives. We are connected with our machines as they think and inform us artificially, but efficiently, giving us the surplus of control and providing the maximum information on our everyday lives which by that become increasingly programmable. This means, first, that the whole of culture and the everyday becomes increasingly more and more likely to being described and run by code, and, second, that the notion of the internet as a phenomenon separated from life becomes outdated. The essence of the internet is, actually, the essence of contemporary life as we know it. Cultural theory, media studies and anthropology should now be replaced with the study of networks, frameworks, assemblages and *figurations*.[5] With this development we are entering the stage in our history

that we can describe as the post-internet, meaning that the internet itself became fully integrated or, better yet, fully realized in the modern way of life and should no longer be thought of as something separate or distinct from it.

The new digital art of the second decade of the 21st century is predominantly marked with the further exploration of the code and the heritage of the internet/digital enthusiasm of cybercultures of the 1980s, 1990s and the first decade of the 21st century. It is an anthropological experimental art that features research of life practices in a new and radical way considering our internet-of-things way of life. New methodological tools become available, while the old doctrines become inapt to fully integrate and comprehend the changes in the media, art, culture and politics exactly because of digital art's radical overlapping and transparency, not to mention its gravity—speed, space, time and other seemingly physical factors that become more and more metaphysical conditions of the mere possibility of life as such, giving us the sole appearance of stable and physical space and time. The *gravity of data* remains to be considered in this remark as a digital/network pull that holds the everyday together in an ironic but consumer-liquid state of the *spectacle of disintegration*. As we mentioned earlier, digital or post-digital art has its history that follows the basic stages of reception of the possibilities given to us, with the radically new technology of computer and internet-based communication, connectivity and creativity, which stimulated specific sociological research fields such as cyberculture studies. What we experience today, in a time where being-emerged-in-the-internet is a normalized form of life, is the new radical artistic practice that uses this normalized state as a starting point of the critique aimed no longer at the computer, the internet and its phenomena, but at the life itself as being constructed on the basis of the code, giving us the conceptual base for a radically different theoretical consideration of the new phenomena of life. This means that we are discovering the possibilities to use the code to our advantage on the dangerous path of the blurred line between the radical overcoming of the machine and total immersion in it. The first of the movements that exemplifies best the emergence of the gravity of data as well as it reveals the abstract landscape of the internet is the practice of glitch art.

14.1 Beautiful Errors of Glitch Art

The notion of the landscape first and foremost should not be mistaken with the notion of the geographies and topologies of the network; just as if we are talking of artificial intelligence (AI) there seems to be no need to talk of the psychology of AI. In order to understand glitch art we will need the tools given to us by sciences largely outside the conventional notions of art history. This is mainly because, in a philosophical sense, but also in a profoundly radical way, we can no longer speak about art with any certainty, as well as we can no longer communicate historic thoughts over, through and about the internet. Its way of operation is in essence non-linear, and its history cannot be important in the way that we understand the ideas behind glitch art. It is the art of the mistake, error and the sublime (de)visualization of virtual data, discovering the haunting landscapes of cyberspace that was until now just a figment of imagination for many of the greatest science fiction writers of our time. Consider the first sentence of one of the greatest cyberpunk novels ever written, William Gibson's *Neuromancer*: "The sky above the port was the color of television, tuned to a dead channel".[6] This white noise is the haunting landscape behind every digital visualization imaginable. It is the gravity of data on its basic level. What are we to say of art which has as its

canvas a screen that is just a flickering visualization of a vast world of constantly moving bits of data? The (glitch) artist would propose a halt. And this is the principal point of emergence of glitch art. If we could stop the code from interpreting data in the common way of constructing and disseminating information, we would arrive at a point where code can be overtaken and used as a facility for a more immediate expression—the glitch, or the art of errors. We are then soon arriving at the point beyond mere data aesthetics and digital aesthetics. Through a ludic understanding of hacking, or, to say, by using hacking tools and methods as means of artistic expression, glitch art also becomes a virtualization of the practice of hacking as well as the disenchanted image of our everyday experience of the world constructed in the technosphere.

It is important to note that data aesthetics as a conceptual model has been a prominent figure of artistic and cultural expression ever since the first great encyclopedic projects and ever-growing exploration of the distant worlds and cultures, namely, since Enlightenment onward.[7] This is important because since those times we are faced with a shift in the representative role of the image. Beyond the mythological and theological substance of the work of art, image now represents data, and its aim is to inform the viewer. This shift comes about with the coming of what Heidegger calls the *age of the world picture*.[8] In this manner, data aesthetics can stand as a signifier of the broadest field of modern image production. On another important note, we should distinguish the abovementioned digital art practices from data aesthetics. While data aesthetics is a certain worldview and can be considered an essence of many if not all of today's visual practices, distinguished from it is the code aesthetics, aesthetics of the code or code-based art as digital aesthetics. Of course, here we are thinking about the digital code. This lively, beautiful or even sublime mutual cancellation through the code can be understood with one-word umbrella term—"design", or "digital design-ation". Keeping this in mind, the same model of explanation can be made of every digital rendering program that uses code as means of delivering a visual result. Think of digital picture processors, visualization tools or even some forms of digital photography.

On the other hand, talking of data aesthetics we are limited to data visualization such as digital graphic generators, mapping and such. In that way data aesthetics refers to the process of the artifice of data design. With the artistic intention both can become works of art, but they are not mutually inclusive terms; they precede the computers, and they both are conditions of today's notion of design. The main difference here is the completion of the post-aesthetic tirade of the everyday. Besides communication and connectivity stands compression, or optimization of data in the form of code. Also, this is the main tool with which glitch art is made, communication and connectivity being the conceptual background of the post-aesthetic being in a much broader sense. Early digital art, such as the art of the Bit International and some Fluxus works, utilized, on the other hand, the perceived technical advantages as means of advancing art into the age of conceptual aesthetics of performance, happening and installation that remains today an institution of multimedia art and new media art. In opposition to glitch art, this is the art of experiment which advances art as history but not as a culture. The locus of the new media art is the museum and the gallery. In the age of suspicion of the possibility of an artwork, the art itself becomes an event, at the same time integrated as the spectacle and disintegrated as the recycled product of art history.

Data aesthetics, digital aesthetics and their art forms belong to the realm of art history, of art proper and visual culture at large. Glitch art goes beyond all of them and forms a movement which, in opposition to art, we can historically call an art

praxis, digital art praxis, as it brings into question the solid state and metastability of contemporary art and culture. In a way it disconnects the naturalized form of bio-technological nexus of contemporary art and pushes for a reconceptualization of our relationship to machines. For the mere understanding of the conceptual backdrop of contemporary digital art praxis, we need an overall, or at least a rough, understanding of the cultural shift that shapes our everyday through technology and science. Just one of the sources can be the communicational aspect of the *technical image* proposed by Vilém Flusser,[9] as it dispenses with the aesthetic notions of images and moves us closer to the ontological and technical description of the conditions of the possibility of images at large. From this stance, we find ourselves in the open trying to understand the subversive notion of the aesthetics of error—"aesthetics" acting here as a stand-in term developed in the circle of the practitioners of the concrete image making method. It is not just about disturbing the code and the image, but also subverting the communication path of the conventional digital image, creating the possibility of erroneous interaction with its surroundings, a new humanism to counteract the *iRationality* of the machine. An image produced by the error in the code can act, being essentially a corrupted computer file, as a bug or a virus. This is the uncanny gravity of data that transforms the digital art into a reformed, rebellious form of art practice, digital art praxis or, as we will see, the post-digital art proper. Namely, the corruption of data does not erase but disrupts information that is again pulled together by a script of the program interpreting data. This gravity pull then creates a result that is an actual anti-design, a meaningless output, unfunctional and aesthetically disturbing. The mere discharge of this erroneous aesthetic is the subversive value of this praxis. Glitch here acts as a point of indeterminism, uncertainty and unpredictability of the event that is nevertheless absolutely determined. Why is this so important? Because this puts the glitch art back on track of the historical avant-garde criticism of the everyday life.[10]

Glitch art is a new form of digital art, the digital art praxis as a way of dispensing with the total assemblage of digital art to date, of which vaporwave is the end result. Glitch brings to the forefront the structure of the image by developing a series of errors of the machine that expose the "canvas" or look "behind" the image, a landscape that belongs to the aesthetical ineffability of the code. We can identify the same phenomena at the beginning of contemporary artistic tendencies through dispensing with geometry and with the multiplication of perspective in the works of artists from the beginning of the 20th century. As futurism knew that realism lies in the multitude of perspectives and not in mimesis, so the glitch art knows that realism of contemporary everyday is embedded in the digital code as an absolute landscape, pure perspective and gravity of data and not in the space and time of subjective intentionality. Its main novelty comes from the renewed conception of information process in the post-digital age; space is overcome by landscapes, image-landscapes of data, corruption of which reveals the gravity of scripts holding the code together.

14.2 After Cyberspace: The Spectacular Cyberscape

Let's now turn from glitch art and its technical diversion of art to another phenomenon that revisits in the radical manner the everyday life and its potential of becoming a real and notably first digital avant-garde movement. There are currently very few people writing on vaporwave and predominantly without the art-history background; rather they are artists or media theorists with background in postmodern

and poststructuralist theories. But we have to keep in mind that it is not the idea that should overwhelm the world, but, as Heidegger noted, the world in its historicity should be contained in the work of art as an openness to the truth.[11] There is no need for art-historical idealization of vaporwave, but the time seems right for a movement capable of captivating the essence of the specific contemporary moment in time. With this notion we are lifted from the common ground of aesthetics to a position that questions the responsibilities and the roles of the artwork in general in our modern condition. On a more cautious note—that still gives in to the academic research—we should investigate what are the conditions open to us in today's world for the possibility of an avant-garde. We can surely find part of the answer in the wasteland of the internet and the apparent chaos of information in everyday life. With the advent of contemporary technology and interactive media we are in need of a new term that would successfully grasp the totality of our experience of the everyday—we need the notion of the spectacle.

Apart from the apocalyptic graveyard of modern technology, we are faced with an age where information waste surpasses the actual information gain. Under the horizon of Gibson's white noise sky lies the wasteland of vaporware,[12] disposed and used up ideas, phenomena, products and designs of our techno-enthusiastic everyday. The art of vaporwave comments on the distinct forms of the contemporary everyday in a direct and contrasting manner. It started as a movement of experimental low-fi remix music genre that has grown way out of proportion as its postmodern aesthetic developed as an overall ludic critique of equally postmodern conditions of the everyday life in late capitalism. As a music genre, vaporwave uses early 1980s' pop dance music, chops it down and slows it down to simulate the soothing effect of the so-called elevator or airport music that has proliferated during the boom of shopping malls of the 1990s and early 2000s. This music, fueled with (analog) nostalgia and the repetitiveness of the already recycled cultural artifacts, found its supplement in the corporate culture of the 1990s and actually derived its name from an obscure economic model from the turn of the century. A vaporwave product is a product that is advertised, put on display and even offered for pre-order but never actually reaches the market, a product without relations, a body without organs, a schizo-product so to say or a mere registry[13]—the *vaporware*. It is a specter, and as such it represents all the false promises promoted by the technological enthusiasm of the 1990s and the early 2000s that led to subsequent disappointment by the actual effects of the information age: the hyperreal detachment from the real life, its historicity and naturality, promise of freedom detoured in order to enjoy the full immersion in the cyberspace of the internet. This is the rough principle of vaporwave: to bring forth with a splash of color all the virtual plazas of our hopes in the future that was fueled by our reinvention of history and nature to our own contemporary image. As we have dispensed with everything that pushed us into collective narcissism during the emergence of social networks and interactive internet, all those images now come back to haunt us.

From the art of ancient Greece to the mall aesthetics of the "American Tropicana", space and time find themselves condensed in the experience of the highly saturated information landscape of pure virtual artifacts. It is the first full readaptation of Dada that follows the disappearance of art and culture as the collateral damage of the ongoing information wars of the present day. In the age of solid-state technologies, vaporwave is the movement not much unlike the child's play with the old broken radios, VCRs or other equipment that becomes the ludic exploration of the uncanny

mechanical apparatus of our desires. This project belongs, of course, to the historical line of the development of the avant-garde artistic practice that draws most of its connections and similarities to the theory of the everyday and the critique of the spectacle proposed by the Situationist international and its main exponents who pushed us into collective narcissism: Guy Debord and Raoul Vaneigem. *Dérive* and *détournement*, drift, deflection and diversion as genuine situationist methods of critique are exposed in their theory as the contingents of the spectacle inside of which they need to become a tactic for a subversive or revolutionary role of the situationist avant-garde. Vaporwave is not the art of the spectacle, as some would surely suggest. Rather, vaporwave is the art of the void which appears between life and the spectacle if we are to consider the now classical definition of the spectacle proposed by Guy Debord in his *Society of the Spectacle*: "Everything that was directly lived has receded into representation. [...] The spectacle [...] is a social relation between people that is mediated by images".[14] This spectacular taboo of disintegration of the immediate experience is encountered in vaporwave imagery as the recreated solitude of artifacts in the image and the slowed-down music remix that is describable only as an ironic anti-aphorism stating "that is aesthetic", dwelling on the question posed by electro-pop duo AIR through the artificially created computer voice: *How does this make you feel?*

There's an image (artifact) inside the image-landscape (cyberscape) of vaporwave. Artifacts ranging from antique busts to palm trees and Coca-Cola cans haunt the surface of the abstract digital landscape, reminiscent of the computer commercials of the 1980s and 1990s. Taken together, they represent something very important, and what philosopher Žarko Paić called "the image without the world".[15] Namely, image artifacts that pop-up in the landscape of the vaporwave no longer have a reference in time or space; nor do they have nature or history. They represent the haunting freedom of representation in terms of the artificiality of the (virtual) world. As new media are the sole creators of the new world of information science and cyberculture, images are in themselves art-and-facts of life as communication and connection between every aspect of the world. "Art of the new image is, at the same time information-communication, virtual, simulation and collective 'thing' of the network actors".[16] Images of vaporwave no longer describe the world in terms of the world-image, but, on the contrary, they are the postscript on the dismissal of the world itself for the future being of the image as a space of multiple virtual "nows".

This image thrown in the image-landscape of digital art praxis of vaporwave is an example of what Flusser calls the *techno-imagination*[17]—a praxis of critique and decoding of the internet as an image of our world-less state. Having much to do with the historical avant-garde, Dadaism and surrealism, it should only be natural to consider vaporwave as a next exit from art history and mediology to a reconception of our relationship to the everyday at large. This is why it is safe to say that the specter is haunting the spectacle—the specter of vaporwave, just so to stay on the critical track of what later became *marxistwave* or, even more haunting, *fashwave* subgenre of commodified ironic vapor-fashion. It is our lives imagined as slowed-down, etheric, monolithic and abstract, through objects that make our past seem like a voyage back—to the future.

Grafton Tanner's book *Babbling Corpse* shows us how this spectacle works, without the somber tones of a Debord critique exposing the initial and essential features of vaporwave as music genre, but which should stand as tools for the contestation of the spectacle's whole: anonymity, hauntology, defamiliarization, mundanity and,

yes—anti-humanism. From the spectacle to the technosphere there is only growth in cultural saturation, commodification and techniques of artificial life (likeness) design. Tanner says: "we live in a time without time when the past ceaselessly haunts the present—a fantasy world in which we can utilize the endless capabilities of digital technology while copping the visual imagery of previous decades".[18] In this way, the surreal "space" of vaporwave and glitch art invite us into hounting in themselves, for they both stand for impenetrable landscapes of a cultural decline, embedded in the design of the technosphere as an artificial horizon.[19]

14.3 Landscape without the World?

The idea of the landscape is—in the images of vaporwave movement and its aesthetics—the creation of the "space" of discord, which in return recreates the possibility of political interpretation of the image as the locus of its implicit contents. For the reversal of perspective[20] we need to make the perspective present and realize it in the form of a landscape, landscape as a concept and a plane of the cyberscape. Theory that a philosopher Jacques Rancière proposes—as well as the Situationist project in general—points to a necessity of connection and even transparency between aesthetics and politics, the aesthetical and political regimes which in accord create the common space of human action, its everyday and its future potentials. They allow for the creation of difference that is in essence the finding of a voice, the *logos* or the reasonable (dis)accord with the present state.

The real problem is though, while vaporwave transforms to the spectacular aesthetic commodity, glitch art fueled by contemporary cynicism rises to the artistic expression in and for itself. There is a lot to keep in mind while trying to navigate through the production of the post-internet art and also while trying to make sense of its radical potentials and dangers of recuperation. The tenuous speed of recuperation of the new artistic forms must be shadowed by the radicality of the questions and motivation we are ready to enrich them with, so the art praxis would not remain contained in the mere spectacle of the everyday. The coming-out of the vaporwave from the confines of the underground avant-garde that happened in the first half of this decade signifies the uncanny powers of the spectacle to recuperate revolutionary or avant-garde potentials of new movements in aesthetic commodities. Vaporwave therefore sprung out numerous subgenres (futurefunk, retrowave, darkwave, distroid, marxistwave, simpsonwave, fashwave, ...) and digital aesthetics (seapunk, oceangrunge, VHS pop, ...) and developed pop culture at large. Iconology of vaporwave is successfully assimilated by commercial televisions such as MTV and marketing campaigns of youth-oriented brands like Coca-Cola by means of the ironic use of commodity-artifacts in collage aimed at meeting the consumer needs and interests. This effect is made possible only by spectacular hyper-aestheticization and deprivation of voice or logos to the totality of the movement, ripping it off from its own concept of the digital landscape and pushing it into the recycle-imperative of the spectacle of disintegration.[21] The idea of virtual plaza, digital beach and neon cityscape is overcome with the concretization of iconography in symbols of consummation that are connected to the general tendency toward ironic consumerism.

The concept of the landscape finds its essence in understanding it as a situation-image, and as in vaporwave and glitch art it is a *mélange* of the situationist understanding of aesthetics (spectacle of disintegration) and Marxists' take on economy

(commodity fetishism). The necessary method of the vaporwave image is the collage, critical remix and deconstruction of discourse. Landscape as a general theme or as a visual presence is brought up to the limits of representation. It is no longer a theme as an artistic preoccupation, but it is the essence of the post-pictorial critical response of vaporwave. This notion is important. As an idea of the image itself and its use as a method of exposition of the false consciousness of capitalism, the use of landscape brings us close to the unfulfilled or betrayed idea of the virtual beach and life extended through and not compressed to the network. Vaporwave provokes the idea of surreal *scapes* of empty images reminiscent of Giorgio de Chirico as a ludic contemplation of our own cyberfuture. Grafton Tanner gives a definite momentum to this speculation in *Babbling Corpse*, saying that "vaporwave is the [...] product of a culture plagued by trauma and regression in late capitalism",[22] as a culture which denies us the possibility of making new memories[23] where "forgetting becomes an adaptive strategy".[24]

There is an important ontological distinction to make in the final remark on the digital art praxis. Namely, every digital image is a landscape, because the notion of the landscape implies a system, a perspective of the process and the horizon of meaning. If we consider them as signs, they are always signifying in a sense the limits of information and design in its own frame, reminiscent of understanding the concept of enframing[25] [*gestell*]. We need the concept of the digital landscape to overcome the fictitious fantasy of cyberspace. Over space (as a void or as a vacuum) we need to reach a surface, a perspective and the recreation of the technical network (Simondon) in order to fully grasp the magnitude of the spectacular post-internet era of thinking things. Absolute landscape, digital landscape or the landscape without the world is always present, as long as there is data and as long as the screen is flickering, and the glitch is only its exposition in which the landscape itself is simultaneously concealed by glitch art being also an image in itself, and not just a distortion of an image. In forms of vaporwave and glitch art, it is a tactic of the contestation of digital aesthetics of the technosphere and its total life design, meaning it is a post-aesthetic praxis, insomuch as neo-avant-gardes of the second half of the 20th century certainly were.

There is a certain indignation against the computer becoming a multi-purpose typewriter, machine for developing programs and executing operations demanded by the work process. Because of today, we no longer talk about computers being the main necessity of postmodern life; we no longer compute but rather document and observe, hiding the spectacle in our pocket. It is the "little dark age of smartphones" that leads us to regress as individuals—everybody again having the same mobile ringtone—and, as a collective body, computers became highly specialized for gaming, office and studio. Culture follows, as we no longer dread its uniformity but embrace it as an ironic product of consumption; we choose the same phone and same shoes, and all want to watch *Home Alone* for Christmas. Vaporwave brings us one step further in explaining the importance of the questions on recycling, repeating and difference from the point of entropy in our culture, questions that arise with the philosophies of Deleuze, Stiegler, Simondon and others, as the question concerning technology is the question that stands embedded in the culture of digital landscapes of the network. As the artistic avant-garde of the technosphere, vaporwave and glitch art are to be considered as an anti-design as well as an ambiguous aesthetics of the ugly and uncanny, in the sense of its total realization in the art-life or the space of *thinking things* that can only simulate its appearance but never its essential nature. The digital art praxis is the recaptcha test for the upcoming revolution. While spectacle uses it to learn more and more about

the way we use signs for motivating the revolutionary action, it is up to us to realize its potentials to hack the system.

Vaporwave is the specter of cyberspace and the hubris of information capitalism that imagines a new space of exchange and the use of data on the internet. The turn needed is exactly to see that on the internet we are not moving through space, but we observe and drift over the haunted landscape of information. Our only possessions are the ambiguous experiences of these observations and not the real conquest of the cyberspace. Because it is everywhere, we do not see it, and we ought to find the landscape and the frame of this transparency. Glitches are happening, always and at random; vaporwave emerges at the compressed horizon of our memories; techno-aesthetic[26] that Simondon wished for still awaits for the contestation of the spectacular technosphere. As it is with the most influential theories and philosophies of our times, the aim of the digital art praxis is to ignite the free experimental creativity of all and for all, not just for the commodity of the spectacular success. There would certainly be no point in philosophizing if it just creates a commentary and an answer. As Bergson pointed out, it is about formulating a question, and, as Deleuze concluded, it is about the creation of concepts of the contestation of present answers.

Notes

1 Manuel Castells, *The Internet Galaxy*, New York: Oxford University Press, 2001, pp. 36–63, 116–137.
2 Žarko Paić, "Technosphere—A New Digital Aesthetics?", in K. Purgar and Ž. Paić (eds.), *Theorizing Images*, Newcastle upon Tyne: Cambridge Scholars Publishing, 2016, p. 123.
3 David Silver, "Looking Backwards, Looking Forwards: Cyberculture Studies 1990–2000", in David Gauntlet (ed.), *Web.Studies: Rewiring Media Studies for the Digital Age*, Oxford: Oxford University Press, 2000, p. 19-31.
4 Max Bense, *Aesthetica: Einführung in die neue Aesthetik*, Baden-Baden: Agis, 1965.
5 Nick Couldry and Andreas Hepp, *The Mediated Construction of Reality*, Cambridge: Polity Press, 2017.
6 William Gibson, *Neuromancer*, New York: Ace Books, 2000, p. 4.
7 Stephen Wright, "How to Do Things with Data", in Stephen Wright (ed.), *Dataesthetics*, Zagreb: Arkzin, 2006, p. 9.
8 Martin Heidegger, *The Question Concerning Technology and Other Essays*, New York: Garland Publishing Inc., 1977, p. 115.
9 Vilém Flusser, *Into the Universe of Technical Images*, Minneapolis: University of Minnesota Press, 2011, p. 48.
10 Aleš Erjavec, "Conclusion. Avant-Gardes, Revolutions, and Aesthetics", in Aleš Erjavec (ed.), *Aesthetic Revolutions and Twentieth Century Avant-Garde Movements*, Durham: Duke University Press, 2015, p. 255.
11 Martin Heidegger, *Off the Beaten Track*, Cambridge: Cambridge University Press, 2002, pp. 20–21.
12 "Vapour-ware", Computer Desktop Encyclopedia, accessed December 31, 2018, https://en cyclopedia2.thefreedictionary.com/Vapour-ware.
13 Gilles Deleuze and Felix Guattari, *Anti-oedipus: Capitalism and Schizophrenia*, Minneapolis: University of Minnesota Press, 2000, p. 4.
14 Guy Debord, *The Society of Spectacle*, London: Rebel Press, 2005, p. 7.
15 Žarko Paić, *Slika bez svijeta: ikonoklazam suvremene umjetnosti*, Zagreb: Litteris, 2006, pp. 160–165. Also consider: Žarko Paić, *White Holes and the Visualisation of the Body*, London: Palgrave Macmillan, 2019, p. 187 and on.
16 Paić, *Slika bez svijeta*, p. 162.
17 Vilém Flusser, *Schriften, Vol. 4: Kommunikologie*, Frankfurt am Main: Fischer Taschenbuch, 1998; 2007, p. 209.

18 Grafton Tanner, *Babbling Corpse—Vaporwave and the Commodification of Ghosts*: Washington: Zero Books, 2016, p. 60.
19 Paulo Virilio, *The Information Bomb*, New York: Verso, 2005, p. 14.
20 Raoul Vaneigem, *The Revolution of the Everyday Life*, Oakland: PM Press, 2012, p. 162.
21 McKenzie Wark, *The Spectacle of Disintegration*, New York: Verso, 2013, p. 3.
22 Tanner, *Babbling Corpse—Vaporwave and the Commodification of Ghosts*, p. 9.
23 Mark Fisher, *Capitalist Realism: Is There No Alternative?*, Washington: Zero Books, 2009, p. 60.
24 Ibid., p. 56.
25 Heidegger, *The Question Concerning Technology and Other Essays*, pp. 3–35.
26 Gilbert Simondon, *Du mode d'existence des objets techniques*, Paris: Aubier, 1989, p. 179.

Part IV

Abstraction in Science and Technology

15 The Material Site of Abstraction

Grid-Based Data Visualization in Brain Scans

Silvia Casini

Grids can be found everywhere from scientific images to modern artworks, from graphic design to architecture. Gridded systems are used to visualize bodies, populations, data and biological organisms. According to the comparative historian Phillip Thurtle, the grid is the most pervasive medium for illustrating natural life in the early part of the 20th century. Biology owes more to the abstraction of the grid than to an aesthetics of wholes.[1] The grid allows disparate pieces of information (both analog and digital) to come together in the guise of a technical image, that is, in the form of an image which is instrument-based or resulting from imaging procedures.[2]

Anne Friedberg defines the grid as a framing and drawing device which appeared in the 15th-century treatise *De Pictura* (1435) written by the humanist and artist Leon Battista Alberti who describes the veil [*velo*], a framing device which functions as a grid-like frame positioned between the eye of the onlooker and the object to depict.[3] The grid-like veil serves the purpose to assist artists in their attempts to map the three-dimensional world into the two-dimensional picture plane of the canvas. From its early appearance, the grid prompts the question of what is included and excluded from the frame.

This chapter examines the role of the grid as a matrix of epistemological and aesthetic relations that enable, in the case of biomedical imaging, the translation of data into an image and, in the case of art, the opening of creative possibilities for the artists using it. The grid, which is a conventional coordinate system present both in modern art and in the sciences,[4] has been described as "a way of announcing that something is going to happen: an object is going to be measured, or an image is going to be transferred from one scale to another, or a form is going to be drawn and studied".[5] The grid, thus, becomes a set of alignments for enabling transformations/transpositions to occur. Once invented, the grid never disappears. It becomes a tool for re-configuring our perception, experience and display of the world and of the body exercising an impact across our visual culture. The processes I describe in the chapter (the process of creating an image from data in biomedical imaging and the process of creating an artwork in modern art) have the grid in common.

The perspectival frame constitutes the basis of Descartes's coordinate system (x,y,z), a model of measuring space at the core of his entire philosophical method.[6] The coordinate system of the grid is also central to the procedure of acquiring and visualizing data in biomedical imaging. Since the time of Descartes's coordinate system applied to the study of life, it seemed impossible to envisage a world without using a grid as a scaffolding device. Taking the technique of magnetic resonance imaging (MRI) as a case study in biomedical imaging, later in this chapter I discuss the central role played by the grid in moving from data to images and data again, in the ongoing instrumental

mediation between the brain, data and theories. The grid is a realistic representation of science that leads to the idea that this is a clear picture even when there is a large amount of mediation and reconstruction. I will then show how MRI images are not analogical snapshots of the brain. Rather, they are reconstructed out of k-space, a grid-like modular and repetitive structure (the virtual space where digitized magnetic resonance signals are stored during data acquisition). At the end of the scan, the data are processed with algorithms and the final image is created.

The chapter engages the reader with some of the key historical and conceptual milestones in the passage from the logic of a linear, centered, single-point perspectival space to brain imaging techniques and modeling. I argue that this shift is enabled by the Cartesian coordinate system, which is, simultaneously, a drawing device, a graphed image for visualizing the relationship between variables and the setting for experiments to take place. The grid shifted from being a device enabling to look at a painting as if we were seeing a three-dimensional world through a window to becoming a means to achieving abstraction in modern art. Here, the grid becomes a medium used against itself to challenge the onlooker's position, to overcome the single viewpoint perspective in favor of the surface.

In science, the grid signals the attempt to reconfigure a set of disciplinary, epistemological and aesthetic relations between data and bodies so that the final visual output (the image-data) can be effectively read by the different communities of users (physicists and radiologists) to perform decisions/interventions on the actual body of the patient. The grid enables the breaking down of complex structures, which form into simpler modular elements that can be more easily controlled and reconfigured. In the final section of the chapter, I argue that the underlying organizational structure of the grid fosters the passage from an anatomical organic body to self-contained atomized components organized in new assemblages disconnected from the whole.[7]

The structure of the Cartesian grid enabled the construction of a new type of visual space in modern art. The grid has been then reapplied to another type of space (that of the human body visualized through biomedical imaging) without properly acknowledging what was at stake in this new transposition. With biomedical imaging, representation of the body and the brain is less charged with realistic and mimetic elements, and more with graphical and geometrical elements—the grid being one of them. What the final image obtained with MRI can say and cannot say to the different readers/ onlookers (the physicist, the radiologist, the patient) can only be understood if one grasps the sets of epistemological and aesthetic transpositions produced by the grid.

The first half of the chapter engages with the role played by the grid-based data visualization pipeline and protocol for converting data into images. This analysis foregrounds the discussion undertaken in the second half of the chapter, which discusses how in the atomized body the dimensions of risk and prediction play a key role. At the beginning of the 21st century, genes, cells, bodies, technologies and research areas become imbued with potential. Is there anything unrepresentable in the field of today's biomedical imaging and neuroscientific research saturated by data, information and visualization? Whether it is stochastic uncertainty, model uncertainty or uncertainty about the future, finding ways to convey uncertainty is one of the most important challenges in data visualization today. As I discuss in the second half of this chapter, the profiling and management of potentiality, uncertainty and risk is the implicit framing underpinning the development of biomedical imaging technologies and the challenges related to their data visualization pipeline and output in healthcare.

15.1 From Data to Image: The Grid in Biomedical Imaging

The historian of science and technology Peter Galison provides us with a conceptual framework to describe two traditions present in the field of 20th-century microphysics. The first, called the image tradition, describes images as natural, illusionary or mimetic. The second, the logic tradition, substitutes images with the notion of statistical projection of data and digital information.[8] These two traditions employ different forms of experimental arguments: the first seeks to base its demonstrations not on statistics but on single "golden" events such as those proving the forms of the subatomic world or, recently, the discovery of gravitational waves. A single picture can provide the onlooker with evidence about an entity or a phenomenon. The second tradition uses statistical demonstrations and is based on the aggregation of data. The images belonging to this second tradition tend to be pixelated or statistical graphs rather than mimetic. This is quite evident in graphs representing curves, which are averages, rather than a direct visualization. Galison argues that these two traditions have recently merged into a hybrid one. Being able to move between these two traditions and to produce good quality image-data (not just measurements or just images) is paramount to enabling physicists to reach out to different communities—radiologists, clinicians, patients and the lay public. Brain scans produced by biomedical imaging techniques such as MRI embody both image traditions, functioning as authoritative visual objects that are part of a multi-layered ensemble of networked techniques and technologies (both analogical and digital), and human mediations.

MRI is one of the key diagnostic imaging technologies of the 20th century used in biomedicine and the neurosciences sometimes in combination with other non-imaging techniques. MRI is a non-invasive technique using strong magnetic fields, radio waves and field gradients to visualize the anatomy and the physiological processes of the body in both health and disease. Different from X-ray-based computed tomography, MRI allows one to visualize soft tissues. MRI uses a magnetic field, radio waves and field gradients to create detailed images of the organs and tissues within the body (Figure 15.1). The patient lying inside the tube-shaped magnet is exposed to a strong magnetic field, which temporarily realigns hydrogen atoms in the patient's body. Radio waves cause these aligned atoms to produce very faint signals, which are then analyzed by the scanner to indicate whether they came from normal or diseased tissue. After being collected by the scanner, these signals are used to create cross-sectional images of the patient's tissues and organs.[9]

Unlike any other medical imaging modality, in MRI the nuclei of atoms within molecules are the signal carriers. The principle leading to MRI technology is based on the physical effect in which atomic nuclei absorb external radiofrequency waves and then re-emit them in a magnetic environment. This phenomenon only regards nuclei with a magnetic moment and is highest for protons. The spin of the atoms becomes temporarily aligned with the direction of the applied external magnetic field. The atoms, having been forced out of equilibrium to artificially align themselves parallel to the external field, will return to their original equilibrium. It is during these readjustments, which take just a few microseconds, that the atoms emit a nuclear resonance radiation which can be recorded. Namely, this interval is called "relaxation time" T1. A coil surrounding the specimen under examination (for example, a bodily organ) picks up this emission.

MRI images are maps of tissue-specific relaxation rates of the protons of tissue water. The clinical usefulness of MRI derives from the fact that pathological tissues

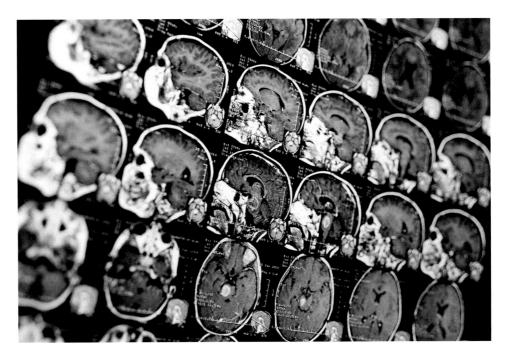

Figure 15.1 Multi-layered medical scans done using an MRI technology; photo: iStock.

have different relaxation characteristics than healthy tissues (T1 and T2 parameters).[10] An average MRI examination comprises a set of around 120 images of a thickness of around 4 millimeters. The images comprise different planes (axial, sagittal, coronal), types (T1, T2, proton density) and slices. The images are taken sequentially from top to bottom, right to left or anterior to posterior depending on the specific body part that is imaged. Although the images are two-dimensional, because they are taken from contiguous slices of a body part and in more than one plane, they give a three-dimensional view of the bodily part under examination. Compared to other imaging technologies that use a single parameter to create images of the internal parts of the body, MRI uses multiple parameters such as relaxation times and proton density to produce the set of images.

The generation of images takes place through the repeated acquisition of signals coming from the body, and through the appropriate modulation of the gradient coils. By making sure that each image voxel has a different frequency and/or phase than all the others, it is possible to separate the signals coming from a single portion. Both noise (data noise) and signal are present in an MRI image: the signal is the voxel or pixel brightness in the image; noise is the random differences in pixel values generated by the patient's body. Like acoustic noise, data noise can get in the way. Noise disturbs the reading of the image and must be eliminated to allow radiologists and clinicians to make a diagnosis. Designing, analyzing and interpreting MRI data is challenging mainly because MRI research brings together ideas from a number of fields including physics, engineering, medical imaging, statistics, Bayesian inference and cellular and systems biology. For example, in the case of brain images, Bayesian inference is

used to decide whether a portion of the brain image belongs to white or gray matter. Researchers use a probabilistic approach to determine the information given in the voxel of the image and create tissue probability maps. Prior knowledge about the tissue and current data are both expressed as distributions, which means that the presence of variance or error is always a possibility.

The process of turning the signal into a meaningful image is far from straightforward. Like most scientific breakthroughs and discoveries, the development of MRI, involving different scientific laboratories and research teams across the world and the UK, has not been a linear one. In his transnational history of MRI, Amit Prasad dismantles the myth of a single "origin" of MRI: "[T]he 'invention' of MRI was not a singular event, or a set of events, frozen in time (the early 1970s), but, rather, the result of entangled activities of a number of actors that extended over decades".[11] Comparable to the discovery of X-rays in 1895, there were multiple steps leading toward the scientific, technological and diagnostic breakthrough of MRI. In 1973, Paul Lauterbur described a new imaging technique called zeugmatography (which later became known as nuclear magnetic resonance imaging). His technique enabled a completely new way of making images, unknown to other techniques used in physics those days, such as microscopy and infrared and ultraviolet imaging. With zeugmatography, the two fields of long wavelength and low energy were connected. Lauterbur used the magnetic field gradient to encode spatial information as a spectroscopic frequency and then to reconvert the frequency back into an image. No optics or diffraction was involved. This means that MRI imaging cannot be understood in the guise of analog or digital photography.[12]

The University of Aberdeen occupies a peripheral place within the historiographical accounts of the invention and development of MRI. This is partially motivated by the fact that research carried out by the Aberdonian group, which was "at the forefront of MRI development until 1981",[13] was then quickly superseded by research centers that could count on cutting-edge scanners manufactured by big companies. The biomedical physics laboratory in Aberdeen developed MRI in two periods. The first occurred between the late 1960s and the early 1980s. The research team led by John R. Mallard constructed *Mark-I*, the world's first whole-body MRI scanner for clinical use. The physicists Jim Hutchison and Bill Edelstein then invented the spin-warp method, a nuclear magnetic imaging technique, which still is the gold standard for data–image conversion in MRI scanners across the globe. The spin-warp method is applied to whole-body imaging, and fundamental mathematical relations in the signal are readily transformed into an image.[14]

At present, the biomedical physics laboratory at the University of Aberdeen, researchers are working on fast field-cycling MRI (FFC-MRI), a new non-invasive biomedical imaging technique which breaks a fundamental law of MRI—that the applied magnetic field must be held constant during image acquisition.[15] Unlike conventional MRI, FFC-MRI uses a variable magnetic observation field, ranging from high values to very low values.[16] FFC-MRI enables the visualization of biochemical information at a molecular level not detectable by conventional MRI, and it is potentially suitable for predictive medicine.

Albeit different, the two techniques of MRI and FFC-MRI rely on the spin-warp method for turning data into meaningful visual information. No organ is immediately imaged as in a photographic snapshot, but each organ or part of the body to be imaged is preselected, organized into slices and gradually reconstructed. Even though

MRI allows the acquisition of images of the body in all orientations (sagittal, coronal, axial), the acquisition of data to recompose the image of a head or another organ is sequential. The body is stimulated with multiple radio frequency pulses and variable gradients. The MRI scanner acquires (samples) the signal over time. This signal is digitized and stored in the computer, in a matrix known as k-space. The computer performs a *discrete Fourier transform (DFT)* on the data, converting the spatial frequencies into pixel values needed to reconstruct the final image. The spatial frequencies in the MRI image are contained in the k-space—this abstract concept is usually represented as a matrix and is the first visual output combining all the signals that come out of the scanner.[17] Put simply, the k-space holds the raw data before the reconstruction of the image (Figure 15.2).

In his *Questions and Answers in Magnetic Resonance Imaging*, radiologist Allen D. Elster explains the concept of the k-space in plain terms:

> The cells of *k-space* are displayed on a rectangular grid with the xy axes. These axes of *k*-space correspond to the horizontal (*x*) and vertical (*y*) axes of the image. The *k*-axes, however, represent spatial frequencies in the *x* and *y* directions rather than positions. The individual points (*kx,ky*) in *k*-space do *not* correspond one-to-one with individual pixels (*x,y*) in the image. Each *k*-space point contains spatial frequency and phase information about *every* pixel in the final image. Conversely, each pixel in the image maps to *every* point in *k*-space.[18]

To obtain the image, the k-space needs to be charted, which can be done by using a variety of methods, among which is the Cartesian grid. One of the earliest methods for reconstructing the image was the radial sampling of k-space data. This method was supplanted by the "spin-warp" technique, which I discussed above, that employed

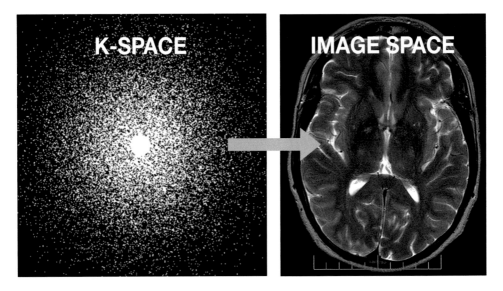

Figure 15.2 An example of phantom k-space and a corresponding visual image; illustration: courtesy of the author.

Cartesian data acquisition. The Cartesian grid exercises a crucial function in the imaging process within the laboratory biomedical practice, particularly in relation to the purification of data from artifacts.

To this day, Cartesian methods remain dominant, but other non-Cartesian approaches (radial and spiral) are gaining ground. The k-space can be charted in different sequences to give the physicist the chance of mapping out a different area each time. The physicist, however, needs to bear in mind two things: first, beyond a certain distance from the center of the picture, the background noise makes futile any charting of the space in k-space; second, given that the magnetic resonance signal is transient and subject to decay it must be collected as quickly as possible. A bad signal leaves its trace in the image.

The density of the various parts composing an MRI image is represented in k-space, obtained by mapping the spatial information onto a frequency scale, a procedure called "frequency encoding".[19] K-space influences the final appearance of an MRI image. Information in the center of k-space is responsible for the contrast in MRI images, whereas the spatial resolution of the image is given by the data present in the outer edges of k-space. Although the k-space and the final MRI image look very different, they contain the same information about the body which underwent the scan procedure. One could convert each representation into the other using the *Fourier mathematical transform*. The image rather than the number is what radiologists need to read in order to make a diagnosis. The radiological reading concerning the presence or absence of pathology is achieved through a "'differential analysis' of diverse sets of MRI images […] and through cross-referencing different 'inscriptions'—images, diagnostic data, and so on, which together […] function to detect and fix pathology".[20] Every MRI image presents only a partial perspective on the bodily part being scanned. MRI maps a previously framed area of the body—that is, an area that is already organized as if it were an image. Therefore, the procedure of creating MRI images using mathematical functions of transformation is an action incised onto the image rather than onto the object to imagine (for instance, a part of the brain).

15.2 The Cartesian Coordinate Grid: From a Generative Matrix in Modern Art to Predictive Modeling

Underpinning brain models is the grid, a geometrical structure related, like mapping, to location, orientation and the itinerary of subjectivity. As Katherine Hayles argues, "when we design technical cognitive systems, we are partially designing ourselves".[21] In this section I will discuss the passage from the grid conceived as a medium for achieving abstraction in modern art to the grid as the scaffolding device underlying predictive modeling. As an algorithmic-based device that reconfigures how bodily data are made available in a visual form, the grid used in biomedicine contributes to transform how we perceive our bodies and brains and the way in which we then take decisions related to them.

The grid shares with maps the premise that the body and the world are measurable landscapes whose information can be conveyed in various forms. In the early modern period, mapping was associated with the research and procedures present in a variety of fields, among them geography and anatomy. As a system for mapping surfaces, the grid is a figure common to biomedical imaging and modernist art. Early study of the anatomical body was the study of spatial organization and the composition

of the various elements that made up the body. Self-knowledge was gained through anatomy, through the perceptual grasp (using our eyes, nose and hands) of the various bodily organs and humors. In peering inside the human body, the anatomist was confronted with the unfamiliar geography of the interior of the body, which was only rarely glimpsed.[22]

Although the anatomical body seems to have dissolved, scattered into impalpable molecules and synapses with the advent of the Visible Human Project (1994–1995), first, and then the Genome Human Project (1990–2003), the Medusa myth, that is, curiosity and fear of looking into our own interiority, still survives.[23] With brain imaging, representation is less charged with realistic and mimetic elements, and more with graphical and geometrical elements: modern medicine, for all its seeming ability to map and then to conquer the formerly hidden terrain of the interior landscape, in fact renders it visible only through scenes of representation. The atomization of the body started with the grid.

Scientists and the general public, too, are familiar with the practice of plotting information on a system with an xyz axis. People have been arranging data into tables (columns and rows) at least since the 2nd century C.E., but the idea of representing quantitative information graphically did not arise until the 17th century thanks to the French philosopher and mathematician René Descartes. He developed a two-dimensional coordinate system for displaying values, consisting of a horizontal axis for one variable and a vertical axis for another, primarily as a graphical means of performing mathematical operations. An example of the use of the Cartesian grid for quantifying life phenomena is Étienne-Jules Marey's late 19th-century analyses of human and animal motion, resulting in the graphic representation of classified parameters. The physiologist Marey constructed devices to record movements to minimize the flaws of the human sensorium and construct a new language, that of the graphic method.[24] Thanks to this method and the invention of chronophotography, Marey was able to translate the phases of movement into a synthetic and abstract visualization in which a series of lines, curves or graphs were set against the Cartesian grid.

The use of the grid in modern art, which can be recognized retrospectively in Marey's practice, is an auto-referential mapping system of surfaces, not a form of pictorial representation as the historian of art Rosalind Krauss explains: "It is a transfer in which nothing changes place. The physical qualities of the surface [...] are mapped onto the aesthetic dimensions of the same surface".[25] In its precise geometrical order, therefore, the grid eliminates the center, any hierarchical order, any reference and inflection. Krauss conceives the grid as a spatio-temporal structure underlying artistic modernity.

The Cartesian coordinate system opened the way to the development of the graphed images that eventually led to the digital grid, the structure that underpins the scans for visualizing body and brain anatomies and functions created thanks to biomedical imaging techniques. The graphic method enabled the schematic visualization of data extracted and "abstracted" from the body. The historian of technology Cornelius Borck coins the concept of "vital abstraction" to address "a form of theorizing that anchors the brain model in empirical data but abstracts it from biological, organic, or morphological specificity in order to model the brain's activity".[26]

The process of abstracting from the vitality of the organ/phenomenon under examination is interesting to study in reference to brain images. In the early days of neuroscience, neuroscientists attempted to read and make sense of functional images

like positron emission tomography (PET) and functional MRI (fMRI) as if they were anatomical images like X-rays. Anatomy and metabolism (blood flow, oxygen consumption and so on) were related by means of a visual (optical) comparison between the brain scan and the paper anatomical atlas. The two representations of the brain were compared by the researcher's eye. This is the same kind of optical reading that occurred also at the time of Mallard before the availability of statistics and powerful computers. This "optical" reading, as Beaulieu calls it, was superseded by a digital way of reading brain scans made possible by Talairach.[27]

The Talairach is a coordinate grid system developed in the early 1980s (when the spin warp was invented), which is used to describe the location of brain structures that become "activated" in neuroimaging. Because MRI scans vary due to differences both in brain features (size and shape) and in slice orientation, it is useful to "normalize" a brain (that is, to translate, rotate, scale and warp a brain) to roughly match a standard template image. The location of brain structures is reported using the Talairach digital grid. This system uses Cartesian coordinates (X, Y, Z) to describe the distance from the anterior commissure, the "origin" of Talairach space. With Talairach, brain and scan become digital grids (a set of values in a coordinate space) rather than regions to be correlated.

The logic of probabilistic thinking has been facilitated by the passage from the analog to the digital and from an actual observer using an optical instrument to a virtual one who is not necessarily human.[28] A database logic and a probabilistic thinking are at work in the making of brain images. Researchers put efforts in developing probabilistic atlases:

> the voxels do not represent absolute values such as averages, but rather probabilistic outcomes of calculations across scans in the database. Such atlases will indicate, for example, that the probability of a particular coordinate being located in area X of the brain is 89%. [...] By articulating a set of variables, a query can be formulated that leads to the constitution of a specific atlas.[29]

Atlases function like classification systems that make visible or render invisible particular aspects of knowledge. These atlases depart from traditional ones in so far as they "foreground objects as both variable and relational, rather than as discrete 'specimens' or autonomous instances that can be understood on their own".[30] In this way, the onlooker is prompted to consider quantitative values within a register of possibilities rather than as absolute values.

Although the most advanced approaches to neuroimaging use time graphs for predictive modeling, the coordinate system still works as the backbone for reconstructing the image from digitized signals in biomedical imaging. Statistical graphics are one of the earliest attempts to analyze and visualize quantitative data. Whereas statistics and data analysis procedures generally yield their output in numeric or tabular form, graphical techniques allow such results to be displayed in some sort of pictorial form. They include plots such as scatter plots, histograms and probability plots. The scatter plot is a type of display using Cartesian coordinates to display values for two variables for a set of data. This is the most common visualization used also in FFC-MRI. Across centuries, the scatter plot shifted its focus from spatial organization in the 17th and 18th centuries to multivariate distribution and correlation in the late 19th and 20th centuries.

Data can be described, explained or predicted. All three processes employ statistics but in a different way. Explanatory modeling applies statistics to data for testing causal hypothesis about theoretical ideas; predictive modeling is the process of applying a statistical model or data mining algorithm to data predictions. Being able to distinguish between the two ways of employing statistics that I have just described (explanatory modeling and predictive modeling) is important in scientific practice, although it is difficult because the two are often conflated.[31] The gap is between the explanation of a phenomenon at the conceptual level and the ability to generate predictions at the measurable level. Ultimately, predictive and explanatory modelling embody two different approaches to managing uncertainty.

FFC-MRI, in a similar fashion to other risk technologies in the world of healthcare, has a specific relationship with the present and future dimensions when it comes to how they manage uncertainty and enable the calculation of risks/probabilities to make predictions. FFC-MRI is set out to assist researchers in the quest for biomarkers enabling the early diagnosis of certain conditions (for example, neurodegenerative diseases) before they become symptomatic. This emerging technology and its way of seeing, then, are perfectly inserted within the paradigm of personalized and predictive medicine by seeking to control (govern) the spectrum of uncertainties that patients might or might not have to face. Precision medicine is an emerging approach for treatment and prevention that considers individual variability in genes, environment and lifestyle for each person. Precision medicine makes true predictive analytics possible. One is a requirement for the other.

15.3 Practices of Seeing, Uncertainty and "Politics of Possibility"

Practices of seeing and their visual cultures have always been crucial to medicine. Evidence-based medicine relies on the recording of visible symptoms and on an understanding of "seeing", which coincides with the diagnosis.[32] In the case of predictive medicine, "seeing" is accompanied by statistics in the categories of "potential" and "probability".[33] Potential is the undefined and unrealized set of all possible variables and states of a given problem or argument. Probability is the mathematical distillation of all those potential outcomes into a singular result, the most probable observed outcome to a given set of variables in each argument. With predictive medicine, a branch of medicine that aims to identify patients at risk of developing a disease, the relationship between data, images and patients is organized around categories of probability, potentiality and risk.

The visual output produced by FFC-MRI is a graph expressing dispersion curves. One curve, the T1 dispersion curve, has a particular shape and a typical behavior depending on the sample. The molecular dynamics of the sample affects the behavior of the curve. Neurodegenerative diseases and different types of cancer are two areas of interest for FFC-MRI. With neurodegenerative diseases, the hope is to be able to identify early, low-level brain pathology and treat it before it develops in severity. With tumors, the hope is to open up a window on new therapies targeting subcellular dynamics. What is the "thing" that FFC-MRI visualizes? What does the biomarker reveal? It becomes very hard to draw a line between knowing and not knowing, to give a reading of a clinical condition, a reading that is inherently fragile because it has been exposed to the deluge of data and counter-narratives that other biomarkers might provide.

Problems arise not just at the level of modality (real/possible) but also at the level of scale. In contemporary biomedical laboratory practice, there is a co-presence of molecular and molar exactitude. This co-presence of the two scales for imaging, talking about and understanding the body, however, does not show up at the public level, for the answers concern patients in their entirety: their bodies, brains and circumstances of life.[34] Data, in contrast, are often related to the molecular body, even when they are arranged in grid-based patterns and correlations that move beyond the level of molecular organization. The issue of scale shows up when researchers try to understand the meaning of data patterns—their evidence. To do so, they need to be able to ascertain the reliability of data; their reliance upon previous knowledge of the phenomenon under investigation; and the relationship between the data, the sample or the body of the patient and the experimental setting.

In her genealogical study of the "politics of possibility" at work in security techniques and technologies (algorithms, biometrics, data visualization), Louise Amoore argues that "what matters is not so much a question of whether or how the world is more dangerous, more uncertain, or less safe but how specific representations of risks, uncertainty, danger, and security are distinctively writing the contours of that world".[35] At its core, predictive analytics encompasses a variety of statistical techniques (including machine learning, predictive modeling and data mining) and uses statistics to estimate, or "predict", future outcomes. The management of uncertainty is the horizon biomedical imaging technologies such as FFC-MRI are inscribed. The relationship with the present and future dimensions shapes how risk/probabilities are calculated to make predictions, for example, in the world of biomedical physics applied to healthcare. The anticipatory logic is what Amoore criticizes:

> The specific modality of risk that I address […] acts not strictly to prevent the playing out of a particular course of events on the basis of past data tracked forward into probable futures but to pre-empt an unfolding and emerging event in relation to an array of possible projected futures.[36]

Uncertainty is incorporated into decision-making in the present. Authoritative decisions are taken not on the basis of what is known, but on the basis of risk profiling, scenario building, algorithmic modeling and data analysis. Algorithms, which Amoore defines as the "mathematical map of associational relationships",[37] are not informed by past historical data, but operate by making multiple correlations among contingent events seeking to anticipate future ones. The model departs from the standard distribution of data in a bell curve, which is the graph used to depict a normal distribution for a variable.

The theoretical reflections put forth by Amoore gain concreteness when applied to a variety of contexts from state security to the world of healthcare. Understanding the condition of health or the disease of a patient nowadays depends on a massive amount of data (anatomical, physiological, molecular and environmental) that are analyzed using a predictive model approach. The result is a virtual patient acting as a model enabling the clinicians to predict the optimal treatment personalized to the individual patient.[38] What counts is not the accuracy of data but the kinds of correlations and associations that one can draw across them. What matters is not whether a predicted neurodegenerative condition manifests itself or not, but the idea that one is prepared to proactively address it.

Statistics and graphs continue to be the methods of analyzing and visualizing data in order to manage the uncertainty in biomedical physics applied to healthcare. The visual output produced by FFC-MRI is a graph expressing dispersion curves. One curve, the T1 dispersion curve, has a particular shape and a typical behavior depending on the sample. The molecular dynamics of the sample affects the behavior of the curve. The aesthetics of the curve—aesthetics as the science of what is sensed and imagined—is an instance of *profiling* a condition of pathology in the organism. The absence or difficulty of establishing a direct correlation between the visual output (the profiles) and the phenomenon under investigation (a condition of pathology) is present with FFC-MRI too as it is with other biomedical imaging technologies based on probabilistic parameters.

Aesthetics comes into play when discussing not only the T1 curve but also the meaning of image-data quality for different professionals (physicists, biologists and clinicians). "Beauty" is a word often used to talk about quality at different levels such as when it comes to signal-to-noise ratio, to the quality of the signal itself, to the final visual output and to the shape of the dispersion curve in FFC-MRI. One of the key challenges facing researchers is what kind of information one wants to extract from the dispersion curve, for a change in the curve's shape is not necessarily directly related to something happening in the tissue; in biology, several different pathways may lead to the same kind of change in the dispersion curve. The *form* of the profiles acts as an interface between research and the clinics: the shape of the T1 curve affects the response and the decisions taken upon the body of the patient.

Scattered data points can be organized into patterns of distribution to produce statistical profiling whose visual manifestation is a graph, or a curve based on the Cartesian grid. The problem is that "the form of the object—once conceived as points and lines—can precipitate effects even when the body of the object is itself absent".[39] If the Gaussian algorithm or the bell curve were the means to govern anomaly through the logics of normal distribution, predictive algorithms are the new form of perception whose horizon, Amoore argues, is that of the possible future to manage and control. In the world of healthcare in which biomedical imaging technologies are made to operate, the logic is that of prediction and probabilistic thinking. In a post-Newtonian world dominated by entangled objects at the subatomic level, phenomena are not necessarily connected by a cause–effect relationship. Although the visual has long been considered the domain of algorithms and interfaces, the interest now is increasingly focused also on haptic and entangled forms of relations between humans and algorithms.[40]

To conclude, whether within the world of software design, risk management or biomedical data visualization, the Cartesian grid is one of the computational devices giving shape to this world in which uncertainty is framed against a coordinate system of constants and variables in space and time. We interact with the world by means of the interface which gives us the boundaries of the world. Now, thanks to electronic technology, we are a variable in the system we interact with. The interface becomes extended in an area beyond that which is graspable by our sensorial apparatus. Although we might feel able to break out of the time and space constraints of the Cartesian coordinate system, the grid is still the underlying structure of every interface we interact with, including the image-data of our brains and bodies. The grid has the power to associate and transform data that, taken individually, might not have any intrinsic meaning. The grid is the backbone used to first structure one specific type of looking in atomic physics and then another one in medical prediction

and intervention. Both types of looking are lined up upon the same data. A different action, though, aligns this second type of looking and the purpose for which it will be used. While the first action is aimed at turning data into information that can be visualized by the radiologist, the second is aimed at introducing the categories of risk and probability within the diagnostic reading. Uncovering this double action, as I have attempted to do in this chapter, is the first move toward a better understanding of patients' *lives in the grid*.

Notes

1 Phillip Thurtle, *Biology in the Grid: Graphic Design and the Envisioning of Life*, Minneapolis: University of Minnesota Press, 2018.
2 Horst Bredekamp, Vera Dünkel and Birgit Schneider (eds.), *The Technical Image. A History of Styles in Scientific Imagery*, Chicago/London: The University of Chicago Press, 2015.
3 Anne Friedberg, *The Virtual Window: From Alberti to Microsoft*, Cambridge, MA: MIT Press, 2006, p. 40.
4 Rosalind Krauss, "Grids", *October* 9, 1979, pp. 50–64.
5 James Elkins, *Six Stories from the End of Representation*, Stanford: Stanford University Press, 2008, p. 66.
6 The idea of this system was developed in 1637 by Descartes. In part two of his Discourse on Method, Descartes introduces the idea of specifying the position of a point or object on a surface, using two intersecting axes as measuring guides. René Descartes, Discourse on Method, Optics, Geometry, and Meteorology. Trans. Paul J. Olscamp. (Indianapolis, IN: Hackett Pub, 2001).
7 On the passage from the anatomical to the atomized body, see Max Liljefors, Susan S. Lundin and Andrea Wiszmeg (eds.), *The Atomized Body: The Cultural Life of Stem Cells, Genes and Neurons*, Lund: Nordic Academic Press, 2012.
8 Peter Galison, *Image and Logic. A Material Culture of Microphysics*, Chicago: The University of Chicago Press, 1997.
9 Donald W. McRobbie, Elizabeth A. Moore, Martin J. Graves and Martin R. Prince, *MRI: From Picture to Proton*, Cambridge: Cambridge University Press, 2003.
10 In T1 the magnetization occurs in the same direction as the static magnetic field; in T2 the magnetization is transverse to the static magnetic field.
11 Amit Prasad, *Imperial Technoscience: Transnational Histories of MRI in the United States, Britain, and India*, Cambridge, MA: The MIT Press, 2014, p. 13.
12 Paul Lauterbur, "MRI: A New Way of Seeing", *Nature* 242, 1973, pp. 190–191.
13 Prasad, op. cit., p. 5.
14 Jim Hutchinson, William A. Edelstein and Glyn Johnson, "A Whole-Body NMR Imaging Machine", *Journal of Physics E: Scientific Instruments* 13 (9), 1980, p. 947.
15 Funded by EU Horizon 2020 program, the IDentIFY project engages research partners across Europe led by Aberdeen University and aims at improving diagnosis with FFC-MRI. See www.identify-project.eu/
16 On FFC-MRI see David J. Lurie et al., "Fast Field-Cycling Magnetic Resonance Imaging," Comptes Rendus Physique 11 2(2010), 136–148.
17 MR signal is detected in quadrature. Each digitized data point of the MR signal can be represented as a complex number, with real and imaginary components. Alternatively, each data point can be defined as having a magnitude and phase, computed by simple trigonometric relations.
18 Allen D. Elster and Jonathan M.D. Burdette, *Questions and Answers in Magnetic Resonance Imaging*, Chicago/London: Mosby, 2000.
19 Amit Prasad, "Making Images/Making Bodies: Visibilizing and Disciplining through Magnetic Resonance Imaging (MRI)", *Science, Technology, and Human Values* 30 (2), 2005, pp. 291–316.
20 Ibid., p. 292.

21 Katherine N. Hayles, *Unthought: The Power of the Cognitive Nonconscious*, Chicago: Chicago University Press, 2017, p. 141.

22 Jonathan Sawday, *The Body Emblazoned: Dissection and the Human Body in Renaissance Culture*, London/New York: Routledge, 1996.

23 Catherine Walby, *The Visible Human Project. Informatic Bodies and Posthuman Medicine*, New York/London: Routledge, 2000.

24 Marta Braun, *Picturing Time: The Work of Etienne-Jules Marey*, Chicago: University of Chicago Press, 1992.

25 Krauss, op. cit., p. 52.

26 Cornelius Borck, "Vital Brains: On the Entanglement of Media, Minds, and Models", in T. Mahfoud, S. McLean and N. Rose (eds.), *Vital Models. The Making and Use of Models in the Brain Sciences* (Progress in Brain Research Book 233), 2017, 1–24, p. 3. https://www.sciencedirect.com/bookseries/progress-in-brain-research/vol/233/suppl/C

27 Anne Beaulieu, "A Space for Measuring Mind and Brain: Interdisciplinarity and Digital Tools in the Development of Brain Mapping and Functional Imaging, 1980–1990", *Brain and Cognition* 49, 2002, pp. 13–33.

28 William J. Mitchell, *The Reconfigured Eye: Visual Truth in the Post-photographic Era*, Cambridge, MA: The MIT Press, 1992.

29 Sarah de Rijcke and Anne Beaulieu, "Brain Scans and Visual Knowing at the Intersection of Atlases and Databases", in C. Coopmans, J. Vertesi, M. Lynch and S. Woolgar (eds.), *Representation in Scientific Practice Revisited*, Cambridge, MA: The MIT Press, 2014, pp. 138–139.

30 Ibid., p. 139.

31 Galit Shmueli, "To Explain or to Predict?", *Statistical Science* 25 (3), 2010, p. 291.

32 Sander Gilman, *Illness and Image: Case Studies in the Medical Humanities*, New Brunswick/London: Routledge, 2014.

33 Karen-Sue Taussig, Klaus Hoeyer and Stefan Helmreich, "The Anthropology of Potentiality in Biomedicine. An Introduction to Supplement 7", *Current Anthropology* 54 (7), 2013, pp. 3–14.

34 Nikolas Rose, *The Politics of Life Itself. Biomedicine, Power, and Subjectivity in the Twentieth-First Century*, Princeton: Princeton University Press, 2007.

35 Louise Amoore, *The Politics of Possibility: Risk and Security. Beyond Probability*, Durham: Duke University Press, 2013, p. 7.

36 Ibid., p. 9.

37 Ibid., p. 50.

38 Babette Regierer, Valeria Zazzu, Ralph Sudbrak, Alexander Kühn and Hans Lehrach, "Future of Medicine: Models in Predictive Diagnostics and Personalized Medicine", *Advances in Biochemical Engineering/Biotechnology* 133, 2013, pp. 15–33.

39 Amoore, op. cit., p. 139.

40 For an examination of the aesthetics and politics of the interface, see Alexander L. Galloway, *The Interface Effect*, London: Polity Press, 2012.

16 Reference and Affect

Abstraction in Computation and the Neurosciences[1]

Michael Reinsborough

Twenty-first-century computational neuroscience and psychoanalysis have two very different ways of representing the mental life of the subject, each with its own merits and limitations. This chapter performs a superimposition of Peircean semiotics onto André Green's model of unconscious representation. The idea of reference in Charles Sanders Peirce (distinct from representation) can be better understood in light of how affect emerges from the unconscious according to Green. The mental representation, according to Greene, is accompanied by a quantum of affect. From this I construct a theory of reference: the role of affect within mental representation is what we can describe as the "feeling" of reference. While this is primarily a contribution to linguistics or semiotic theory, it could also be used to think about how the sciences consider their objects of knowledge—in this case the mental life of the subject. Perhaps the most relevant example is the application of neuroscience to computing and in particular "affective computing", the computational recognition of human emotion. I therefore begin with a brief description of the neurosciences.

Interest in the brain and neurological functions of the body has a long history. In the 1890s the aesthetic skill and early staining and microscopy techniques of Santiago Ramón y Cajal enabled him to make the first hand-drawn pictures of the long, extended cells that we now call "neurons". The physician Sigmund Freud originally hoped to make a careful materialist study of the object (if we take that object to be the brain/neurological body) of the mental life. Indeed, he initially published on the topic of neurology and his early models of the unconscious were conceived as a type of neural stimulus/memory model of the mental life of the subject.[2] Perhaps because the mechanism of the mental life was simply too complicated to know with the methods of the 1890s, he developed instead a method of asking the subject about their mental life, what I will call a more subjectivist method. Advances in psychology were achieved by Freud's new method, which came to be known as psychoanalysis. Freud continued to identify this as a scientific method. Later psychology also developed what could be described as a more objectivist framework of knowledge—basing knowledge on a more traditional type of controlled experimental method. Throughout the 20th century the objectivist tradition, with its strict materialist interest in the neurological basis of mental life, continued the gradual accumulation of knowledge, leading to the interdisciplinary establishment of the neurosciences.[3] What would now be thought of as several different traditions of considering the mental life of the subject can trace part of their origin story through the heady mixture of ideas and experiments in the cauldron of the 1890s when, in some important ways, they were not differentiated (Figure 16.1a).

a

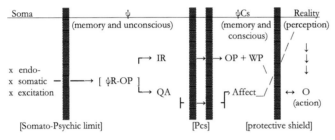

ψR = psychical representative of the drive
IR = ideational representative
QA = quantum of affect
OP = thing or object presentation
WP = word presentation
O = object

The three zones of transition are the Somato-Psychic limit (ψUcs), the barrier of the Preconscious (Pcs), and the protective shield (PS). These separate the four territories (soma, unconscious, conscious, and reality)

b

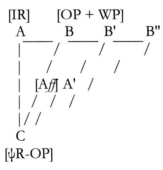

c

Figure 16.1 (a) Differentiation trajectories of traditions considering the mental life of the subject; (b) André Green's schema of unconscious representation; (c) reference derived from representation using the logical forms of representation—iconic, symbolic, indexical; illustrations: courtesy of M. Reinsborough.

The leading edge of contemporary neuroscience seeks to model brain structure, function and activity using computational systems. More recent research investments include large-scale projects for computational neuroscience such as the Human Brain Project. This EU initiative uses several different computational platforms to map brain structure and model brain activity. This in turn creates innovation in computer science which benefits from the attempt to emulate brain activity. Ever since Cajal saw and drew the first pictures of a neuron in the 1890s, scientists have tried to understand the electrical properties of our constantly changing brains. In 1952 the Hodgkin–Huxley nonlinear differential equation to describe relations of charge and exchange (sodium–potassium ion gradient) at the synaptic cleft between the neurons was discovered in a patch clamp study of the giant squid. The changing relationship between neurons has been simplified as "What fires together wires together".[4] This neural plasticity allows the brain to strengthen links that acknowledge patterns in its environment.

This same principle is emulated when building neuromorphic computer chips—chips that mimic the decentralized memory and unusual firing patterns of the brain. Since much energy loss in computing happens between the memory storage location and the central processor, a decentralized structure of memory stored in/near the relationships of firing patterns that do simple calculations can be more energy efficient and crucial for supercomputers. This efficiency is like a video graphics card that performs calculations and stores memory away from the central processing unit of a computer.

The 86 billion neurons within the human skull utilize 20 watts of power (up to a thousand trillion synaptic interconnections) and can solve complex problems like movement or recognizing a face. In comparison an exascale supercomputer (probably the size of a football field, requiring the equivalent of a small coal-fired power station to run) would be necessary to simulate this amount of neuronal interconnection.[5] Most visual or other pattern matching tasks (such as those necessary for moving in an environment) quite simple for a person are beyond the ken of advanced computing and robotics.

Our smartphones now guide us to our destination using mapping algorithms and speech recognition software. Brain-inspired machines are expected to have numerous applications (in robotics, surveillance, self-driving cars, knowing what consumers want and potentially medical informatics). But they won't make motivated decisions that take into account embodied existence in an immediate environment (as any simple-minded rodent can do). The science fiction imagination of AI (the so-called strong AI) is either not possible or a long way off.

16.1 Affective Computing

In most discussions of artificial intelligence, it is the cognitive capacities of computers that are at the forefront. However, the increasing sophistication and greater uptake of intelligent calculation machines raise another key issue, which concerns the affective dimension of the relation between humans and such machines. The recognition of emotions is an important part of human-to-human communication, providing the context and sometimes the content of communications. Even when we do not know the precise feelings of another, we often estimate or impute a sentiment and respond accordingly. As computers come to have a greater capacity to provide information to humans in an interactive and situationally responsive way, it is likely that we will judge these interactions by the standard of our human interactions. *Affective computing* is

the ability of computers to recognize human emotions and thus to be able to respond more appropriately.[6]

Charles Darwin was one of the earliest writers to suggest that we might be able to classify emotions scientifically.[7] But it is only more recently that science has attempted to classify and categorize these distinct bodily expressions and therefore also make them measurable. In 1978, Paul Ekman published the Facial Action Coding System (FACS), which is used to describe how faces express emotions through muscle movements.[8] The development of computer systems that can visually recognize these movements and then classify them according to the FACS has been a strong driver of further investigation in affective computing. Facial micro-expressions, brief muscle movements that indicate an emotion sometimes too quickly for another human to see, can be discerned by more sophisticated facial recognition systems.[9]

The growing literature in the 1990s around the physio-psychological FACS system encouraged the development of affective computing. As two researchers explain,

> [E]motion detection in general and FACS in particular each lends itself naturally to the field of pattern recognition research that has a rich literature and a wide scope of techniques from the simple template-matching to multilayered neural nets and scores of classifiers, all of which gave researchers in computational emotions the basis to start developing emotion detection systems.[10]

Research interest then extended to many more potential modes of affective computing such as the analysis of speech, video, text and images and other forms of physiological responses such as electrodermal measurements of arousal linked to the sympathetic nervous system.

Affective computing typically relies on collecting some type of physiological data from the user. There are various modalities for the analysis of the emotional content of interaction.[11] The user's emotion can then be classified using some theory of how emotions express themselves physiologically. There are various theories of this, and how precisely to classify emotions is still a matter of debate. The physiological data could be as varied as the sound of the voice, a visual image of the face or the galvanic response measured from the skin. Even word semantics or how the user physically interacts (smoothly or agitatedly) with the keyboard, touch screen and mouse are being investigated for recognizable patterns of emotion.

Regardless of computing power, advances in algorithm development or the use of ever smaller wearable devices more efficient at measuring response, the validity of affective computing will, in some ways, still have to do with the theories that are used to correlate physiological indexes with their emotion explanation. A brief review reveals affective computing researchers have been building their affective models from psychology theorists, including Millenson's 3-Dimensional Scale of Emotional Intensity (1967), in the lineage of Watson (1930) with a behaviorist model; Scherer (2005) with the Geneva Emotion Wheel—valence and control—or the Circumplex Model—valence and arousal wheel adapting Russell (1980) in the lineage of Wundt (1903); Watson et al. (1999) with the PANA model—quite similar to the Circumplex; Ekman (1967); Damasio (1996); Plutchik (1980); and Pörn (1986).[12] Many measurement systems use a two-dimensional arousal and valence scale. Sometimes a third category, "dominance", is also used to express the strength of the emotion, or in some categorizations, "control", how much control the person expressing the emotion feels

with regard to an event, is a variable paired with valence as in this emotion wheel (Figure 16.2).

Beyond identifying emotion, some types of affective computing hope to respond to the user with an appropriate emotion. When a computer does this, it simulates the outward signs of an emotion rather than having the emotion itself. Thus, it is simulating the expression of an emotion (providing expected emotional aspects in message communication) rather than feeling the emotion.[13] Nonetheless, this may lead the human interactor to mistakenly impute an internal world to the computer—or robot—and this may have consequences for future interactions.

Finally, it is worth noting that, under the label of "affective computing", a small subset of researchers are examining the role of emotional memory in cognition. By linking an emotional valence to aspects of a cognitive representation (possibly through the hypothalamus), an organism has an advantage in understanding its environment through its past experience of similar situations. Specifically, emotional memory records a situation in reference to the conative goals of the organism. By modeling in robots this emotional memory representation of conative goals, these affective computing researchers might be said to be going beyond mere surface simulation of an emotion, at least to the extent that one understands the "feeling" of an emotion as the expression of conative goals (for examples see Gokcay and Yildirim).[14] In some ways this is similar to the idea that a mental representation of an object is accompanied by a quantum of affect.

Figure 16.2 The Geneva Emotion Wheel. Illustration done by M. Reinsborough according to Klaus R. Scherer, "What Are Emotions and How Can They Be Measured?", *Social Science Information* 44 (4) 2005, pp. 469–729; illustration: courtesy of M. Reinsborough.

16.2 Reference and Affect

The difference between reference and representation is an elusive but useful distinction to think about how it is that we come to know what an object, or indeed anything in our lifeworld, is and how it is that we have some interpretive connection to a thing. Our knowledge of the object is always "situated knowledge"; to know a thing is also to have some affinity to it, to be in relation to it.[15]

I will be grafting Peircean semiotics onto André Green's model of unconscious representation. It is particularly the idea of reference in Peirce that I am interested in reinterpreting, in light of how affect emerges from the unconscious according to Green. Peirce defines a sign, or *representamen*, as "Anything which determines something else (its interpretant) to refer back to an object to which itself refers (its object) in the same way, the interpretant becoming a sign, and so on ad infinitum".[16] Thus for Peirce we might say that a reference is the illusive relation between an interpretant (or subsequently the interpretant's interpretant) and the original object. This line of reference can never be studied directly but instead can only be intuited from the logical relations of representation. These relations of how a sign can represent its object (for example, as an icon, symbol or index, etc.) are the subject of Peirce's philosophy of logic and especially the portion of his philosophy dedicated to semiotics. I will return to this idea of what a reference means within Peirce's system after introducing the work of Green.

André Green has been publishing in the field of psychoanalysis for fifty years. *Key Ideas for a Contemporary Psychoanalysis: Misrecognition and Recognition of the Unconscious* (2005) is an excellent survey of contemporary psychoanalysis and a sort of Rosetta Stone for reuniting what had seemed (especially for the non-analyst) like an increasingly diffuse, splintered and contradictory field.[17] The failure of the original subject-oriented approach (Freud, Strachey) to adequately account for the effects of an external object of affection upon the subject (Klein) leads to departures from the early theoretical framework.[18] Some insights were left behind in the quest for new explanatory powers. However, Green has now re-inscribed the original and differing directions within one another by using a subject line/object line continuum approach (or theory of complementary series). This sensibility of inclusion and translation reunites the many insights of what had been a fragmenting discipline and opens the way for a major contemporary renewal of theory.

Because of the breadth of peripheral topics that psychoanalysis touches upon *Key Ideas* could be mistaken for an exercise in interdisciplinarity. However, Green, writing for the practicing analyst, makes the first section of the book a nuanced discussion on practice. Readers unfamiliar with the field will have some difficulty. Nevertheless, the description of analytic listening is instructive even for those without the advantage of an apprenticeship in psychoanalysis. The analysis is rooted in a dialogical couple, where the patient speaks as much as possible in free association and the analyst listens with "benevolent neutrality". Discernable in free association are hesitations of speech and discontinuities of narrative logic, which indicate the unconscious organization of the patient's psyche. "Transference" is the situation where learned patterns of attitude toward a previous listener (for example, the patient's primary caregiver in childhood, subsequent romantic relationships, etc.) are adopted toward the analyst. The representation of external reality within the psychical mechanisms of the person forms a type of internal reality. It is toward the correlation of external and internal reality (which

is, to some extent, shaped by the learned influence of previous dialogical relationships) that the psychoanalytic process directs the patient.

Theoretical frameworks for psychoanalysis do finally show up in the second half of the book but chiefly in such a way as to inform a practicing analyst. Again, the primary achievement of the book is to provide a common platform from which the insights of both object relations theory (Klein, Bion, Guntrip, Fairburn, Winnicott) and the more traditional subject-oriented approach (Freud, Strachey) can be united.[19] Jacques Lacan's premise that the unconscious is structured like a language (important for structuralism) is refuted by Green. The method of psychoanalysis, "speech delivered lying down to a hidden addressee", creates psychoanalytic discourse.[20] Psychoanalytic discourse is, according to Green, "the result of the transformation of the psychical apparatus into a language apparatus".[21] From the unusual character of dreams this transformation process was first intimated.[22] In the illogic of dreams, certain wish fulfillment phantasies of the unconscious are discernable despite being reinterpreted to protect the conscious from the disorganized "primary processes" of the unconscious. Primary processes relate drive activity to the memory traces of previous relations with the external world. For example, an infant that is hungry cries (seeking to end unpleasure) and creates a relationship with an object in its environment that is either fulfilling or unfulfilling. The memory of this is laid down in the unconscious.

> The system unconscious is made up of representations which exclude the sphere of word presentations, or of ideas and judgments representing reality (material). Representations and affects are governed by the characteristics […] (1) absence of negation and contradiction; (2) absence of doubt or degree in certitude; (3) ignorance of the passage of time; (4) mobility of the intensity of cathexes; (5) prevalence of mechanisms of condensation and displacement, together defining the primary processes. On the other hand, all these characteristics, qualified negatively here, are present and make it possible to recognize the secondary process.[23]

Because primary processes relate directly to memories of pleasure/unpleasure rather than the material reality facing the individual at any given moment, and because of the potential intensity or mobility of these emotional memories (cathexes), primary processes are not suitable for an organism that must engage with external reality or perish. Thus secondary processes are used to translate the system that is unconscious to a consciousness that engages with reality. Language is found here, in the region of consciousness.

One of the themes that Green delivers in the book is the importance of the original drives that motivate a living organism. The first topography (1900) of the psyche (a sort of virtual diagram distinguishing unconscious and preconscious from conscious space, primarily from secondary processes) was updated (1920, 1923) with a set of conceptual structures that take specific roles in relation to the psyche (id, ego, superego).[24] While the first and second topography are not incompatible, Green is keen to note the differing conception of the ego and the role of the drives in the second topography or structural model. The id (rooted in the somatic level of the body) is a function of the drives, whereas the ego attempts to be a form of coherency that can relate the drives to reality. But note the ego has both conscious and unconscious aspects.[25] Thus the function of mediation between the drives and external reality is not solely

the remit of conscious thought. Affect also now has a greater role in the explanation of psychical phenomena.

According to Green, "one could conceive of the entire psyche as an intermediate structure between soma and thinking".[26] This intermediate structure correlating internal and external reality is the subject of Green's schema of unconscious representation. Green's figure 9.1 is reproduced here as Figure 16.1b.[27] The internal reality is a function of the psychical representative of the drives (ψR) plus the internal presentation (that is, memory traces derived from a previous interaction) of the object (OP), whereas the external reality consists of the action of the subject in relation to an external object. We might think of a linguistic statement in the form of subject–predicate where the predicate includes the object in relation to which action is taken. What can we say about this linguistic statement (WP) by situating it within Green's model of unconscious representation?

From the unconscious, according to Green's schema, the combined psychical representative of the drive and internal presentation of the object (ψR-OP) splits into both an ideational representative (IR) and a quantum of affect (QA). The ideational representative is a set of memory traces of an object outside the psyche. Traditionally representation (memory traces) and affect (discharge of excitation) have always been seen as distinct. Because affect is discharged it cannot remain as a representation. But Green introduces the idea of residual quantum of affect. It is easy to conceive of an affective memory. If affective discharge can itself be remembered (leaving memory traces), it can itself have a relation to representation. Thus in the consciousness when the "thing presentation (OP)" (previously the ideational representative) is associated with the word presentation, affect, as a representation, is also available for association (OP + WP/A*ff.*). Green writes, "if one takes into account the product of the division of the psychical representative [of the drive] into ideational representative and affect representative, it is not illegitimate to see in affect a derived form of the instinctual representative".[28] Between the external reality (perception-action taken in relation to an object) and the internal reality (ψR-OP) lies any linguistic statement. For the purpose of consideration let the statement be in the form subject–predicate (inclusive of the object). If ψR is a significant referent for the statement (WP) then the affect presentation (A*ff*) forms a more direct link than does the thing presentation (OP) via the ideational representative. Recent science has intimated that affective memory is an important aspect for successful intuitive associations.[29]

16.3 The Unconscious Representation and Semiotic Theory of Reference

I would like to now set Peirce's triadic theory of the sign upon this schema. We can differentiate representation from reference by noting the logical forms of representation (iconic, symbolic, indexical, etc.) that allow one sign to represent another. Thus, in triangle 1 (see Figure 16.1c), A determines interpretant B to refer back to object C to which it itself refers. The logical set of relations AB and AC are forms of representation describable by logical semiotic principles; i.e., A represents C to B because it has the shape or is visually similar to C (iconic sign). B is also a sign because it can represent C to B′ perhaps because it is also iconic or perhaps because it is a symbol (representation by rule or convention, such as a word which by convention refers to such and such a thing). Whereas the relation BC, or through subsequent signification B′C or B″C, is only

formally describable through the AB–AC relation (add BB′–BC and B′B″-B′C for subsequent signification). BC, B′C and B″C are forms of reference. Semiotic logic has no way of directly representing them, but intuitively we know they are meaningful.

Using Green's schema of unconscious representation, Peirce's theory of reference can be thought of as two triads: thing combination presentation/word presentation (B/B′) links back to the ideational representative (A) (because thing presentation OP is the *representamen* interpreted by word presentation WP); and via affect OP + WP (B/B′ thought of as a combined single interpretant) also links to the original psychical representative of the drive C. Thus affect is a more direct link to the drive or at least another link and a qualifying link. Both triads can be considered independently as representation (neither as reference), but, *comparatively*, affect "refers" the word presentation (an interpretant determined by the sign) to the original drive "referent" to which the sign (thing presentation or ideational representative) itself refers (C = ψR-OP). The line of reference BC or, for the linguist, B′C can be thought of as passing through the affect presentation (A*ff*). Thus reference can be thought of as affective and uncanny. I am suggesting that affect, rather mundanely, represents reference (Figure 16.1c).

One potential advantage of this, for the linguist, is an operational definition for "reference": affect presentation (A*ff*) is also a sign A′ which determines interpretant OP + WP (B/B′) to refer to the referent ψR-OP (C). The relations A′[B + B′]–A′C are in this case determinable by the semiotic principles of representation, although admittedly the principles specific to this particular situation are unknown. These relations A′[B + B′]–A′C (determined using the affect presentation) could serve as an operational definition of linguistic reference BC, B′C of the original triad in which the word presentation was considered in the traditional linguistic manner (through an ideational representative and without any consideration of affect). If so, linguistics would require semiotic rules particular to understanding affective representation as well as methods to "see" the affect presentation in action.

In addition to methodological gaps it seems to me there may also be moral gaps in such a project. For whose purposes would the scientific objectification of affect through linguistic study be suited? This is to say, if "linguistic knowledge" is thought of as word presentation (WP) associated through an object presentation with a particular ideational representative, what might the affect presentation for this particular word presentation tell us about the ψR of ψR-OP in an increasingly commercialized knowledge economy? Or, as Nietzsche might ask, whose will animates the form and purpose of this apparently neutral knowledge?[30] Unlike advertising or governance applications, at least psychoanalysis, for whatever its other occasional moral failings, is clear about for what use the affective knowledge is to be put: providing interpretations within a dialogical relationship that might better enable the analysand (by their own will and on timing of their own choosing) to correlate internal and external realities. We begin to appreciate the virtue of a very disciplinary approach to psychoanalytic knowledge.

Regarding the utility of knowledge, the ending discussion of science (linguistics, in particular) has a resonance with a particular theme of Green's book announced in the subtitle: "misrecognition and recognition of the unconscious". The third and final section situates psychoanalysis in relation to the knowledge claims of several other disciplines. Green considers both philosophy and the sciences, of which biology (particularly neuroscience) and anthropology seem to be the most relevant. A host of intriguing references are provided, a few of which I will reproduce for those interested

in pursuing further the various directions here initiated: in mathematics, concerning salience and prégnance, René Thom; in law, Peirre Legendre; in complexity theory, Edgar Morin; in psychoanalysis/neurobiology, suggesting a possible brain topology of psychoanalytic functions, K. Kaplan and M. Solms; in neurobiology, a theory of primary and secondary emotions, J. Panksepp; in neurobiology, a theory of the selection of neuronal groups, G. Edelman; in anthropology, Godelier, Jullierat, and Héritier; and in linguistics, for his defense of Spinoza's "affect-concept", Meschonic.[31]

Most remarkably, the long claim of psychoanalysis to the status of a "scientific" discipline has been left aside by Green in favor of a greater disciplinary self-confidence in psychoanalysis' own particular epistemological contribution:

> Scientific knowledge is not knowledge about objective reality but only knowledge of that which lends to treatment by the scientific method, in contradistinction to knowledge of the psyche which has to account both for that which is treatable by the scientific method and that which is not.[32]

Green goes on to note the particular way in which certain partisans of scientific method have minimized or misrecognized the human unconscious, "Wittgenstein for his part lent support to the critique of the unconscious with his theory of logical positivism. One could not 'explain' what language referred to; one could only say what things looked like through its bewitching effects".[33] From this history we might take caution. Linguistics in particular has held a leading role in building an "objective" science, free from the disturbances of the affect.

> The human sciences were keen to show that they had emerged once and for all from a childhood and laid claim to the respectability belonging to objective knowledge, in the image of the exact sciences. Hence the interest of recognizing linguistics as a pilot science; for, as phonology showed, it knew how to rise to a level devoid of subjectivity, while flourishing in the sphere of what is significant.[34]

This review does not present a critical reading of Green.[35] I have myself added only a small overlay to the extensive work of Green (who himself writes on the shoulders of a century of psychoanalytic investigators, himself among them for half that time). The overlay adds little for psychoanalysis, but for semiotics or linguistics it offers an insight into how we might conceive of reference or even how we think about what we do.[36]

If we wish to construct an iconology of abstraction in the sciences (laws or the description of how images in the sciences represent or attempt to represent their object), then this theory of reference points to the role of the affective, which in science seems underacknowledged. By contextualizing how the brain might see an object in relation to a situated, embodied affect, we can begin to write a theory of reference for objects and compare this to computational strategies in neuroscience. The role of emotion theories in affective computing (what types of emotions, how and why do they occur) or the modeling of brain visual circuits on a computer could be productive starting points. The concept of affective memory from psychoanalyst André Green's schema of unconscious representation (here translated into the semiotic terms of Charles Sanders Peirce to generate an interpretation of Peirce's theory of reference) could be used to explore how affective memory may weigh into cognition, vision, visual abstraction, the presentation of evidence and, more generally, the culture and visuality of science.

Notes

1 Different parts of this writing appeared previously in an earlier form: *Future Computing and Robotics: A Report from the HBP Foresight Lab* (Christine Aicardi, Michael Reinsborough, Nikolas Rose, 2016, deliverable 12.1.3 under FLAG-ERA project award 604102); "The quest for brain-like machines" newsletter 2015–2016 winter issue, Scientists for Global Responsibility; "Reference and Affect" (Université de Reims Champagne-Ardenne, France: Res Per Nomen 3, Conference Publication, 2011).

2 Elizabeth Wilson, *Psychosomatic: Feminism and the Neurological Body*. Durham: Duke University Press, 2004.

3 Nikolas Rose, *The Politics of Life Itself*, Princeton: Princeton University Press, 2007.

4 Donald Hebb, *The Organization of Behaviour*, New York: John Wiley & Sons, 1949; Carla J. Shatz, "The Developing Brain", *Scientific American* 267 (3), September 1992, pp. 60–67.

5 An exaflop is a billion billion floating point calculations per second, a thousand-fold increase in the performance of the first petascale computer developed in 2008.

6 Rosalyn Picard, *Affective Computing*, Boston: MIT Press, 1997.

7 Charles Darwin, *The Expression of the Emotions in Man and Animals*, London: John Murray,1872. Other writers in the 19th century had also considered this issue, for example, Sir Charles Bell, *The Anatomy and Philosophy of Expression*, London: John Murray 1824. Henry James suggested that some emotions have "distinct bodily expression" and thus opened up the possibility of physiological measurement. Henry James, "What Is an emotion?" *Mind* 9, 1884, pp. 188–205.

8 Available at www.paulekman.com/product-category/facs/ [accessed November 2, 2019].

9 In some cases, these cues to what another human is feeling might be more readable by a machine observer than a human observer. See P. Ekman and W. Friesen, "Nonverbal Leakage and Clues to Deception", *Psychiatry* 32, 1969, pp. 88–97; P. Ekman, "Lie Catching in Microexpressions", in Clancy Martin (ed.), *The Philosophy of Deception*, Oxford: Oxford University Press, 2009, pp. 118–133.

10 A. Ayesh and W. Blewit, "Models for Computational Emotions from Psychological Theories Using Type I Fuzzy Logic", *Cognitive Computation* 7 (3), June 2015, pp. 285–308.

11 Speech acoustic properties such as pitch, intonation, loudness or speaking rate and voice quality can be combined to estimate the emotional content. Body gesture recognition focuses on finding body alignment patterns of movement that indicate some emotional state, perhaps agitation, enthusiasm or being tired. By using a Facial Action Encoding System, developed by Ekman, muscle movements in the face can be categorized and learned by a computer with a camera and a visual recognition system. Slightly more intrusively, facial electromyography measures the muscle movement in the face. Electroencephalography (EEG) measures electrical patterns in the cortex, which can sometimes be correlated to emotions. Normally EEG is not thought to provide a good indication of the activity of the lower part of the brain, which some theorists associate with certain types of affect. Galvanic skin response can be used to measure arousal. The changing electrical properties of the skin are thought to be closely associated with the sympathetic nervous system (which, for example, in situations of extreme arousal, is associated with the so-called fight-or-flight response). Other physiological measures influenced by emotions include heart rate, breathing, blood pressure, perspiration or muscle contractions. Affective computing methods are normally accomplished by initially correlating physiological measurement with some judgement of the actual emotion (perhaps self-reported). When intense emotions are correlated with physiological measurement values, these can be used to predict affect in computing scenarios [G. Stemmler, "Introduction: Autonomic Psychophysiology", in Davidson, Scherer, and Goldsmith (eds.), *Handbook of Affective Sciences*, New York, NY: Oxford University Press, 2003, pp. 131–134; J. Schwark, "Toward a Taxonomy of Affective Computing", *International Journal of Human-Computer Interaction* 31 (11), 2015, pp. 761–768]. Algorithms are developed that the developers can then test against more examples where it is thought that the actual emotion is known. Often training sets of data are used to train an algorithm to recognize particular emotions.

12 J.R. Millenson, *The Psychology of Emotion: Theories of Emotion Perspective*, 4th ed., Hoboken: Wiley, 1967; J. Watson, *Behaviorism, Revised edition*, Chicago: Chicago University Press, 1930; K.R. Scherer, "What Are Emotions and How Can They Be Measured?", *Social Science Information* 44 (4), 2005, pp. 469–729; J. Russell, "A Circumplex Model of Affect", *Journal of Personality and Social Psychology* 39, 1980, pp. 1161–1178; W. Wundt, *Naturwissenschaft Und Psychologie*, Leipzig: W. Engelmann, 1903; D. Watson, D. Wiese, J. Vaidya, and A. Tellegen, "The Two General Activation Systems of Affect: Structural Findings, Evolutionary Considerations, and Psychobiological Evidence", *Journal of Personality and Social Psychology* 76 (5), 1999, pp. 820–838; P. Ekman and W. Friesen, "Head and Body Cues in the Judgement of Emotion: A Reformulation", *Perceptual and Motor Skills* 24, 1967, pp. 711–724; A. Damasio, "The Somatic Marker Hypothesis and Possible Functions of the Prefrontal Cortex", *Philosophical Transactions of the Royal Society of London. Series B, Biological Sciences* 351, 1996, pp. 1413–1420; R. Plutchik, *Emotion: A Psychoevolutionary Synthesis*, New York, NY: Harper & Row, 1980; L. Pörn, "On the Nature of Emotions", *Changing Positions, Philosophical Studies* 38, 1986, pp. 205–214.

13 Rosalind Picard, "Affective Computing: Challenges", *International Journal of Human-Computer Studies* 59, 2003, pp. 55–64; J. Schwark, "Toward a Taxonomy".

14 D. Gokcay and G. Yildirim (eds.), *Affective Computing and Interaction: Psychological, Cognitive and Neuroscientific Perspectives*, Hershey, PA: IGI Global, 2011.

15 Donna Haraway, "Situated Knowledges: The Science Question in Feminism and the Privilege of Partial Perspective", in ibid., *Simians, Cyborgs, and Women: The Reinvention of Nature*, New York: Routledge, 1991, pp. 183–201.

16 Charles Sanders Peirce, "Elements of Logic", in C. Hartshorne and P. Weiss (ed.), *Collected Papers of Charles Sanders Peirce, Volume 2*, Cambridge: Harvard University Press, 1931.

17 André Green, *Key Ideas for a Contemporary Psychoanalysis: Misrecognition and Recognition of the Unconscious*, trans. Andrew Weller, London/New York: Routledge, 2005.

18 Sigmund Freud, *Mourning and Melancholia*, Collected Works S.E. X1V, 1917, p. 237; S. Freud, *Beyond the Pleasure Principle*, Collected Works S.E. XVIII, 1920, p. 7; S. Freud, *The Ego and the Id*, Collected Works S.E. XIX, 1923, pp. 3–66; J. Strachey, "The Nature of the Therapeutic Action of Psychoanalysis", *International Journal of Psychoanalysis* 15, 1932, pp. 127–159; Melanie Klein, *The Psychoanalysis of Children*, London: Hogarth, 1932; M. Klein, "Envy and Gratitude", in *Envy and Gratitude and Other Works 1946–63*, London: Hogarth, 1975 (1957).

19 Klein, *The Psychoanalysis of Children*; Klein, *Envy and Gratitude*; W. Bion, *Learning from Experience*, London: Heinemann, 1962; W. Bion, *Elements of Psychoanalysis*, London: Heinemann, 1963; W. Bion, *Second Thoughts*, London: Heinemann, 1967; H. Guntrip, *Personality Structure and Human Interaction: The Developing Synthesis of Psychodynamic Theory*, New York: International University Press, 1961; W.R.D. Fairburn, *Psychoanalytic Studies in Personality*, London: Routledge, 1952; D. Winnicott, *Collected Papers: Through Pediatrics to Psychoanalysis*, London: Tavistock, 1958; Freud, "The Ego and the Id".

20 Green, *Key Ideas*, p. 205.

21 Ibid.

22 S. Freud, *The Interpretation of Dreams*, Collected Works S.E. IV and V, 1900, pp. 1–621.

23 Green, op. cit., p. 99.

24 Freud, *The Interpretation of Dreams*; Freud, *Pleasure Principle*; Freud, *The Ego and the Id*.

25 Acknowledging the majority unconscious aspect of the ego allows the therapist to consider problems that do not arise out of the instinctual drives but instead are a dysfunction of ego. Ego is defined functionally as relating drives to reality.

26 Green, op. cit., p. 128.

27 Ibid., p. 129.

28 Ibid., p. 130.

29 A. Bechara and H. Damasio, "Deciding Advantageously before Knowing the Advantageous Strategy", *Science* 275, 1997, pp. 1293–1295.

30 For commentary on Nietzsche's critique of sciences, see Gilles Deleuze, *Nietzsche and Philosophy*, London/New York: Continuum, 1983, pp. 68–70. For Green's comment on a psychoanalytic response to questions of utility, see Green, *Key Ideas*, p. 286.

31 R. Thom, "Saillance et Prégnance.", in R. Dorey (ed.), *L'inconscient et la Science*, Paris: Dunod, 1991, pp. 64–82; Peirre Legendre, *Jour du Pouvoir*, Paris: Editions de Minuit, 1981; E. Morin, *Introduction à la penseé complexe*, Paris: ESF Editions, 1950; E. Morin, *La Méthode, vol. 5 L'humanité de l'humanité*, Paris: Le Seuil, 2001; K. Kaplan and M. Solms, *Clinical Studies in Neuro-Psychoanalysis*, London: Karnac, 2000; J. Panksepp, "Emotion as Viewed by Psychoanalysis and Neuroscience: An Exercise in Consilience", *Neuropsychoanalysis* 1 (1), 1999, pp. 5–15; G. Edelman, *Bright Air, Brilliant Fire. On the Matter of the Mind*, New York: Basic Books, 1992; M. Godelier and M. Panoff, *La Production du corps. Approches anthropologiques et historiques and Le Corps humain, supplicié, possédé, cannibalisé*, Amsterdam: Archives Contemporaines, 1998; F. Héritier, "Inceste et substance", in F. Héretier (ed.), *Incestes*, Paris: Gallimard, 2001; B. Jullierat, *Penser l'imaginaire. Essai d'anthropologie psychanalytique*, Lausanne: Payot, 2001; H. Meschonic, *Spinoza. Poème de la* pensée, Paris: Maisonneuve and Larose, 2002.

32 Green, op. cit., pp. 282–283, 290.

33 Ibid., p. 290.

34 Ibid., p. 291.

35 If forced to write in this direction one might start with examining to what extent that the psyche Green describes can be considered historically, to what extent Green's smooth and admittedly attentive language liberates/fails to liberate analytic theory from particular formulations (Oedipal narrative, death drive), accused in the past of being ideological or even reifying particular narratives about the reactionary possibilities of human nature. Green's debate with anthropologists about the universality of a prohibition of parricide makes one wonder how far Green is prepared to universalize a narrow body of psychoanalytic research knowledge gathered in only one particular (industrialized) portion of world during one particular century. The issue of the psyche's historical relation to economic exchange [G. Deleuze and F. Guattari, *Anti-Oedipus: Capitalism & Schizophrenia, Vol. 1*. Trans. Robert Hurley, Mark Seem and Helen R. Lane, London: Athlone, 1984] does not seem to be considered anywhere in the book. One wonders whether Green saw past Deleuze and Guattari's at times awkward anti-establishment language and their propensity to celebrate a world universally and permanently populated with "partial" objects (such as what circulate in the psyche of an infant). Thus while ethics (analyst/patient) are prominent in Green's writing, the role of institutional ethics and the historical imbrications of methods/theories of subjectification into existing power relations are unaddressed. Perhaps for a book intended as a practical reference for practicing analysts, this is an understandable omission.

36 Questions of utility regarding "what" we do might best be considered in a continuum "what/why/for whom" (ψR).

17 Reality Effect of (Abstract) Maps in the Post-digital Era

Ana Peraica

Contemporary unmanned images, although having realistic effects, are in the tradition of abstraction of modern art, which itself was influenced by a type of abstraction made not by the natural vision, but rather a reduced perception. Their precursors were aerial images, which, not having been an ordinary thing to the eye of that time, produced an effect of the abstract. Bird angle view, introduced in the visual culture since the Neolithic times, developed as yet another mathematical possibility of perspective construction already in Renaissance, strongly influencing cartography.[1] With early flight testings in the 18th century, the aerial view developed further.[2] The invention of photography led to its implementation in military mapping, introducing abstract vision of the reality itself by reducing it. Aerial photographs were so abstract that Gertrude Stein concluded that aerial view influenced the rise of abstraction in painting in general.[3] Kracauer also noted: "The ornament resembles aerial photographs of landscapes and cities in that it does not emerge out of the interior of the given conditions, but rather appears above them".[4] Suprematist artists were fascinated by a new dimension, so Kazimir Malevich gave a speech on aerial view, while Wassily Kandinsky painted the Red Square in Moscow from above without ever experiencing that view in real. Still, a hundred years later, after the process of abstraction of reality passed, yet another, although reverse process, is initiated—of the realistic effect of abstraction itself.

Contrasting the realistic versus the abstract field, a short movie *Impressions of the Old Marseille Harbour* [Impressionen vom alten marseiller Hafen, 1929] by László Moholy-Nagy can be seen as a paradigm of a divided universe of the early digital era, which in the post-digital times merges and loses its strict definitions. Still, contrary to the superimposition of maps and aerial images, in which an aerial view finds its way through the hole on a map, contemporary techniques merge once strongly separated photographic and cartographic technologies in such a way that it is impossible to distinguish them anymore. New aerial data, produced by unmanned devices (drone and satellite imagery), are now merging with maps, leading to the process in which photography, as we knew it, disappears. This chapter analyzes the level of abstraction in aerial photography and photography-related media like films, by referring to the accepted division between a landscape and a map. By showing how modernists were abstracting the reality, based on the case of László Moholy-Nagy's film (Figure 17.1), this text focuses on the opposite transition present in the post-digital photography: from the abstraction of reality to the reality effect in abstraction.

Contrary to painting, it is quite hard to point to the first abstract photograph, although it may be anticipated that such a photograph was neither a micro or macro photograph, but may rather be one that used common photographic tools for the

Figure 17.1 László Moholy-Nagy, *Impressions of the Old Marseille Harbor*, 1929, frames from
the motion picture (work in public domain).

abstraction of reality: exposure, aperture and framing. Thus, elements of the photographic abstraction can already be found in early photographic pieces.[5] But yet another process of abstraction occurred within the medium of photography: with each technological invention that enforced human vision as prosthesis, the image was less and less real and more abstract as it contained information beyond the human view-range. Such possibilities have expanded even more since the digital age. Finally, with complete loss of control of the image-recording process, the realism of the image was replaced by a mere "reality effect", turning out to be a simple code by which only humans can perceive images recorded by machines and transferred among them.

17.1 Post-digital Photography

Limited wideness of the human field of vision, lack of overall sharpness and the incapacity to provide a total image along with the details pointed to the weakness of the human perception in comparison to that of technology. Today machines are not only focusing, calculating and measuring, but also suggesting the points of the image junction in order to produce a complex photographic visualization. The machine vision leads a human, pointing where to shoot. Even the end results are not analyzed by humans anymore, but rather by programmed intelligence agents, having perfected concentration to patterns and errors in details. Images are not even made for humans but rather for another machine that will process them. Photographic tools today can self-interpret themselves by simultaneous image comparison, overlaying, overlapping and cross-fading. They can also learn by that process and compete in it independently of human acts.

We now live in an era of automated photography of "machines for machines", in which the photographer is no longer a guarantor of the truthfulness of the representation. Finally, a new type of vision has become a networked one, so that CCTV networks and satellite networks share images shot in the ways humans could never position themselves and directly transmit the images, beyond the reach of the (human) vision. Unmanned photography, or photography without humans, is thus slowly becoming a fully nonhuman one.[6] By enhancing the vision, the new type of photography shifts from the modality of vision to the technology of visualization.[7] The type of photographic image today belongs to what we may call "a longer aesthetics", with a long-lasting purpose of musealization, and thus becoming merely functional and purpose related.

It is not only photography, but all human representations that are becoming temporary, or what Martha Jecu names "catalytic" and "trajectory". From the miniaturization of camera, its prosthetic enhancing of the eye, automatization of its functions and unmanned recording to the recordings out of the capacity of human vision, our relationship to the reality has changed and continues to morph even further. Our reception of the reality, once closely tied to our field of vision and physical reality, is replaced by not only automated or semi-automated photo-like artifacts, visible in funny corrupted artifacts (glitches) and lags, but also images that are fully separated from our reception of reality, as an autonomously generated photography.

This new reception of the actual reality is shifting from a traditional meaning, in which the photographic medium employed as an ontological device of recording (and storing) reality, producing a nonsensical archive, is transformed into an epistemic tool in which it functions as a mere medium of transmission. Today photography does record, but it does not necessarily represent the reality, or it represents

indistinguishably the physical with the generated reality. Still, with the photography resembling the world in a traditional sense, our relationship to it remains epistemic, and with resources changing occasionally—even deluding.

17.2 Split Among Two Representations of Reality

The difference between a direct vision of reality and the visualization of it used to be clear in the split among traditional genres that represent our physical reality in completely different ways: landscape and a map, which depict the reality in completely different ways—as a representation and an abstraction.[8] Geography as science was initiated already in Antiquity, in works by Ptolemy and Strabo. Ptolemy is usually seen as the founder of cartography, for the use of maps in his *Geographies*, while Strabo is considered the father of the landscape. In the times of Antiquity, there was a strict division among two types of space representation: a map was taken as "a construction of that world. A landscape is the way of seeing the world".[9] Or, one was quantitative, while the other qualitative; one was employed as a tool in geography, whereas the other as an aesthetic object of topography; finally, one has found its way into archives, the other into museums.

The symbolic relation of mapping to reality, still, was more often taken as more accurate than the approximate vision of landscape paintings, made upon observation and memory, as the vision contained a gaze of the subject limiting the perspective. For that reason (the medium quantifies its own existence), it is the landscape that is necessarily a medium, as W.J.T. Mitchell claims, as it represents only a way of seeing, thus containing some epistemic qualities, not the reality itself.[10] Map, on the other hand, is closely tied to reality, from which it abstracts. Moreover, the place on the map is believed to necessarily exist (even the so-called pirate maps, or the one on Thomas More's *Utopia* claims so). Still, according to Clare Reddleman, maps can also be forged on various levels: scale, projection and symbolization.[11] Monmonier here goes into detail explaining how it is possible to lie with maps.[12] Thus, Cosgrove's claim that both the landscape and a map can be true and false, in terms of being accurate or inaccurate, objective or subjective, can be taken as a common ground.[13]

The difference between the landscape and a map may be grounded in the difference between the two types of geometry employed: Euclidian and Cartesian. The first one does not have a general concept of space, but it is rather case related, located as the *precise place*, while the other presumes an *endless space*. The first one refers to the image space while the other to the real space. In the first, the viewer is set outside the definition of the space, defining his or her own view to the scene, while in the latter he or she is necessary inside the spatial description of what is defined as reality. One form of calculus has led to the invention of camera obscura and photography, while the other to the invention of panorama and stereoscopy.

Still, since the invention of both photography and flight, the division between visualization and vision has lessened, making technologically produced landscapes look like their perfect representations. Aerial photography soon has become an even more advanced form of mapping than maps ever were, although it contained the error of the human perspective. A ground difference between maps and aerial photographic imaging is in the positioning of the subject's, thus relative, view. Even when technically recorded, the landscape is a product of Euclidian geometry, subjective view, while a map provides a simultaneous, Cartesian, non-subjective polycentric view of the location. An aerial photograph thus informs on the subjectivity, while a map eradicates

subjects and also any objects that are not immanent to the site.[14] In cartography, the viewer's angle is not visible and the viewpoint is evenly distributed, while in aerial photography, previous to its correction in orthophoto, it is distinguishable. Thus, one can be seen as subjective while the other as objective or absolute space. Still by elimination of the subject-positioning in aerial imaging, the private view is erased too, making an originally photographic image its own abstraction.

17.3 Abstract Vision of Photography

The invention of aerial photography led to its implementation in military mapping, introducing an abstract vision of the reality itself. Modern art preferred new tools of visualization rather than direct imaging, exploited by landscape artists in the previous century. Artists of the 20th century were interested in the aerial view since the beginning.[15] Also, at this early stage of the aero industry, many famous photographers joined the aerial forces, Edward Steichen being one of them.[16] Aerial photographs were so abstract that Gertrude Stein concluded that the aerial view influenced the rise of abstraction in painting in general.[17] Kracauer also noted similarly: "The ornament resembles aerial photographs of landscapes and cities in that it does not emerge out of the interior of the given conditions, but rather appears above them".[18]

Indeed, many authors, fascinated by the idea of flight and aeronautics, have introduced an aerial-like imaging, which they have defined in various ways: Suprematism, Constructivism and Futurism. Suprematists were especially fascinated by the new dimension; for instance, Kazimir Malevich spoke on the aerial view. He described it fully as a system of lines representing streets and rectangles being houses, while dots were passengers.[19] Wassily Kandinsky painted the *Red Square from above* (1916), a painting said to be painted in a collapsing perspective as if he was standing in the middle of the square. Other modern artists, for example, László Moholy-Nagy, also experimented with the bird's view (Nágy, 1932).

Nagy is also one of the earliest representatives of what we name today "cartographic cinema".[20] In the beginning shots of the film *Impressions of the Old Marseille Harbour* (1929), Nagy displays a paper map of the old harbor of Marseille, in order to release a live image behind it. The first shot is aerial, while the succeeding shots are recorded from the street angle wide views and close-ups, depicting different places of the harbor, from the seashore itself down to the small dirty street. Throughout the film, aerial shots are superimposed on the ones from the street level, contrasting corrected and purified abstract vision from an approximate angular bird's view.[21] Nagy exits out of the detail into an aerial view, contrasting them not only in antipodes of the private versus objective story but also in the realistic versus abstract field. The aerial view here contributes to the modernistic, geometric layout, especially at places where the camera focuses on the construction systems of building supports and bridges. At certain moments, the film camera monitors local population in upper view close-ups from the window. Nagy also employs aerial shots in his *Dynamics of Metropolis* (1921–1922), which is full of different cinematic devices such as split screens, image overlaps and other abstracting methods.[22] The view Nagy offered can be correlated to the Google packet of "the earth experience", from the Google Street map, ending not only in 360 degree views of Google Street but also with aerial images offered by Google Earth. Still, contrary to the filmic sequence in the movie, in these projects, maps and aerial views are overlaid and merged.

17.4 Aerial Images and Maps

In order to produce a map out of the aerial image, a sequential and planar nature of perspectival, i.e., Euclidian, space had to be denied by denying the perspectival appearance, in which aerial imaging arises mainly from the spherical shape of the Earth, which makes all records unsharp in border areas, i.e., producing a vignette. Still, a correction of the error marked what Reddleman names "a view from nowhere". There are two ways by which a photographic image can be abstracted into an absolute, non-subjective one: an assemblage method of image conjunction and image stretching method.

The assemblage as a method or, more specifically, photomontage, has been introduced to photography early, at the beginning of the 19th century, in order to correct the technical errors of the medium.[23] Ever since, artists have deliberately assembled materials that were not photographic at all.[24] Different methods in the construction of an assemblage were researched by modernist authors: collage, bricollage, photomontage and others. Among the technical methods that merge maps and landscapes, the most frequently used are panoramic images, orthophotos, photomaps and hypermaps. Panoramic images are shots recorded in a serial or a sequence with its borders overlapped. Orthophoto images are also a sort of assembled image recorded in a series and are corrected by the orthophoto method. When a photographic layout is added to a map, it becomes a photomap, while hypermaps are maps that have a photographic shot included as a sequence.

A specific photographic illusion comes from merging photographic images, as in a photographic assemblage or photomontage, featuring multiple perspectives, not necessarily having the relationship and panoramic images featuring a sequence of perspectives. Such images have many vanishing points and can, as other polycentric images or serials, produce dizziness. Moreover, such images make the position of the viewer hardly definable, thus converting the specific place described by the conventional photography into a generally conceived space. Latour notes: "By looking at the satellite image we extract ourselves from our particular point of view, yet without, bouncing up to the bird's eye view; we have no access to the divine view, the view from nowhere".[25] Such a view may be describes best the posthuman view, a view liberated of any interpretation of cartography, of any human view at all, not only the ones from far outside the planet of the Apollo's mission, but also of every malicious intention of Panopticon or actively targeted view of the drone. "The view from nowhere is a highly abstract viewpoint and is the signature view—point of modern cartography", Reddleman noted.[26]

17.5 In the Assembled World

The idea of assemblage in theory has been implemented by Deleuze[27] and succeeded by Saskia Sassen and Manuel de Landa,[28] although not being a theory directly relying on the art historical use of the concept (as in collage, photomontage, montage, bricollage, etc.), but rather a relativist social organization of the space. This theory may be useful in order to understand the difference between the original absolute space and the assembled total space of the post-digital era.[29] De Landa gives the following definition of totality, as produced by the assemblage functions and by distinguishing the unity from totality:

> We believe only in totalities that are peripheral. And if we discover such a totality alongside various separate parts, it is a whole of these particular parts but does not totalize them; it is a unity of all these parts but does not unify them; rather it is added to them as a new part fabricated separately.[30]

The new total space is not integral, but computed from sections. One assemblage can be included in the other, forming a micro and macro assemblage according to de Landa, or molecular and molar according to Deleuze and Guattari.

Deleuze and Guattari define the abstract machine in this way: "The abstract machine is like the diagram of an assemblage. It draws lines of continuous variation, while the concrete assemblage treats variables and organized their highly diverse relations as a function of those lines".[31] In post-digital photography, such images are automatically merged in computational photographs. Social theories of assemblage, especially in terms of territorialization and deterritorialization of the assemblage, have found their practical implementation in the analysis of the hybrid geographies that merge maps with photographs, as in Google Earth. Here deterritorialization and territorialization refer to the degree of reality indexing. A type of such image development is Google Earth, which introduces remote imaging from the satellite, but can easily shift to Google Maps, which includes geospatial mapping, having parts of it reconstructed by the machine. Such abstractions today are not anymore conducted by humans but by AI machines that calculate and fuse a large set of images in order to produce a map-like imaging of the reality, or to code it the way humans actually see.

17.6 Google Earth Project

Google Earth, as the synthetic view, relies on images from the satellites of NASA, USGS's Landsat 8 and previously Landsat 7, as various aerial images and crowd-sourced GIS mapping platforms such as Panoramio used to be, which contained millions of geotagged photographs, partially used in the early days of Google Earth. Satellite records are capacitated to focus as close as 15 centimeters above the Earth's surface. Missing parts are algorithmically generated with an intuitive Graphical User Interface. Still, the whole Earth is not simultaneously uploaded but can have, according to Google, up to three years of update period, for parts of the representation of the Earth are not synchronous with other ones. The diachronic appearance of this map is enhanced by its "historical imagery" option, showing before–after options. Thus, while offering a total image, it is actually being completely sliced timewise.

The new genre, being neither a photograph nor a map, came to its final form when Google Earth merged with the Google Street project, integrated since 2008, bringing more than a realistic effect to the map and more mapping layout of the photographic record. Combining the Google Earth project, organized around satellite imagery, with the Google Street project, which was by then strictly cartographic, has led to the creation of a unified service. Separately, there used to be some differences between the two projects: the Google Earth project allowed sliding aside the orthogonal view for about 5 degrees, maintaining the shadows fixed, while Google Street allowed traveling through streets, with an immersive 360 degree view. Today, Google Maps combines

flattened abstract street organization not only with Google Earth satellite images but also with users' photographs. Today the same location is covered by satellites, Google Car, photographs, all maintained by an abstract system, all at once. Anna Munster sees in it a "revenge" of the map and territory: "the skeletal, deterritorialized image of the link-node network".[32]

Photographs included in Google projects serve to introduce the reality effect into maps, which are themselves abstract. At the same time, a new generation of fully emancipated places—such as virtual places—are expanding our perception of the real space, changing its (also spatial) meanings. Moreover, parts of images are generated. What we used to name photographs is negotiated with an abstract machine merging them with maps into complex assemblages.

Although reminding us of the idea of absolute space, the contemporary space represented in maps is hardly integral. It rather produces a calculated combination of different perceptions, ones of humans and of machines, producing a poly-perspectivalism of the modernist assemblage, or maybe even medieval dis-perspectivalism, that is unified only by the idea. Bird thus concludes:

> So it is not a coincidence that these images, which record elaborations and disruptions in the infrastructure of a city, also evince ruptures in its image. These images are sewn together by the machinery of Google Earth from multiple satellite images taken at different times.[33]

17.7 Where is That Old Harbor of Marseille Today?

Now, let's undertake an experiment of traveling to the same place from above, with Google Earth. Contrary to old versions, using the metaphor of the spheric planet as a navigation bar, a new version of Google Earth offers a mapped version of the place, which can be searched by the geotag, or the name-place. The first place provided when searching for Marseille is a flat map of the city, a corrected orthophoto map, containing also some non-photographic elements as political divisions and texts. It is possible to move closer to the Old port of Marseille, now having a quite similar shape to the one represented in Nágy's film. Going even more closer, it is possible to dive into a pixelated version of an image of boats, now having a certain abstraction element of the Impressionism. There are few levels of abstraction present: a realistic map, a close aerial shot and a macro detail with glitch effect, all distorting our knowledge of reality (Figure 17.2).

Inherited distinction between the landscape and a map is no longer functionable as the two genres are merging in the contemporary post-digital era, producing hybrids such as realistic maps and mapped photographs. These two hybrids, besides gaining much with their fusion, also loose in realism of the original landscape. Today the distinction between the map and the landscape has almost completely vanished. Landscapes are mapped by GPS, while maps are added with realistic photographic appearance. The landscape seems abstract while maps have fully photographic layouts. The crucial difference between the aerial landscape and the map falls in the visibility of the point from where the viewer observes the area. In watching a landscape, including an aerial one, there are always engaged traveling eyes—on a condition that the perspective, Cyclopean eye or (photographic) technology, describing the site and

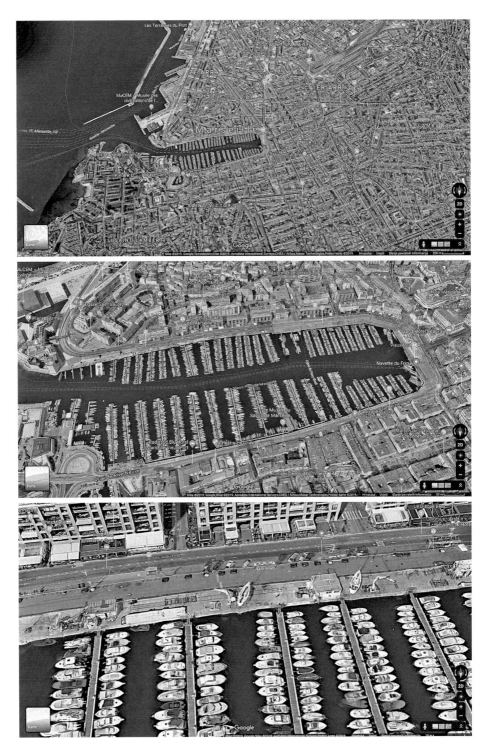

Figure 17.2 Images of the old Marseille harbor, taken with Google Earth Service on Sunday, September the 20th, 2019; photo: courtesy of Ana Peraica.

its position can be reconstructed—contrary to the position of the map drawer, which seems to be distributed everywhere on the map. The reason for this distinction is that the landscape anticipates the private view of the viewer, while a map imagines a movement through territory, which can start at virtually anywhere within the territory. A map, thus, was only a vehicle, a parable of the reality, while the landscape served to duplicate it. This, highly codified view still cannot be completely reduced to cartography. Namely, in painting and photography, it is the world in motion that is depicted, a world without purification and reduction of information.

17.8 Conclusion

Photographs included in Google projects serve to introduce the reality effect into maps, which are abstract. At the same time, a new generation of fully "emancipated places", such as virtual places, are expanding our perception of the real space to many overlapping visualizations; in many digitally virtualized situations, the real places may level the loose parts of their naturally apprehended meanings by replacing them with the technically constructed augmented realities. Augmented realities may take place even when we are supposed to be able to make a distinction between the natural and technical reality, a phenomenon we may grasp in artworks by Clement Valla's postcards, for example. Thus photographs are becoming abstract too, as they are negotiated by an abstract machine merging them.

But do machines see that way? A recent project by Valla shows that they don't.[34] A machine's error is the result of the impossibility of understanding purposes as well as the orthophoto merging. Thus, besides the orthophoto method of merging photographs, there are parts that are, in classic photographic terms, being retouched, sometimes not successfully enough. Still, that this synthetism is not fully indexical is shown by the work of Valla, in which the artist is compiling the errors of Google machines trying to merge different shots, almost as defined by Keller Easterling, who speaks of the disruptions, dissensus and discrepancies of the space structures.[35] Usually not understanding the concept of the road, rail and bridge in terms of transport and speed of driving, Google's machines have managed to morph the transportation routes by melting them down, to be more in accordance with the landscape, somehow behaving more human to nature than humans actually are. Still, although reminding us of its size and clarity of the Baroque idea of absolute space, our contemporary space—which is also visible in Valla's project—is hardly integral and continuous. It is rather a calculated combination of different perceptions, humans and machines, combined without discrimination, producing a poly-perspectivalism of the modernist assemblage, or maybe even the medieval dis-perspectivalism, that is unified only by the idea. Bird thus concludes,

> it is not a coincidence that these images, which record elaborations and disruptions in the infrastructure of a city, also evince ruptures in its image. These images are sewn together by the machinery of the Google Earth from multiple images taken at different time.[36]

The difference between a map and an aerial image vanishes, as in the movie of Nágy, which can be seen as a paradigmatic travel from the map to the view, from the abstract to the concrete and real. Still, whereas the map in his movie served to provide precise

information on the place, in contemporary photography, map is inscribed in every image. In contemporary image technology, the place is represented by coordinates (GPS, satellite, etc.), while space is freed of its obligation to represent anything at all. Most of the photographically based images of reality today carry its placeable data (in EXIF files), whereas networked images are directly imputed into a hybrid geography of satellite tracing. Google Maps and other mapping systems are realizing our spaces of imagination into a concrete, unique and, in a way, obligatory place (see also Yahoo Maps, OpenStreetMap, and Bing Live Map). Triangulation, aerial photography and space imaging have led cartography far from the ground into an emancipated visualization space.[37] While modernist aerial photography has introduced abstraction in painting, it seems that the contemporary post-photographic tools have introduced abstraction in the photographic medium.

Notes

1 Cf. J.B. Harley and David Woodward, *The History of Cartography: Cartography in Prehistoric, Ancient and Medieval Europe and the Mediterranean*, Vol. 1, Chicago: The University of Chicago Press, 1987.
2 Cf. Marc Dorrian, and Frederic Poussin (eds.), *Seeing from Above: The Aerial View in Visual Culture*, London: I.B. Tauris, 2013.
3 Hillel Schwartz, *Culture of the Copy*, New York: Zone Books, 2014.
4 Siegfried Kracauer, *Mass Ornament*, translation and introduction: Thomas Y. Levin. Cambridge/London: Harvard University Press, 1995, p. 77.
5 John Beck and David Cunningham, "Introduction: Photography and Abstraction", *Photographie* 9 (2), 2016, pp. 129–133. doi: 10.1080/17540763.2016.1181971
6 Cf. Joanna Zylinska, *Nonhuman Photography*, Cambridge, MA: The MIT Press, 2017.
7 Cf. Martha Jecu, *Architecture and the Virtual*, Chicago: The University of Chicago Press, 2016.
8 Cf. Denis Cosgrove, *Apollo's Eye, A Cartographic Genealogy of the Earth in Western Imagination*, Baltimore, MA: John Hopkins University Press, 2001; Denis Cosgrove, *Geography and Vision: Seeing, Imagining and Representing the World*, London: IB Tauris, 2008.
9 Denis Cosgrove, *Social Formation and Symbolic Landscape*, Madison: University of Wisconsin Press, 1988 (1984), p. 13. Cf. also W.J.T. Mitchell, *Landscape and Power*, Chicago: The University of Chicago Press, 2002.
10 Cf. Mitchell, op. cit.
11 Cf. Claire Reddleman, *Cartographic Abstraction in Contemporary Art*, London/New York: Routledge, 2018.
12 Cf. Mark Monmonier, *How to Lie with Maps*, Chicago: The University of Chicago Press, 1991.
13 Cf. Cosgrove, *Social Formation and Symbolic Landscape*, op. cit.
14 Ibid., p. 161.
15 Cf. Dorrian and Poussin, *Seeing from Above*, op. cit.
16 Allan Sekula, "The Instrumental Image". Few artists also participated in World War II. One of the most intriguing acts of the artwork was that of Joseph Beuys, a pilot during World War II, who survived a plane crash in Tatar country, where he was rescued by shamans who rubbed him with fat, wrapped him in blankets, both of which he later used as parts of his art installations. Still later, letters that were found indicate that the event did not take place. www.spiegel.de/international/germany/new-letter-debunks-myths-about-german-artist-joseph-beuys-a-910642.html
17 Schwartz, op. cit., 2014, p. 158.
18 Kracauer, *Mass Ornament*, op. cit., p. 77.
19 See his Analytical Chart No. 16 (1927), in which he directly refers to Suprematism as to the idea of flying. Ten out of seven images represent flight. See: Christina Lodder,

"Transfiguring Reality: Suprematism and the Aerial View", in Marc Dorrian and Frederic Poussin (eds.), *Seeing from Above*, op. cit. See also: Kazimir Malevich, *The Non-Objective World*, Chicago: Paul Theobald, 1956 (1927). Art has certainly got used to this view quite early. Modernists Kazimir Malevich and Wassily Kandinsky, among others, have been fascinated with the abstract insight offered by aerial views. Malevich directly referred to the importance of the aerial view in his lecture in Warsaw in 1927. His opera *Victory over the Sun* (1913) directly refers to aerial power. Lodder concluded that four of the thirty-nine works at the *0,10 The Last Futurist Show* (1915) referred to the fourth dimension, while *Analytical Chart No. 16* refers to Suprematism as directly connected to flight and flying.

20 Cf. Tom Conley, *Cartographic Cinema*, Minneapolis: University of Minnesota Press, 2007.

21 László Moholy-Nagy, *Impressions of the Old Marseille Harbour*, available at www.youtube.com/watch?v=-gzEKwuh3ok

22 www.youtube.com/watch?v=FhrMGj73-eg. Apparently its scenario was used by Leander Kruizinga, Vincent Bonefaas and Daniël Oliveira Prinsand to make an animation movie (2002). www.youtube.com/watch?v=hfQiMXKfZCo

23 Cf. Dawn Ades, *Photomontage*, London: Thames and Hudson, 1986.

24 Cf. William Chapin Selz, *The Art of Assemblage*, New York: MoMA, 1961.

25 Bruno Latour and Emilie Hermant, "Paris: Invisible City", 1998, p. 17. Available at www.bruno-latour.fr/sites/default/files/downloads/viii_paris-city-gb.pdf

26 Reddleman, *Cartographic Abstraction in Contemporary Art*, op. cit., p. 35.

27 Cf. Gilles Deleuze and Felix Guattari, *Thousand Plateaus: Capitalism and Schizophrenia*, Minneapolis: University of Minnesota Press, 1987.

28 Cf. Saskia Sassen, *Territory, Authority, Rights: From Medieval to Global Assemblages*, Princeton, NJ: Princeton University Press, 2006; Manuel de Landa, *Assemblage Theory*, Edinburgh: Edinburgh University Press, 2016.

29 Deleuze and Guattari analyze the assemblage in the territorial, statist, capitalist and nomadic layers, as well as their amalgams, in a constant change of predicate logic functions. De Landa furthermore defines parts of the assemblage as coded, arbitrary and variable, contrary to stratum. See also Thomas Nail, "What Is an Assemblage?", *SubStance* 46 (1), 2017 (Issue 142), pp. 21–37.

30 de Landa, *Assemblage Theory*, op. cit., p. 19.

31 Deleuze and Guattari, *Thousand Plateaus*, op. cit., p. 121.

32 Ana Munster, *An Aesthesia of Networks: Conjunctive Experience in Art and Technology*, Cambridge, MA: MIT Press, 2013, p. 51. This type of non-figurative images Claire Reddleman names as "cartographic abstraction". Cf. Reddleman, *Cartographic Abstraction*, op. cit., 2018.

33 Lawrence Bird, "Territories of the Image: Disposition and Disorientation in Google Earth", in Steve Hawley, Edward Clift, and Kevin O'Brien (eds.), *Imaging the City: Art, Creative Practices and Media Speculations*, Chicago: The University of Chicago Press, 2016, pp. 11–31.

34 See also Jessica Becking's "Clement Valla's Postcards from Google Earth", *Media Theory* 2/1, July 2018, pp. 307–315.

35 Cf. Keller Easterling, *Extrastatecraft: The Power of Infrastructure Space*, London: Verso, 2016.

36 Lawrence Bird, "Territories of the Image", op. cit., p. 19.

37 Cf. Antonin Moore and Igor Dretksy, *Geospatial Visualisation*, Berlin: Springer, 2013.

18 Coda

Visualizing the End of Visibility: M87* Event-Horizon Image

Yanai Toister

The night sky is the one feature of our environment that has been shared, revered and marveled by all cultures throughout history. The shimmering stars have been described by some indigenous cultures as "ancestors" and have elsewhere been thought to embody our past, our future or our deities. Throughout the centuries, we have repeatedly turned to those celestial objects to navigate the planet, seek spiritual guidance and corroborate our theories and we continue to do so with a never-diminishing incredulity, coupled with new and scientifically substantiated awe.

Present in all these long-lasting functions of the firmament are two fundamental activities. The first, common to virtually all human traditions, is observation: applying our sense of vision to admire the heavens and, consequently, make inferences and judgments about our place in the cosmos. It is thus not surprising that from Plato onwards, Western philosophy, and later science—to name one tradition that has come to dominate the planet—has consistently acclaimed vision as the ultimate human sense, practically indistinguishable from thinking and even knowing, as captured by such common phrases as "to see the light". It may therefore be said that whereas human bodies have only ventured as far as the moon, human vision (and foresight) has always ventured beyond our solar system, with little to stop them in the foreseeable future.

The second activity, shared by most cultures, is using our sight for celestial observations, enhancing our nightly experiences and, perhaps most commonly, creating durable representations of them—by permanent inscriptions, drawings and images of celestial objects. Human civilization owes much of its splendor and inspiration to these ubiquitous endeavors: from the Stone Circles of Orkney to the Nabatean city of Petra, from the Greek Constellation Wine Cup to the Mayan Calendars, to the less spectacular but omnipresent Southern Cross on national flags and the multiple suns, moons and stellar constellations on uniforms, badges and logos.

As one cannot hope to capture all such representations in one text, I focus here on a particular, contemporary image: a round black disk encircled by a reddish doughnut-like ring, itself emerging from and dissolving softly into a black void locked within the hard rectangular borders of its frame. Somewhat reminiscent of an after-hours Robert Delaunay flamboyance (Figure 18.1), the image, released in April 2019, has been stimulating our collective imagination since. It is the first-ever direct observational image of a black hole, with its accretion disk and event horizon—in this case, the supermassive black hole[1] that lies at the center of the huge Messier 87 galaxy (M87* in astronomese), in the Virgo cluster, 55 million lightyears from Earth. In deciphering this image, I will argue that pictorial language and image history are inseparable (Figure 18.2 up). The twilit interface between our terrestrial existence and this fantastic, but nonetheless real,

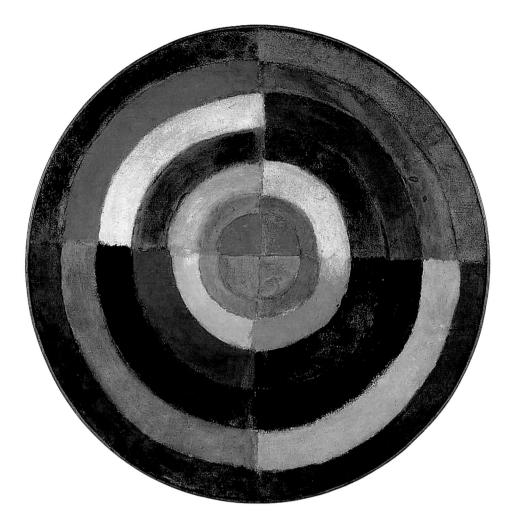

Figure 18.1 Robert Delaunay, *Le Premier Disque*, 1913, oil on canvas, 134 × 134 cm (work in public domain).

astronomical discovery will be explored here to understand—and problematize—our utopian yearnings for abstraction. The glare adorning the black hole—hitherto a theoretical construct—will shed the light of doubt on a long-lasting cultural trope.

The idea of a body so massive that nothing can escape its gravity was briefly proposed in 1784 by English astronomical pioneer and clergyman John Michell. Black holes, as these bodies are now referred to, became mainstream research objects starting from the 1960s, during what is known as "the golden age of general relativity". Oddly enough for our predominantly visual culture, throughout the decades since, astrophysicists have studied black holes and made astonishing discoveries about them without actually possessing any direct observational evidence of their existence. This is but one significance of the recent image.

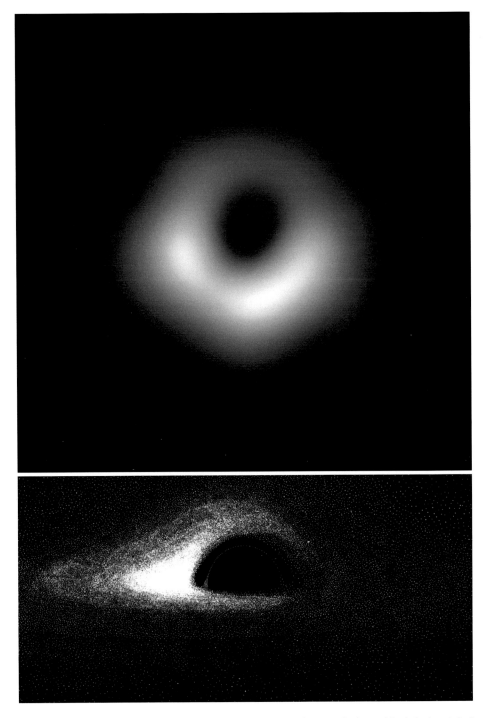

Figure 18.2 (Down) Jean-Pierre Luminet, computer simulation of what a black hole might look like, 1978 (work in public domain); (up) The Event Horizon Telescope image of the core of Messier 87—black hole—using 1.3 mm radio waves. Source: European Southern Observatory (eso 1907a). Reproduced under terms: CC BY 4.0.

Black holes are the most extreme objects in the universe. They are massive bodies that come into being out of various momentous circumstances: the death of stars, the gravitational collapse of huge amounts of gas in the early universe or the high-energy collisions between two or more celestial objects (the latter situation may also result in the expansion of an existing black hole). Their masses may be so great as to shackle entire galaxies into their orbit. Astonishingly, however, despite their gargantuan mass and its far-reaching impact, black holes are relatively small and even the biggest of them could fit snugly within our solar system.

Black holes are not only massive, but also voracious: they constantly suck in matter and energy—including light, hence their epithet. At their very center, these cosmological nutrients collapse into a condensed region of practically infinite density called "singularity", of which we know very little. Outside of Hollywood films, by definition, no human astronomer, physicist or photographer has ever ventured into this heart of darkness, of which everything we know is theoretical, everything is pure abstraction.[2] In fact, from our distant perspective, black holes are completely featureless. The only properties they exhibit to the wider cosmos are their mass, charge and angular momentum (the latter two may be zero).[3] Two black holes that share these properties would be virtually indistinguishable from the outside and even the chemical composition of anything that has been gobbled into them would have become irrelevant. This result is whimsically known as the "no-hair theorem". As with some hats, so too with every black hole: whatever has gone into the interior, whatever may be still going on under the cover, no incriminating evidence sticks out. This theorem therefore poses challenging conundrums: Do black holes actually "forget" their past or does it make any sense to talk of black holes having any past, or any temporal progression at all? Do they somehow "remember" their cosmological childhood in ways we do not know yet? Is there a celestial palimpsest, a proverbial Rosetta Stone, that can provide indirect evidence thereof? If black holes actually "delete" their autobiography after collapsing into themselves, much of what we know about information may need to be relearned. For all our observations, this remains nature's most closely guarded secret.[4]

Whenever mass gets packed into a gravitational singularity, surprising things occur around its edges. Gas, dust and other stellar debris that has come perilously close to the hole but not quite fallen into it form a flattened band of spinning matter called the accretion disk. Although no one has ever actually seen a black hole directly—and as we have seen, only one indirect piece of visual evidence exists—this disk can be seen glowing brightly. Because of the black hole's huge gravity, the particles being yanked by it are accelerated to tremendous speeds and heated to millions of degrees as they smash into each other, discharging heat into the universe as well as powerful X- and gamma rays. These accretion disks are also known as "quasars" (quasi-stellar radio sources). Quasars are the oldest known bodies in the universe and, with the exception of gamma ray bursts, they are the most distant as well brightest and most massive celestial objects we can see, outshining trillions of stars. A quasar is then a bright halo of matter surrounding and being drawn into a black hole, effectively feeding it with matter, feeding it with itself. It eventually dims into a black hole when there is no longer any matter in it to devour: the depletion of information annuls the possibility of representation and it fades into oblivion.

Moreover, due to the black hole's immense gravitational pull, the light generated by the heated matter that tumbles into its bowels follows a hyperbolic trajectory—sometimes even looping back on itself instead of traveling in a "straight" line.[5] The

result is a penumbral sphere that encloses the pitch-black epicenter, as seen in Figure 18.2. Encircling this spherical void is an invisible edge called the "event horizon".[6] This is not a surface, neither is it a physical barrier in any familiar sense, but it is very real. Outside the event horizon, an object can escape the black hole's gravitational pull if it is moving sufficiently fast. Inside the event horizon, it would have to have an escape velocity that equals or exceeds the speed of light, something deemed impossible according to special relativity. It is, we could say, the perfect one-way membrane. The event horizon is referred to as such because if an event occurs within the boundary, information about it can never reach an external observer, making it impossible to determine if it has in fact occurred—thus raising fundamental epistemological questions. In a meaningful sense, then, a black hole is metonymized by its event horizon to the point of being indistinguishable from it, as far as the human eye is concerned: not only a boundary that nothing, not even light, can escape, but more importantly, the boundary of what is visible and thus potentially knowable. The pernicious charm of the recent image is that, in addition to beautifully depicting elements of knowability-by-virtue-of-visibility, it also presents the ultimate paradox—a perfectly invisible threshold of perceptibility within which looms visible an underworld of the unknown.

This enigmatic image cannot be grasped without fathoming, or at least pondering, the huge theoretical challenges connoted by its genesis. Black holes bend light to such an extent that it can wrap around their horizon multiple times. Any resulting image would therefore be too complicated to capture with existing apparatuses or to calculate with simple equations in humanly tolerable timespans. Consequently, although the math involved was known since the 1920s, it was only in 1978 that physicists got a first glimpse of what a black hole might actually look like. In that year, French astrophysicist Jean-Pierre Luminet programmed a calculation on an IBM 7040 mainframe, an early transistor computer with punch-card inputs. Notwithstanding his previously impossible calculations, he had no better recourse but to draw the resulting 10,000-point image by hand (Figure 18.2 down).

Directly observing M87* has required a huge collective effort, as its shadow is only 3.8 micro-arcseconds.[7] This took various advances in science and engineering. It also involved a kind of pointillism, as well as a kind of "linism". Of course, the hundreds of people responsible for this image did not have access to a telescope with an angular resolution comparable to that of the event horizon—such an instrument would have to be roughly the same size as our planet. Instead, the Event Horizon Telescope (EHT) that astronomers resorted to relying on was based on a radio-astronomy technique known as "very long baseline interferometry" (VLBI). Using this method, synchronized radio signals from an astronomical source are picked up by a global network of nine individual radio telescopes, located from Greenland to the South Pole and from Hawaii to the French Alps, acting in concert as one. The distance between each pair of telescopes determines a baseline, and together these lines effectively create a massive virtual telescope the size of a continent or larger. The signals received at each so-called antenna (each individual telescope dish) are tagged with a time stamp determined by an atomic clock at each location. Weather conditions must be favorable at all locations simultaneously. Once recorded, the amount of data is so staggering that it must be shipped on a hard disk to a central location for processing, where the individual signals can be correlated and used to build up a complete image (which, in this case, requires two years).

This technique therefore enables astronomers to build an Earth-scale mirror-like apparatus, with only little silvered points to indicate the site of each individual antenna. As a radio source is observed over the course of a night, the Earth's rotation means that each silvered point spins out into a line, filling in enough of the mirror to produce an image. The resolution that can be obtained using the VLBI technique is proportional to the frequency of observation, which is at the sub-millimeter wavelength. With this image, and others like it undoubtedly awaiting us in the near future, scientific modeling becomes depiction-by-way-of-observation and any attempt to distinguish one from the other can, in Vilém Flusser's words, only bring us grief.[8]

This elegant algorithmically driven abstract image has important parallels in, and repercussions for, art. In particular, its ideological origination is comparable to the political positions and conceptual paradigms that surrounded the birth of modern abstract art. Clearly, the philosophical presuppositions and historical roots that have informed the emergence of abstraction are multiple and diverse. Nonetheless, we can point to a single paradigm that both differentiates modernist abstraction from the realist paintings of the 19th century and simultaneously connects it to modern science—reduction. Only through reduction could artists progressively streamline and abstract the images of visible reality until all recognizable traces of the world of appearances have been removed, resulting in the deconstruction of visual art into its most basic elements and their combinations.[9] Whether the case in question is Malevich, Mondrian or Kandinsky, only repeated reduction could bring art to its logical conclusion.

Much in the same way that general relativity cannot account for quantum effects, this classical abstractive approach, attempting to explain the world through simple rules, fails to account for extreme phenomena such as black holes. It does not expound the M87* event-horizon image. Arguably, the universality of this by-now classical approach is limited by scale, broken by granularity and always medium-dependent. Study any canvas closely enough, and every circle will eventually appear grainy. Inspect Malevich's iconic black square and cracks will appear. If perfection is what we seek, abstraction by way of asceticism is not the way to go about it. In fact, looking at the M87* event horizon, it becomes clear that the scientific texts that have underwritten its theory represent the abstraction by way of abundance. Their evolution and recent historical conjuncture form an altogether inverse type of abstraction. The image born from these is indeed abstract, but it is the abstraction that relies on conceptual construction rather than deconstruction: calculation of appropriate conditions, their meticulous enhancement and distribution and finally image emergence.

We could think of this as the reversal of what Friedrich A. Kittler described as the *n*-1 dimensional signifier—the symbolic abstraction from time-space reality to object to image to script to code.[10] The proposed *n*+1 dimensional signifier resurrects these discarded dimensions[11] to calculate a cumulus at the peak of which awaits imagery that unfolds in time or, as in this particular case, in its freezing point.[12] Crucially, such additive or calculative abstraction is rarely an option, unlike traditional or reductive abstraction that is always a latent depictive or sensory possibility. Additive abstraction cannot be achieved by merely stripping away superfluous elements in the hope of arriving at a core that is indivisible beyond all question. Rather, it is a dressing up of the questionable, the bewildering and the paradoxical in the quest for visible perfection.

Visualizing invisibility or visualizing the end of visibility is indeed a paradox capable of crippling thought. It illuminates the inconsistencies and inadequacies of the concepts with which we make sense of our experience in the world. It casts doubt on

vision, our most reliable framework of perception and knowledge, and it questions our perception of knowledge itself. Whatever tower of thought we may have erected on the foundations of vision teeters with the M87* event-horizon image and, with slight perturbation, may plague other images too. Fortunately, such paradoxes can also become a vehicle of epiphany, if only we wield them skillfully enough. This is something the pre-Socratic philosopher Heraclitus understood well enough to have gained him the title "the Obscure". Nowadays, the paradox is increasingly seen to be inherent in every discipline we use to make sense of our world: analyzing the inner workings of the human brain as human societies become ever more dependent on artificial intelligence; deciphering the human genome while exposing ourselves to radiation-related mutations; and understanding the origins of our species as we contemplate our possible extinction. This, I suspect, is why Flusser referred to image-makers as "envisioners": to clarify that the very nature of what nowadays constitutes vision emerges from invisibility and must progressively adopt it.

If this thought is intimidating, we must bear in mind that our external experiences of nature are never processed directly, but rather always filtered through a web of concepts that develop and link to each other over time. If we are not careful, this mess of concepts and categories we use to understand nature becomes confused with nature itself. We develop models and theories that act as lenses to tell us what the world looks like. Sometimes, however, there is tension between our different models, our different concepts, which is a result of the world not fitting nicely into the web we have created. So is the case with this image. It frustrates us because its appearance—what we are told is in it and how we understand it—depends on which (lay) theory we have been taught or have chosen to embrace. Our present definitions of abstraction have been forged by European languages assuming that stable cores exist and are discoverable by way of aesthetic frugality and ascetic deconstruction. The M87* event-horizon image cuts through these beliefs. It not only depicts an absent, or at least an unattainable core, both theoretically and of course literally, but also reveals that some cores, theoretical as well as literal, simply defy asceticism or otherwise put vision out to pasture.

In our culture, the more technological an image is said to be the more authoritative it appears. This is why the widespread acclaim of the EHT's nonhuman precision has thus far guaranteed a welcoming reception for the M87* event-horizon image. This makes the paradox expressed in and by the image all the more troubling: an object with a huge mass cannot be seen nor can it be imaged. It can only be "seen" if we generate an image of what it *negates*—its only image is not of itself, but of what humans can neither see nor independently imagine.

Perhaps it is futile to talk about a black hole's image in terms of its appearance, since the black hole's "visible" attributes depend upon emissions of wavelengths that mostly lie far beyond what we humans can see. The very fabrication of our concept of "image" is defined by us and strictly for us. This conception is necessarily limited by how we have been evolutionarily equipped and, perhaps more importantly, how we have been culturally trained to expect that beauty and wonder would forever be aligned with precision rather than suggestion. In short, technological breakthroughs notwithstanding, the horizon of events available to the mind's eye remain painfully confined to the human skull.

This potential finitude infiltrating our modes of signification is only troublesome if one holds firm to the idea of image-by-observation as ineffably true. If one were of a different imaginative persuasion and believed that imaging were always a polemical

process by which theories currently interpreted as true were reviewed by skeptics keen to follow alternative narratives, and if such new narratives could be substantiated, then the volatile semiotics of the M87* event-horizon image would become a godsend. Indeed, it is beautiful therefore, as its abundant abstraction heralds the demise of many preconceptions—and the birth of many more.[13]

Notes

1 The largest type of black hole, containing a mass of the order of hundreds of thousands to billions of times the mass of the Sun.
2 In the unlikely event one were to travel to the heart of a black hole, there is little hope of returning with measurements or visual depictions, as black holes probably do not function as wormholes.
3 A Schwarzschild Black Hole is a static black hole with no angular momentum or charge. A Kerr Black Hole is one with angular momentum and no charge. A charged black hole can be of two types: with zero angular momentum (Reissner–Nordstrom) or with angular momentum (Kerr–Newman).
4 It is worth noting, if only in passing, that infinite gravity brings rise to a paradox that captures the fundamental conflict between quantum theory and general relativity. It states that if black holes behave how general relativity demands, then the objects falling into a black hole cannot behave how quantum theory demands. Conversely, if the quantum objects falling into a black hole behave as expected, then the geometric description of black holes must be faulty. Whichever theory we privilege, the other must be cast aside.
5 The shadow is of great interest as its size and shape depend mainly on the mass, and to some small extent the possible spin, of the black hole, thereby revealing its inherent properties.
6 For non-rotating (static) black holes, the geometry of the event horizon is precisely spherical, while for rotating black holes the event horizon is oblate.
7 A micro-arcsecond is one millionth of 1/3600th of a degree.
8 Vilém Flusser, *Into the Universe of Technical Images*, trans. N.A. Roth, Minneapolis: University of Minnesota Press, 2011, p. 42.
9 Lev Manovich, "Abstraction and Complexity", in Oliver Grau (ed.), *Mediaarthistories*, Cambridge, MA: MIT Press, 2007.
10 This is Kittler's interpretation of Flusser's theoretical ouevre. Friedrich A. Kittler, *Optical Media: Berlin Lectures 1999*, trans. Anthony Enns, Cambridge: Polity Press, 2010, pp. 226–227.
11 In Kittler's construal, this reverse trajectory begins from the zero-dimensionality of code, proceeds to the one-dimensionality of UNIX operating systems and the two-dimensionality of graphic operating systems and arrives at the three-dimensionality of augmented and virtual realities.
12 As an object approaches a black hole, the flow of time slows down for it, compared to the flow of time further away from the hole. Near a black hole, the slowing of time becomes so extreme that, from the perspective of a hypothetical observer outside the black hole, an object falling into it would appear frozen in time at the edge of the hole.
13 I am indebted to Ross Gibson's analysis of photography which is paraphrased here. Ross Gibson, *South of the West: Postcolonialism and the Narrative Construction of Australia*, Bloomington: Indiana University Press, 1992, p. 308.

Index

Page numbers in *italics* reference figures.